Tradition & Revolution in French Art 1700–1880

Paintings & Drawings from Lille

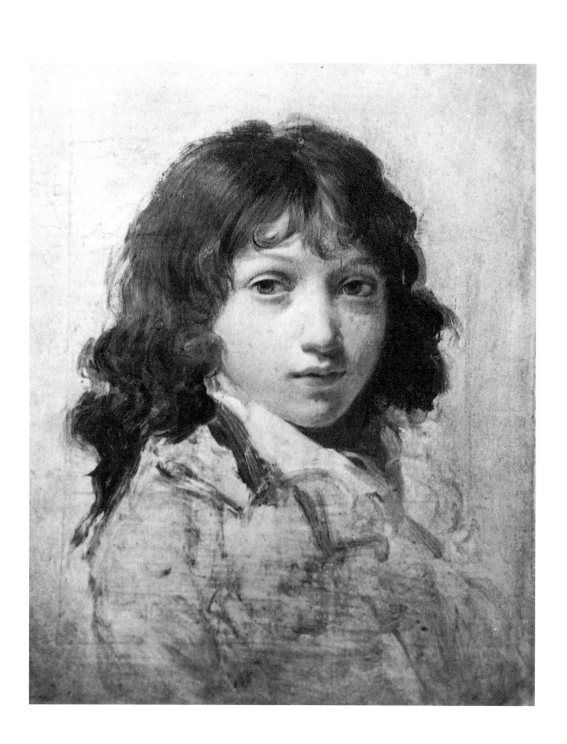

Tradition & Revolution in French Art 1700–1880

Paintings & Drawings from Lille

Essays by

Humphrey Wine
Jon and Linda Whiteley
Alain Gérard

National Gallery Publications, London

This book was published to accompany an exhibition at
The National Gallery, London
24 March–11 July 1993

First published in Great Britain in 1993 by
National Gallery Publications Limited
5/6 Pall Mall East, London SW1Y 5BA

ISBN 1 85709 018 7 hardback
ISBN 1 85709 017 9 paperback

British Library Cataloguing-in-Publication Data.
A catalogue record for this book is available from the British Library.

Library of Congress Catalog Card Number: 92–64372

Translation of French texts by Fiona Fraser

Designed by Simon Bell

Printed and bound in Great Britain by
Butler and Tanner, Frome and London

FRONT COVER
Théodore Géricault, *The Race of the Riderless Horses* (No. 55, detail).
BACK COVER
Jean-Charles Cazin, *Tobias and the Angel* (No. 26, detail).
FRONTISPIECE
Louis-Léopold Boilly, *Portrait of One of the Artist's Sons* (No. 5, detail).

Authors' Acknowledgements

We are indebted to Arnauld Brejon de Lavergnée, Conservateur Général, Musée des Beaux-Arts de Lille, who encouraged us to mount this exhibition and supported it with unstinting generosity and enthusiasm at every stage. In preliminary discussions of the exhibition and in subsequent visits to Lille the organisers and compilers were greatly assisted by Annie Scottez-De Wambrechies. We are also grateful to Barbara Brejon de Lavergnée for her help with the study and selection of the drawings, and to Annie Castier and A. Donetzkoff, also of the museum.

Among colleagues at the National Gallery who have helped us we are especially grateful to John Leighton for numerous valuable comments on the catalogue.

Many of the photographs of paintings and drawings at Lille were made specially for this catalogue and we are indebted to Philip Bernard for his efforts in this matter.

In addition we wish to thank the following: Janine and Reginald Alton, Colin B. Bailey, Aimée Brown Price, Anna Ottavi Cavina, Margaret Charlton, Candice Clements, Christina Colvin, Philip Conisbee, Iain Fenlon, John Gere, Colin Harrison, Lee Johnson, Simon Lee, Walter Liedtke, Christopher Lloyd, Danielle Maternati-Baldoux, Edgar Munhall, David Rankin-Hunt, Marianne Roland Michel, Anne Stevens, Marie-Paule Vial.

Contents

Foreword

This exhibition of paintings from Lille, tightly focused on French art of the eighteenth and nineteenth centuries, and necessarily excluding some of the great treasures of the Musée des Beaux-Arts, is one that the National Gallery very much wanted to devise and bring to London. At first blush this may seem surprising, for London is, outside France, perhaps already the richest of all cities in French art. Claude and Poussin are shown in remarkable depth in the permanent collection at Trafalgar Square. Enthusiasts of French Rococo painting have the Wallace Collection, and could hardly ask for more. And for the later nineteenth century, the combined Impressionists of the Courtauld Institute, the Tate and the National Gallery, though not great in number, include some of the most celebrated icons of the period.

But there are key aspects of French art which the British have never collected, which are little represented in our public galleries; and it is on these aspects that we have concentrated in selecting from the Musée des Beaux-Arts. Lille is rich precisely where we are poor: rich in the Neo-Classicism of David, in Géricault's and Delacroix's Romantic transformations of the classical tradition, and in Courbet's politically charged Realism. These artists are hardly represented at all in British public collections, as visitors to recent exhibitions in Paris will ruefully have observed. The London public will therefore, we believe, find much to discover and to enjoy.

We have begun with some of the serious history paintings of the eighteenth century (most notably Restout), attempts to escape from the routines of *galanterie* and to forge a new pictorial language, one capable of moral earnestness. In David's *Belisarius*, painted in 1781, we can show the picture that achieved it and changed French art in the process. Its lucid rhetoric of loyal service cast aside even now has the power to trouble the conscience, and in the pictures that come after it there is still much that can shock the modern viewer. Géricault's *Race of the Riderless Horses* quite subverts the supremacy of reason over animality, and points to a world where rational control breaks down and founders. Courbet's *Après-dinée à Ornans* in its self-conscious awkwardness seems designed to cause both aesthetic and social discomfort in the spectator, while in the *Medea* Delacroix coolly transforms Raphael's tender *Belle Jardinière* – the Virgin and Child with John the Baptist – into the child-killing mother of antique myth, the familiar formula dynamised and made demonic.

For Baudelaire David was 'le père de toute l'école moderne', yet his work found so little response in this country that no attempts were made to buy his paintings as, in the years after the war, several of the greatest left France for the United States. More surprising, but equally symptomatic of British taste, when his full-length portrait of Napoleon in his study, commissioned by the Duke of Hamilton and arguably the finest Neo-Classical portrait in Britain, had to be sold in 1954, it went not to a public collection in this country, but to the National

Gallery of Art in Washington. The same history of indifference holds true for most of the artists represented here.

But for a few months, thanks to our generous colleagues in Lille, all this will change. We shall be able to show not just the heroes of Neo-Classicism, Romanticism and Realism, welcome as they are. There is also a room devoted to that great 'little master', Boilly, the first significant showing of his work in this country, and, it may be hoped, the prelude to a full-scale exhibition. The presence of paintings by Bonnat, Amaury-Duval and Puvis de Chavannes, bought when their authors enjoyed great reputations and high prices, underlines the fact that the Lille collection, formed in its essentials in the last century, helps us to see how French art was regarded by the French themselves a hundred years ago.

The introductory essays tackle this point, and they address also the institutional structures that shaped the making and the reception of pictures in France during the two centuries represented here.

We hope therefore that this catalogue will provide students with a clear account in English of a crucial period in the history of French art, and illustrate its achievements through the masterpieces now in Lille.

The main purpose of the exhibition is not, however, didactic. It was conceived above all for pleasure, and we have ourselves had a great deal of pleasure in our close collaboration with our colleagues in Lille, to whom we owe a large debt of gratitude. When Diderot saw David's *Belisarius* at the Paris Salon in 1781, he was so moved that, for once, he could find no words of his own, and had to borrow those of Racine:

Tous les jours je le vois
Et crois toujours le voir pour la première fois.

We hope that the visitors to this exhibition will have the same repeated experience of discovery and delight.

Neil MacGregor, Director

Introduction

The Musée des Beaux-Arts at Lille, one of the great French provincial museums, is at present closed for building work. It is this closure that has made possible the loan of some of its finest paintings and drawings to London – and to other exhibitions held in Japan and the United States. The new galleries at Lille, scheduled to open in 1993, will reflect much new thinking concerning the purpose of the museum and will doubtless prompt further thoughts and initiatives, contributing to the debate in France as a whole concerning the purpose of her provincial museums.

In many respects the Lille museum is a special case – the importance of its collection of drawings is extraordinary, and its palatial accommodation and pre-eminence within the city is unusual (it is the only museum in Lille whereas in Marseilles, Lyon, Toulouse and Bordeaux there are many). The museum's collections of course reflect the region of which it is the capital: it is extremely rich in Flemish art, especially of the seventeenth century, and in work by local artists, of whom Wicar and Boilly (both well represented here) are perhaps the best known. But the collections are also of international scope and stature, as is demonstrated by this and other loan exhibitions.

With the development of a new network of European rail travel Lille will become the first major French provincial museum which the traveller from Belgium, the Netherlands, Germany or Great Britain is likely to encounter. As this catalogue shows, it can supply an admirable and in some respects surprising survey of French art of the eighteenth and nineteenth centuries.

Much that we have recently achieved in Lille is apparent in this exhibition. The scholarship of the catalogue springs in part from the intensive research conducted in recent decades, often for other exhibitions at Lille. Numerous paintings have been cleaned and some have been extracted from our reserves as the direct result of a vigorous programme of conservation and a thorough reappraisal of our holdings. One of the most beautiful paintings, *The Silver Goblet* by Chardin (No. 27), is a recent acquisition, for we have not despaired of extending the collection, although it has never been more difficult to do so.

However, much more conservation remains to be done, and whole portions of the collections await scholarly attention. Grateful though we are for all our local support we would like to be still more closely related to the educational, commercial and administrative life of the city and the region. The museum should be an institution in which local politicians take pride, which local businesses compete to support, a centre both for the teaching of art history and the training of artists. I hope that the success of this exhibition in London in demonstrating the importance of Lille's collection of French art will help to make the museum central to the life of Lille itself.

A. Brejon de Lavergnée, Conservateur Général Chargé du Musée des Beaux-Arts de Lille

The End of History? Painting in France c.1700–1880

Humphrey Wine

At the Exposition Universelle of 1867 only one of the eight painting prizes went to a history painter. Six prizes were awarded to painters of genre (including historical genre) and one to a landscapist. Such a situation, in which scenes of everyday life so overwhelmingly received official recognition at the expense of history painting, would have been inconceivable in France around 1700. Then 'history painting', a term used to cover scenes from the Bible, the stories of the saints, myth, ancient history and allegory, was regarded as superior to painting of every other kind – a supremacy accepted without question since the Renaissance. Further, it had recently been institutionalised in France, where the rules of the Académie Royale de Peinture et de Sculpture adopted in 1664 permitted only history painters to become professors and hold high office.

History painting's supremacy was rooted in its subject matter, the grand themes of traditional religion and ancient literature, from which it followed that history was not something which could be copied from life or could overtly refer to the present day, but had to incorporate qualities of timelessness and universality. Unlike portraiture or still life therefore, a history painting required an intellectual and imaginative effort from its inception. The painter's imagination, however, was not supposed to run free, but to be tempered by learning: settings and costumes were to be probable for the time and place of the story being depicted, kings were supposed to look regal and heroes and heroines to look suitably noble. What was required was the imitation of human life in its superior rather than its average forms. Academic theory accordingly approved of Poussin's figures, which were idealised to the point of abstraction, but not of the more earthy types of Caravaggio.

A further reason for the supremacy of history painting, which inevitably increased the difficulties in its execution, was its function. This was not primarily to be decorative, but to be morally elevating. Painted histories therefore had to be easily understandable. The depiction of the variety of human passions became a particular concern in this connection, and from the end of the seventeenth century the plates from numerous editions of Charles Le Brun's lecture on human expression were copied by generations of art students. In the later seventeenth century, when painting practice was most dominated by academic theory, it was less important for a painting to be immediately agreeable than to be readily understood, less important for it to please than to instruct.

The tension between moral instruction on the one hand and visual pleasure on the other was connected with that between drawing and colour. If a story was to be told clearly, with the outcome imposed on the viewer rather than left to his imagination, a Poussinesque manner of painting which emphasised outline, gesture and expression must have seemed appropriate. For André Félibien

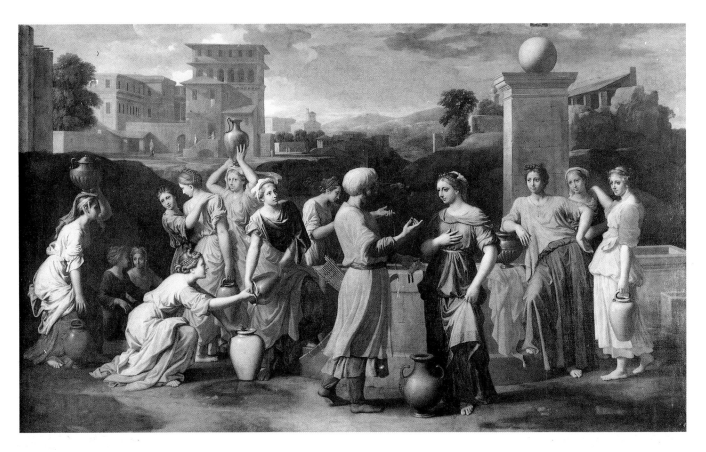

Fig. 1 Nicolas Poussin, *Eliezer and Rebecca at the Well*, 1648. Oil on canvas, 118 x 197 cm. Paris, Musée du Louvre.

(1619–95), at one time official historiographer to Louis XIV, it was only necessary to imitate Poussin's *Eliezer and Rebecca* (fig. 1) to make a second masterpiece. Hence the dominance, around 1660–90, of those who argued that the most important element of painting was drawing not colour. By 'drawing' was meant not just outline but the design of the painting, its preliminary conception, and by 'colour' was meant not just different shades but the manual application of paint.

It followed from this that drawing in its extended sense was an intellectual activity, whereas colour was a manual activity. Both the function and style of painting therefore became bound up with the question of the status of painters: were they artists or artisans? In a self portrait of 1690, now in the Louvre, Pierre Mignard (1612–95), the then director of the Académie, shows himself surrounded by antique sculpture and books, symbols of his learning, and significantly he is engaged in the art of drawing rather than painting. In France,

by the late seventeenth century, the function and manner of painting and the status of painters were interrelated issues.

Roger de Piles (1635–1709), appointed Conseiller Honoraire Amateur at the Académie in 1699, provided a theoretical justification for the more visually pleasing style attempted by some French academicians from around 1690. He argued that a painting could not in practice instruct unless the spectator was first drawn to it. As he crudely put it: 'the first glance to painting is what beauty is to women, when this quality is missing, one does not bother to examine the rest.' One may assume that patrons and painters broadly agreed with this assessment.

Certainly from the closing years of the seventeenth century the more purely visual qualities of painting began to emerge and French painters looked to Rubens as well as to Poussin, to the Venetian School as well as to the Roman. One may compare Mignard's *Perseus and Andromeda* of 1679 (fig. 2) with that of C.-A. Coypel painted in 1727 (fig. 3). Mignard's Andromeda remains petrified in spite of having been rescued, and pleasure actual or anticipated has been suppressed; that of

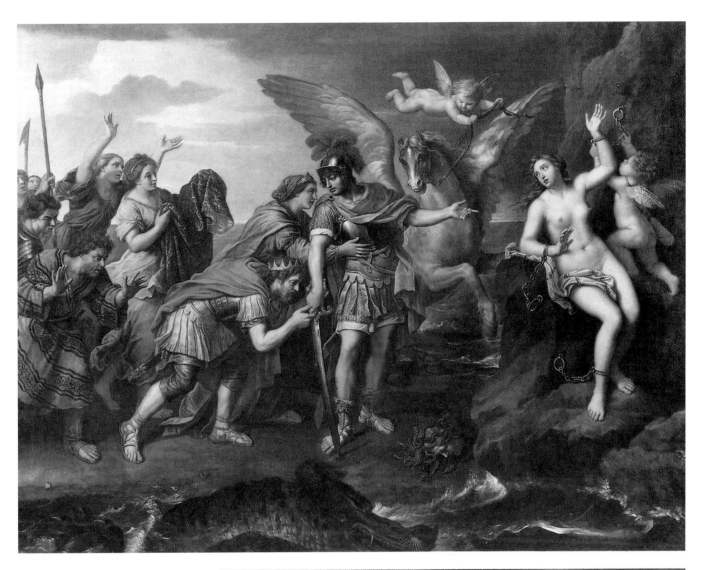

Fig. 2 Pierre Mignard, *King Cepheus and Queen Cassiope thank Perseus for rescuing their Daughter Andromeda*, 1679. Oil on canvas, 150 x 198 cm. Paris, Musée du Louvre.

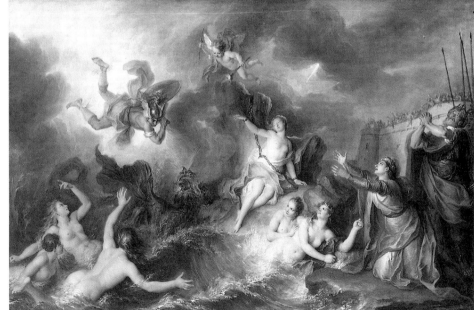

Fig. 3 Charles-Antoine Coypel, *Perseus rescuing Andromeda*, 1726–7. Oil on canvas, 131 x 196 cm. Paris, Musée du Louvre.

Coypel with her languorous despair, her vulnerability emphasised by the line of the neck, her softer modelling, her ankle exposed as ankle rather than attachment for a chain, is suggestively erotic. Neither Coypel nor other early eighteenth-century history painters, however, abandoned the idea that history painting should illustrate a text. On the contrary, in 1727 an article in the *Mercure de France* noted that Coypel's painting was based not on Ovid, but on Hyginus, who alone explained Andromeda's predicament as having arisen from her mother vaunting Andromeda's beauty at the expense of that of Neptune's sea nymphs, who are duly shown in the painting. Coypel was therefore careful to legitimate his generous employment of

the female nude; nevertheless his painting was emphatically designed to delight the eye and stimulate the imagination of the male viewer.

Leaving aside religious painting, the moral earnestness associated with history painting was largely discarded during the first seventy years or so of the eighteenth century in favour of erotic subjects of which Jean-François de Troy's *Rinaldo and Armida* (No. 46) is a modestly clothed example. The reinstatement of morally didactic subject matter, proposed by the writer La Font de St Yenne in 1747, was more widely sought some twenty-five years later. Meanwhile the vacating by history painting of the moral high ground left a space for painters of other genres to occupy. This was not taken by Watteau. True his *Pilgrimage to the Isle of Cythera* (Paris, Louvre) had used some of the conventions of history painting – size,

Fig. 4 Jean-Baptiste Greuze, *The Village Betrothal*, 1761. Oil on canvas, 92 x 117 cm. Paris, Musée du Louvre.

gesture, expression and distancing of the subject from everyday reality – but it is an amoral high ground which Watteau's pilgrims occupy and from which they so gracefully descend. Watteau's type of subject was hived off into a specially created genre, the *fête galante*.

More threatening was the example of Greuze. Diderot, referring in his review of the Salon of 1763 to that artist's *Filial Piety* (St Petersburg, Hermitage), wrote: 'This is moral painting. What then, hasn't the brush been too much and for too long devoted to debauchery and vice? Should we not be pleased to see it compete at last with dramatic poetry in touching us, instructing us, correcting us and inviting us to virtue?' (*Salon of 1763*, p. 233.) And of Greuze's *Punished Son* (No. 62) he exclaimed 'What a lesson for fathers and for children!' (*Salon of 1765*, p. 158.) Diderot's view of the function of painting was traditional, ultimately based on Alberti's adaptation to the visual arts of Quintilian's and Cicero's theories of rhetoric. The latter had explained the aims of oratory as being to teach, to delight and to move. This traditional role of history painting was, according to Diderot, capable of being fulfilled by scenes of everyday life, at least in Greuze's hands. On the other hand, Diderot's criticism of history paintings shown at the Salons was widespread. François Boucher, Jean-Baptiste Pierre, Noël Hallé and Louis Lagrenée the elder were among the history painters verbally lashed by him, all of them in his view, and increasingly in the view of other critics, unable to fulfil the history painter's true function.

Greuze's pictures did more than just preach morality. They were also emotionally affective, as Diderot showed by imagining *The Ungrateful Son* (No. 61) being addressed by his sister: 'Wretch! What are you doing? You push your mother away! You threaten your father! Get down on your knees and apologise.' (*Salon of 1765*, p. 156.) In the same year Diderot was explicit in accepting Greuze's pictures, even drawings, as history paintings: 'Yet I swear that *The Father reciting the Bible to his Family*, *The Ungrateful Son* and *The Village Betrothal* [fig. 4] of Greuze . . . are for me as much history paintings as Poussin's *Seven Sacraments*, Le Brun's *Family of Darius* or Van Loo's *Susanna*.' (Quoted by E. Munhall in Paris 1984–5, p.248.)

Greuze did not himself challenge the supremacy of history painting as a genre: he himself tried and failed to gain admission as a history painter with a subject from ancient history, *Septimius Severus reproaching Caracalla* (Paris, Louvre). In any event, Greuze's tragic subjects were unappealing to many and it was twelve years before he exhibited paintings based on the drawings of *The Ungrateful Son* and *The Punished Son*.

Greuze did however challenge history painters to produce work which was as affective and morally didactic as his own. After the disappointments of the death of the promising Jean-Baptiste Deshays (1729–65), and of Fragonard's failure to follow up the grand manner of his *Coroesus and Callirhoe* (1765 Salon; Paris, Louvre), or indeed to exhibit at all after 1767, a serious attempt to revive history painting was made following the comte d'Angiviller's appointment as Directeur des Bâtiments (Director of Royal Buildings) in 1774. This was more sustained than the attempt instituted in 1747 by the then Directeur des Bâtiments, Lenormand de Tournehem, and the director of the Académie, C.-A. Coypel, which petered out after the former's death in 1751.

D'Angiviller instituted regular government commissions for artists to paint large-scale pictures to be exhibited at the Salon. Their function was, he said, to 'reanimate virtue and patriotic sentiments' (1776). (Locquin 1978, p. 51.) Part of the programme was specifically to commission subjects based on national, as opposed to ancient, history. This was not an entirely original idea. Charles-Joseph Natoire for instance had painted a series on the life of the fifth-century King Clovis in the late 1730s, which, however, probably alluded to the alleged achievements of Louis XV rather than containing any more general moralising message. Nor was it a new idea for the government to commission moralising history paintings as such. In 1764 Abel Poisson, the marquis de Marigny, then the Directeur des Bâtiments, and Charles-Nicolas Cochin, secretary of the Académie, commissioned four paintings (only three were completed) for the king's château and country retreat at Choisy with the specific purpose of providing Louis XV with examples of the virtuous actions of Roman emperors. The critical response to the paintings was lukewarm if not hostile, and Louis XV rejected them as too serious for Choisy. D'Angiviller's programme was, however, more ambitious – eight large-scale paintings were proposed for the 1777

Salon, to be followed by eight more at every successive (biennial) Salon, all destined, along with the paintings in the royal collection, for a projected museum at the Louvre. Furthermore the subject of each painting had to conform to some specific moral category. Thus Brenet's *Caius Furius Cressinus* (1775 and 1777 Salons; fig. 5) showing the hard-working farmer explaining that his industry, rather than sorcery, had produced his abundant crop, was commissioned to show an example of an 'Act of Encouragement to Work among the Romans'. These paintings differed from previous state commissions in one important respect – whereas former commissions had usually glorified the king, or, as in the case of the Choisy pictures, been painted as exemplars for the king and a small elite, the messages in d'Angiviller's commissions were directed at a wider public.

Although in many cases the critical reaction was cool, there were positive consequences from the point of view of history painting. Firstly, and at the most mundane level, there were financial rewards – each commissioned painting was to be bought by the government for 4,000 *livres*. Although this was a small amount compared to the 24,000 *livres* which d'Angiviller was in 1782 prepared to spend at auction on the king's behalf for Greuze's *Village Betrothal* (fig. 4) – it in fact realised 16,650 *livres* – it was nevertheless a respectable sum, especially considering the difficulties contemporary painters were experiencing in selling history paintings at all. Secondly, history painting as a genre had its supreme status reaffirmed at a time when on the administrative front d'Angiviller was increasing the authority of the Académie and the Salon as against rival institutions. Finally, after years when the stars of the Salon had been practitioners of other genres – Greuze, Chardin, Maurice-Quentin de La Tour, Claude-Joseph Vernet – history painting started to produce stars of its own, artists who were admired by all or most Salon critics. The success of François-André Vincent at the 1779 Salon with *The Death of Leonardo da Vinci in the Arms of François I* (Amboise, Hôtel de Ville) was followed by that of François-Guillaume Ménageot at the Salon of 1781 with *President Molé seized by Rebels during the Fronde Uprisings* (Paris, Chambre des Députés). These must have been significant encouragements both to them and to

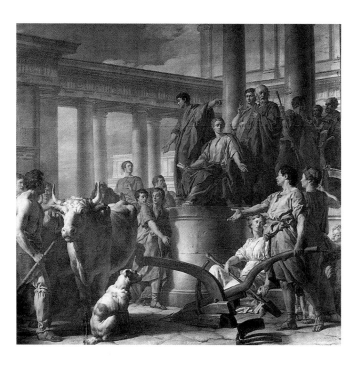

Fig. 5 Nicolas-Guy Brenet, *Caius Furius Cressinus*, Salons of 1775 and 1777. Oil on canvas, 324 x 326 cm. Toulouse, Musée des Augustins.

other painters born in the 1740s, such as David, Suvée and Peyron, who were now reaching maturity. At the same time the social identity of the artist was changing: painting came to be seen more as a vocation than a craft, which promoted the artist's sense of individuality as well his status. It is not entirely coincidental that by the 1780s recognition of the artist as an exceptional type, excused from the usual rules of society, began to emerge.

Used to the regularity of the Salons and of the attendant published criticism, these younger painters acknowledged the public nature of history painting. J.-J. Taillasson, then a student at the Académie, restated a notion expressed by Alberti centuries before when he commented: 'Monsieur Vien is currently painting a picture of the Annunciation which is of no great beauty: he's doing it for the money. Now he doesn't think beyond the main chance, and leaves it to youth to work for glory; that's not something for his generation.' (Quoted by Abbé Charles, 1921, p. 134.) In the context of the Salons and Salon criticism, however, Taillasson's comment was also an acknowledgement that a history painting needed validating by persons beyond its commissioner, namely by that indefinable mass, part real, part literary construct

– 'the public'. The need to gain the approval of a public wider than the patron and his or her immediate circle was a significant change; painters had to respond to a public mood which in the later eighteenth century was increasingly seeking something beyond the charming but amoral eroticism of ancient authors such as Ovid and Apuleius, whose stories had hitherto provided so much of painting's source material. J.-L. David's *Belisarius* (No. 35) both caught and helped to promote this mood, and in it Diderot saw the re-emergence of 'la grande manière' of French seventeenth-century painting.

David was an exemplar of a new kind of artist, committed to imposing his art and himself on society; manipulative of the Salon to attract notice, and of his clients to express independence. This was certainly true in respect of *The Oath of the Horatii* (see No. 36; fig. 64), which was submitted late at the 1785 Salon and which was larger than the size commissioned on the king's behalf. David's part in the history of history painting was to underline its relevance and the status of history painters. He offered both instruction and sentiment by presenting a painful moral choice – duty to state as against duty to family in the *Horatii*, and similarly in *The Lictors bringing Brutus the Bodies of his Sons* (1789; Paris, Louvre), whose execution for treason Brutus had himself ordered. By his choice of subjects, so affirmatively of the Antique, and by his adoption of certain traits of Poussin, whose posthumous reputation was then scaling new heights, David stopped, at least temporarily, history painting being blurred at the edges by the incursion of other genres.

Both David's *Horatii* and his *Brutus* were part of d'Angiviller's programme, and so intended by the latter 'to reanimate virtue and patriotic sentiments'. This programme had room only for secular subjects, although its twin purposes could be accommodated by the subject matter of some religious paintings, for example Carle Van Loo's *Vow of Louis XIII*, exhibited at the Salon of 1746 and then installed in the Paris church of Notre-Dame-des-Victoires. Religious subjects remained an important part of the history painter's repertoire until the Revolution, but there were fewer new churches built in the eighteenth century than in the seventeenth and so less demand for paintings to fill them. This meant not only fewer commissions, but also fewer exhibition opportunities for

artists, since aside from the Salon, which did not occur regularly until after 1736, commissions destined for churches to which the public had access were a particularly valuable form of publicity for painters. Paintings in churches were on permanent display and were often referred to in Paris guidebooks. One author connected the relative dearth of religious commissions with painting's decline in quality: 'One is forced to believe that it is the lack of opportunities to undertake substantial works [in churches] which has stopped the progress of the greater part of our painters. The painting which has just been presented at the Foundlings Chapel, where M. Natoire uses all of his knowledge, confirms the public in the idea it had of him.' ([baron Louis Guillaume Baillet de Saint Julien], *Lettre sur la peinture, la sculpture et l'architecture à M . . .*, 2nd edition, Amsterdam 1749, p. 60.)

Because working for the religious institutions of Paris was one way of attracting and remaining in the public eye, artists had long been willing to undertake such commissions at reduced prices. The practices of some painters were significantly weighted towards religious painting. Foremost among these was Jean Jouvenet (see No. 67), who worked at numerous churches including the Royal Chapel at Versailles and the cathedral of Notre-Dame, and his nephew Jean Restout. In the latter's *Supper at Emmaus* (No. 88), a simple composition presents the viewer with an easily understandable message.

Religious imagery whether in the form of paintings or prints was probably the most frequently produced, the most widely owned and the most accessible. It was not confined to large altarpieces. Many smaller devotional pictures were cheap painted reproductions, such as Watteau is said by his biographers to have turned out when he first arrived in Paris, but also included smaller paintings on canvas for (presumably) private contemplation (No. 21) and delicate, finely executed paintings on copper such as Lagrenée painted for Madame Geoffrin (fig. 6). As in so many other aspects of life, however, the French Revolution was a watershed. Churches and religious institutions were stripped of their paintings, which in some cases were later retained for the Musée National (which opened in 1793) or for provincial museums, while others were eventually restored to

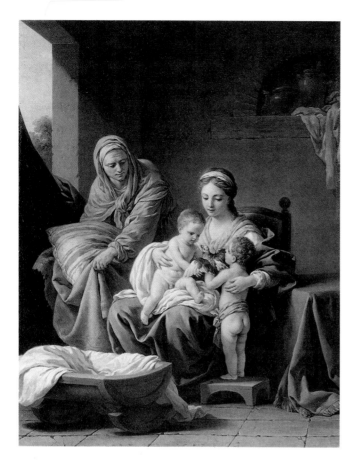

Fig. 6 Louis-Jean-François Lagrenée, *The Virgin and Child with Saint Anne and the Infant John the Baptist*, 1771. Oil on copper, 42 x 33 cm. New York, private collection.

their owners. Biblical subjects were not entirely absent from the Salons of 1789–99, but those exhibited were often devoid of religious significance, such as François-Xavier Fabre's *Death of Abel* (1791 Salon; Montpellier, Musée Fabre), which was essentially a study of the male nude.

The Revolutionary Salons were dominated by history paintings with secular subjects from ancient history. Louis Gauffier's *Generosity of the Roman Women* exhibited at the 1791 Salon (fig. 7) is paradigmatic, showing the women of ancient Rome voluntarily giving the Republic their gold and jewellery, an episode of exemplary patriotic conduct which had actually been emulated by a group of artists' wives in 1789, soon after the fall of the Bastille. This continuity of the perceived function of painting to 'reanimate virtue' can be seen too in the brochure which accompanied David's paying exhibition of his *Sabines* (see No. 37; fig. 66), in which he said he wished 'to contrib-

ute to taking the arts to their true destination, which is to serve morality and to elevate souls. . . .' David's justification for a paying exhibition – the first such held by an individual artist in France – namely that the ancient Greek painter Zeuxis had by so enriching himself been able to make frequent gifts of his masterpieces to his country, confirms how history painting and painters had entered the public sphere in a way inconceivable fifty or so years earlier (Paris, Versailles 1989–90, pp. 329–30).

This new relationship between history painters and the public allowed a new kind of history painting to emerge in France during the Revolutionary years. Contemporary events, hitherto allegorised, as in Rubens's Medici Cycle (1622–5; Paris, Louvre), were depicted using the conventions of history painting. The difficulty was to prevent such painting 'degenerating' into mere genre, since the more painting partook of the everyday the less it partook of the timeless universality which was one of history painting's features. The other difficulty during the Revolutionary years was that events moved so fast politically that between the planning of a large-scale work and its execution the painting might become inappropriate, if not dangerous, to finish. The political discrediting, and indeed execution, of some of the participants in David's projected *Tennis-Court Oath* was largely the reason for its not being finished, although a highly

Fig. 7 Louis Gauffier, *The Generosity of the Roman Women*, Salon of 1791. Oil on canvas, 194 x 113 cm. Musée de Poitiers.

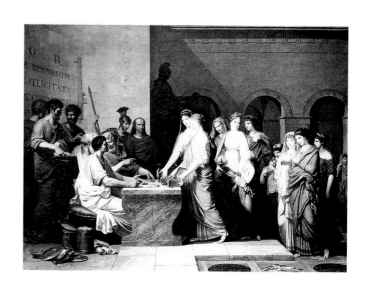

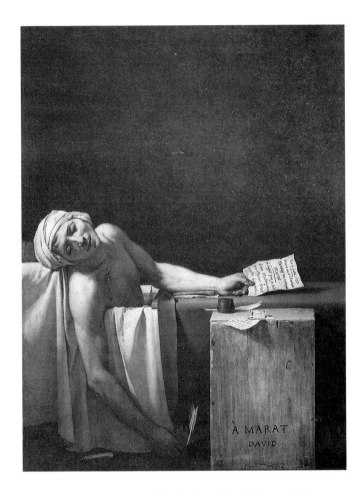

Fig. 8 Jaques-Louis David, *The Death of Marat*, 1793. Oil on canvas, 165 x 128 cm. Brussels, Musées Royaux des Beaux-Arts.

finished drawing was completed and exhibited at the 1791 Salon (Versailles). *The Death of Marat* (fig. 8), requiring only one figure, did not share the complexity of *The Tennis-Court Oath*, and was finished by David in October 1793, three months after he started it. That *The Death of Marat* is on the borderline of history painting and posthumous portraiture underlines the problems faced by history painters in showing a contemporary event. David solved this difficulty by reducing detail to what was significant, idealising Marat's features and body, and recalling images of the dead Christ in the pose. But even an experienced academician like F.-A. Vincent, in trying to depict the merits of contemporary agriculture, could produce the (presumably unintentional) irony of an idealised farmer pointing to the least dignified part of his cattle's anatomy (fig. 9).

Few paintings successfully overcame the difficul-

ties of making a transcendent image of a contemporary event. The two best-known images of the first half of the nineteenth century, Géricault's *Raft of the Medusa* (see Nos. 56 and 57; fig. 73) and Delacroix's *Liberty leading the People* (Paris, Louvre), both inspired by the recent past, are atypical in their successful appeal to the heroic and in not attempting any precise historical record. Propagandist images of Napoleonic courage or clemency, commissioned by the state, often suffered from too much detail in their attempts to document actual events and the people present at them, or relied too greatly on gestures traditionally taught in the Académie, which failed to translate well into a contemporary idiom (fig. 10). Antoine-Jean Gros's efforts to record recent Napoleonic events in the grand style of history painting were more successful, but only at the expense of historical truth. When more emphasis on historical and archaeological exactitude was demanded, as with Horace Vernet's battle scenes in the National Gallery, London (inv. nos. 2963–6), commissioned by the duc d'Orléans (later King Louis-Philippe), the effect was to overwhelm the significant moment with the depiction of the merely anecdotal.

Most history painting after 1789, however, was not concerned with contemporary events – Girodet's *Endymion* (fig. 11) was highly praised when exhibited at the 1793 Salon. During the last decade of the eighteenth century Prud'hon alternated between allegories and erotic reveries, two

Fig. 9 François-André Vincent, *The Ploughing Lesson*, Salon of 1798. Oil on canvas, 213 x 313 cm. Bordeaux, Musée des Beaux-Arts.

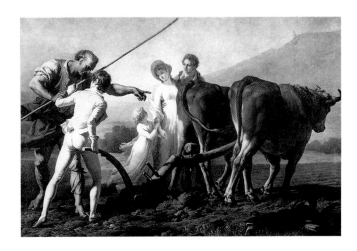

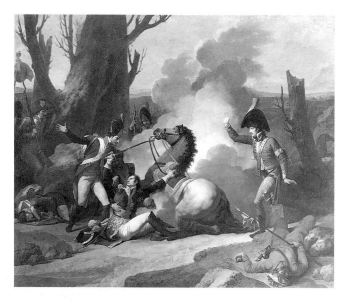

genres which he continued to practise together with portraiture. In spite of the vogue for ancient history, the reign of Psyche and Cupid over the imagination of French painters was not terminated by the Revolution.

In the nineteenth century, just as under the *Ancien Régime*, large-scale secular history painting was substantially dependent on state commissions. Examples are the commissioning from 1833 of a

Fig. 10 Jean-François-Pierre Peyron, *The Death of General Valhubert*, 1808. Oil on canvas, 228 x 278 cm (with additions). Musée National du Château de Versailles.

Fig. 11 Anne-Louis Girodet, *Endymion: Effects of Moonlight*, Salon of 1793. Oil on canvas, 197 x 260 cm. Paris, Musée du Louvre.

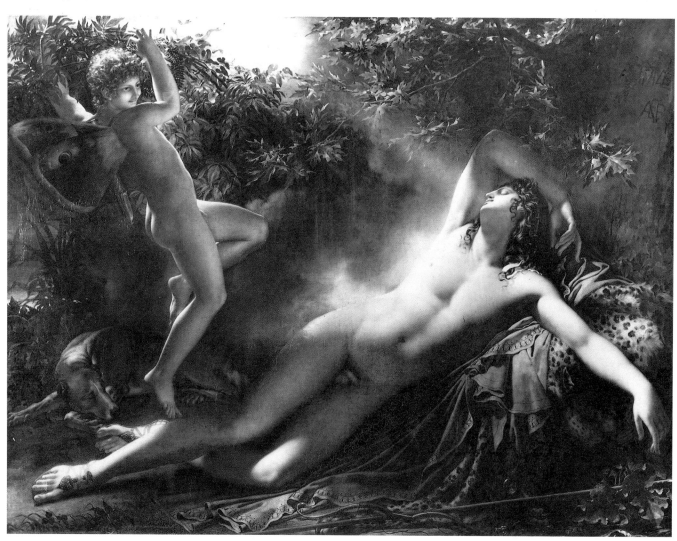

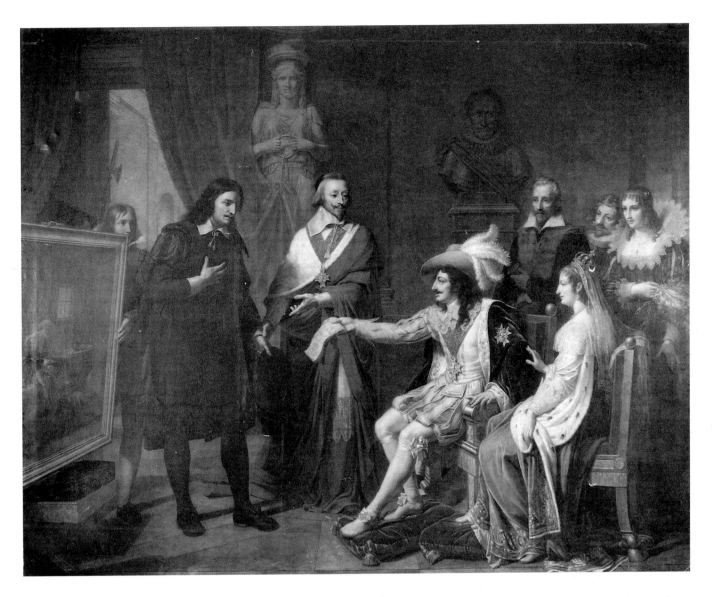

Fig. 12 Jean-Joseph Ansiaux, *Cardinal Richelieu presenting Poussin to Louis XIII*, 1817. Oil on canvas, 262 x 325.4 cm. Bordeaux, Musée des Beaux-Arts.

cycle of paintings of subjects from French national history for the Galerie d'Apollon in the Louvre, and of a suite of pictures for the Galerie des Batailles at Versailles, on which construction began in 1835. The paintings themselves received lukewarm praise from critics, a criticism of the paintings in the Galerie d'Apollon being that historical exactitude had made for tedious pictures lacking in emotion, whereas of Vernet's three battle scenes for the Galerie des Batailles one critic said that the impression produced by viewing them 'falls far short of the gravity and grandeur of the events which they represent.' (Marrinan 1988,

p. 152.) Yet these paintings were popular with the public, which in turn satisfied its own appetite for the anecdotal by buying numerous small-scale paintings of intimate scenes from the lives of historical characters. The vogue for national history, which had started in the 1770s, gathered pace after the restoration of the Bourbons in 1815, and provided subject matter for easel pictures in which painters attempted to depict historical events with an archaeological attention to detail. In J.-J. Ansiaux's *Richelieu presenting Poussin to Louis XIII* of 1817 (fig. 12), the artist's careful research is evident in the features both of Poussin, taken from his self portrait in the Louvre, and of Richelieu, copied from portraits by Philippe de Champaigne. Ironically, the incident shown is unrecorded and unlikely. It was Paul Delaroche's

ability to combine historical detail with emotion, as in his *Execution of Lady Jane Grey* (1833; London, National Gallery), which was responsible for his success. The more anecdotal subjects taken from national history, such as Ansiaux's picture, provoked the formal recognition of 'genre historique' as a new category of painting part way between history painting and genre.

Although the term 'genre historique' was not used, at least officially, before 1833, a distinction between paintings of this type and paintings of the grand style was noted in the first decade of the nineteenth century. David was reported to have remarked in 1808: 'In ten years the study of the Antique will be forsaken. All these gods, these heroes will be replaced by knights, by troubadours singing under the windows of their ladies at the foot of an ancient dungeon.' (Pupil 1985, p. 396.) A new found enthusiasm for the medieval was encouraged by the museum of medieval French sculpture opened in 1795 at the former convent of the Petits-Augustins, and was shared by public and artist alike. Painters eagerly sought new source material in Shakespeare, Byron, Scott and Goëthe, as well as in the myths of the supposed Nordic

Fig. 13 Jean-Auguste-Dominique Ingres, *François I receives the Last Words of Leonardo da Vinci*, Salon of 1824. Oil on canvas, 40 x 50.5 cm. Paris, Petit Palais.

Fig. 14 Jean-Victor Schnetz, *Suffering People invoking the Aid of the Virgin*, Salon of 1831. Oil on canvas, 282.5 x 490 cm. Paris, Musée du Louvre.

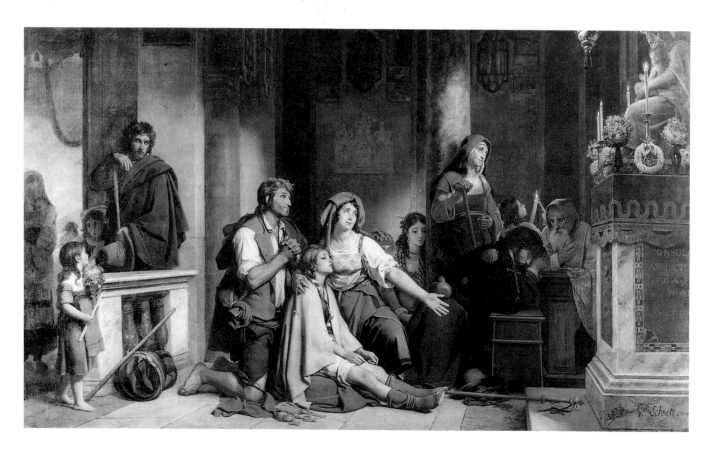

bard Ossian, in whose works were to be found the mystery and the themes of death and consuming passion dear to the Romantics. Implicit in David's comment, however, was a concern not merely with the antique being replaced by the gothic, but with the heroic being replaced by the anecdotal, the ideal by the specific, the public by the intimate. From this point of view David might have been more sympathetic to Delacroix's *Medea* (No. 39), or even Géricault's *Race of the Riderless Horses* (No. 55) in which a genre subject is transformed into a picture of elemental forces, than to a painting like Ingres's *François I receives the Last Words of Leonardo da Vinci* (fig. 13). When the latter was exhibited at the 1824 Salon, Stendhal said the work belonged to the minor arts and advised porcelain painters to use it as a model.

Laments at the blurring of boundaries between history painting and genre were a recurrent theme of nineteenth-century Salon criticism, and went hand in hand with complaints about the decline in the quality of history paintings. Merson's *Wolf of Agubbio* (No. 76) painted in 1877 bears witness to the longevity and popularity of the genre historique, in this case as applied to one of the legends of Saint Francis. Although painting of traditional religious subjects maintained a stricter boundary between itself and genre than did painting of secular history subjects, scenes of prayer and death offered possibilities for a mixture of religiosity and Greuzian sentiment. J.-V. Schnetz's *Suffering People invoking the Aid of the Virgin*, Salon of 1831 (fig. 14), demonstrated by its size, some three metres high by five wide, and its destination, the church of St-Etienne-du-Mont in Paris, that the traditional scope of history painting could be widened. Equally, an earlier painting by the same artist, *Saint Geneviève distributing Bread during the Siege of Paris*, Salon of 1822 (fig. 15), contains figures (at the left) which recall David's *Belisarius* (No. 35), as well as figures and architecture, in the background, which have the specificity of genre. Schnetz's paintings show that, even in the religious sphere, history painting was not free of contamination by genre.

After the Restoration there was considerable state spending on religious painting. Idealisation of form in religious art was encouraged by Victor Cousin, whose lectures during the period 1815 to 1821 (repeatedly published during the nineteenth

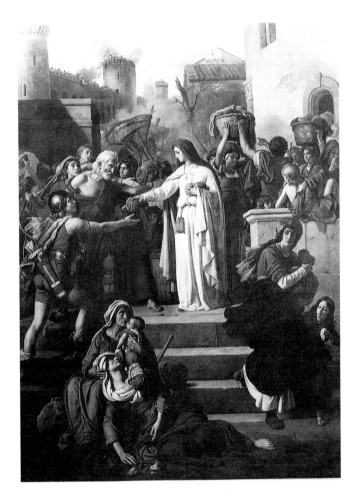

Fig. 15 Jean-Victor Schnetz, *Saint Geneviève distributing Bread during the Siege of Paris*, Salon of 1822. Oil on canvas, 470 x 336 cm. Paris, Notre-Dame-de-Bonne-Nouvelle.

century as *Du vrai, du beau, du bien*) praised the tranquillity of Eustache Lesueur and Raphael in contrast to the voluptuousness of Rubens. Ingres's taste for Raphael was thus validated. From the late 1830s the French Catholic aesthetic moved towards the Quattrocento and in particular Fra Angelico (active 1417–55), because of the perceived spirituality of his art. Hippolyte Flandrin was invested with the role of the archetypal Christian artist. Mural paintings, which he and others executed in substantial quantities – possibly in greater numbers than ever before in the history of French painting – were seen as allowing the church more control of content, given that they were executed in situ. There was, however, no single style of painting for religious art. The state awarded commissions without reference to style,

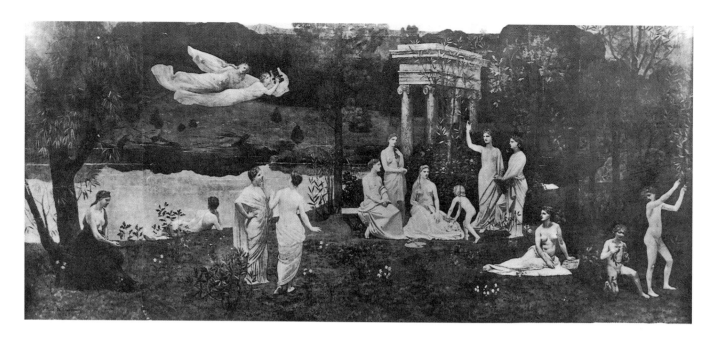

Fig. 16 Pierre Puvis de Chavannes, *Sacred Grove, Beloved of the Arts and Muses*, Salon of 1884. Oil on canvas, 460 x 1,040 cm. Lyon, Musée des Beaux-Arts.

so that in the same period that Flandrin was decorating St-Germain-des-Prés (No. 51) another of Ingres's pupils, Henri Lehmann, exhibited an altarpiece in a late Mannerist style (*At the Foot of the Cross*, 1848 Salon; Paris, St-Louis-en-l'Isle) and Delacroix painted his Rembrandtesque *Pietà* (1843–4; Paris, St-Denis-du-St-Sacrament). Furthermore, in spite of a widespread admiration for the Quattrocento, paintings were not often executed in fresco. Victor Mottez was among the artists who did attempt the technique, and in 1835 wrote approvingly of it to the architect Charles Benvignat (see No. 80). (Foucart 1987, p. 59.) However Mottez soon had to restore the frescoes he executed at St-Germain-l'Auxerrois using wax, presumably in a technique similar to that employed by Flandrin (see No. 51).

The permanence of mural decoration, according to the critic Gustave Planche, gave it a gravity and elevation which cabinet pictures, liable to constant changes of location, could never possess (Foucart 1987, p. 61.) This did not reflect any conventional religious feeling on the part of Planche who was anti-clerical, but rather a renewed appreciation of monumental painting, both religious and secular. Puvis de Chavannes was a practitioner of the latter (see No. 83). His huge allegorical canvases (thirty square metres or more was not uncommon) decorated the walls of a number of France's public buildings, particularly municipal museums and city halls – the new 'cathedrals' of the nineteenth century. Puvis's paintings were generally well received, evoking admiration from sources as diverse as Ingres's admirer, Théophile Gautier, and Vincent Van Gogh. The critic L. de Fourcaud, however, saw Puvis's large-scale allegory *Sacred Grove, Beloved of the Arts and Muses* (fig. 16), painted in 1884, as out of touch with modern life: 'I am not quite sure to whom the subject is addressed. . . . You may, if you please, treat me as a savage, but I remain a citizen of France, not of the Vale of Tempe.' (Quoted by Louise d'Argencourt in Paris, Ottawa 1976–7, p. 192.) Against this can be set the enthusiastic words of one of Puvis's obituarists, L. Riotor, whose more traditional vision of the function of history painting rejected the notion of modernity: 'The energy of this art, created for the crowd, will win the hearts of the people . . . it will awaken their deep-seated pride and sustain their courage. . . . These are teachings for all time, fresh waves that wash over the prison dirt of humanity. . . . The art of fresco may thus affect the moral unity of a nation.' (Quoted by L. d'Argencourt, op. cit., p. 15.)

This mixed reaction was perhaps inevitable, given that history painting's supremacy was being increasingly questioned. On the one hand the Ecole des Beaux-Arts continued a traditional teaching

method in which that supremacy was assumed; on the other hand, aside from the decoration of public buildings, large-scale history painting became irrelevant and even the state encouraged the 'genre historique'.

The medal awarded at the 1843 Salon to Charles Gleyre's *Evening* (Paris, Louvre), an antique scene evocative of passing time but without textual source or specific action, is indicative of the encouragement given to the presentation of the Antique as familiar rather than heroic. Jean-Léon Gérôme's *Cock Fight* (fig. 17), one of the most popular works at the 1847 Salon, shows how far David's prophecy made in 1808 underestimated both the continuing fascination of ancient Mediterranean subject matter and the potential for the trivialisation of the Antique. At the Salon of 1849 – where it was bought by the state – was Courbet's

Après-dinée à Ornans (No. 31), which by its scale and concentration on the human figure engaged in insignificant action subverted the genre of history in a different way. That is not to say that there was no serious history painting in the later nineteenth century, nor that the supremacy of history painting did not have its defenders, but rather that history painting, other than mural decoration, was carried out despite a climate of public indifference. What is significant about Lecomte du Noüy's *Invocation to Neptune* (No. 70) in this context is its small size. As Gautier implicitly acknowledged, part of the appeal of the work, which he considered to be one of the most serious and elevated at the Salon of 1866, was that it would escape the attention of the crowd – it was in other words, a painting for the connoisseur, and, so far as Gautier was concerned, it was legitimate for history painting to cease to engage with a wider public.

The threat to history painting was not confined to its subversion by genre. Landscape also

Fig. 17 Jean-Léon Gérôme, *The Cock Fight*, 1846. Oil on canvas, 143 x 204 cm. Paris, Musée du Louvre.

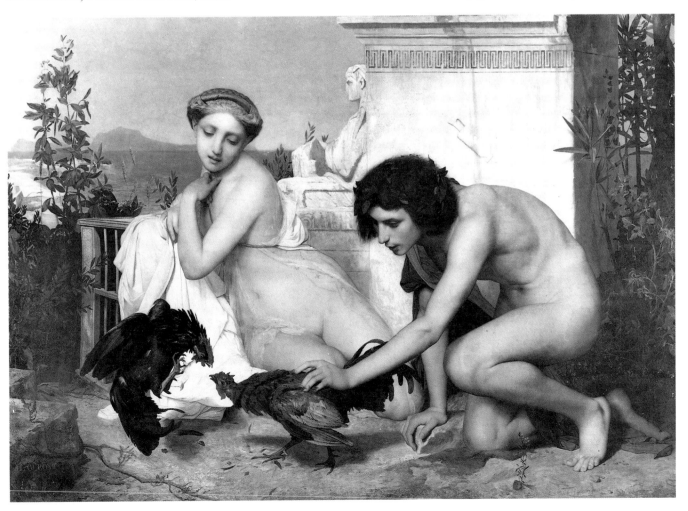

'invaded' painting of religious subjects. This was not confined to subjects that can be defined essentially as genre, such as Jules Breton's *Plantation d'un calvaire* (No. 22), but extended also to traditional religious subjects like Cazin's *Tobias and the Angel* (No. 26). Nevertheless the problem for history painting in the later nineteenth century was more acute in relation to secular subjects. To justify its elevated status it had to be both a source of instruction and of emotion. The taste for traditional mythology and ancient history was dying,

and history painters were unable to find a language with which to address spectators in a way which was both meaningful and appealing and which had the essential quality of universality. The exceptional attempts by Géricault and Delacroix to do so with subjects based on contemporary events each met with only partial success. In this context the fact that genre swept the board in terms of prizes at the Exposition Universelle of 1867 is not so surprising. It was in that year, however, that Manet painted the first of three versions of *The Execution of the Emperor Maximilian*, in the final version of which (fig. 18) he clearly demonstrated that history painting did not need its academically taught gestures and expressions or its traditional

Fig 18. Edouard Manet, *The Execution of the Emperor Maximilian*, 1868–9. Oil on canvas, 252 x 302 cm. Mannheim, Städtische Kunsthalle.

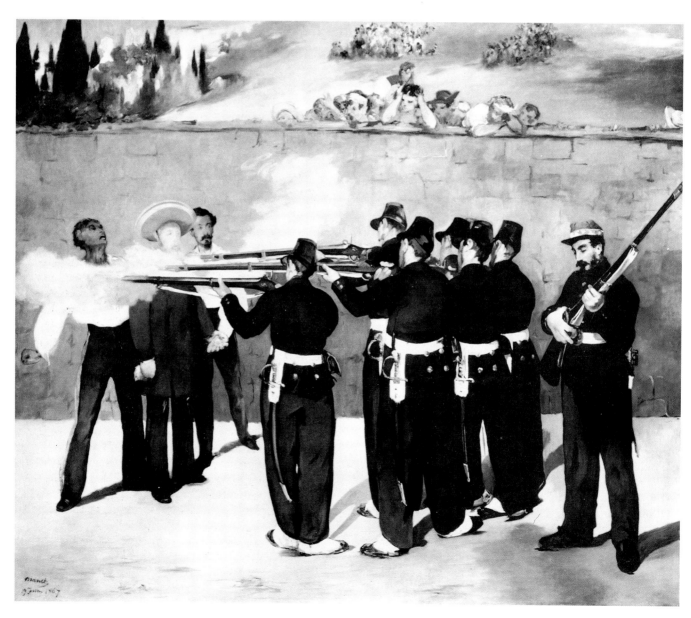

rhetoric in order to be effective.

By what John House has called 'its ambivalence [its] studied lack of dramatic rhetoric or moral signposting' (London, Mannheim 1992, p. 108) Manet's picture introduced into history painting a demand on the spectator's knowledge and imagination. The message was no longer within the painting, but within both it and the spectator. If history painting was indeed to teach, to delight and to move, it was to do so, not dogmatically, but in a participatory way. In that sense Manet's painting was democratic and the autocracy that underlay the academies and their rules was bypassed.

Notes on further reading

The relative indifference to history painting that occurred later in the nineteenth century is reflected in the historiography of the history of art. While considerable archival research was conducted into the life and work of eighteenth-century artists of all kinds, the most widely read overview of French eighteenth-century painting was that of the brothers Jules and Edmond de Goncourt. Their *L'Art du XVIIIème siècle* (3 vols., Paris 1880–2), a compilation of essays which had first appeared over the previous twenty-five or so years, gave prominence to artists who for the most part had not been history painters. The emphasis on painters of the 'lesser' genres continued until recently and was reflected in the major exhibition *France in the Eighteenth Century* (London, Royal Academy, 1968), and to some extent in *Art and Architecture of the Eighteenth Century in France* by W.G. Kalnein and Michael Levey (Harmondsworth 1972). Philip Conisbee's *Painting in Eighteenth Century France* (Oxford 1981) gave greater emphasis to the importance of history painting as a genre. This book also contains brief biographical details on many of the eighteenth-century artists whose works are discussed here. A recent, important work which is not restricted to history painting, but has much to say about its exhibition and public reception, is Thomas E. Crow's *Painters and Public Life in Eighteenth-Century Paris* (New Haven and London 1985).

Of publications wholly or largely devoted to eighteenth-century history painting Jean Locquin's *La Peinture d'histoire en France de 1747 à 1785* (Paris 1912, reprinted Paris 1978) remains an excellent summary. More recently the increasing interest in the genre is reflected in exhibitions and their catalogues, for example (in date order) *The*

First Painters of the King by Colin B. Bailey with an essay, 'Religious Painting in the Age of Reason', by Philip Conisbee (New York, Stair Sainty Matthiesen, 1985); *La Grande Manière, Historical and Religious Painting in France, 1700–1800* (New York, Rochester Memorial Art Gallery; New Brunswick, Jane Vorhees Zimmerli Art Museum; Atlanta, The High Museum of Art at Georgia-Pacific Center, 1987–8); and *Les Amours des dieux. La peinture mythologique de Watteau à David*, meticulously catalogued by Colin B. Bailey, with several accompanying essays by different authors (Paris, Grand Palais; Philadelphia Museum of Art; Fort Worth, Kimbell Art Museum, 1991–2). Although the exhibition *Courage and Cruelty* (London, Dulwich Picture Gallery, 1990–1) was concerned with works by Charles Le Brun (1619–90), the excellent catalogue is helpful to an understanding of late seventeenth-century painting and subsequent attitudes to it.

The clearest expression of the hierarchy of genres was that of André Félibien, who wrote extensively on the arts from 1660. His works and theories are discussed by Claire Pace in *Félibien's Life of Poussin* (London 1981), and his long commentary on Poussin's *Eliezer and Rebecca* is in his *Entretiens sur les vies et sur les ouvrages des plus excellens peintres anciens et modernes* (Paris 1666–88). Roger de Piles' *Cours de peinture par principes* (Paris 1708) adopts a more visual as opposed to literary approach to painting. It does not, as is sometimes thought, expressly question the hierarchy of genres. For commentary on de Piles, see Thomas Puttfarken, *Roger de Piles' Theory of Art* (New Haven and London 1985). The quotation in the essay is from de Piles' *Conversations sur la connaissance de la peinture* (Paris 1677, p. 81). On the relationship between L.-B. Alberti's *De Pictura* (Florence 1435) and the writings of Quintilian and Cicero, see J.R. Spencer, 'Ut rhetorica pictura. A study in Quattrocento Theory of Painting', *Journal of the Warburg and Courtauld Institutes* (vol. XX, 1957, pp. 26–44). For Diderot and a full bibliography relating to him, see *Diderot et l'art de Boucher à David. Les Salons: 1759–1781* (Paris, Hôtel de la Monnaie, 1984–5) and E.M. Bukdahl's *Diderot, critique d'art* (2 vols., Copenhagen 1980–2). For d'Angiviller's commissions of history paintings, see J. Locquin (op. cit.) and Barthelemy Jobert's 'The "Travaux d'encouragement": an Aspect of Official Arts Policy in France under Louis XIV', *Oxford Art Journal* (1987, vol. X, no. 1, pp. 3–14). For the changing status of the artist at the end of the eighteenth century, see George Levitine, *The Dawn of Bohemianism* (Philadelphia and London 1978) and, more recently, Richard Wrigley, 'Apelles in Bohemia', *Oxford Art Journal* (1992, vol. XV, no. 1, pp. 92–107). The comment by J.-J. Taillasson is from Abbé Charles, 'Un peintre blayais: J.-J. Taillasson', *Revue Historique du Bordeaux* (14e année, 1921, num. 3, pp. 129–44, and num. 4, pp. 208–22, at p. 134). This article includes extracts from Taillasson's letters to his family while a student at the Académie.

The bicentenary in 1989 of the French Revolution further boosted studies on J.-L. David. The magisterial catalogue of the 1989–90 exhibition (Paris, Versailles – see bibliography) is important to all studies of French painting around 1800 because of David's pivotal position. Also to be consulted for this period are Robert Rosenblum's *Transformations iu Late Eighteenth-Century Art* (Princeton 1967); *The Age of Neo-Classicism* (London 1972), which is confined neither to painting nor to France; *French Painting 1774–1830: The Age of Revolution* (Paris, Grand Palais; Detroit Institute of Arts; New York, Metropolitan Museum of Art, 1974–5); Philippe Bordes and Michel Régis, eds., *Aux armes et aux arts! Les arts de la révolution 1789–1799* (Paris 1988); J.-F. Heim, C. Béraud and D. Heim, *Les Salons de peinture de la révolution française 1789–1799* (Paris 1989); and *1789: French Art during the Revolution* (exhibition catalogue, New York, Colnaghi, 1989).

For the nineteenth century, Albert Boime's *The Academy and French Painting in the Nineteenth Century* (London 1971) contains comment on the genres; other important books in this respect are François Pupil's *Le Style Troubadour ou la nostalgie du bon vieux temps* (Nancy 1985), which also comments on subjects from French national history in eighteenth-century painting; and Bruno Foucart's *Le Renouveau de la peinture religieuse en France (1800–1860)* (Paris 1987). For Orléanist history painting, see Michael Marrinan's *Painting Politics for Louis-Philippe, Art and Ideology in Orléanist France, 1830–1848* (New Haven and London 1988). A recent study of the Galerie d'Apollon commissions is M.-C. Chaudonneret's 'Historicism and "Heritage" in the Louvre, 1820–40: from the Musée Charles X to the Galerie d'Apollon', *Art History* (1991, pp. 488–520). The same author has also written on Marrinan's book and other publications relating to the art of the July Monarchy in 'La peinture en France de 1830 à 1848: Chronique bibliographique et critique', *Revue de l'Art* (no. 91, 1991, pp. 71–80). The information at the beginning of the essay about the 1867 Exposition Universelle is taken from Patricia Mainardi's 'The Death of History Painting in France, 1867', *Gazette des Beaux-Arts* (6ème période, vol. 100, 1982, pp. 219–26, at pp. 221 and 225, n. 16). Her theme of the decline of history painting and the rise of genre painting has since been amplified in her *Art and Politics of the Second Empire: The Universal Expositions of 1855 and 1867* (New Haven and London 1987). For an overview of Second Empire art, not restricted to painting, see *The Second Empire 1852–1870: Art in France under Napoleon III* (Philadelphia, Detroit, Paris 1978–9 – see bibliography). Reference should also be made to the publications listed at the end of Jon and Linda Whiteley's essay.

The Institutions of French Art, 1648–1900

Jon and Linda Whiteley

The Académie

The Académie Royale de Peinture et de Sculpture (the French Royal Academy of Painting and Sculpture), was founded in Paris in 1648 by a group of artists in an attempt to prevent the ancient guild of painters from interfering in their affairs. Like earlier associations in Rome and Florence, the Académie in Paris allowed its members to escape from the influence of the craft guild, which traditionally regulated the work of artisans, and gave them an intellectual status alongside poets and scholars. Although the officers of the guild resented this attempt to undercut their authority, the readiness with which they tried to imitate the Académie's new life class and, at one point, to join forces with the rival society, suggests that the idea of the Académie, imported from Italy along with most that was worthwhile in early seventeenth-century French art, had a wide appeal among painters, sculptors and engravers in Paris.

The success of the Académie in its quarrel with the guild was ensured after 1662 by the support of Louis XIV who, in return, secured the services of a well-organised community of artists. Over the next century and a half many similar associations were set up throughout Europe by monarchs who admired French art and imitated French institutions, but these would not have become so powerful and effective if they had not also been supported by the artists themselves. Artists prized the benefits of belonging to an association which gave them professional status. They were also, no doubt, tempted by the titles of nobility and great wealth which a very small number of artists in the higher ranks of the Académie earned by working for the king. But access to a communal life class, which would have been beyond the means of most of the members, was, as the guild realised, a more immediate and practical attraction for the majority of artists.

The life class (fig. 19), from which the modern public art school evolved, provided an opportunity for drawing from a professional model under the supervision of one of twelve professors who attended in a monthly rota, but it did not, in itself, constitute a school. It was set up to supplement the existing system of apprenticeship at private studios and was available only to students who had already been accepted as pupils by a Paris master. Elsewhere in France, where academic life classes evolved out of single local teaching studios, the modern art school developed more quickly than it did in Paris where technical instruction was not introduced into the general curriculum until 1863.

Students did not enter the life class immediately but graduated through various preliminary stages. In their first months, they copied drawings or engravings of anatomical details, followed by drawings or engravings of whole figures, before they advanced to study plaster casts of bas-reliefs and statues, taken mostly from the Antique. Studies of the cast prepared students to draw a professional

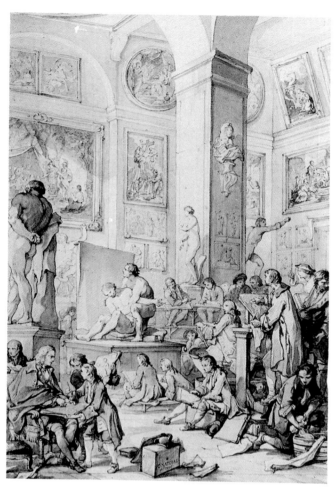

Fig. 19 Charles-Joseph Natoire, *A Life Class*, 1746. Black chalk and watercolour, 45.4 x 32.3 cm. London, Courtauld Institute Galleries, Witt Library.

model, posed with the aid of ropes and blocks under the strong steady light of an 'academic lamp', often in a posture associated with one of the stock characters from the artist's repertory (fig. 20). This training in drawing the human figure in action or repose gave young artists a chance to develop the skills required for painting the biblical, historical or literary themes which academic artists and writers valued above all other types of subject matter.

Normally, a composition began life as a *croquis*, a scribbled indication of the image in the artist's mind, 'hastily thrown off with pen or other drawing instrument', as Vasari described this kind of drawing. The artist then drew each figure separately in the nude (fig. 21), using the experience which he had acquired in the life class to recreate the rapid contours of the *croquis* in solid light and

shade. Accessories, draperies (fig. 22) and minor alterations were also drawn in isolation and combined with the nude figures at a later stage. Artists often traced their figure drawings in simple outline as a basis for a separate, finely finished drapery study (fig. 23), made from a draped figure or from a length of cloth placed over a wooden, jointed doll, which was cheaper and more practical than using a live model. Finally, the setting, with the individual figures carefully traced or copied from the studies, was constructed according to the long-established laws of recession which would have been familiar to students who had attended the lectures of the professor of perspective (fig. 24).

Fig. 20 Jean-Baptiste Wicar, *Academic life study of a Male Nude*. Black chalk with white heightening on paper, 57 x 38 cm. Lille, Musée des Beaux-Arts, Inv. Pl. 1730.

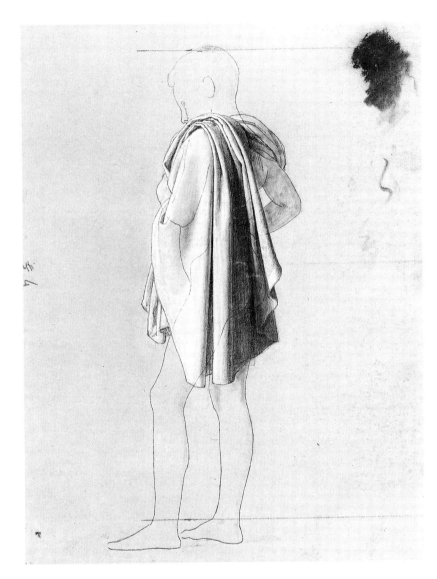

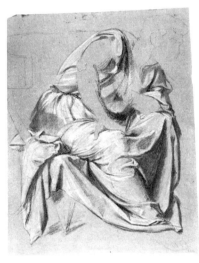

Fig. 21 Alexis-Joseph Mazerolle, *Life study for 'Nero'*, c.1859. Charcoal and black and white chalk on greenish-grey paper, 49 x 30 cm. Lille, Musée des Beaux-Arts, Inv. 1559.

Fig. 22 Alexis-Joseph Mazerolle, *Drapery study for 'Nero'*, c.1859. Black and white chalk on grey-blue paper, 49 x 38 cm. Lille, Musée des Beaux-Arts, Inv. Pl. 1558.

Fig. 23 Michel-Martin Drölling, *Drapery study*. Black chalk, stumped, with white heightening on yellow paper over an outline in pen and ink transferred from another drawing, 44.5 x 30 cm. Lille, Musée des Beaux-Arts, Inv. W. 2440.

Fig. 24 Jean-Germain Drouais, *Perspective drawing for 'Marius at Minturnae'*, 1787. Graphite on white paper, squared-up in ink, 21 x 28 cm. Lille, Musée des Beaux-Arts, Inv. Pl. 1324.

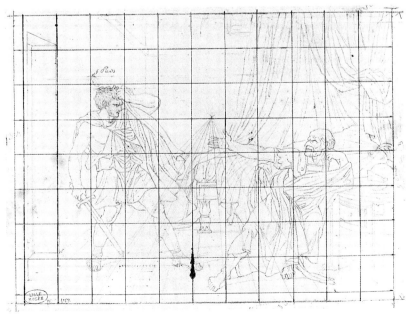

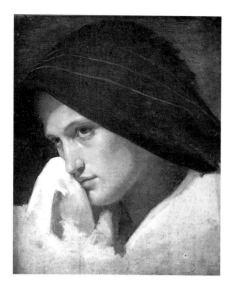

This was never a popular subject, but as it had a basis in mathematics it enjoyed a high status in academic circles.

The practice of composing pictures through a structured series of preparatory drawings was neither new nor controversial in 1648. It derived from Italy, and was particularly associated in France with Simon Vouet (1590–1649), who championed the guild in its quarrel with the Académie. There was no argument between the guild and the Académie about the value of drawing and through the influence of Vouet's pupil, Charles Lebrun, the Italian manner of preparatory drawing became part of the French academic tradition. It was accepted without question by generations of French painters as the proper way to begin a composition. Colour, which implied brushwork as well as hue, was more controversial, but the misleading tendency to divide French painters into colourists and draughtsmen (leaving room for a hybrid *juste milieu*) conceals the universal importance of this kind of drawing to artists of all schools. Drawings by Rubens, the common model for French colourists from La Fosse to Delacroix, are far closer to the academic tradition than those of Poussin, whose followers, the so-called 'Poussinistes', attempted to promote drawing at the expense of colour in the later seventeenth century.

Academic theorists from Alberti to Lebrun claimed a place for painting among the liberal arts by insisting that the recently perfected techniques of composition were proof of intellectual effort. Artists, not surprisingly, had no quarrel with a

Figs. 25–7 Alphonse Colas, *Head studies for 'The Raising of the Cross'*, c.1848. Oil on canvas, each 38 x 31 cm. Lille, Musée des Beaux-Arts, Inv. P. 1137.

theory which flattered their self-esteem and confirmed the practical importance of drawing; but in a series of famous debates at the Académie, they attacked colleagues who questioned the value of common tastes and practices which did not conform to a rigorous application of the theory. Philippe de Champaigne and Lebrun provoked an outcry by suggesting that the high status of drawing implied an inferior role for painting. Abraham Bosse, at the end of a protracted and heated debate, was banned from the Académie in 1661 for insisting too strenuously on the theoretical importance of perspective. The attempt by the Poussinistes to demote the Venetians in favour of Raphael and Poussin irritated many artists in the later seventeenth century who could not see why their respect for Raphael should make them admire Titian any less. The argument revived in the early nineteenth century when it was suggested that artists should turn from nature to pursue a *beau idéal* which was visible only in the art of the Greeks and Raphael. This proposal, derived from Winckelmann, infuriated Ingres and many artists of his generation who had been trained to copy nature and who admired Raphael and the Greeks as the greatest naturalists.

It is tempting to interpret these debates as symptoms of a conflict between draughtsmen and colourists or between classicists and romantics but, in

reality, there was little fundamental disagreement between the different camps. Most artists accepted that drawing was of the first importance, that Raphael was the greatest artist who had ever lived, and that art should depict ideal beauty, but they were angered by doctrinaire attempts to discredit common working habits on this account. The attempt to give art a higher status by insisting on the intellectual character of composition was an important element in the history of academies but the success of the French Académie among the artists at large depended on its practical benefits.

The practice of drawing the human figure at the life class was supplemented by studying the expression of emotion on the human face. Various published accounts of Lebrun's illustrated lecture on the passions, given to the Académie in 1668, and Lavater's *Essays on Physiognomy* (1775–8), provided painters with a codified system for depicting simple emotions such as 'Terror' or complicated emotions such as 'Admiration mixed with Astonishment', which made the pictures easier to paint and easier for the spectator to understand. The importance of face painting was reinforced by the competition for 'the study of heads and of expression' set up by the comte de Caylus in 1760 to encourage artists to pay as much attention to this aspect of their art as they paid to the human figure. Studies such as Alphonse Colas's paintings of

isolated heads (figs. 25–7) became an important ingredient in preparing pictures. These studies by Colas were made in preparation for a larger composition, but by this date the study of the human head, which started as an aid to representing emotion and character, had evolved into a subject in its own right. It was practised by history painters like Géricault, whose studies of the insane strike a perfect academic balance between art and science, and by genre painters like Greuze and Boilly who exploited the head study as a popular and commercial kind of art.

The skills in figure drawing, gesture, expression and composition taught in these classes were tested in a series of competitions held at the Académie, of which the annual Prix de Rome was the most famous. The winner, chosen according to his ability to paint a composition on a given subject, invariably taken from an antique or sacred text, earned

Fig. 29 Joseph-Benôit Suvée, *The Combat between Minerva and Mars* (No. 94).

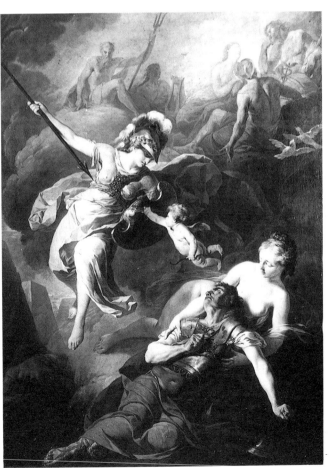

Fig. 28 Jacques-Louis David, *The Combat between Minerva and Mars* (No. 34).

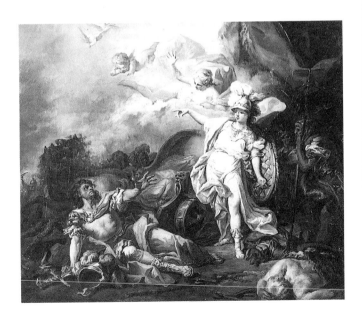

between three and five years of study, paid for by the state, at the Académie de Rome (the French Academy in Rome). The subject with which Joseph-Benoît Suvée won the prize in 1771 in competition with David, *The Combat between Minerva and Mars* (Nos. 34 and 94, figs. 28 and 29), allowed the artists to demonstrate their expertise in treating drapery and anatomy, and in depicting a complicated expression of bewildered rage on the face of the defeated Mars.

The link with Rome was constituted formally when Colbert established an outpost of the French Académie at the Villa Capranica in 1666. The prize-winners who stayed there were encouraged to perfect their talent in figure painting by studying ancient marbles and Renaissance and Baroque paintings. They were also required to make a copy of a designated work of art and send back other evidence of progress to the Académie in Paris. The first artists who were sent to the French Academy in Rome were employed to make copies of famous works of art for decorating the royal residences. By the beginning of the eighteenth century this aspect of the scholarship had declined but copying remained on the curriculum and was always an important part of an artist's education.

Copies form a huge hinterland in the history of French art, particularly in the nineteenth century when hundreds of third-rate painters were employed by the state, sometimes out of charity, to copy official portraits or religious pictures for churches throughout France. All art students were encouraged by their masters to make sketches after famous works of art or more careful, full-size copies as part of their tuition. Raphael was the clear favourite but Rubens and Titian were never far behind and Murillo joined their company in the course of the century. Collections of copies were often assembled in the art schools, of which the best known was set up in Paris from the copies sent back from the Academy in Rome. They had the same value to the students as the collections of casts which were an essential part of the well-equipped school of art. Adolphe Thiers, shortly after becoming Minister of the Interior in 1831, reorganised the collection at the Ecole des Beaux-Arts into an official museum of copies for which he commissioned a full-scale replica of Michelangelo's *Last Judgement* from Xavier Sigalon and copies of Raphael's Stanze from the Balze brothers.

The idea was taken up on a more ambitious scale by Thiers's friend, the Director of Fine Arts, Charles Blanc, who opened a Museum of Copies in the Industrial Palace on the Champs Elysées in 1873. But, as Albert Boime has pointed out, the time, in 1873, was too late for copies. The idea of 'originality', on which those who criticised the Académie in the nineteenth century always placed an exaggerated importance, had become too deeply entangled with the notion of quality to allow the museum to survive more than a few months.

An artist who had won the Prix de Rome would generally apply for membership of the Académie on return to France. Membership was unlimited and awarded on the basis of a preliminary presentation piece, a *morceau d'agrément*, of which David's *Belisarius* (No. 35, fig. 30) is perhaps the most famous, followed by a *morceau de réception*, which was necessary for full membership. The preliminary work gave access to the Académie and to the exhibitions, known as the Salons, since they were held at regular intervals in the Salon Carré of the Louvre from 1737. Many artists ignored the requirement to submit a reception piece once they had been granted the privileges of membership. An artist who failed to become a full academician could not hope to rise in the academic hierarchy, but this was not a serious handicap to the painters

Fig. 30 Jacques-Louis David, *Belisarius* (No. 35).

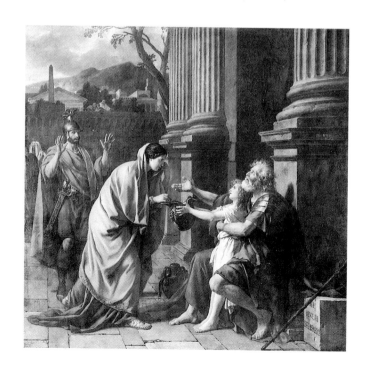

who specialised in landscape, portraits or still life as only history painters were promoted to the higher offices.

The Académie, as it was reconstituted by Lebrun and Colbert in 1663, was administered by approximately thirty-five officers. The director, elected for between one and three years, presided at assemblies and was responsible for the conduct of affairs. The chancellor, appointed for life, sealed official letters and statutes. Four rectors presided in the absence of the director and judged the work of students, assisted by two deputies who acted in their absence. Twelve professors supervised the life class, assisted by eight deputies. There were also professors of anatomy and perspective, a secretary and a treasurer. In addition, there were two classes of counsellors, one consisting of amateurs and connoisseurs, the other of talented academicians. A history painter who was ambitious, talented and well connected could rise through this hierarchy to occupy a place of wealth, prestige and influence. The normal route was through a deputy professorship to a professorship which might be followed by an appointment as director of the French Academy in Rome, or election to a deputy rectorship, ending as director, rector or chancellor. These posts were sometimes held by members of the same family through two or three generations (the Boullognes and Coypels were particularly successful) and were occasionally the subject of acrimonious rivalry.

Joseph-Marie Vien, who won the Prix de Rome in 1743 and survived to see the dissolution of the Académie in 1793, held every office in succession from deputy professor to chancellor. He was also a successful private teacher and a notable director of the Academy in Rome who passed through the office of Premier Peintre du Roi (First Painter to the King) to become a senator under Napoleon and a founding member of the Institut. He was, however, directly responsible to the comte d'Angiviller who, as Directeur des Bâtiments (Director of Royal Buildings), dictated policy and instituted reforms. Dependence on the Director of Royal Buildings was the price that the Académie had to pay for the protection of the king. But royal patronage secured for the Académie a near monopoly of exhibitions and life classes in Paris, provided an income and offered an opportunity for a few to study in Rome, and although some might have grumbled about the regulations, there was no serious opposition to the

Académie as an institution until the Revolution of 1789.

It is sometimes said that the Académie in Paris was the centre of an absolutist system for governing the arts in France. This was certainly the intention of Colbert and his successors. But France has always managed to combine a tendency towards centralised government with a strong element of regional independence. Despite the strength of the Académie, which always made it difficult for rivals to survive in Paris, regional France, in the eighteenth century, had more institutions for educating and supporting living artists than any other state in Europe. These were established on the Paris model but lead an independent existence, despite an attempt by d'Angiviller to impose central control. By 1789, there were at least thirty academies in the French provinces, each linked to an art school based on the academic school in Paris. Several of these academies also followed the original in Paris by organising exhibitions of contemporary art, notably at Toulouse and Lille, where exhibitions were held annually until the Revolution, and at Bordeaux, where they were less frequent but made more glamorous by the addition of work by Paris artists.

In 1775, the director of the School of Drawing at Dijon, François Devosge, persuaded the town council to establish a local Rome Prize, in imitation of the Paris competition, which was won by Bénigne Gagneraux, Jean-Claude Naigeon and Pierre-Paul Prud'hon in succession, but this was an unusual initiative in the provinces where town councils tended to send promising pupils to Paris or, more rarely, to Rome, with a grant which was renewed according to results. Wicar was sent to Paris by the town of Lille and repaid the debt by endowing a 'Prix Wicar', which enabled Carolus-Duran to study in Rome between 1862 and 1866.

None of the academies in France survived the Revolution. The institutions which took their place in the 1790s and early 1800s in Paris and elsewhere were different in character from the earlier associations of artists whose chief purpose had been to provide a life class and promote the interests of members. Where they survived, the art schools, exhibitions and art collections which the academies had fostered became the responsibility of the Minister of the Interior in Paris and of municipalities elsewhere. The Institut, founded in

1795 to represent the best of French intellectual life, included space for several members of the former Académie de Peinture et de Sculpture who continued to supervise the life class in a monthly rota and to judge the competitions. But their responsibilities were mainly advisory and honorific. The artists at the Institut were not part of a hierarchy, as the members of the Académie had been, but a small, self-perpetuating pressure group which often criticised official policies and did not take kindly to advice on how to carry out its duties.

Museums

Museums were, in general, a creation of the Revolution, although something like a museum existed earlier at the art schools of Aix, Dijon and Valenciennes where the directors assembled collections of paintings by Old Masters, as well as copies, to instruct the pupils, and from 1750 to 1778 some hundred paintings from the royal collection were accessible in a public gallery at the Luxembourg Palace in Paris. Most art schools would have had collections of prints, drawings and plaster casts for use as models. These collections were not of much importance in the formation of museums in the regions in the 1790s and early 1800s, but the existence of an art school and the needs of local artists were certainly important reasons for siting a museum in one town in preference to another. The first public art gallery in Lille consisted of a collection of religious pictures which had been removed from local churches in 1793 and were installed by the painter Louis Watteau in the local academy along with the *morceaux de réception* submitted by the members.

The French regional museums were created principally to preserve works of art confiscated from the church and nobles in the 1790s. To these, Napoleon added many hundreds of paintings taken from French collections and from the conquered states of Europe, which he distributed in the regions from the overflowing stores in Paris and Versailles. These works, by Flemish, French, German and Italian painters, remained, on the whole, in the regional museums after 1815, despite requests for their return, and still constitute an important element in the museums at Grenoble, Lyon, Bordeaux, Rouen, Marseilles, Caen, Montpellier, Nantes, Dijon, Toulouse, Lille,

Rennes, Nancy and Strasbourg, as well as those at Brussels, Geneva and Mayence which also benefited. This was a cheap and effective policy from the state's point of view, since the cost of restoring and transporting the pictures was undertaken by the municipalities.

Apart from occasional deposits by the state of surplus works of art, particularly in 1862 and 1872, few Old Masters were added to the regional museums before the end of the century. The distribution of 1862 consisted of works from the collection of the Marchese Campana, purchased by the state as the basis of a museum of decorative arts to rival the South Kensington museum in London but dispersed after a campaign by those who feared that it would diminish the importance of the Louvre. The 1872 distribution was principally intended to remove surplus works from Paris. Once the paintings had been distributed, the state seems to have been curiously indifferent to their fate and to the question of ownership which, in many cases, remained ambiguous. There is no doubt that, for the state, the regional museums represented a convenient answer to the problem of disposing of unwanted paintings; but a growing concern about the condition of the distributed works among the bureaucrats of Paris in the second half of the century led to a tightening of control and to a certain loss of independence among the more important of the municipal museums.

After 1815 most of the provincial museums, left in the care of a local artist, concentrated on acquiring contemporary art, particularly by painters of the region, assisted by the government in Paris which regularly distributed works by living artists to a growing network of municipal galleries. From the beginning of the July Monarchy in 1830 until 1914, the number of French museums increased at the rate of several a year. Nearly all felt the benefit of these distributions, from major centres like Amiens and Lille, both of which received over two hundred works, mostly by living artists, to the art school at Parthenay where four Sèvres vases, sent by the state, constituted the entire museum. The policy of sending contemporary paintings to Lille – which included Delacroix's *Medea* (No. 39), Courbet's *Après-dinée à Ornans* (No. 31), Mazerolle's *Nero Testing Poison*, Carolus-Duran's *Assassinated* and Bonnat's *Death of Abel* (No. 18, fig. 31) – gave a modern character to the collection

which has been continued to the present by the acquisition of contemporary art. While this policy has given undue prominence to the fashions of the twentieth century in some regional museums, in the nineteenth century at least it ensured that a number of masterpieces found their way to the provincial centres, particularly to Lille, which, as a consequence, has one of the best museums outside Paris for studying nineteenth-century French art.

The Sociétés des Amis des Arts, established across France in the course of the nineteenth century, gave a different kind of support to local artists by purchasing smaller genre and landscape paintings which would not normally have interested the state and, occasionally, by donating a more important work to the local museum. One of the earliest of the nineteenth-century provincial societies was founded in Avignon in 1827. It organised exhibitions and bought works of art for the museum but also established a drawing school, which survived the disappearance of the society in 1830. The drawing school was an unusual feature since most of these societies were established to organise exhibitions and purchase works of art, but took little part otherwise in the lives of artists. They were, principally, associations of patrons or antiquarians, unlike the former academies in which the interests of the artists took priority. On rare occasions the society founded and administered the local museum but, more commonly, it confined its support to gifts of paintings purchased at the annual exhibitions. As the most successful of the provincial exhibitions included many works by

Fig. 31 Léon Bonnat, *The Death of Abel* (No. 18).

Fig. 32 Amaury-Duval, *The Birth of Venus* (No. 1).

artists from outside the locality, brought in by dealers or appointed agents who had Paris links, important compositions such as Amaury-Duval's *Birth of Venus* (No. 1, fig. 32) and Roqueplan's *Spy Morris* (fig. 33) reappeared in the provinces following a début at the Paris Salon before they were purchased for a provincial museum.

This private initiative, which was imitated with success in most of the capitals of Europe, was never as effective in Paris as it was in the French provinces. By comparison with the Société des Amis des Arts du Bouche du Rhône, which held

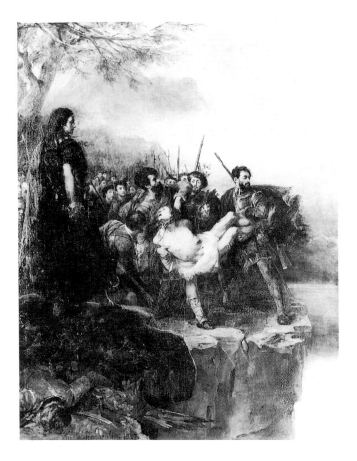

Fig. 33 Camille Roqueplan, *The Death of the Spy Morris*, 1827. Oil on canvas, 257 x 200 cm. Lille, Musée des Beaux-Arts, Lenglart 662.

regular exhibitions in Marseilles, published an art magazine and had a substantial budget for buying works of art, the Paris society was insignificant. Founded in 1790, largely, it seems, by the artists themselves in an attempt to attract support for their art, it succumbed, in 1792, to the growing crisis of the Revolution. It was revived in 1816 and continued as before to patronise genre and landscape painters through an annual lottery, but competition from the Salon and the growing importance of the state as a major purchaser of works by contemporary artists diminished its role.

State patronage

The state, in nineteenth-century France, commissioned works of art for a mixture of practical and ideological reasons. Artists were asked to depict memorable events for successive heads of state – battles, official events and royal acts of charity – as

Lebrun and his team of artists had done for Louis XIV, in the cause of propaganda. Official portraits, also, were commissioned from the best artists and copied in large quantities by inexpensive hacks for distribution throughout France. There was no nineteenth-century equivalent to Lebrun or d'Angiviller to supervise these enterprises. The authorities responsible for ordering works of art scattered commissions among a variety of artists, as a matter of policy, making it difficult to ascribe a character to nineteenth-century official art but offering, as was intended, the widest opportunities to artists hoping for a commission.

The choice of artists who collaborated in the secular schemes initiated by the state became increasingly eclectic as the century progressed. There is nothing surprising about Manet's application for a place among those who received commissions to decorate the Hôtel de Ville alongside Puvis de Chavannes, Luc-Olivier Merson and other artists with whom he had, otherwise, not much in common. The artists approached by the Director of Fine Arts to paint murals in the Panthéon in the 1870s, who included Millet, Meissonier, Puvis and Gustave Moreau, represent an interesting but equally incoherent choice.

Commissions to record official events were generally reserved for well-tried artists. Official subjects were not the safest speculation for a young painter looking for government support, as Ingres discovered when criticism of his portrait of the emperor at the Salon of 1806 severely damaged his credit as a reliable state artist. Fear of criticism made the government very sensitive on the subject of official art and any artist who assumed that a flattering subject alone would win a place at the Salon and the approval of the state was more likely than not to see his work refused.

After 1815, religious pictures were a safer option for an artist hoping for state work. Although the patronage of the churches and the religious orders, which had been of such consequence for artists in the seventeenth and eighteenth centuries, ended with the Revolution, and although none of the regimes from 1789 to 1815 did much to make amends, successive government officials from 1815 to the end of the Second Empire in 1870 supplied the clergy with abundant works of art for decorating their churches. This was a practical way of giving work to artists, of supplying churches with the

pictures which they required, and of securing the goodwill of the church authorities. The Prefect of the Seine, the comte de Chabrol, began the trend during the Restoration by commissioning dozens of large altarpieces which, as a rule, appeared at the Salon before going to the churches in Paris for which they were intended.

The development of mural painting, in oil or fresco, which became the standard form of church art in the July Monarchy (1830–48), deprived the later Salons of the best of the current work, although the quantity of religious art which appeared at the Salon continued to reflect the importance of church art in general. Some at least of the pictures of pious subjects at the Salon were sent in by artists hoping for a commission; others were submitted by established religious artists or by those who had been encouraged to specialise in such works by their training.

Hippolyte Flandrin, the best known of the nineteenth-century church painters, came to Paris from Lyon with the idea of becoming a battle painter but, in common with a number of Ingres's pupils and followers, was drawn into the enterprise of decorating churches by the Paris Prefecture and by the Ministry of the Interior. According to Amaury-Duval, Sébastien Cornu sent a religious picture to the Salon of 1838 in the hope of catching the eye of an official on the look-out for church painters. Amaury-Duval (who painted chapels in a refined archaic style) disapproved of this attempt to exploit religious art for gain. But it is a pious fallacy to suppose that religious painters were necessarily more devout than any of the other painters who regularly used the Salon as a shop window. Many of the religious pictures exhibited by young or minor artists in these years were probably submitted in the hope of attracting official attention at a time when there was an unprecedented demand for religious art.

The policy of the state in buying pictures from the artist was less clear-cut than the policy of commissioning works. After the office of the Director of Royal Buildings had been suppressed in the Revolution, there was a chronic lack of centralised control to regulate the increasingly important role of the state as a patron of the arts. Despite efforts in 1815, 1863 and 1881 to reintroduce a unified authority, no nineteenth-century official succeeded for long in controlling all the different artistic interests of the state. The Consulate created four directors under the Minister of the Interior who were responsible for education, civil buildings, manufactures and the fine arts. The director who was responsible for the fine arts controlled the palaces, museums, art schools and public monuments until 1802, when Napoleon transferred responsibility for the Louvre to Dominique Vivant Denon, a minor etcher and protégé of Josephine, who became the first director of the Louvre. Despite administrative changes which saw the fine arts shift to and from the civil list and settle in the 1870s at the Ministry of Education, these divisions were not lastingly altered in the course of the nineteenth century.

The habit of using places in the administration of the fine arts as a reward for political services or as a job for those with influential friends at court did not help the process of establishing an effective policy and gave particular importance to the director of the Louvre, who was usually an artist with close contacts in the world of art and was responsible for recommending purchases from other artists at the Salon. The founding of a museum of contemporary art in the Luxembourg Palace in 1817 increased the importance of the directors and gave artists an incentive to paint ambitious compositions for the Salon in the hope of selling them to the state. The success of Delacroix in the 1820s was largely due to the comte de Forbin, director of the Louvre throughout the Restoration, who bought both *The Barque of Dante* (Paris, Louvre) and *The Massacre of Chios* (Paris, Louvre) for the Luxembourg. Quality appears to have been the chief reason for purchasing pictures at the Salon. Favouritism also played a part, but politics had a surprisingly low priority in dictating the director's choice. Forbin's attempt in 1819 to acquire Géricault's *Raft of the Medusa* (No. 56, fig. 73), a subject which could only have been embarrassing to the royalists, was in fact thwarted by the artist himself. Couture's *Romans of the Decadence* (Paris, Musée d'Orsay), which was seen as an attack on the society of the July Monarchy, was bought in 1847; Alfred Stevens's *Vagabondage* (Paris, Musée d'Orsay), criticising Napoleon III's vagrancy laws, was bought in 1855 and Couture's republican *Voluntary Enlistment* (Beauvais, Musée Départemental de l'Oise) would have followed if the artist had finished it, as requested.

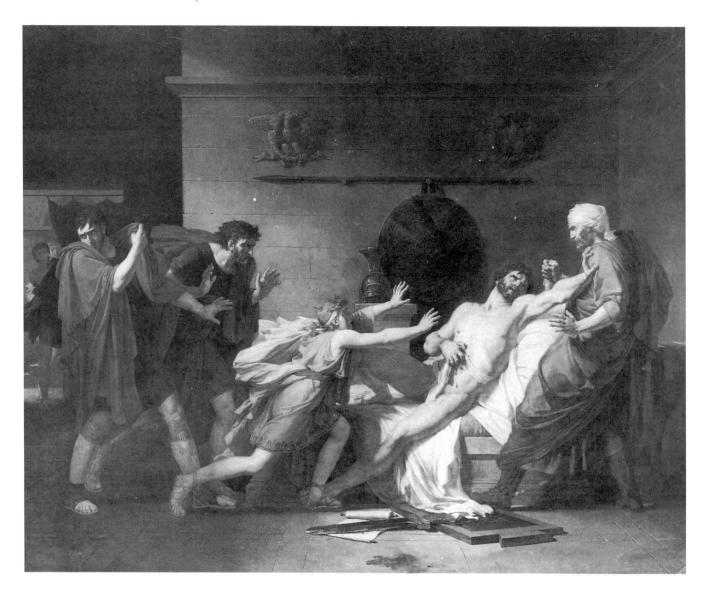

Fig. 34 Pierre-Narcisse Guérin, *The Death of Cato*, 1797.
Oil on canvas, 111 x 144 cm. Paris, Ecole Nationale
Supérieure des Beaux-Arts.

The role of the director of the Louvre declined in
the July Monarchy when Louis-Philippe took a
more active interest in contemporary art than his
predecessors, but it revived during the Second
Empire under the comte de Nieuwerkerke who had
more experience in dealing with artists than the
emperor or his mediocre directors of the Fine Arts.
His appointment as Superintendent of Fine Arts in
1861 gave him the authority to tackle long-delayed
reforms at the Ecole des Beaux-Arts in Paris which
he linked, unwisely, to an attack on the Institut.
Incited by the novelist Prosper Mérimée and the
architect Viollet-le-Duc, and supported by the em-
peror, he stripped the artists at the Institut of their
rights and their responsibilities for organising the
Salon jury, appointing the teachers at the Ecole,
and judging the annual Prix de Rome. The reforms
also included a Salon des Refusés for victims of the
jury and the establishment of three painting classes
at the Ecole which fundamentally changed the
character of the curriculum. These measures were
intended to be liberal and popular and were based
on the belief that the Institut was an oppressive or-
ganisation which was resented by the majority of
artists.

As an independent body of strong-minded art-
ists, the Académie (as the class of artists at the
Institut was somewhat misleadingly called) had

never been a docile instrument of official policy. No other institution in nineteenth-century France had so consistently and so effectively opposed the wishes of successive governments. Thus by 1863, the Académie must have seemed a safe target for the reformers. The standards of painting with which it was associated did not appear to represent the best in contemporary French art and it had few friends in the press. But Nieuwerkerke and his allies at court underestimated how effective the wrath of the Académie could be and failed entirely to anticipate the hostility of the great body of French artists who rallied in support of the old system. This did not improve the emperor's popularity and although Nieuwerkerke enjoyed greater powers than any administrator in the fine arts since d'Angiviller, he was isolated and weakened by the affair.

The art school

While the academies of France disappeared in the 1790s, the art schools mostly pulled through. The practices and standards of the eighteenth-century Académie in Paris continued more or less unchanged until the reforms of 1863. This not only affected the way artists were taught but it predisposed them to favour certain kinds of subject matter so that they could make the most of the skills which they had acquired as students of the academic school. Mastery in the depiction of gesture and expression allowed the artist to tell a story, in the manner of a pantomime, without

Fig. 35 Lethière, *Oil sketch for 'The Death of Virginia'* (No. 74).

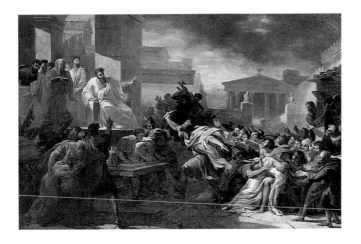

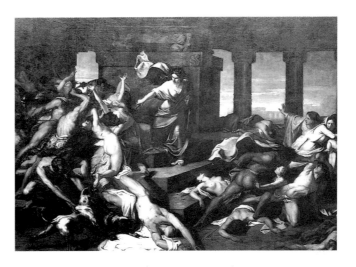

Fig. 36 Xavier Sigalon, *Athalia*, 1827. Oil on canvas, 428 x 600 cm. Nantes, Musée des Beaux-Arts.

words. Episodes with a strong visual appeal made better pictures than the kind of static confrontations, common in the classic French theatre, in which words count for more than action. Dramatic or violent subjects were ideal, particularly if they included a nude or semi-nude figure who might be depicted in the contrasting light and shade of the academic lamp.

The subject of Cato's suicide (fig. 34), which earned Pierre Guérin a place at the Rome Academy in 1797, would not have appealed readily to a private buyer, but it was well chosen by the organisers of the competition to test the artist's skill in modelling the human figure and in indicating a range of strong emotions. Lethière's *Death of Virginia* (No. 74, fig. 35), Bonnat's *Death of Abel* (No. 18, fig. 31) and Géricault's *Raft of the Medusa* (No. 56, fig. 73), the grandest of all the academic masterpieces by an artist in the early nineteenth century, were good subjects for painters who had been trained in the art of physiognomy and figure drawing and who could make a virtue of the sensational effects of artificial light commonly employed in the studios of the period. Massacres were particularly inspiring. The literary sources of Guérin's *Death of Priam* (Angers, Musée des Beaux-Arts), Sigalon's *Athalia* (fig. 36) and Delacroix's *Sardanapalus* (Paris, Louvre) were of much less importance to the artists than the opportunity which these sources provided for communicating ideas and feelings to the spectator through the familiar conventions of history paint-

ing. It would be absurd to deny that Delacroix and Guérin were not profoundly inspired by the themes which they painted. But the painter's inspiration, however strongly felt, is conditioned by his training, by his public, by his knowledge of the Old Masters, and by the character of the medium, which, as Delacroix realised, often prevents the artist from competing with the writer.

Although pictures of suicides and massacres were not particularly popular with collectors, the academic tradition which encouraged painters to tackle these subjects gave French artists a command of figure painting which they could adapt to a more popular type of picture. The studies of the academic model, painted by the students at Rome as part of the curriculum, inspired a common sub-genre of single figures of the nude, like Amaury-Duval's *Birth of Venus* (No. 1, fig. 32), especially in the Second Empire when Ingres's pictures of this kind were widely imitated. Gérôme was launched on his career as a favourite of the dealers and collectors when his *Cock Fight* (fig. 17, p. 27), an academic study painted while he was training for the Prix de Rome was transformed into an antique genre picture by the addition of accessories and exhibited, successfully, at the Salon of 1847. Bouguereau, who won the prize in 1849 and seemed on course to become a virtuoso painter of history and religion, was persuaded instead to paint appealing pictures of mothers and children, executed with a flawless sense of form, which made him rich and famous.

Almost half the artists who won the Prix de Rome, from the opening of the Rome Academy in 1666 to the end of the nineteenth century, were born in Paris. No single regional centre produced more than a handful of successful candidates and most of the prize-winners were trained, at least in part, in the capital. Before 1863, provincials who came to Paris to attempt the Prix de Rome registered for classes at the Ecole des Beaux-Arts by entering the studio of a Paris master. This gave the private studios an importance in contemporary art which was not equalled by any other institution. The variety and quality of French painting in the nineteenth century derive largely from the masters who ran these private studios: Gros, Guérin, Drölling, Ingres, Delaroche and others, whose pupils formed distinct groups within the larger community of French artists.

Some studios had more success than others in training students for the Prix de Rome. Jean-Baptiste Regnault and François-André Vincent, both former scholars at the Rome Academy, were particularly successful in sending their best pupils to Rome in the late eighteenth and early nineteenth centuries; but none equalled David, whose pupils dominated the competition between 1784 and 1816, and Antoine-Jean Gros, who took over David's studio and taught a further generation of prize-winners from 1816 until his death in 1834. Neither Delaroche nor Charles Gleyre, who took over the studio in succession, were so successful, and the next teacher to dominate the competition was François Picot, followed by his pupil Alexandre Cabanel, who continued the tradition until late in the century. Failure to produce prize-winning pupils did not, however, prevent other studios from attracting students. Thomas Couture, whose lively manner of painting and contempt for the Académie would not have endeared him or his art to the academicians who administered the competition, had no winners to his credit, and the many students who came to his studio after 1847, including Manet and Puvis de Chavannes, must have known in advance that their chance of a place in Rome was very slight.

As the prestige of French art attracted artists increasingly to Paris, the private studios in the capital and, after 1863, the three painting classes at the art school were responsible for forming schools of painting in the regions and abroad. The painting of scenes from national history, which came to be closely associated with artists from Bordeaux, had been established in Paris in the late eighteenth century by François Vincent, whose pupil, Jean-Baptiste Lacour, became director of the Bordeaux art school and, in turn, sent his best pupils to Vincent. By this route, Jean-Paul Alaux, one of Lacour's most successful pupils, became the most active of the painters employed by Louis-Philippe to celebrate the history of France at the new historical museum at the palace of Versailles. The school of mystic and religious painters, trained at Lyon, was likewise a creation of Rome and Paris in which the influence of Ingres and Victor Orsel (who between them took a succession of students from the Lyon art school) and the example of Overbeck (who befriended them in Rome) was very marked.

Genre painting

Genre painting was also an important aspect of art in eighteenth-century Paris. Pictures of everyday life, inspired by Dutch and Flemish art, were popular with collectors. Watteau, Chardin, Etienne Jeaurat, Joseph Vernet, Greuze, and others who specialised in branches of painting which were considered inferior to history painting, were admitted to the Académie and exhibited at the Salon. Many history painters who occupied important places in the academic hierarchy also painted scenes from daily life. But the academic system in Paris was not designed to encourage artists to specialise in genre painting and those who did were generally trained at centres outside the capital.

As the century progressed and the number of painters from Paris and the provinces increased, genre and landscape painters came to rely on other outlets for exhibiting and selling work, presumably because they found access to the Académie difficult. The Académie de St Luc, as the guild of painters now called itself, instituted an important series of alternative exhibitions in 1751 which were well attended particularly by the genre and landscape painters until the guild was finally suppressed in 1774. Otherwise, the artists outside the Paris Académie had access to the annual exhibitions which were held one day each year in the Place Dauphine, known because of their association with young, untried painters as the Exposition de la Jeunesse. These exhibitions were not an ideal market for the sale of paintings and became less so after 1737 with the rise of the academic Salon.

At a time when the need for more accessible exhibitions was most apparent and when several attempts to provide them were put in hand, the Director of Royal Buildings, the comte d'Angiviller, suppressed or discouraged them in order to maintain the Académie's monopoly of public exhibitions. This was part of a policy intended to strengthen the standards of the Académie by eliminating rivals and strictly enforcing the rules for scholars and applicants on the threshold of membership. This was irritating to the young both inside and outside the Académie and probably did more than anything to provoke the campaign, led by David and his fellow Jacobins in 1793, to abolish the Académie in the name of liberty.

With the disappearance of the Académie, the Ecole des Beaux-Arts and the Salon became the direct responsibility of the state. The survival of the Ecole meant that the standards of painting associated with the Académie persisted into the nineteenth century but the Salon, open to all comers from 1791, changed character. Although an admission jury was reinstated after an experiment without a jury in 1791, there was now nothing to prevent any French painter from submitting original work. Genre painters from Paris and the provinces, who had previously relied on the exhibitions in the Place Dauphine took advantage of the access to patrons and publicity offered by the Salon and caught the attention of the public as never before. Of all groups of artists, the genre painters gained most by the Revolution, not enough, perhaps, to compensate for the loss of patrons but enough to give them a new status and allow them in the longer term to become the most favoured and prosperous of painters.

When organising a competition in 1794 to celebrate the events of the Revolution, the Société Populaire et Republicaine des Arts accepted the argument that the hierarchy of genres was not compatible with its egalitarian principles and permitted the genre painters to compete with the history painters on equal terms. The experience of the genre painters in dealing with contemporary life gave them an advantage over their competitors among the history painters, who had tended to avoid dealing directly with subjects from modern life. Like Boucher and his contemporaries who commonly treated subjects from modern life in the form of allegory, one third of the competitors, as William Olander has pointed out, submitted allegorical compositions. Genre painters like Boilly, who submitted *The Triumph of Marat* (No. 4, fig. 37), accounted for a further third. The remaining works were submitted by history painters who evolved a kind of heroic naturalism, based on David's pictures of the Revolution, in which the traditional skills in drawing, gesture and expression were adapted to deal with the new subject matter. The 1794 competition, and other commissions and competitions of the 1790s, allowed all three approaches to the art of commemorating contemporary events to evolve in the service of propaganda, but by the end of the Empire, allegory had given way to the greater realism of the genre painters and had become mainly the province of

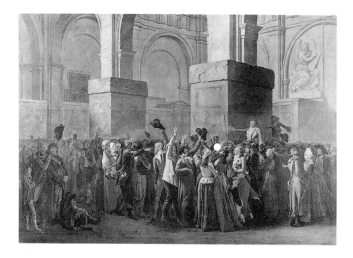

Fig. 37 Louis-Léopold Boilly, *The Triumph of Marat* (No. 4).

Fig. 38 Théodore Géricault, *The Race of the Riderless Horses* (No. 55).

those who painted walls and ceilings.

Despite disappearing from public view between 1815 and 1830, when images celebrating the Revolution and First Empire were considered too dangerous to show in public, the pictures of contemporary history painted by David and his pupils before the fall of Napoleon never passed from the memory of artists, and did not go out of fashion in the 1830s as did the antique subjects painted by the same artists. Perhaps because paintings of contemporary life were traditionally associated with genre painting, these pictures inspired a number of artists to look for the heroic in the life of the common people. Italy, North Africa and the East, where travellers were frequently reminded of the ancient Greeks and Romans, offered a more abundant supply of subjects than day-to-day events in nineteenth-century France. Géricault's *Race of the Riderless Horses* (No. 55, fig. 38), Léopold

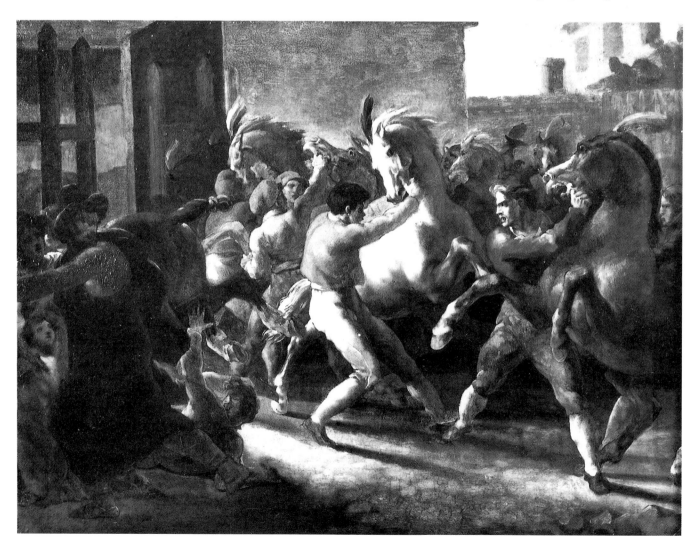

Robert's scenes of popular life among the Italians, Delacroix's pictures of Morocco, the paintings of the Greek War and the images of the 1830 Revolution, all attempt to depict episodes in the lives of the common people with a sense of drama and an academic mastery of form which bring to mind the kind of heroic subject matter which artists previously had taken almost exclusively from ancient history.

While the cult of history painting made Paris pre-eminent in high art, provincial schools had a more important role in the development of genre painting. Just as local traditions in England encouraged talented and ambitious painters to specialise in portraits, conditions in the French provinces, where the art schools were often run by a genre painter, favoured artists who wished to specialise in painting scenes from daily life. Watteau, Pater, Boilly and Demarne, who came from the north-east where links with Flemish art were traditionally close, established influential traditions of genre painting in the capital. A smaller group of genre painters from Alsace and Lorraine – Leprince, Loutherbourg, Schall, Zix and Drölling – who settled in Paris between 1750 and 1800, became Salon favourites. But neither of these regions equalled Lyon, where the work of Dutch flower painters, landscapists and genre painters was imitated by artists who later acquired a national status when they came to Paris. After the sack of Lyon by the Jacobins in 1793, Michael Grobon, Fleury Richard and Pierre Revoil moved to Paris where Grobon made his Salon début with a *tableau de genre flamand*, while his companions followed the conventional path of the provincials by entering the studio of a Paris master. But David, with whom they enrolled, had little lasting impact on their art, chiefly because their southern taste for Dutch painting counteracted his example. Richard made his reputation at the Salon of 1802 with *Valentine de Milan* (whereabouts unknown), a picture of medieval history which, as contemporaries pointed out, was lit, coloured, composed and painted in the manner of a seventeenth-century Dutch genre painting. The subject, however, was inspired by a visit to the Musée des Monuments Français, the best known and most influential of all the museums established in France in the 1790s from the spoils of church property.

François-Marius Granet, Richard's friend from Aix, had already discovered the connection between devastated churches and Dutch art while crossing the ruined cloister of the Feuillants in Paris in the late 1790s. The effect of light reminded him of the Dutch pictures which he admired in the Louvre and inspired the first of many Salon pictures of interiors, romantically lit from the centre or from the side, which he painted for an international clientele

Landscape painting

The Salon, which encouraged genre painters to experiment and innovate, had a less decisive influence on the landscapists. The link with the fashionable Dutch artists of the seventeenth century which ensured the success of Marguérite Gérard, Boilly, Fleury Richard, Louis Watteau and Demarne in the late eighteenth century, did not work so effectively for the few French landscape painters who imitated Ruisdael and Hobbema in the same period. Genre painting, because it gave prominence to the human figure, had a higher status in the academic hierarchy of subjects than landscape. In the light of all these disincentives, it is therefore surprising to notice that, in practice, academic painters valued landscape painting above the depiction of daily life. The nineteenth-century Académie, like the old Académie Royale, always included at least one place among its members for a landscape painter. Landscape painting occupied an important place at the Academy in Rome and from 1816 the landscapists had their own Prix de Rome, awarded every four years for the best depiction of an historical subject in which the human figure was of secondary importance.

The prestige of landscape painting in France was linked to the reputation of Claude Lorraine. By 1800, Claude had become firmly established in the very small pantheon of French artists who were internationally honoured. His influence spread among the French artists in Rome, chiefly through the presence there of Joseph Vernet who arrived in 1734 and, apart from trips to Naples and Paris, remained until 1753. Vernet encouraged visitors to Rome to make rapid sketches out of doors, in oil paint, in order to recreate effects of light and weather in studio compositions. Through the many artists who came to Rome in the late eighteenth century, the habit of painting studies out of doors

47

Fig. 39 Pierre-Henri de Valenciennes, *Forest of the Villa Borghese*, *c*.1783. Oil on paper mounted on canvas, 28 x 40.5 cm. Paris, Musée du Louvre.

Fig. 40 Pierre-Henri de Valenciennes, *Arcadian Landscape* (No. 96).

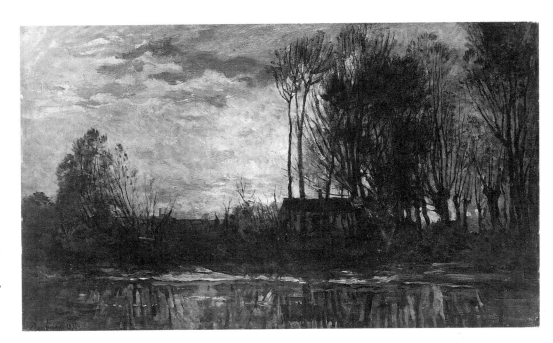

Fig. 41 Charles-François Daubigny, *Evening at Bas-Meudon,* 1874. Oil on panel, 38 x 67 cm. Oxford, Ashmolean Museum.

passed to Germany, Scandinavia, England and France, where Vernet's follower Pierre-Henri de Valenciennes founded a school of landscape painting based on a blend of naturalism and ideas derived from the work of Claude and Gaspard Dughet.

Studies did not rank as works of art but were painted as exercises or records of effects of light and weather (fig. 39). They related to finished pictures (No. 96, fig. 40) much as studies of the human figure related to historical compositions. The Prix de Rome for landscape painting established the oil study in the mainstream of academic practice. Pierre-Etna Michallon, the first winner of the new Prix de Rome, acquired the habit from his master, Valenciennes, and passed it to his most famous pupil, Camille Corot, who had a poetic talent for capturing subtle light effects in the studies which he painted out of doors. The tradition which Corot represented contributed more than any other influence towards the formation of a school of French landscape painting in the second half of the nineteenth century in which the historical element was discarded in favour of increasing naturalism.

Charles Daubigny, like Théodore Rousseau, had been an unsuccessful applicant for the Prix de Rome who turned away from the Claudian tradition at a time when the prestige of historic landscape was in decline. Salon critics had become disenchanted with the genre and, in 1864, the reform-ing administration abolished the Prix de Rome for landscape on the grounds that the most important developments in landscape painting in recent years had all been associated with artists who had remained in France. By this date, landscapes had overtaken pictures of daily life as the largest category of painting at the Salon, after portraits, which, despite the best efforts of the Salon jury, remained in the majority. The focus of the landscape painters, however, had shifted from Italy, and the forest of Fontainebleau, which had been popular with artists since the 1770s as a source of picturesque motifs, had taken the place of the Roman *campagna* as the most important international site for landscape painters.

Most landscape painters before the 1870s worked in the open air but painted their finished pictures in the studio. Daubigny, the first artist who consistently tried to eliminate the gap between the study and the finished work, overcame the physical difficulties of painting in the open air by building a studio on a barge from which he could paint directly from the site. He was not, therefore, a forest painter. The subjects which he painted gave him a boatman's view of the world, crossed with horizontal bands of water, bank and sky, that allowed him to study effects of light, reflected light and shadow (fig. 41). He acquired his interest in tonal painting and the habit of working out of doors from Corot but, unlike Corot, valued light as a subject for a work of art in its own right.

The dealers

When the thoughts of certain Paris dealers turned to the sale of modern art in the late eighteenth century, they naturally looked to the Salon as a model and set up exhibiting societies or associated themselves with those already in existence. These societies, formed by artists outside the Académie, were attractive on account of the independence they offered. The initial impetus to this development came after the suppression of the Académie de St Luc in 1776, when the engraver Antoine de Marcenay de Guy and the painter Jean Antoine de Peters set up an exhibition in the Salon des Grâces of the Colisée, a place of fashionable entertainment modelled on the Vauxhall Gardens in London (and later imitated at Lille). The government suppressed the exhibitions in August 1777, but Claude Mammès Pahin de la Blancherie, a man of letters with an interest in the arts, immediately devised an alternative outlet with a broader and more ambitious programme featuring lectures and recitals as well as exhibitions. Martin Drölling exhibited there in 1781; in 1783 Pahin planned a great retrospective of French painting beginning with Jean Cousin and the Clouets, but provoked by Pahin's mounting ambition, d'Angiviller outlawed his enterprise. In spite of this setback, Pahin's exhibitions continued until 1787. In 1783 he devoted one of these entirely to the work of the landscape artist Joseph Vernet, probably the first instance of a one-man retrospective focusing on the work of a living artist.

From the mid-eighteenth century until well into the nineteenth, the main opposition to the exhibiting societies came from the government. D'Angiviller's policy of suppressing these societies to protect the Académie's monopoly of public exhibitions, and promote the interest of the history painters, coincided with an increase in the number of young artists working in landscape and genre. Genre painting did not always occupy a comfortable position within the official Salon and the private exhibitions were designed to give it more prominence.

It is not surprising that the men who took up the challenge left by Pahin were themselves the leading dealers in seventeenth-century Dutch art, Jean-Baptiste-Pierre Lebrun, Alexandre Paillet and Hippolyte Delaroche. In 1789, two years after the closure of Pahin's exhibiting salon, Lebrun gave asylum to the Exposition de la Jeunesse in his vast gallery in the rue de Cléry. The exhibition was repeated in 1790 and lasted ten days, in contrast to the two hours normally permitted to these exhibitions, held out of doors in the Place Dauphine. Carol Eliel has recently pointed out that many of the artists who exhibited there were an important force in the development of painting in the Dutch taste in the years around 1800. These included several of the artists depicted by Boilly in the studio of Isabey: Van Dael (see No. 11), Taunay, Swebach and Boilly himself. At one of the sessions of the Société Républicaine des Arts (of which Duplessi-Bertaux was an important member, see No. 9), Lebrun made a warm speech defending the merits of genre and its usefulness as a model of democratic art.

The assistance Lebrun offered the living artist went far beyond providing an exhibition space; in 1789 he founded a scheme for the sale of modern pictures, the Lombard des Arts, through which artists or owners could place works for sale, at a charge of two per cent of the asking price, and no commission on the sale. Works by David, Girodet, Gérard, Gauffier, Taunay, Van Dael, Boilly, Demarne, Valenciennes, Drölling, Lethière and Isabey, among others, appeared at the first exhibition. It is impossible to judge the success of this scheme but it soon found imitators; in 1798 Paillet and Delaroche published a prospectus for the Société de l'Elysée for exhibiting and selling Old Master and modern paintings. In 1801 an anonymous prospectus proposed a society with the similar aim of selling contemporary art, but the author's claim that there was no other organisation of this type available to artists in Paris suggests that by 1801 the other two had ceased to function.

The Revolution removed the main reason for the existence of the independent societies by throwing the Salon open to all comers. Before the Revolution, painters like Boilly, Swebach, Demarne and Drölling had all appeared at private exhibitions. After the Revolution, young successful genre painters began their careers at state exhibitions. This, more than anything else, must explain the absence of such initiatives until the 1820s, when the increase in the numbers of artists wishing to exhibit, and the infrequency of the Salons, as well as an

emerging hostility between schools of painting, provided new openings to private enterprise.

On 21 April 1826 Delacroix wrote to his friend Soulier: 'We hope to form a society of painters on the model of the London organisation. I have asked Fielding to bring over the "Laws and regulations".' These, almost certainly, were those of the Society of Painters in Water Colours, of which Copley Fielding was secretary from 1819 to 1826. The proposed society allied itself with a topical, political and humanitarian cause and two weeks later the Exhibition for the Benefit of the Greeks opened in Paris at the Salle Lebrun. Charles Paillet, son of Alexandre Paillet (who had helped to found the Société de l'Elysée) and himself a dealer, organised the exhibition which to a certain extent took its occasion as its theme and included five subjects from the Greek War of Independence, and four inspired by the life and work of Byron. The most dramatic items, however, must have been seven pictures by David (who had died at the end of 1825), including a reduced version of *The Oath of the Horatii*.

In 1829, when there was no official Salon, Paillet opened a second exhibition at the Salle Lebrun but it was by no means as spectacular as the first. There were fewer historical pictures and most works were on a small scale. Of all genres, history painting suffered most when state patronage was limited and there was no official Salon. This must have been one of the factors in the triumph of genre at the Salon of 1831, though this was also encouraged by a number of entrepreneurs who had taken advantage of the infrequency of the official Salon to establish exhibitions for selling smaller, more commercial pictures. Henri Gaugain, a print-seller from Rouen, set up an exhibiting organisation in the Galerie Colbert which was particularly associated with the young Romantic school. Delacroix's *Murder of the Bishop of Liège* was first seen at the Galerie Colbert, and Ary Scheffer exhibited his '*Les morts vont vite*' (see No. 91) there at the beginning of 1830. Gaugain's activity as a lithographer brought him into contact with Bonington and Camille Roqueplan as well as with Delacroix and Scheffer, all of whom provided lithographs for the sets of prints illustrating scenes from fashionable literature which he published. Like other lithographic publishers in the 1820s, Gaugain was associated with a particular kind of literary subject matter, which frequently drew its inspiration from English sources. Through the patronage of the lithographic publishers, Delacroix and the artists of his generation were given a taste for illustrating scenes from the works of Scott, Byron and Shakespeare, which subsequently became an essential part of the nineteenth-century painter's repertory of subjects.

Two other dealers, Claude Schroth and John Arrowsmith, were also associated with an interest in English art, and, like Gaugain, published prints after the artists whose work they were hoping to sell. Such activities were an important factor in promoting a widespread interest in modern painting and were often, though not invariably, associated with dealers in pictures. Schroth and Arrowsmith, who are now best remembered for importing a number of works by John Constable into France in the 1820s, employed the engraver S. W. Reynolds to produce mezzotints after Ary Scheffer, Thomas Lawrence and Géricault, among others. Although within a few years they were forced out of business by a lack of capital, these dealers gave an important impetus to landscape painting, which became the basis of several galleries in the early years of the July Monarchy. These galleries were frequently run by suppliers of artists' materials and took work in exchange for such supplies. Their stocks consisted most frequently of landscapes, often simple sketches and studies. The magazine, *L'Artiste*, founded in 1831, took an interest in this kind of commerce and gave frequent puffs to the newly established dealers: Durand-Ruel (a supplier of artists' materials), Susse (a bronze founder) and Souty (a gilder and framer). The founder of the magazine and its first editor, Achille Ricourt, who was born in Lille in 1791, took lessons from Guérin and became a lifelong friend of Delacroix (and of Baudelaire). With funds from Aimé Brame, a research chemist and a member of a distinguished Lille family, Ricourt set up as a print-seller in Paris in the rue du Coq and later, again with funds from Brame, founded *L'Artiste*. Later still, he encouraged Brame's son, Hector, to become a picture dealer. Brame frequently collaborated with the young Durand-Ruel, whose tastes he shared, but he retained a liking for artists from his native Lille. Carolus-Duran, who was patronised by Brame and by his brother-in-law, the dealer Gustave Tempelaere, painted several portraits of

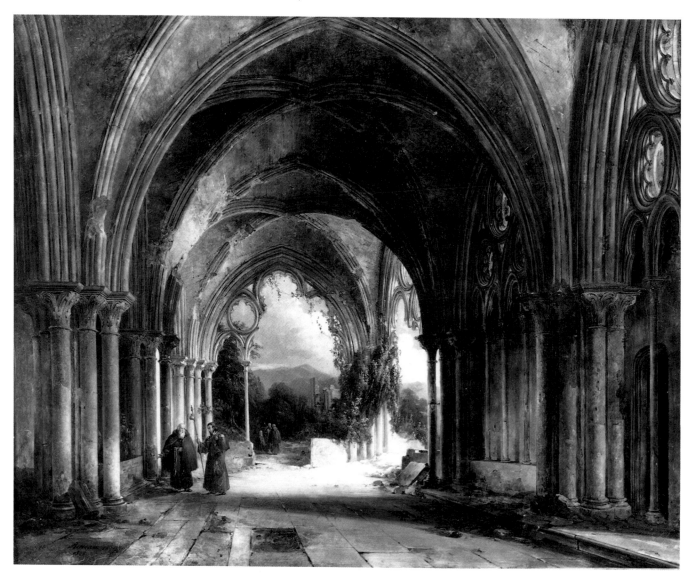

Fig. 42 Charles Renoux, *Pilgrim before a Tomb*, 1828. Oil on canvas, 72 x 92 cm. Musée de Grenoble.

Tempelaere's family which have found their way back to the museum at Lille.

The association of particular dealers with certain trends in contemporary art began as early as the Restoration, when a picture restorer, Alphonse Giroux, began to build up a stock of small 'gothic' pictures, particularly those of Charles Renoux (see fig. 42) and comparable artists, some of whom also worked for the *Voyages Pittoresques* and the Diorama, two enterprises which encouraged artists to paint atmospheric pictures of gothic buildings. In the 1830s Durand-Ruel was particularly associated with landscape, while the neo-Rococo style in which Diaz, Millet, Couture and Daumier, and a number of less familiar artists like Henri Baron (see fig. 43) specialised in the 1840s was closely connected with the dealer Armand Deforge. Similarly, in the early years of the Second Empire, Adolphe Goupil patronised a group of painters who shared a link with the work of Paul Delaroche. Goupil had become a close friend of Delaroche during the July Monarchy while publishing reproductions of his work. In the 1850s, when Goupil began to purchase pictures for resale, he commissioned work from a number of Delaroche's pupils. Under his protection the school of the neo-Greeks developed (see No. 70) and became commercially very successful. This was perhaps the first time that a major movement in painting had been sponsored, if not initiated, by a dealer.

When Paul Durand-Ruel (son of the founder of

the gallery), a recent and reluctant convert to his father's business, visited the Fine Arts section of the Exposition Universelle in 1855, the largest retrospective ever held of living French artists, he was attracted, above all, by the painters of an earlier generation – Delacroix, Decamps, and the landscapists who represented the Romantic school, which was at its height in 1831 when he was born. This taste for Romanticism determined his future course as a dealer. Like Francis Petit and Louis Martinet, two dealers with whom his firm became

associated, he attempted to promote a tendency in the art of the nineteenth century which he associated with a specifically French character. Petit and Martinet organised major exhibitions of French painting from Watteau onwards in the early 1860s as well as showing pictures by Delacroix and Manet; for Durand-Ruel, the whole modern movement in figure painting, as well as landscape, was contained in Delacroix. The sense of mission with which he exploited and promoted his favourite artists has given Durand-Ruel a pioneering role in accounts of nineteenth-century picture dealing, although his link with a specialised school of painting conformed to a common pattern. Durand-Ruel differed from his fellow dealers not by his

Fig. 43 Henri Baron, *Summer Evening in Italy*, 1846. Oil on canvas, 55 x 66 cm. Lille, Musée des Beaux-Arts, Inv. P. 487.

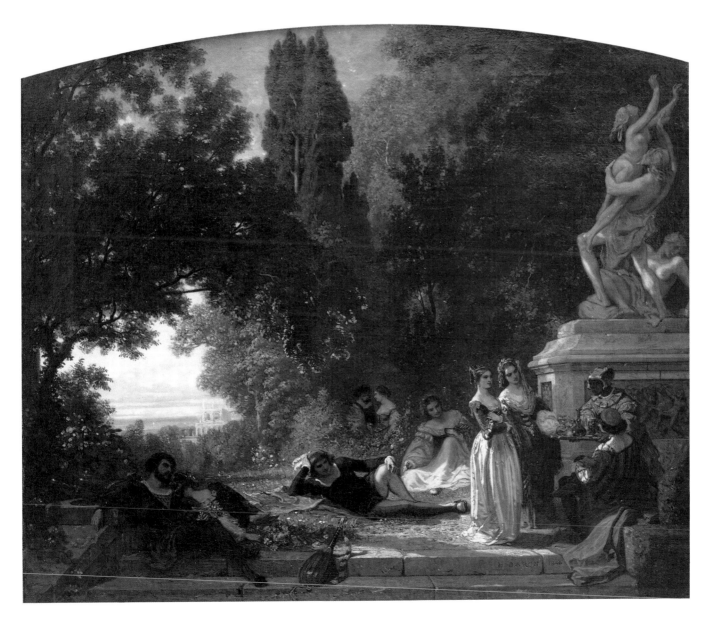

methods but by his spectacular foresight, which led him to invest in artists at a time when their works were difficult to sell, but who later became highly sought after.

Soon after 1855 Durand-Ruel began to buy works from several of the Prix de Rome winners returning from Italy: Bouguereau, Hébert and Emile Levy. Bouguereau later specialised in picturesque and tender genre scenes (fig. 44), comparable with those of Hébert, with certain works by Bonnat and with pictures such as Henri Lehmann's *Le Repos* (No. 72). In Bouguereau's case the move to genre was deliberately promoted by the dealer, though Durand-Ruel was soon to lose his most successful artist to the rival firm of Goupil. It is curious to reflect that this generation of artists, who came to stand for everything that was the opposite of Impressionism, was also launched on a career of huge financial success by Durand-Ruel when in the late 1850s he was looking for young and promising talent.

In the year of Delacroix's death, 1863, Durand-Ruel took his father's business into his own hands. He established a link with Hector Brame, with whom he visited the studios of a number of landscape artists in search of pictures: Troyon, Dupré, Daubigny (who was producing work for a number of dealers), Barye, Courbet and Jongkind. From 1867 Millet reserved his pictures exclusively for them. Durand-Ruel admired several artists of a younger generation such as Thomas Couture, whose work owed something to the example of Delacroix, and Puvis de Chavannes, whose very personal manner developed from the work of Delacroix and the artists in his circle, namely Chassériau, the Scheffers and Couture. Although Puvis's mural paintings impressed the critics, his easel paintings were in general neglected until 1872 when Durand-Ruel, anxious to revive his stock after the Franco-Prussian war, bought a number of his recent pictures, including *John the Baptist* (No. 85) and *Hope* (Baltimore, Walters Art Gallery), both of which had outraged the Salon critics, as well as *Death and the Maidens* (Williamstown, Sterling and Francine Clark Art Institute), which had been rejected by the Salon jury.

It has been said that the rising numbers of artists in nineteenth-century Paris forced the collapse of the academic system and brought about a shift towards the dealers as the mainstay of the artists.

However, it is unlikely that dealers were any better equipped than the state to deal with the thousands of artists who submitted annually to the Salon. Dealers provided a more constant outlet and a guaranteed income by offering the kind of contract which Bouguereau and the pupils of Delaroche made with Goupil, or which the Impressionists made with Durand-Ruel. This, however, benefited only a small number of the thousands of artists who exhibited pictures at the public exhibitions. There was no 'system' in the art world of the nineteenth century. The Salon, the state and the Institut served different interests, which sometimes shared a common cause and sometimes conflicted. The Institut lost control because it was rendered ineffective by the state. The Salon, abandoned by the

Fig. 44 William Bouguereau, *Girl Knitting*, 1869. Oil on canvas, 144.7 x 99 cm. Omaha, Nebraska, Joslyn Art Museum.

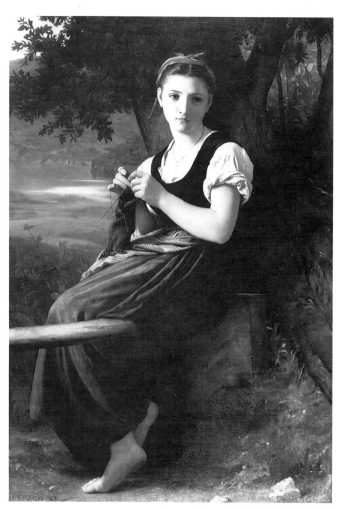

state in 1881, fragmented into a number of exhibiting societies in the 1890s, which, together, provided artists with a larger and more flexible outlet for their work. The rapid decline in the importance of these exhibitions in the course of the present century was not brought about by force of numbers nor by the rivalry of dealers but appears to have been linked to a contraction in the taste for contemporary art which affected both the dealers and the exhibitions. The state, after 1914, was no longer a significant patron of the artist. The Prix de Rome marked time until 1968, when it fell victim to the student riots. For reasons which are buried in the mysteries of fashion, the prestige of modern art declined from its high point in the nineteenth century allowing Old Masters to occupy the centre of popular affection and to dominate the market at the expense of the living artists.

Notes on further reading

For a comprehensive history of academies of art Nikolaus Pevsner's *Academies of Art, Past and Present* (Cambridge 1940) should be read in conjunction with the essays in *Academies of Art* (*Leids Kunsthistorich Jaarboek*, V–VI, 1986–7), ed. Anton Boschloo et al. The history of the Paris Académie has been chronicled by Anatole de Montaiglon, *Mémoires pour servir à l'histoire de l'Académie Royale* (Paris 1853); Louis Viter, *L'Académie Royale de peinture et de sculpture* (Paris 1870); Henri Jouin, *Conférences de l'Académie Royale de peinture et de sculpture* (Paris 1883); Henri Delaborde, *L'Académie des Beaux-Arts* (Paris 1891). Louis Courajod's *L'Histoire de l'Ecole des Beaux-Arts au XVIIIe siècle* (Paris n.d.) is the best account of the early years of the Ecole. There are excellent studies of eighteenth-century academic drawing practice in Marianne Roland-Michel's *Le Dessin français au XVIIIe siècle* (Fribourg 1987) and in James Henry Rubin's *Eighteenth-Century French Life-Drawing* (exhibition catalogue, Princeton, N.J., Art Museum, 1977). Henri Lapauze's *Histoire de l'Académie de France à Rome* (Paris 1924, 2 vols.) provides a detailed account of the early history of the Rome Academy and the Prix de Rome. The best introduction to the history of the Prix de Rome, the Salon and other institutions in the eighteenth century is Jean Locquin's *La Peinture d'histoire en France de 1747 à 1785* (Paris 1912). For more recent discussions of the Salon and other eighteenth-century exhibitions see Thomas Crow, *Painters and Public Life in Eighteenth-Century Paris* (New Haven and London 1985), Robert Isherwood, *Farce and Fantasy* (Oxford 1986), and the introductory essays to the five volumes of Diderot's Salon reviews, ed. Jean Seznec and Jean Adhémar (Oxford 1957 to 1967). Since the bicentenary of the French Revolution in 1989 there have been a number of studies of institutions in the 1790s, including *Les Salons de peinture de la révolution française* by Philippe Heim, Jean François Heim and Claire Béraud (Paris 1989), and the catalogue of the exhibition, *1789: French Art during the Revolution*, ed. Alan Wintermute with particularly informative essays by Colin B. Bailey, Donald Garstang, William Olander and Carol Eliel (New York, Colnaghi, 1989).

The nineteenth century has been less well served by the work of archivists. Harrison and Cynthia White's *Canvases and Careers: Institutional Change in the French Painting World* (New York 1965) was a bold attempt to provide an account of the institutions of nineteenth-century French art which was hampered by limited sources and a lack of secondary literature. Since then, the history of the Salon and other exhibitions has been broadly established in *Saloni, gallerie, musei e loro influenza sullo sviluppo dell'arte dei secoli XIX e XX*, ed. Francis Haskell (Bologna 1979). Pierre Angrand's *Le comte du Forbin et le Louvre en 1819* (Paris 1972) complements the essays in this volume with an enjoyable and detailed study of the

organisation of the Salon of 1819. Patricia Mainardi's *Art and Politics of the Second Empire: The Universal Expositions of 1855 and 1867* (New Haven and London 1987) discusses art at the World Fairs in Paris in the context of state patronage. Albert Boime's *The Academy and French Painting in the Nineteenth Century* (London 1971) is a lively, comprehensive and pioneering account of the influence of the Ecole des Beaux-Art and the circumstances of the Prix de Rome which has subsequently been discussed and illustrated in detail in Philippe Grunchec's *Le Grand Prix de peinture: les concours des prix de Rome de 1797 à 1863* (Paris 1983).

There has been no extensive study of the administration of the arts in nineteenth-century France since Louis Hautecoeur's informative, if tendentious, *Les Beaux-Arts en France; passé et avenir* (Paris 1948), which, like Philippe de Chennevière's *Souvenirs d'un directeur des beaux-arts* (Paris 1883–9), was written by a former bureaucrat with a policy to defend. Michael Marrinan's *Painting Politics for Louis-Philippe, Art and Ideology in Orléanist France* (New Haven and London 1988), analysing aspects of patronage in the July Monarchy, is a useful source book. Two articles by Pierre Angrand dealing with the patronage of the Second Empire (*Gazette des Beaux-Arts*, September 1967 and June 1968) are illuminating and detailed in the best traditions of French art history. The development and patronage of French museums has been discussed thoroughly in Daniel Sherman's *Worthy Monuments: Museums and the Politics of Culture in Nineteenth-Century France* (Cambridge, Mass., 1989).

Apart from studies of Durand-Ruel (Lionello Venturi, *Les Archives de l'Impressionnisme*, 2 vols., Paris 1939) concentrating on the Impressionists and studies of Impressionist collectors (Anne Distel, *Les Collectionneurs des Impressionnistes: amateurs et marchands*, Paris 1989, is a basic source but Sophie Monneret's *L'Impressionnisme et son époque*, Paris 1978–81, 2 vols., has useful biographies), there is a lack of work discussing collectors and dealers of contemporary art in nineteenth-century France. However, a number of recent books and articles on collectors (Albert Boime, 'Entrepreneurial patronage', in *19th and 20th Century France*, ed. E. Carter II and R. Forster, Baltimore and London 1976; Francis Haskell's *Rediscoveries in Art*, London 1976; and *Past and Present in Art and Taste*, New Haven and London 1987) and on dealers (John Rewald, 'Theo van Gogh, Goupil and the Impressionnists', *Gazette des Beaux-Arts*, January 1973; Linda Whiteley, 'Accounting for Taste', *Oxford Art Journal*, no. 2; and 'Art et commerce d'art en France avant l'époque Impressioniste', *Romantisme*, no. 40, 1983) have provided the basic evidence for a revised view of the artistic institutions of nineteenth-century France in which the role of the avant-garde painting as an agent for change has been called increasingly into question.

The Citizens of Lille and their Museum

Alain Gérard

The social structure of Lille in the first half of the eighteenth century meant that only religious establishments and some nobles were able to put together large collections of works of art. The people of Lille, however, demonstrated their interest in art, especially pictorial art, long before there was a museum in the town. The first guides which gave detailed lists of collections open to the public – the *Voyage pittoresque de la Flandre et du Brabant, avec réflexions relativement aux arts*, published in 1760 by Descamps, and the *Guide des étrangers à Lille*, which appeared in 1772 – were very successful. By the end of the century, however, there was a growing demand for greater access to art and for more facilities.

The creation of the museum and its first developments

The municipal authority, aware of these new demands, had opened a school of drawing in 1755, and from 1772 set up an annual Salon to exhibit paintings. It also created an Academy of Arts. These initiatives only partly satisfied the public, who thronged in increasing numbers to the Salons, which were held at the same time as the city's annual fair in order to benefit from the numerous visitors attracted to Lille by this event.

The Revolution brought considerable changes in the arts, as in all other activities in France. Schools and academies were abolished, and the Salon was suspended from 1791 until 1794. Works of art were seized from convents, from the homes of emigrés and from churches, and then collected up and held by the authorities. In Lille the pictures were kept in the deconsecrated convent of the Récollets. From 1794 onwards some of them were exhibited, along with more recent works, in the reopened Salons, held initially every two years and then, after 1798, annually. The painter in charge of organising them, Louis Watteau (nephew of the celebrated Antoine Watteau), was commissioned to compile an inventory of the seized pictures: he counted over 646, of which 197 were judged to be 'worthy of being preserved for educational reasons'.

On 1 September 1801, on the recommendation of J.-A. Chaptal, the Minister of the Interior, Bonaparte, then First Consul, signed a decree which made 846 canvases available to fifteen large towns, on condition 'that they would arrange for a suitable gallery to house them, at the expense of the local government'.

Lille made the necessary provisions to establish a museum in the convent of the Récollets (fig. 45), and Henri van Blarenberghe was appointed curator. He was an excellent choice as, in addition to his professional expertise, he was a friend of General Alexandre Berthier (the future marshal of the Empire, prince of Wagram), one of Bonaparte's closest colleagues, a contact that was bound to be of help in his new task.

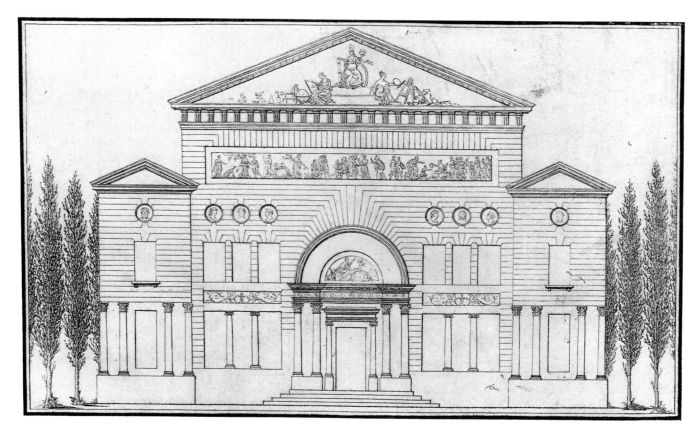

Fig. 45 Design for the façade of the first museum at Lille, originally the convent of the Récollets, by the Lille architect Dewarlez (1767–1819), engraved by Durig.
Engraving, 11 x 17 cm. Collection Alain Gérard.

Nevertheless, van Blarenberghe had to wait until 1803 before Lille had the forty-six canvases allotted by the government. He was advised to make 'a choice of pictures which did not contain examples of the Flemish school, as the town already had a valuable collection of them'.

It took several years to fit out the premises and install the paintings, most of which had been removed from churches in Paris or taken from territories occupied by France, and it was not until 15 August 1809 that the museum was finally opened. The event was not as successful as had been hoped, partly because the population was fearful of the consequences of the landing of English troops at Walcheren, near Antwerp, which had taken place a few weeks earlier. The exhibition consisted of ninety-nine pictures and was accompanied by a short catalogue. Works which came from local sources were moved around several times, since there was a large number of such paintings in reserve. In fact there were so many that in 1813, de-spite the return of many canvases to the churches from which they had been seized, a commission was set up by the *préfet* to sell off 354 paintings deemed to be unimportant. However, there were still more than enough to fill the museum – in 1815 the catalogue mentioned 121 exhibited works. The public could view them two days a week, on Thursdays and Sundays; the other days were reserved for teaching pupils.

Over the next few years the museum's activities remained on a modest scale. Purchases and donations were limited, with two notable exceptions: the arrival in Lille of the extraordinary collection of Old Master drawings put together by Jean-Baptiste Wicar (1834), and the gift from the government of a modern masterpiece, Delacroix's *Medea* (No. 39).

The 'explosive' growth of the museum

The catalogue published in 1835 lists 162 paintings: so the collection had grown little during the preceding twenty years. But around 1840 several factors combined to transform the pace of growth. In 1841 Edouard Reynart (1804–79) was appointed keeper (fig. 46). He was a man of strong

Fig. 46 Carolus-Duran, *Edouart Reynart* (1802–79), curator of the Lille museum from 1841 until his death. Oil on canvas, 61 x 45 cm. Lille, Musée des Beaux-Arts.

personality, born into a wealthy family in Lille, and able to devote himself entirely to the museum, though he gave up his salary in 1848. He fostered friendships with artists (which resulted in a number of gifts), as well as with French and foreign picture dealers.

His contacts enabled him to obtain much of what he wanted (though not everything) from the municipal authorities and even from Paris. A man of excellent taste, he made enlightened choices from the pictures offered to him, and surrounded himself with devoted friends. Auguste Herlin (1815–1900), a painter from Lille, assisted him with great efficiency and on Reynart's death in 1879 succeeded him as keeper.

Bigo-Danel, the mayor, was a little taken aback by Reynart's dynamism, which was in sharp contrast to his predecessor's excessive calm. In 1845 he tried to control Reynart's exuberance by creating an administrative commission for the painting collection. Far from inhibiting the keeper, how-

ever, this commission, which was appointed to take decisions concerning the purchasing of works, donations and the restoration and upkeep of canvases, was often of invaluable help to him. Composed of local art lovers and well-known artists, the commission ensured an excellent link with the people of Lille, helping to maintain their interest in the collections.

A second organisation also promoted the growth of the museum. This was the Society of Science, Agriculture and the Arts, which was created in 1802, and still exists today. It brought together all those involved in promoting cultural and scientific activities in the city, and won the approval of J.-B. Wicar (1762–1833) (fig. 47), a painter from Lille who had lived in Rome for several decades. Wicar had put together a magnificent art collection, mainly of drawings, and he gave the whole collection to the society, which exhibited it in agreement with the museum. The collection later passed to

Fig. 47 Jean-Baptiste Wicar, *Self Portrait*, 1806. Oil on canvas, 99 x 75 cm. Lille, Musée des Beaux-Arts.

the museum. Among these works are a bas-relief by Donatello, *The Feast of Herod*, and the famous *Tête de Cire* (fig. 48), one of the most popular exhibits in the museum. The people of Lille came in large numbers to admire it. The society also founded a natural history museum, which evolved independently, and, in 1824, created and ran a numismatic museum. Finally, in 1849, thanks to a large donation by one of its members, A. Moillet, a novel ethnological section was opened.

Many offers of donations, both large and small,

Fig. 48 '*La Tête de Cire*'. The attribution of this wax bust has given rise to much speculation. It may be the work of François Duquesnoy (1597–1643). Wax, height 45 cm. Lille, Musée des Beaux-Arts.

Fig. 49 Lille calendar for the year 1867. Among the local personalities depicted are one of the museum's principal benefactors, Alexandre Leleux (1812–73) (third from right in the second row), and the Lille painter Amand Gautier (1825–94) (extreme right of the third row). Lithograph, 23 x 34 cm. Collection Alain Gérard.

came from private collectors, testimony to the continuing interest of the people of Lille in the cultural wealth of their town. Like Reynart himself, however, the administrative commission was careful to accept only works of quality. Two donations deserve special mention for their size and value. On his death in 1873 Alexandre Leleux (fig. 49), the director of a local newspaper, the *Echo du Nord*, left his entire collection of paintings to the museum. It consisted of 121 works, including an outstanding group of paintings by the Flemish School.

Another significant donation came from the collector and dealer Antoine Brasseur (1819–86) (fig. 50). Abandoned at birth, Brasseur had been brought up by the main charitable organisation in Lille, the Hôpital Général. A man of tremendous personal energy, he rose from being a labourer to become an important art expert and picture dealer in Cologne. Reynart made contact with him in 1878, thanks to the historian Paul Marmottan, and they became friends. On his death the collector gave not only his magnificent collection of 108 paintings to the town of his birth but also some of his fortune, which was to be used for the purchase of works of art for the museum. He wisely stipulated that the municipality should not use the bequests as an excuse to reduce its annual purchasing subsidy. Among the works which were later bought with some of the money from this bequest are the *Portrait of a young Boy* by Verspronck (1888) and the *Interior of the Nieuwe Kerk in Delft* by Emanuel de Witte (1890).

Encouraged by these examples the French government (that is, the Ministry of the Interior, Committee of Fine Arts) dispatched a steady stream of works to the museum, either on loan or with a grant for half the purchase price. Often these were paintings or sculptures which had won prizes at the Salon in Paris, such as Courbet's *Aprés-dinée à Ornans* (No. 31) and *Sleep* by Puvis de Chavannes (Nos. 83 and 84; fig. 83). The museum's painting collections thus continued to grow appreciably, and in 1859 Reynart wrote a long letter to the mayor, drawing his attention to the need 'to follow a more ambitious course . . . worthy of one of the most important towns in the empire', and putting forward some proposals. Although not all of Reynart's suggestions were acted upon, a substantial increase in the grant for the acquisition and upkeep of works of art was agreed.

M

Le Maire de Lille a la douleur de vous faire part de la mort de Monsieur

Antoine BRASSEUR

BIENFAITEUR DE LA VILLE DE LILLE,

OFFICIER DE L'INSTRUCTION PUBLIQUE, CHEVALIER DE L'ORDRE DU NICHAM,

Né à Lille, le trois juillet mil huit cent dix-neuf, décédé à Cologne, le vingt-huit novembre mil huit cent quatre-vingt-six.

Il a l'honneur de vous prier d'assister aux Convoi et Service Solennels qui se feront le Dimanche cinq décembre, à midi, en l'église Saint-Maurice, d'où son corps sera conduit au cimetière de l'Est, pour y être inhumé.

L'assemblée à l'Hôtel-de-Ville, à onze heures et demie.

HÔTEL-DE-VILLE, le 2 Décembre 1886

Fig. 50 Memorial card for Antoine Brasseur (1819–86), who left an important collection of art works to Lille. Printed card, 27 x 21 cm. Lille, Musée des Beaux-Arts, Archives.

Here we will mention only the purchase of two major paintings by Goya which the Parisian dealer Warneck offered in December 1873. *The Letter, or The Young Woman* was bought for 7,000 francs, but the administrative commission, although usually receptive to Reynart's suggestions, demonstrated their independence by stating their opposition to the *Time, or The Elderly Woman*. However, the keeper raised the necessary 3,000 francs to buy it with the help of two friends.

Thanks to Reynart's enthusiasm the pace of acquisitions quickened, and 154 canvases were bought between 1842 and 1873. His successor, Auguste Herlin, continued along the same lines and a further 91 pictures were bought before he retired in 1892. A few examples will give an idea of the range: Jehan Bellegambe's *'Bain Mystique'*

(The Mystical Bath) (1888), Frans Hals's *Malle Babe* (1872), Titian's *Martyrdom of Saint Stephen* (1888), David's *Belisarius* (No. 35) and Corot's *'Effet du matin' (Morning Effect)* (1869).

However, circumstances were not always favourable, and one example of persistent bad luck was the vain attempt to obtain a painting by Rembrandt. Negotiations failed six times, the first time in 1893. The following year the commission had to give up its attempt to buy *The Man with the Golden Helmet* because the painting lacked sufficient documentation, and in July 1895 a self portrait on sale at Christie's, London, just eluded them.

The collections in the Lille museum were not confined to painting. There were also a number of specialist sections, each administered by an independent commission made up of friends and enthusiasts, who were appointed by the mayor from those with suitable qualifications. Each specialist commission was run by a vice-president, who assumed the responsibilities of the keeper (the mayor, legally the chairman, only attended meetings in exceptional circumstances). There was never a shortage of volunteers to fill the posts in these commissions, in fact there was keen competition to be appointed, which illustrates the commitment of the people of Lille.

As well as the principal commission, which ran the paintings section, there were sections for drawing, ethnology, archaeology and numismatics. By 1865 there was also a separate commission for ceramics, and in 1882 one for antiques. The decorative arts section, created in 1884, lasted only a short time. Sculpture was separated from paintings in 1887 because of the large number of nineteenth-century works which had been acquired. Similarly, engravings were separated from drawings in 1889. The engravings, along with sketches and copies of paintings, were later exhibited in another building, in a new section created by Reynart.

This variety of fields of interest caused enormous administrative problems. A number of reforms were introduced over the years in an attempt to establish the right balance between giving the desired amount of autonomy to the head of each section and yet still maintaining the necessary overall co-ordination. It was not until after the First World War that the general keeper secured undisputed control of all the collections.

The museum buildings

The people of Lille were involved not only in the growth of the various collections, but also in the buildings that housed them. The first quite modest premises were the convent buildings of the Récollets, which the occupants had been forced to abandon at the beginning of the Revolution. Part of the chapel was redesigned so that the most outstanding canvases could be hung there, and the other buildings housed the reserve collection of paintings and the library. Various descriptions and a picture by Bonnier de Layens (keeper from 1829 to 1841) enable us to imagine what the museum was like at that time. The paintings were hung close together right to the top of the walls, and the lighting was unreliable. Obviously this was an unsatisfactory arrangement, especially as the number of works was rapidly increasing. It was decided therefore to take advantage of the rebuilding of the town hall in Lille on the site of the fifteenth-century palace (then almost completely in ruins) built by Philip the Good, Duke of Burgundy. A huge square building in a Neo-Classical style, built around a central courtyard (fig. 51), designed by Charles Benvignat (No. 80, fig. 52), an architect from Lille, was started in 1847.

The museum collections were arranged on the second floor. Three rooms were finished in 1848 and three others in 1860. The architect, who was also a member of the museum's administrative commission, paid scrupulous attention to the interior design of the galleries. Following an inspection in 1853, Philippe A. Jeanron, director of the Musées Nationaux, was able to write: 'these rooms are very suitable . . . everything has been worked out in the interest of the paintings.' He even thought that there was not a room in the Louvre which could provide comparable exhibition facilities. The compliments paid to the Wicar collection were equally fulsome. Here, the system of framing and the presentation of the drawings, described in minute detail, were seen as exemplary.

These favourable notices meant that the number of visitors to the museum grew noticably. Guides to Lille, which previously had only very briefly mentioned the museum, now devoted long passages to it and some of them (Henri Bruneel, *Guide de la ville de Lille*, Lille 1850) even included a detailed description of the rooms, which is invalu-

Fig. 51 Lille Town Hall, *c*.1880. The building was designed by the Lille architect Charles Benvignat; the museum's collection was shown on the second floor from 1848 to 1892. Postcard, 9 x 14 cm. Collection Alain Gérard.

able today. Public demand led the keeper to produce extended catalogues of the collection, rather than dry lists. The one published in 1850 was obviously a great success, as it was reprinted in 1856 and again in 1862. In 1872 it was illustrated for the first time with photographic reproductions.

The large number of purchases and gifts (such as the donation of antique objects by J. de Vicq in 1881) meant that the museum had to be rearranged and enlarged on several occasions. The whole of the second floor of the town hall was gradually allocated to various departments (figs. 53 and 54), the archaeology department being situated in the only remaining part of the original palace of the Dukes of Burgundy.

Fig. 52 Victor Mottez, *Charles Benvignat* (1806–77) (No. 80).

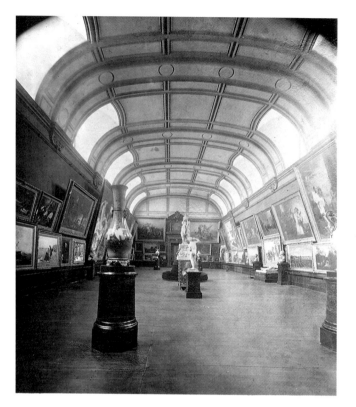

Despite these successive extensions the museum was continually short of space. Furthermore, the security and fire escape arrangements were totally inadequate. As a result, when Géry Legrand was elected mayor in 1881, he decided to construct a completely new building, one specially designed and built as a museum. This was a new and forward-looking initiative. Only the towns of Amiens and Nantes adopted comparable plans towards the end of the nineteenth century, and the Lille proposal reflected the concern of the city to have a building worthy of the collection.

A huge plot was earmarked in the new district which had emerged since 1859, when the process of enlarging the town had begun. The successive

Fig. 53 The main exhibition gallery of the museum when it was housed in the Town Hall of Lille, *c*.1875. Photograph, 23 x 17 cm. Lille, Musée des Beaux-Arts, Archives.

Fig. 54 Another exhibition gallery of the museum showing the section devoted to copies of works of art. Postcard, 9 x 16 cm. Lille, Musée des Beaux-Arts, Archives.

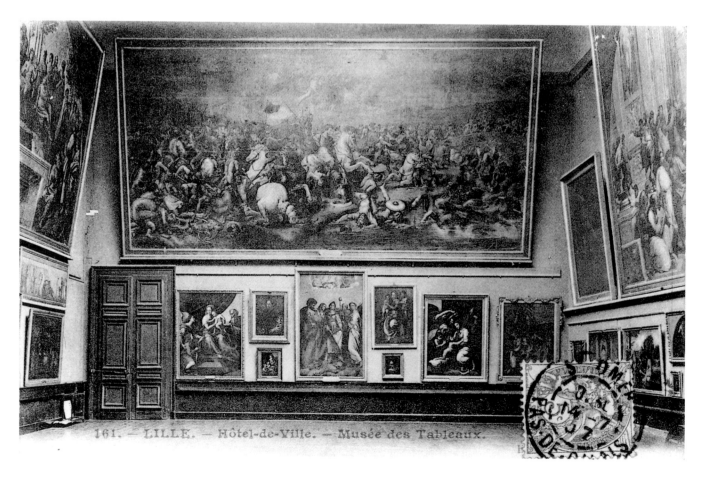

161. — LILLE. — Hôtel-de-Ville. — Musée des Tableaux.

place names, Place Napoléon III, then Place de la République (fig. 55) after the fall of the Emperor, reveal the character of this area. The new prefecture had already been built on the west side, and opposite this was a large undeveloped area measuring 180 by 85 metres; this was to be the site of the new museum.

There was only one problem: money. The municipal treasury was unable to meet the expenditure for the grandiose new building, so it was decided to organise a lottery. After the necessary authorisations had been obtained from the government, 4,500,000 tickets at one franc each were issued in 1882 (fig. 56). The organising committee used every means to publicise their sale – press, posters, leaflets, various festivities – and the response was spectacular. The draw was made in

Fig. 55 Place de la République, Lille, c.1900, showing, centre, the Palais des Beaux-Arts. Postcard, 23 x 28 cm. Collection Alain Gérard.

July 1883, and the lots awarded (the first prize was 200,000 francs). After the various expenses had been paid, a profit of 2,800,000 francs was left.

Fig. 56 Lottery ticket sold in aid of the new Palais des Beaux-Arts, Lille, 1882. Printed paper, 10 x 16 cm. Collection Alain Gérard.

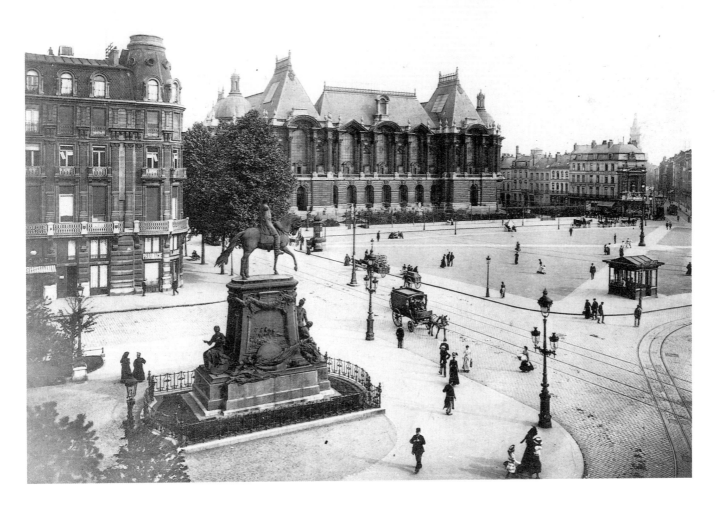

Events now followed a traditional sequence: the specifications for the architects were established; a competition in two successive stages was organised; a jury was formed; and the final results were announced in July 1885. The plan proposed by the Parisian architects Bérard and Delmas was adopted. All these stages were extensively covered by the local press and fuelled heated discussions.

Opinions of the winning design ranged from extreme praise to total denigration; nevertheless a general feeling of approval predominated. Bérard and Delmas's plan undoubtedly won because of its monumental character. The jury wanted a 'palace' and had made their decision on that basis. But the feasibility of this future 'palace of fine arts' as a museum was not neglected to the extent that certain critics liked to maintain. It is true that problems of heating, ventilation and humidity were not scrutinised closely enough, but the exhibition areas and the lighting conditions were assessed correctly. Although the space available soon proved inadequate, this was because of problems which arose only when the building was under construction.

Frustrations started as soon as the work began. The town of Lille was largely built on marshy ground crossed by numerous streams. As the town expanded these were made into underground channels and drains, but as a result cellars were often flooded and foundations had to be built with

Fig 57. One of the museum's galleries after the bombardment of Lille in October 1914. Photograph, 12 x 17 cm. Lille, Musée des Beaux-Arts, Archives.

special care. The new museum was no exception to this rule: the architects' plan had to be adapted to meet the unreliable conditions of the site (a spring was even unexpectedly discovered) and extra expenses were incurred. The expenditure was such that the chief of works was forced to cut the plan down to half its original size, which created serious problems for those responsible for displaying the works of art. These difficulties continued to be a headache for successive keepers.

The opening was delayed several times, but it finally took place on 6 March 1892 amid general enthusiasm. It was certainly a great moment for Lille as hundreds of delighted visitors walked through the rooms. But it soon emerged that the problems of heating and the battle against humidity had not been solved. Mildew began to appear on the pictures and drawings. The damage became so bad that the museum had to be closed from 1896 to 1898 for refitting.

It is interesting to note the extent of the press coverage of these events, which one critic called the 'disaster of the Lille museum'. All the Lille newspapers published articles almost daily on the situation and readers added their comments. The national press also picked up the story.

The repercussions on public life in Lille were important. The municipal council meetings dealing with the museum were followed with passionate interest and the protection of the artistic heritage became an electoral issue. Unfortunately, these events took up too much of the curators' attention. The tensions which resulted from discussions about responsibilities led to a spate of resignations.

However, the purchasing policy was not greatly affected, thanks to Brasseur's donation. Some of the most important painting acquisitions have already been noted, but we must also mention the purchase in 1900 of the exceptional collection of Flemish coins, known as the Vernier collection, the equivalent in the field of numismatics to the Wicar collection in that of drawings. Nor did the donations stop. Among the most noteworthy are the paintings given by the Demoiselles Cottini in 1879 and by Madame Maracci in 1901, and the antique objects in the Ozenfant collection (1894).

Despite various rearrangements in order to maximise the number of objects on view, the museum soon proved to be too small, and certain collections, such as the collections of sketches, copies of

Fig. 58 The museum's gallery of seventeenth-century paintings after the First World War. Photograph, 13 x 18 cm. Lille, Musée des Beaux-Arts, Archives.

paintings, and engravings, had to be moved elsewhere. As a result numerous pieces were lost in 1916 when the town hall, where they were housed, was destroyed by fire.

The problems for the general keeper of museums, Emile Théodore (1875–1937), took on a new dimension when war was declared in August 1914. Lille was occupied by German troops for more than four years, and both the civilian population and the museum suffered during this period. No provision had been made for the evacuation of works of art, and Théodore had to arrange for their safe-keeping in difficult and precarious conditions. During the siege of Lille, 10–12 October 1914, the museum was hit by seventy shells (fig. 57), but the collections remained relatively unharmed, thanks to his precautions.

There were many instances of confrontation between the curators and the occupation authorities. For example, the Germans demanded the return of Piazzetta's *Assumption of the Virgin*, which had been seized in 1796 by the French authorities from the chapel of the Teutonic knights in Frankfurt-am-Main as war booty. It was sent to the museum in Lille in 1801. The museum authorities successfully negotiated its return to Lille after the war.

In May 1917 the Germans began to move key sections of the museum collections to towns further away from the front, despite the opposition of the municipality and the keeper, who feared that they would be damaged or stolen. Most of the works were recovered at the end of the war but inevitably some losses and thefts were recorded.

In November 1918 the town was liberated by the British. General Birdwood, whose troops had led the liberating force, asked to see the museum and especially the *Tête de Cire*, which had fortunately survived undamaged. On 14 July 1921 the staff of the museum were mentioned in the honours list, the Ordre de la Nation. The building itself was now in the process of being restored and would not be reopened to the public until 1924 (fig. 58).

The museum today

The Second World War delayed the expansion of the museum but did not inflict any damage. Over the next few years, the organisation of the museum was improved, and the curators' authority grew as they became part of a state body (which the ministry had wanted for a long time). The various commissions, whose roles could no longer be justified, disappeared. Support and donations for the museum continued unabated and a successful programme of temporary exhibitions was established. The close relationship between the citizens of Lille and their museum led to the creation of a Society of Friends of the Museum, which became one of the most important of such societies in the provinces. But the big problem was still one of space, which has become more acute as the number of acquisitions and donations increased.

The problem was highlighted recently when part of the collection of relief maps, which until then had been kept in the Musée des Invalides in Paris, was deposited in Lille. A considerable amount of room was needed to exhibit these splendid urban models. An agreement signed between the state and the town of Lille in 1987 brought a solution by providing the money needed to totally renovate the building and to extend it to meet today's requirements. This latest episode in the history of the Lille museum demonstrates once again the concern and interest of citizens of Lille in their museum, and their affection for its art collections.

For a more detailed account of the building of the museum in the nineteenth century, see *Un Palais pour un Musée*, Lille, Musée des Beaux-Arts, 1985.

The Catalogue

Contributors

NP Nicholas Penny

VP Vincent Pomarède

SR Sophie Raux

AS Annie Scottez-De Wambrechies

LW Linda Whiteley

HW Humphrey Wine

Amaury-Duval 1808–1885

(Eugène-Emmanuel-Amaury Pineu-Duval)

1 The Birth of Venus

Oil on canvas, 197 x 109 cm
Signed and dated lower right:
Amaury-Duval 1862

In 1856 Ingres exhibited his picture
La Source (Paris, Musée d'Orsay) in
his studio. It was a reworking of a
study for his *Birth of Venus* (fig. 59),
which was itself based on a figure
study of 1808, taken up again some
forty years later – as was Ingres's
habit – and completed in 1848.
These two works offered a stylistic
model which could be adapted by
artists not temperamentally drawn to
the splendid realism of Courbet's
Après-dinée à Ornans (No. 31), and
thereafter a rash of single-figure
studies turned into compositions by
the addition of sea, shells and cupids
was subsequently to be seen at the
Salon.

Amaury-Duval's *Birth of Venus*
may be seen as recreating an ideal of
naïve perfection which Ingres –
although at one time an admirer of
Italian primitives and of John
Flaxman – had already abandoned
when the young Amaury-Duval came
to him as a pupil. Amaury-Duval
was astonished to discover in Ingres
a 'realist', as he termed it. He
described in his memoirs the impres-
sion made on him by Ingres's *Birth
of Venus*, before its reworking: 'Few
things have ever moved me so much
as the sight of that picture. It seemed
to me that Apelles must have painted
like that. The sky was bluish, rather
than blue; the whole figure had the
attractiveness of a sketch, the putti
barely indicated, but charming . . .
Since then, what has happened to it?
The sky is now dark blue, almost
black, the Venus standing out
against it, brightly lit: when I saw it
for the first time, the transition from
the tone of the sky to that of the
figure was scarcely noticeable. Can it
be that Monsieur Ingres has lost the
naïveté he used to boast of, when he
finished this picture which he had

begun in his youth?' (Amaury-Duval 1924, p. 57.)

The Salon of 1863 was popularly nicknamed 'the Salon of the Venuses': those by Alexandre Cabanel and Paul Baudry attracted much of the critical attention, although most accounts also discussed Amaury-Duval's picture, finding it on the whole somewhat cerebral beside the robust sentimentality of the other two. (For a discussion of the myth of Venus in relation to ideas of gender in this period see Shaw 1991, pp. 541–60.) Years after Ingres's commitment to nature had led him away from the mannered style of his youth, Amaury-Duval was copying the frescoes of Fra Angelico at San Marco: the pink and blue world of that artist, and a striking innocence, appropriate to a Birth of Venus, are evident here. The pose, however, is based on Ingres's prototype, the antique *Venus* of Apelles (rather than on the *Venus pudica* of Botticelli), and the elongated grace, the subtleties of transition from background to figure – long ago admired in Ingres's work – the finesse of the passage from light to shade within the figure (a technique he acquired with difficulty, as he recounted), reveal all that Amaury-Duval owed to his master.

LW

Bought from the artist in 1866. Inv. 506.

Montrouge 1974, p. 55, no. 57 (with bibliography); Shaw 1991, pp. 541–60, ill.

Fig. 59 J.A.D. Ingres, *The Birth of Venus*, 1808–48. Oil on canvas, 163 x 92 cm. Chantilly, Musée Condé.

Amaury-Duval *1808–1885*

(Eugène-Emmanuel-Amaury Pineu-Duval)

2 Woman from St-Jean-de-Luz

Oil on canvas, 79 x 61 cm

Pictures of peasant girls in nineteenth-century regional costume were a popular genre. The tradition stems from the work of Léopold Robert, who painted the inhabitants of the country around Rome and Naples, and it was soon taken up by artists working in Spain, North Africa and the French provinces. Amaury-Duval was not generally associated with the practice. This study of a Basque girl, certainly drawn from life and probably made while Amaury-Duval was working in Biarritz for a church commission (1860–4), transforms the genre; he emphasises the ideal rather than the picturesque qualities of the model. Head studies of girls are common in his work, particularly in profile, a viewpoint frequently used by the Quattrocento artists whom Amaury-Duval often imitated. The sharp contours, dilated eyes and carefully limited palette of blue, white and ochre, are a refined commentary on Ingres's early portraits, but Ingres's supple curves have given way to a delicate, rectilinear style, enhancing the faintly ascetic grace which is characteristic of Amaury-Duval.

LW

Gift of the artist's heirs, 1886. Inv. 659.

Yokohama etc. 1991–2, p.168, no. 40 (with full bibliography), ill. p. 57.

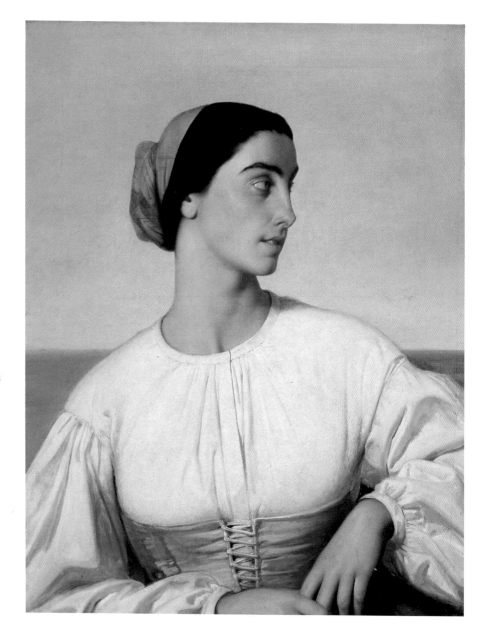

Jules Bastien-Lepage
1848–1884

3 Achilles and Priam

Oil on canvas, 147 x 114 cm
Signed and dated lower left:
J. Bastien-Lepage, 1876

After exhibiting portraits and allegorical scenes in the Salons of 1870, 1873 and 1874, Bastien-Lepage decided to compete for the Grand Prix de Rome. He had been a pupil of Alexandre Cabanel at the Ecole des Beaux-Arts, where he came top in the entrance competition in 1867, which encouraged him to hope for a traditional career in academic painting.

His first entry in 1875, an *Annunciation to the Shepherds* was commended by the judges but not given a prize. He entered again in 1876, when the subject was 'Priam asking Achilles for Hector's body', the text being taken from Book 24 of the *Iliad*: 'The old man went to the part of the tent where Achilles was. The young hero's companions were seated apart. Great Priam entered without being noticed and approaching Achilles he knelt and kissed his terrible hands. Achilles thought of his own father and was moved to weep.'

Whether intentionally or not, the Prix de Rome jury omitted the line: 'murderers, who had killed so many of his sons' after 'kissed his terrible hands', so toning down the hardness of Achilles' character. 'I want it to be heartbreaking to see this noble and wise old man kneeling down in front of the leader of the savages who coveted the treasure of Troy. This is how I understand the subject . . . ', the artist wrote.

The smooth technique used for *Achilles and Priam* is reminiscent of the Neo-Classicism which was revived and modified between 1850 and 1870 by artists such as Cabanel.

The critics were divided. For E. Véron: 'It has a mixture of daring and defiance which is initially surprising. The true Priam is not here: this is not the pain of a father

and a patriarch, it is that of someone in their second childhood bawling without any sense of dignity!' Again Bastien-Lepage failed to win the Grand Prix, which went instead to Joseph Wencker, a pupil of Jean-Léon Gérôme, and this time, he was not even commended. However, he remained philosophical about his failure: 'My picture is one of those that does not go unnoticed. . . . In short, it is a picture which will make people talk about me.' (July 1876; quoted by Gérome 1973.)

Bastien-Lepage already owed much to Puvis de Chavannes. Now he also absorbed some of Manet's style of handling and turned to unheroic, often rural, subjects. Emile Zola analysed his popular success as due to a deft appropriation of some of the more attractive aspects of Impressionism by someone who remained a pupil of Cabanel.

VP

Given to the museum by Mme Verstraëte-Delebart, 1886. Inv. 635.

R. Gérome 1973, pp. 65–70; Verdun, Montmédy 1984, no. 12.

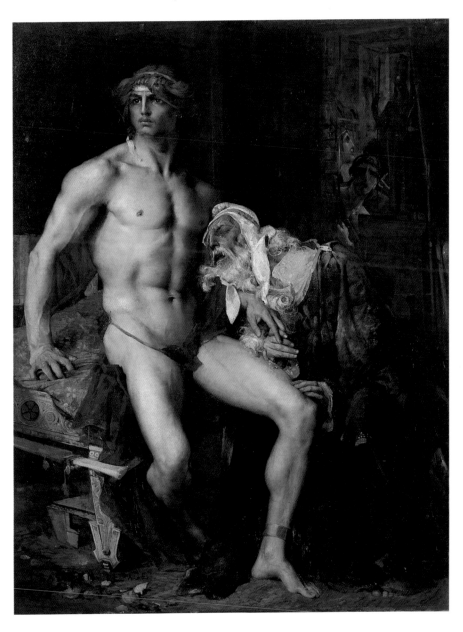

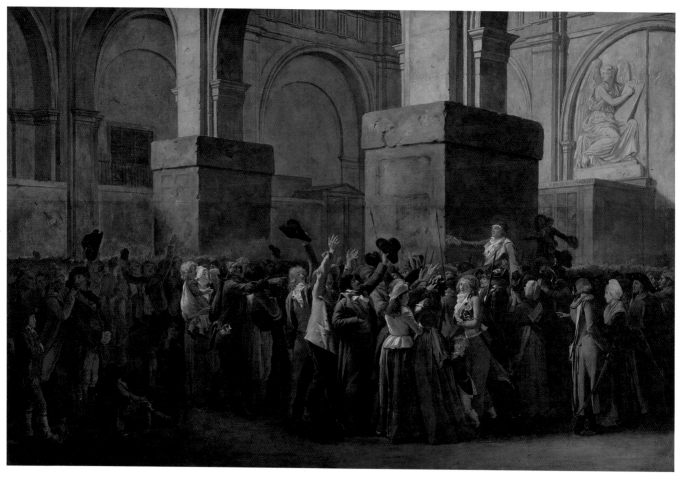

Louis-Léopold Boilly
1761–1845

4 The Triumph of Marat

Oil on seven pieces of paper glued to a
canvas backing, 80 x 120 cm

Marat is carried in triumph and
greeted by a jubilant crowd on 24
April 1793 in the forecourt of the
Palais de Justice after his acquittal by
the Revolutionary Tribunal of
charges brought against him by the
Girondins. The painting consists of
separate sheets assembled (or rather
reassembled) by the artist's son
Julien Boilly, who also admitted to
making additions to the painting –
an intervention which the family
regretted (according to Harrisse).
A drawing by Boilly in the Musée
Lambinet, Versailles (Lille 1988–9,

no. 13), shows the same composition
but with a taller format. It includes
the vaults of the building, and some
prominent figures in the right
foreground, but the figure of Marat
is lit less effectively. The painting
was submitted by Boilly to a national
competition announced by the
Revolutionary Government on 24
April 1794.

According to tradition, Boilly
undertook this work reluctantly in
order to demonstrate his Republican
credentials after he had been
denounced by Wicar before the
Société Républicaine des Arts in
April 1794 for the obscenity of his
paintings and prints. However,
Susan Siegfried has shown that Boilly
was not averse to Republican sub-
jects at this date and questions the
assumption that he never finished the
painting (Lille 1988–9, pp. 6–10).

Despite the debt to David's
drawing of *The Tennis-Court Oath*
(Versailles), which Siegfried empha-

sises, Boilly's painting represents a
highly individual artistic contri-
bution. He deliberately avoids a
theatrical treatment of the incident
or any apotheosis of Marat, instead
describing the event with an attentive
objectivity little practised at that
period, neither deviating into the
grotesque nor the anecdotal
occasionally characteristic of his
drawings. The retouches by Julien
Boilly do not alter the painting's
intrinsic quality: a spontaneity of
drawing and of pictorial realisation
contribute to a remarkably masterful
representation of a crowd – of which
Boilly would produce other examples
under the Empire.

AS

Bought from the collection of Julien Boilly
in 1865. Inv. 395.

Harrisse 1898, pp. 14, 134, nos. 544 and
1184; Lille 1988–9, pp. 44–5, no. 14 (with
full bibliography), also pp. 6–10 and 42–3;
New York 1992, no. 30.

Louis-Léopold Boilly
1761–1845

5 Portrait of One of the Artist's Sons

Oil on canvas, 18 x 14 cm

Paul Marmottan was the first author to propose this unfinished painting of a child as a portrait of Boilly's son Julien-Léopold, who was born on 5 August 1796 in Paris to his second wife, Adelaïde-Françoise Leduc (Marmottan 1913, p. 208). Julien Boilly took up the profession of painter in which he had been trained by his father but devoted himself to advancing his father's reputation, notably by supplying material for his biography (see Benisovitch 1958, pp. 365–72), and by the important gift to the museum of Lille between 1862 and 1864 of six drawings and paintings by his father – not to mention the sale of *The Triumph of Marat* in 1865 (No. 4 here) and of twenty-seven studies for *The Studio of Isabey* in 1863 (Nos. 6–11).

Nonetheless the theory that this is a portrait of Louis XVII has been put forward, based on a drawing attributed to David in the Louvre representing the royal infant. The comparison is dubious both on account of the ineptitude of the drawing and its uncertain identification (reproduced in the auction catalogue, Hôtel Drouot, salle 1, 23 June 1976, no. 28).

The fact that the sketch is unfinished and remained with the family of the artist favours the idea that it is a family portrait and of a son of the artist, the best known of whom is of course Julien. On the other hand, comparison with the attested portrait of the young Julien (also at Lille; Lille 1988–9, pp. 112–13, no. 38) is not entirely convincing despite some similarity of the features. Moreover Julien, as the donor of the work, would surely have specified that he was represented by the portrait. We can at least suppose that the model is one of his half-brothers, born of his father's first wife, Marie-Madeleine Desligne, whose likeness is believed to have been discovered in a drawing in the Musée de Boulogne-sur-Mer (Lille 1988–9, no. 11) and whose features accord with those in this oil sketch. Whether it is Félix, born in 1790, who died as an infantry captain in Senegal, or Marie-Simon, the best known of the children of this marriage, born 24 November 1792, likewise a soldier by profession, who died in Toulouse in 1876, the portrait must be dated to about 1795 to 1800 to judge from the hair-style, in which case the age of the sitter (six to eight years) would match better with either of these sons than with Julien. Despite its incompleteness the handling of this portrait makes it a masterpiece, at once free and precise, and remarkable for its spontaneity and freshness. It exemplifies Boilly's exceptional qualities of observation.

AS

Gift of Julien Boilly, 1862. Inv. 398.

Lille 1988–9, pp. 48–9, no. 16 (with full bibliography).

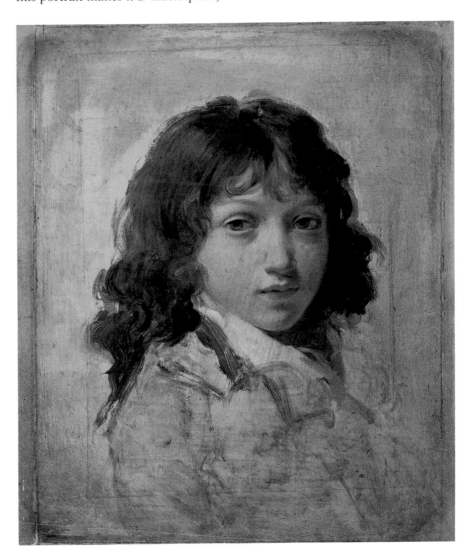

Louis-Léopold Boilly
1761–1845

6 Compositional study for 'The Studio of Isabey'

Black chalk, pen and wash, heightened with white gouache on paper, numbers in pencil above the heads, 56.5 x 79.5 cm

At the Salon of 1798, Boilly exhibited a picture entitled *Gathering of Artists at Isabey's Studio* (fig. 60). The group included a composer, a critic, a librettist and several actors, including François Joseph Talma, as well as painters, a number of whom, like Boilly himself, had been frequent guests at the dealer Alexandre Paillet's evenings in the Hôtel Bullion, in the rue Plâtrière. These informal gatherings

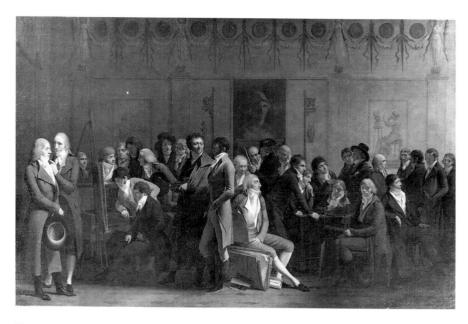

Fig. 60 Louis-Léopold Boilly, *Gathering of Artists at Isabey's Studio*, 1798. Oil on canvas, 71.5 x 111 cm. Paris, Musée du Louvre.

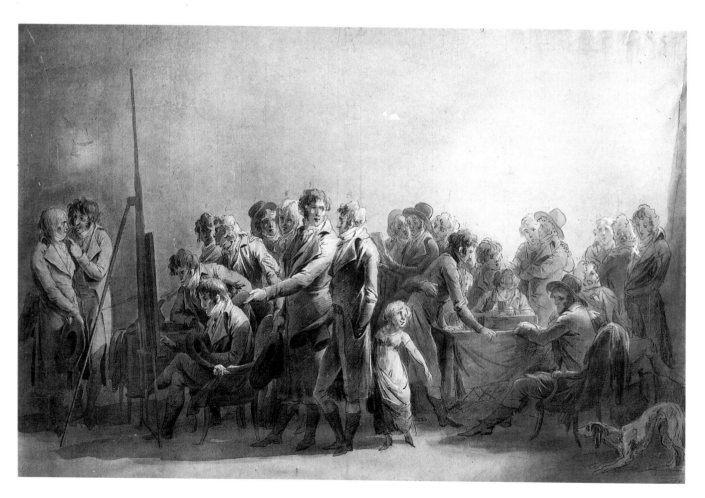

led to the founding of the Société des Amis des Arts in 1790, a club of artists and patrons in which the genre painters occupied a prominent place.

Sylvain Laveissière has described the picture as a 'conversation piece' (Lille 1988–9, p. 52), and in common with many such pictures – often of engaging liveliness and informality – it shows the studio interior in some detail. Jean-Baptiste Isabey's studio was decorated in the fashionable Etruscan taste by the architects Charles Percier and Pierre-François Fontaine, both of whom appear in the picture, and is recorded in the first five plates of their *Recueil de décoration,* published in Paris in 1801.

The present drawing gives no indication of the setting, but is otherwise close to the finished picture, apart from the appearance of the participants. Boilly had not yet made the studies from life from which he worked for the final composition. The little girl, who appeared in several earlier drawings, hiding behind the easel or linking the two sides of the picture as she turns back to her dog, does not reappear. Her position is filled in the final version by the seated actor Baptiste aîné. The painter François Gérard (see No. 7) sits in front of the easel, pondering the work of his friend Isabey, who in an earlier drawing appeared to be indicating something in his own picture but now refrains. Lethière's gesture (see No. 10) becomes less dramatic and disappears in the final version; but that of the critic François Benoît Hoffmann remains, as he stands to the left of the easel speaking emphatically to the composer Etienne Nicolas Méhul, with whom he collaborated in writing operas from 1790 onwards.

LW

Gift of Julien Boilly, 1864. Inv. Pl. 1115.

Lille 1988–9, p.68, no. 19 (with full bibliography), ill. p. 69; Velghe 1989–91, p. 399, ill. 14.

7 François Gérard
(study for 'The Studio of Isabey')

Oil on canvas, 46 x 38 cm

François Gérard (1770–1837) was, like Isabey, a pupil of David, and through his master's influence held a seat on the Revolutionary Tribunal. During the Empire and Restoration he painted several propagandist pictures of contemporary events, but was best known as a painter of graceful portraits. As Isabey's close friend he occupies an important place in Boilly's picture (fig. 60), seated in front of the easel on a fashionable sabre-legged chair, elegant in a dark frockcoat with carefully knotted stock. In 1795 Isabey had bought Gérard's picture of the blind Belisarius (now lost), and Gérard in return painted his famous portrait of Isabey with his daughter (Paris, Louvre), which confirmed his reputation as a portrait painter when it appeared at the Salon of 1796.

LW

Collection Julien Boilly; bought by the museum in 1863. Inv. 385.

Lille 1988–9, no. 20, pp. 55 and 71 (with full bibliography), ill. p. 73.

8 Michel-Martin Drölling

(study for 'The Studio of Isabey')

Oil on canvas, 21 x 17.3 cm

Martin Drölling (1752–1817) came
as a young man from Colmar to
Paris, where he was a pupil at the
Ecole des Beaux-Arts and studied the
work of Northern artists at the
Louvre, making his Salon début in
1793. Boilly places him to the left
and in the background of the picture
(fig. 60), in a pose very similar to
that of Drölling's self portrait of
around 1791 in the Musée des
Beaux-Arts at Orléans, in company
with Jean-Louis Demarne and
Nicolas-Antoine Taunay, two
landscape artists who, like Boilly,
were prominent in the development
of the Dutch-inspired art which
flourished in late eighteenth-century
France.

Drölling's careful, polished style
and his interest in *trompe l'oeil* were
tastes he shared with Boilly, who
made copies of two of his best-
known works, *Intérieur d'une salle à
manger* (1816; private collection)
and *Intérieur d'une cuisine* (1815;
Paris, Louvre). There were several
works by Drölling in Boilly's large
collection of pictures by Northern
painters and by contemporary
French artists working in a similar
vein. The fine, delicate style in which
both artists excelled was admired by
Meissonier, who remarked to Louis
Gonse that he had never seen
anything which so surprised and
attracted him as Boilly's set of
painted studies at Lille (Gonse 1900,
p. 158).

LW

Collection Julien Boilly; bought by the
museum in 1863. Inv. 378.

Lille 1988–9, no. 20, pp. 55 and 70 (with
full bibliography), ill. p. 72.

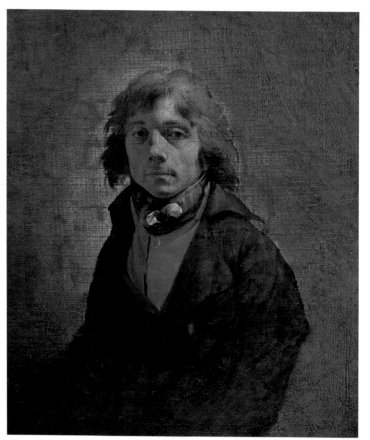

8

9

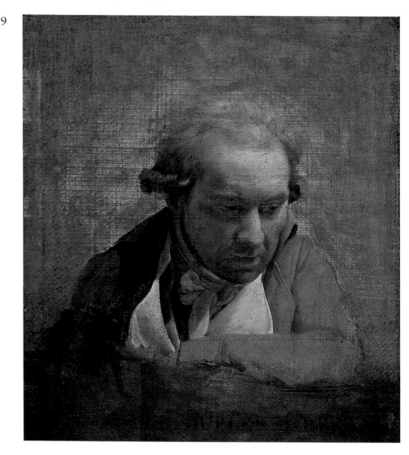

9 Jean Duplessi-Bertaux

(study for 'The Studio of Isabey')

Oil on canvas, 17.6 x 15.4 cm

Jean Duplessi-Bertaux (1747/50–1818/20), who appears at the centre of Boilly's picture (fig. 60) leaning on the back of Baptiste aîné's chair, painted scenes of everyday life and made prints. He engraved his own work and pictures of a number of fellow genre painters, including Carle Vernet and Jacques Swebach, who also appear in the final picture. Little is known about his life, but he made his reputation with a series of views of Italy and Greece, which the duc de Choiseul commissioned, and followed this with a similar set of engraved views of Egypt. During the Revolution Duplessi-Bertaux joined the Société Républicaine des Arts and is now chiefly remembered for his prints illustrating events of that period. A set of gouache pictures relating to these prints has recently come to light (New York, Colnaghi, 1989, pp. 161–6, for a full discussion).

LW

Collection Julien Boilly; bought by the museum in 1863. Inv. 366.

Lille 1988–9, no. 20, pp. 56 and 71 (with full bibliography), ill. p. 74.

10 Lethière and Carle Vernet

(study for 'The Studio of Isabey')

Oil on canvas, 45.6 x 37.8 cm

Lethière's partially realised scheme to paint a series of large-scale pictures illustrating significant events from Roman history, including *The Death of Virginia* (see No. 74) and *Brutus* (both Paris, Louvre), place him among the most ambitious history painters of his generation. In 1807 he succeeded Suvée as director of the Rome Academy, remaining there until he was removed from his post after the fall of the Empire. As Sylvain Laveissière has pointed out, he was a close friend of Boilly in the 1790s and, like him, was among the founders of the Société des Amis des Arts. He appeared in a drawing, now lost, called *The Friends of Boilly*, which probably resembled *The Studio of Isabey*, and he reappears in Boilly's *Arrival of the Diligence* of 1803 (Paris, Louvre), as well as in an album of portraits drawn by Boilly for Lethière on his departure for Rome (Lille 1989–9, p. 56). His friendship with the painter and with artists in his circle accounts for his prominent place in Boilly's picture (fig. 60), where he stands in conversation with Géricault's first master, the fashionable horse painter Carle Vernet (on his left), near the centre of the composition.

LW

Collection Julien Boilly; bought by the museum in 1863. Inv. 387.

Lille 1988–9, no. 20, pp. 56 and 71 (with full bibliography), ill. p. 74.

11 Jean François van Dael

(study for 'The Studio of Isabey')

Oil on canvas, 38 x 27.7 cm

Jean François van Dael (1764–1840) was a pupil of the flower painter Gerard van Spaendonck, and left Antwerp for Paris in 1786 to become a painter-decorator, working on interiors at St-Cloud and Chantilly. Encouraged by Van Spaendonck, he began to specialise in the painting of fruit and flowers, exhibited at the Exposition de la Jeunesse in 1791, and from 1793 onwards sent pictures to the Salon. His best known work was *Offrande à Julie* (untraced), which he painted for the Empress Josephine.

In Boilly's painting (fig. 60) he stands in profile, leaning on a table close to his friend the celebrated flower painter Pierre Joseph Redouté, whose pose contributes to the carefully calculated alternating sequence of seated and standing figures with which Boilly achieves an ordered naturalism.

LW

Collection Julien Boilly; bought by the museum in 1863. Inv. 363.

Lille 1988–9, no. 20, pp. 57 and 71 (with full bibliography), ill. p. 75; Velghe 1989–91, p. 400, ill. 15.

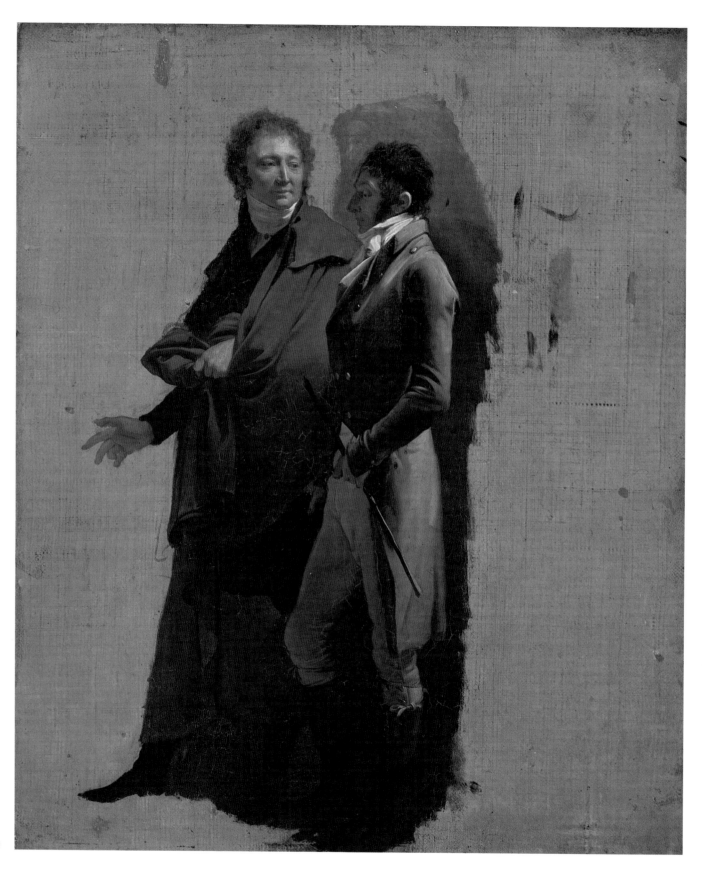

10

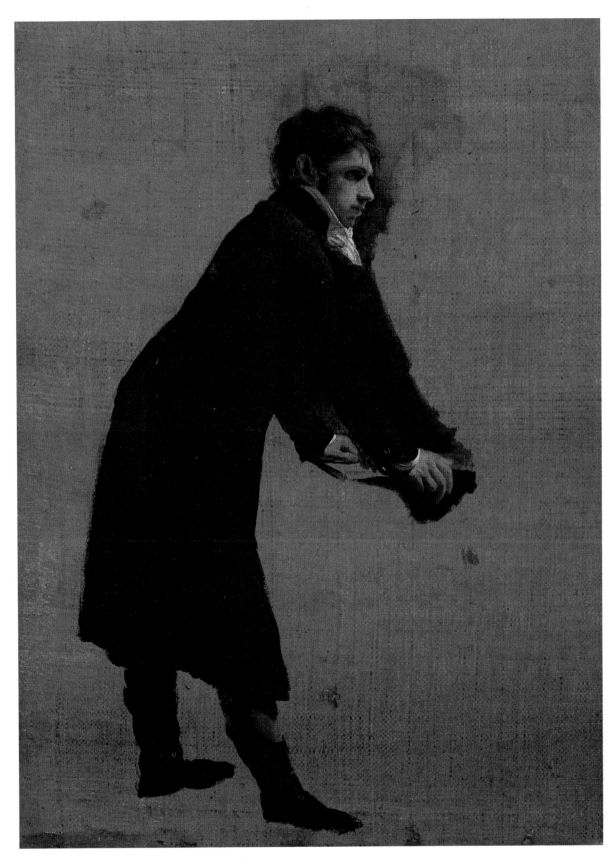

11

Louis-Léopold Boilly
1761–1845

12 and 13 Companion Portraits of a Man and a Woman

Oil on canvas, 56 x 46 cm

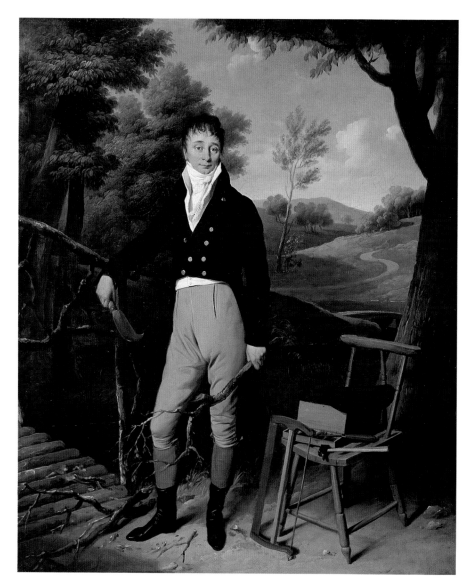

Chiefly known for his small bust portraits, Boilly came to be no less famous for full-length portraits such as this pair of 1800, probably of a married couple. Boilly was always interested in outdoor portraiture, painting landscapes which reflect the sitter's state of mind, and during the Directoire and the Consulat he executed a series of them, of which these are among the most notable.

The man is depicted at work, sickle and branch in his hands, completing a wooden bridge on his property. The performance of such a task in the depths of the country recalls the ideal of the 'gentleman farmer', an aspect of the anglomania prevalent in France in the early nineteenth century. The companion painting shows a cave, in which an elegant young woman nonchalantly reclines against a rock by the side of winding rapids. She has a distant, dreamy and nostalgic look and has removed her coat and hat and one of her gloves. The romantic setting matches the melancholy of her expression. By contrast the pure and factual style of painting gives an astonishing plasticity to the ribbons, gloves and hat, demonstrating the artist's technical virtuosity.

The portrait of the woman, more than its companion, reveals Boilly's romantic sensitivity – a sensitivity close to Antoine-Jean Gros's portraits, for example that of Christine Boyer of 1801 (Paris, Louvre) – but at the same time his attachment to the clarity, linear precision and exactness of detail inculcated by David, but also much indebted to Dutch seventeenth-century art, remains evident.

There is a drawing in black chalk with grey wash and white heighten-ing on grey paper (45 x 36 cm) of the young woman which is either preparatory for, or subsequent to, the female portrait (reproduced Harrisse 1898, p. 169, no. 968; sale of Laurin, Guilloux and Buffetaux, Paris, 12 June 1972, no. 16). It has a different romantic aura: she adopts the same pose but is inside, leaning against a chimney where a fire is burning, with a book in place of her hat.

AS

Bought on the Paris art market 1980. Inv. 1949 and 1950.

Lille 1988–9, pp. 106–8, nos. 35 and 36 (with full bibliography); Scottez-De Wambrechies 1988 (I), p. 129; and 1988 (II), p. 35 (*Portrait of a Woman*); Yoko-hama etc., 1991–2, p. 152, nos. 3 and 4; New York 1992, nos. 31 and 32.

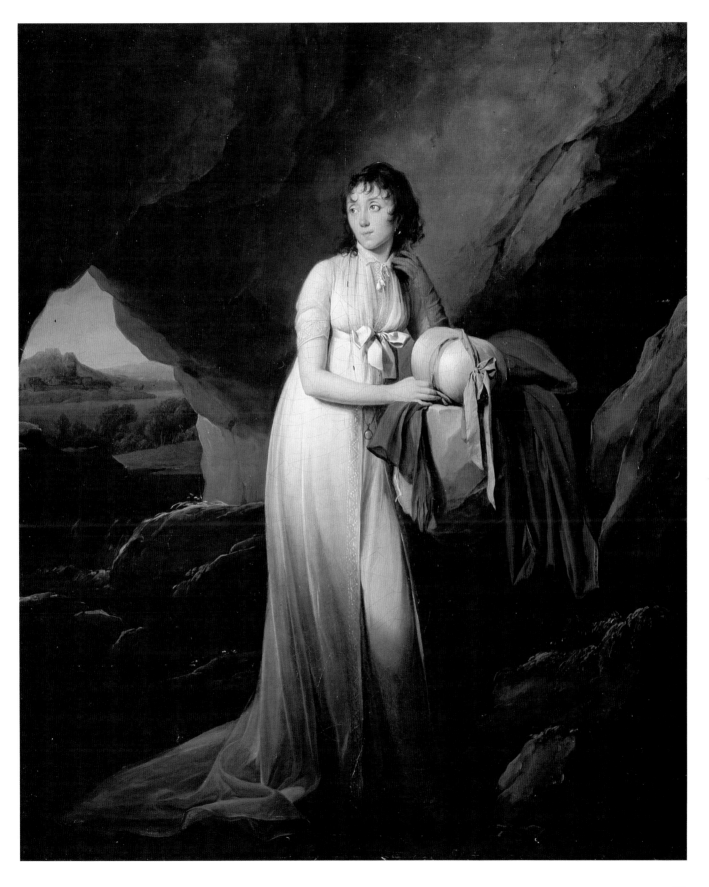

Louis-Léopold Boilly
1761–1845

14 Jean-Antoine Houdon

(study for 'A Sculptor's Studio')

Oil on canvas. 45 x 37 cm (extended from 26 cm)
Inscribed on the right: HOUDON

This is an oil sketch for the central figure in *A Sculptor's Studio: Family Group,* now in the Musée des Arts Décoratifs in Paris, one of four major works among the six items exhibited by Boilly at the Salon of 1804. The painting shows Houdon modelling in clay the bust of Laplace (1749–1827), an eminent professor of mathematics, physicist and astronomer, with the sculptor's wife and three daughters in attendance and casts of Houdon's numerous sculptures (mostly portraits) in the background. Jean-Antoine Houdon (1740–1828) belonged to the artist's intimate circle and in company with other friends such as Hubert Robert, François Gérard and François Benoît Hoffman was included among the admiring figures in his painting of the reception of David's picture of Napoleon's coronation, *Tableau du Sacre exposé aux regards du public dans le grand salon du Louvre,* of 1810 (now New York, Wrightsman Collection). Boilly also made a portrait of Houdon's brother (Harrisse 1898, no. 741). Indeed, according to Marmottan, Houdon's youngest daughter was at one time engaged to the painter's son Julien (Marmottan 1913).

This sketch is clearly related to another of similar format (55 x 45 cm) depicting Houdon modelling a bust of Bonaparte as First Consul (reproduced Lille 1988–9, p. 96), but which was made first is not clear. A pen drawing in black ink with grey wash – bold, dashing and roughly composed – must have preceded both, and in it Houdon is depicted in a more generalised manner.

The present work, finished in

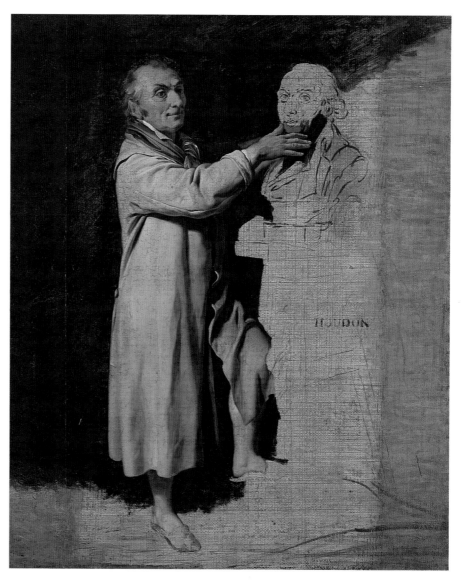

parts, unfinished in others, reveals Boilly's gifts and his method. His purpose here is only to study the figure of Houdon. His skill as a colourist is shown by the delicate touch of dark red, the *lie-de-vin* of the sculptor's scarf, which serves as a foil to the range of ochre greys.

AS

Boilly sale, Paris, 13 and 14 April 1829 (no. 22), and posthumous Boilly sale, Paris, 31 Jan. 1845 (no. 12) – unless these references are to the related untraced painting of Houdon modelling his bust of Bonaparte; given by Julien Boilly, 1863. Inv. 364.

Harrisse 1898, no. 310, p.111; Scottez-De Wambrechies 1988 (I), pp. 131–2; and 1988 (II), pp. 36–7; Lille 1988–9, pp. 96–7 (with full bibliography).

Louis-Léopold Boilly
1761–1845

15 A Crossroads in Paris on Quarter Day

Chalk, pen and black ink, grey wash, watercolour heightening on white ochre paper, 46.5 x 65.2 cm

The drawing evokes a spectacle common in Boilly's day, if strange to our eyes, of the streets jammed with common people moving to cheaper lodgings after their rents have been raised. Several anecdotal episodes are condensed into a composition which amounts to an absorbing study of

84

manners. A horse-drawn cart stacked with furniture in which a young woman, her baby and a bird cage are accommodated, passes a more modest cart pushed by a couple. The latter clears a way past porters pausing at the shafts of a litter. The porters are escorted by two women and a young boy carrying (among other items) a cat. Behind this group a man moves off carrying his meagre belongings on his back. To the left an old pensioner moves forward with difficulty in a cart pulled by two dogs, while in the distance on the right a hearse passes.

This is one of the first large studies for the composition Boilly finally devised for his oil painting, *Les déménagements* (The Removals) (Art Institute of Chicago), which was shown at the Salon of 1822. The drawing is unfinished and varies from the painting in the architectural scenery and in some poses and expressions. The buildings represented are from the Port au Blé in Paris, adapted from a drawing by the Chevalier de Lespinasse (Paris, Musée Carnavalet), but without one of the churches of Piazza del Popolo in Rome which Lespinasse capriciously added in the distance (and which Boilly used in his painting). Other compositional and figure studies are known. Boilly drew the composition for a lithograph and from this (printed in reverse) the small painting now in the Musée Cognacq-Jay, Paris, was made by another artist at a later date.

Although unfinished, this drawing is at once soft, powerful and luminous in handling. It is one of Boilly's most acclaimed and characteristic works, revealing his individual manner and his modern spirit. Heir to the Dutch and Flemish masters of the seventeenth century, the French artist sees beyond the picturesque appeal of such a scene and casts an objective eye upon the society of his day, and, in particular, upon those down on their luck. The hearse adds a note reminiscent of the *vanitas* paintings so much favoured in the seventeenth century – rich and poor, young and old, are equal in the last journey to their ultimate home. Boilly opened the way to a realism in art, coloured by social satire, in particular with his famous series of popular prints, the *Grimaces*, which appeared between 1823 and 1828 and inspired the young Honoré Daumier.

AS

Gift of Julien Boilly, 1862. Inv. Pl. 1110.

Harrisse 1898, pp. 56 and 116, no. 914; Lille 1988–9, pp. 128–7, no. 46; Scottez-De Wambrechies 1988 (II), pp. 38–9; Siegfried 1990; Yokohama etc., 1991–2, pp. 176–7, no. 61.

Louis-Léopold Boilly
1761–1845

16 Mon pied-de-boeuf

Oil on canvas. 46 x 56 cm
Signed lower edge, to right: L. Boilly

The rules of the game 'Mon pied-de-boeuf' (my cow's foot) are as follows: the players place one hand alternately upon another's, counting one, two, three . . . until nine when the one whose turn it is to place his or her hand on top cries 'neuf, je tiens mon pied de boeuf' (nine, I grab my cow's foot), and must immediately snatch the hand of one of the players who then pays a forfeit. The painting was conceived with a companion piece of the same dimensions – *La main chaude* (The Warm Hand) (Musée de Château-roux, on deposit from the Louvre). Boilly was particularly attached, especially in his later years, to themes combining play and domestic life. As studies of rural manners and of the cycle of life from infancy to old age, animated with appropriately varied sentiment, the paintings were anticipated six years previously by Boilly's *Grandmother's Name Day* (previously Feral Collection, sold 22 and 24 April 1901, no. 9) and *Grandfather's Name Day* (Rome, Galleria Nazionale). Together with *L'Intérieur d'un café*, *Mon pied-de-boeuf* and *La main chaude* were exhibited at the Salon of 1824, the last to which Boilly contributed. They excited little critical attention there, Fabien Pillet's condescending praise being characteristic: 'with a little more study he might merit the title "a Teniers of our time"' (Pillet 1824, p. 39). The paintings remained with the artist until his death and were only divided in 1877 at the Bleymuller sale. Boilly himself made a lithograph of *Mon pied-de-boeuf* in 1830 (Paris, Bibliothèque Nationale, Cabinet des Estampes, DC 43 + 4).

There is none of the moralising typical of the Dutch and Flemish school to which Boilly is nonetheless

obviously indebted here in the still life and the detail of the woman nursing by the fireside. Nor in this ordinary scene of daily life is there sententiousness or sentiment in the style of Greuze, from whom Boilly's work descends. Boilly's objectivity in this the last of such compositions painted before he dedicated himself to lithography and caricature is remarkable: the spontaneity of the action, the naturalism of expression, the sensitivity of the still life, the rich but restrained harmony of his palette foreshadow the French Realism and naturalism of the mid-nineteenth century.

AS

Exhibited at the 1824 Salon, no. 181; Boilly sale, Paris, 31 Jan. 1845, no. 33; sale of the 'comte de R. . .' by Ridel, Paris, 27 Dec. 1852, no. 85; Bleymuller sale, Paris, 22 Dec. 1877; Henri Rochefort, from whom acquired by Lille 1897. Inv. 394.

Harrisse 1898, no. 49. p.85; Lille 1988–9, pp. 130–1 (with full bibliography and list of exhibitions).

with honours, accumulating medals from exhibitions all over the world. In 1853 her paintings *Ploughing in Nivernais* (Paris, Musée d'Orsay) and *The Horse Fair* (New York, Metropolitan Museum; another version, London, National Gallery) were tremendously successful and were reproduced internationally in numerous artistic reviews.

Between 1845 and 1850, Rosa Bonheur travelled through France in search of picturesque motifs, visiting the Auvergne, the Nivernais and the Vendée, as well as the Landes and the Pyrenees, where she returned every year from 1849 to 1853. The sketch *The Shepherd from the Landes*, rediscovered by curators at the museum in Lille, dates from this period. Although her animal scenes owe much to Courbet, and her landscapes to the Barbizon School, her studies of people have a rare psychological force, technical skill and compositional strength, recalling the masterly Italian figures of Corot or certain facial studies drawn by

Chassériau in Rome in 1841.

Despite the honours she received, Rosa Bonheur was sometimes misunderstood by her contemporaries, who wrongly assumed that her work contained a moral message. *A Shepherd from the Landes* is not in fact a celebration of the work ethic; it depicts the face of a hard, virile even violent man, whose penetrating gaze, tight jaw and deceptively languid pose strongly evoke the personality of the sitter. This study was one of the three canvases – *Shepherd from the Landes*, *Basque Shepherd*, and *Shepherd from the Pyrenees*, to be sold in 1900 at the posthumous sale of Bonheur's work.

VP

Studio sale of the artist, Paris (Georges Petit), 30 May–2 June 1900; bought by M. Bureau and sold in the same year to the museum. Inv. 604.

Vergnet-Ruiz and Laclotte 1962, p. 227; Yokohama etc. 1991–2, pp. 160–1, no. 22.

Rosa Bonheur *1822–1899*

17 Study of a Shepherd from the Landes

Oil on canvas, 24 x 27 cm
Signed upper left: Rosa Bonheur

Marie-Rosalie Bonheur, known as Rosa Bonheur, was a pupil first of her father, Raymond Bonheur, and then of Léon Cogniet. She exhibited at the Salon for the first time in 1841. She was not at first successful and in 1847 found it necessary to seek financial help from Adolphe Moreau, the stockbroker collector and friend of Delacroix and Thomas Couture, but she was soon laden

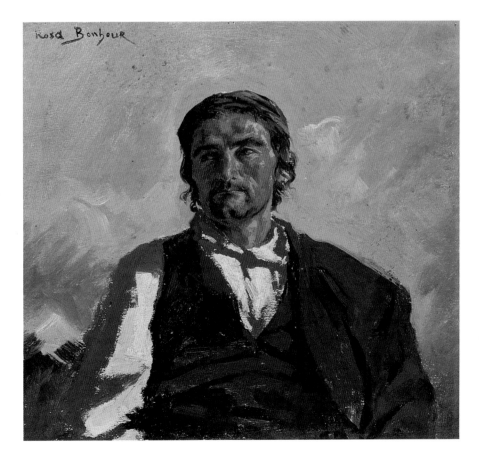

Léon Bonnat 1833–1922

18 The Death of Abel

Oil on canvas, 173 x 250 cm

Bonnat, a pupil of Léon Cogniet, a former Rome prize-winner, competed for the Prix de Rome in 1857. Although he took only second place, he was able to go to the Villa Medici for three years with a grant from his native town of Bayonne. He returned to Paris in 1861, where he later opened a teaching studio, and practised a detailed form of realism exemplified in his *Job* of 1880 (Bayonne, Musée Bonnat).

Abel was slain by his brother Cain. The discovery of his body by Adam and Eve represents man's first encounter with the death of his own kind. *The Death of Abel*, a poem by Solomon Gessner, provided a source: here too the subject is interpreted as a lament for the loss of love and innocence. It had been set as the theme of the Prix de Rome in 1858, which was won by Jean-Jacques Henner. Sometime afterwards Bonnat began work on his own version, sending it to the Salon of 1861, where it won a second-class medal. Henner's figure of Abel, as Philippe Grunchec has noted (Paris 1986, p. 192), owes something to the dead youth in Prud'hon's *Justice and Divine Vengeance pursuing Crime* of 1808 (Paris, Louvre), a work which at the time was frequently taken to be a version of the same subject. Géricault, who made a copy of Prud'hon's picture (*c*.1810–12; Paris, Louvre), incorporated aspects of it into *The Raft of the Medusa* (fig. 73) and may have been thinking of it when composing the group known as *The Father with his Dead Son* (No. 57).

The theme was particularly the province of sculptors in the nineteenth century: Antoine-Louis Barye won a second prize in the Prix de Rome competition of 1820 with his version; Johann Flatters, Antoine Etex, Ernest Barrias and Auguste Rodin all exhibited works on the subject (Ruth Butler in Los Angeles 1980). The Italian sculptor Giovanni Dupré, who won a gold medal at the Exposition Universelle in Paris in 1855 with his *Abel* of 1842, later wrote: 'I had almost fixed upon the Dead Christ with the weeping Mother (a Pietà), and had begun to turn over in my mind a design for the composition, and certainly the *Cristo Morto* is, and always will be, one of the sublimest themes, yet I was not satisfied, for I preferred to handle an entirely new subject, and

as I had been a constant reader of the Bible, very naturally the Death of Abel suggested itself to my mind.' (Frieze 1888, p. 34.)

The similarity of Bonnat's picture to a Pietà is indeed striking, but at the same time it is an exercise in the conversion of a single-figure academic study into a picture – as is Amaury-Duval's *Birth of Venus* (No. 1).

Bonnat developed a particular admiration for Michelangelo while he was in Italy. The figure of Adam is based on one of the nude youths from the Sistine Chapel ceiling, to which Bonnat has added a commonplace gesture indicating anguish, similar to that of Saint John in Flandrin's drawing (No. 52). However, as Joseph Rishel has pointed out, the years which Bonnat had spent as a child in Madrid, where he knew and admired the work of Velázquez and José de Ribera, must account for a resemblance to the recumbent dead or dying subjects of the latter artist (Philadelphia etc. 1979, p. 309).

LW

Bought by the state for the museum at the Salon of 1861. Inv. 628.

Yokohama etc. 1991–2, p. 165, no. 32 (with full bibliography), ill. p. 49.

Fig. 61 François Le Moyne, *Hercules killing Cacus*, modello, detail, 1718. Oil on canvas, 35 x 46.5 cm. Paris, Musée du Louvre.

François Boucher 1703–1770

19 France bemoans the Troubles dividing Her

Oil on canvas, 63.2 x 42.3 cm

Although most readily associated with paintings of nymphs and shepherdesses, Boucher also sometimes designed book illustrations.

This grisaille served Laurent Cars as a modello for the frontispiece he engraved for Poullain de Saint-Foix's *Catalogue des chevaliers, commandeurs et officiers de l'Ordre du Saint-Esprit* (Paris 1760). The engraving was exhibited at the 1761 Salon. The crowned standing figure is France who embraces Fidelity, while above and to the right Peace, holding an olive branch, embraces the figure of Abundance. The kneeling man below right, dressed in

late sixteenth-century costume, recalls the reign of Henri IV of France (1589–1610), or the foundation of the Order of the Holy Spirit in 1578. That figure may be Boucher's adaptation of the kneeling figure at the left of Carle van Loo's *Vow of Louis XIII* (1746; Paris, Notre-Dame-des-Victoires). The pomegranate he bears was associated from the sixteenth century with the unity of the state under its monarch (Terravent 1958, pp. 204–5). At the top of the painting is the Holy Spirit represented by a dove and at the bottom the figures of Hypocrisy (holding a mask), Envy, with snake hair, and in the background (possibly) Discord.

The Order of the Holy Spirit required its members to defend the country and to propound sound religious principles to ensure peace and prosperity, but the theme of unity of the state may have been prompted by current opposition to the crown by the legal and administrative classes.

The figure of Hypocrisy in Boucher's painting was borrowed with only slight adaptation from the figure of Cacus in François Le Moyne's *Hercules killing Cacus* (fig. 61). As Le Moyne's reception piece at the Académie in 1718, this painting had remained at its premises at the Louvre, and so was well known to artists and connoisseurs. Laurent Cars exhibited an engraving of it at the 1761 Salon. Both Cars and Boucher had studied in Le Moyne's studio, although Boucher was unfairly disparaging about the little he had learnt there. Given this and Le Moyne's reputed jealousy of his colleagues (Bordeaux 1984, pp. 31–2 and 44–6), it seems possible that the borrowed figure was a barbed homage to Le Moyne.

HW

Collection Collet and M. le Baron B.; sold Valenciennes 8 Nov. 1880; acquired 1882. Inv. 338.

Jean-Richard 1978, nos. 461–1 (engraving by Cars); Dunkerque etc. 1980, no. 42 (with bibliography); Ananoff 1980, no. 381; Pupil 1985, p. 338; Brunel 1986 (I), p. 287.

François Boucher 1703–1770

20 Reclining Female Nude

Black, red and white chalk on buff paper, 23.5 x 36 cm

According to Jean Cailleux, this young woman's pose – which Boucher used several times – is derived from a painting by Watteau (untraced; formerly in the Labouret collection), which was in turn inspired by Rembrandt's etching *The Sleeping Negress* (Bartsch 1803–21, no. 205). Watteau's influence is also very noticeable in the woman's elongated figure, her dreamy expression and the way in which her hair is piled up on top of her head to reveal the nape of her neck, which is reminiscent of the figure of Venus in his *Judgement of Paris* of c.1720 (Paris, Louvre).

The very studied rhythm of the curves of the body and an almost scientific approach to the detail of the soft flesh impart a highly sensual character to the richness of form. The strong outlines and dynamic hatching increase the tension of the colour contrasts: black, white and red flicker across the buff paper, contrasting or blending, absorbing or reflecting the light to create a slight effect of movement. Taken together these elements suggest a relatively early date in Boucher's career, between 1730 and 1740.

Among Boucher's works there is only one, a tapestry cartoon, now untraced (known from a photograph preserved in the Frick Art Library, New York), with a very similar female figure: this is of a reclining nymph in the right-hand foreground of *The Sleeping Renaud* (fig. 62), one of the five-part series *Fragments d'Opéra*, three copies of which were woven by the tapestry works at Beauvais in 1752 (these too are untraced; Ananoff and Wildenstein 1976, II, no. 384). A variety of similar poses is employed by Boucher in numerous compositions, for example, the water-nymph in the

90

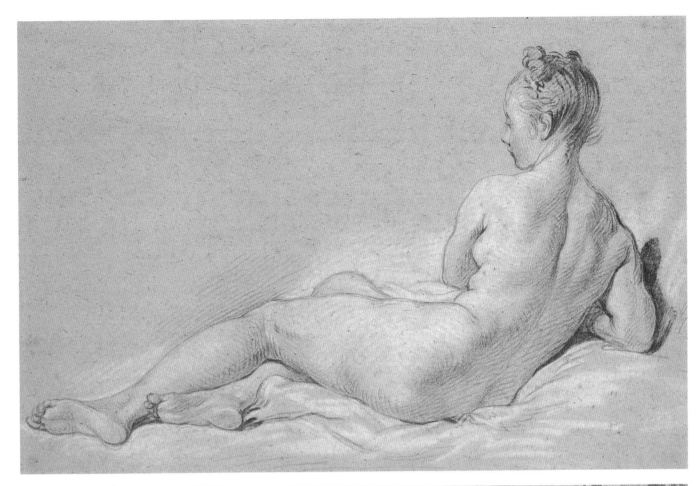

foreground of *The Rising Sun* (1753; London, Wallace Collection), and the corresponding preparatory studies, the nymph in the foreground of *Pan and Syrinx* (1759; London, National Gallery), and another nymph in the right-hand foreground of a black chalk drawing entitled *Diana and Callisto* (private collection; Washington, Chicago, 1973–4, no. 45). The present drawing was engraved by Gilles Demarteau in the style of a red chalk drawing.

SR

Collections Blondel d'Azaincourt and Nestor Régnard of Valenciennes; bought at the latter's sale in 1887, no. 281, by the museum. Inv. Pl. 1126.

Cailleux 1966, pp. I–V; London, Cambridge etc. 1974–5, no. 6; Brunel 1986 (II), p.36.

Fig. 62 François Boucher, *The Sleeping Renaud, c.*1752. Tapestry, untraced; photo. New York, Frick Art Reference Library.

Bon Boullogne 1649–1717

21 Tobias restoring his Father's Sight

Oil on canvas, 61 x 77.5 cm

The episode is recounted in one of the apocryphal books of the Old Testament. Tobit, a devout Hebrew, blind and impoverished, sent his son, Tobias, to collect an old debt. The Archangel Raphael became his travelling companion on the journey, and advised him to catch a large fish and cut out its gall. On his return Tobias, instructed by Raphael, anointed his father's eyes with the gall, and Tobit recovered his sight.

Catholics interpreted this story as a prefiguration of Christ bringing the light to his people who had become blind. Boullogne has emphasised the role of Tobias as a precursor of Christ by distorting the story. Whereas in the Old Testament God acts through Raphael, in this painting Tobias appears to take the principal part. The active, purposeful youth is contrasted with the other characters, and even Raphael, seated at the right, is reduced to the role of an amazed onlooker. Behind them are Tobit's wife, Anna, and Tobias's bride, Sara. The figure at the extreme left is Boullogne's addition, but the dog does feature in the story as Tobias's companion.

The clarity of gesture, the colour harmonies, and the invention of the return wall to break what might otherwise have been a monotonous background, make up for the inaccurate perspective, and the incongruity of the amazed Raphael seated in such a casual pose. However, the effective and accurate rendering of the figures shows one of the strengths of French painting at this period. The painting was probably intended for a domestic setting. A date of around 1705 seems reasonable.

HW

Acquired on the Paris art market in 1973. Inv. 1876.

Dunkerque etc. 1980, no. 44 (including bibliography).

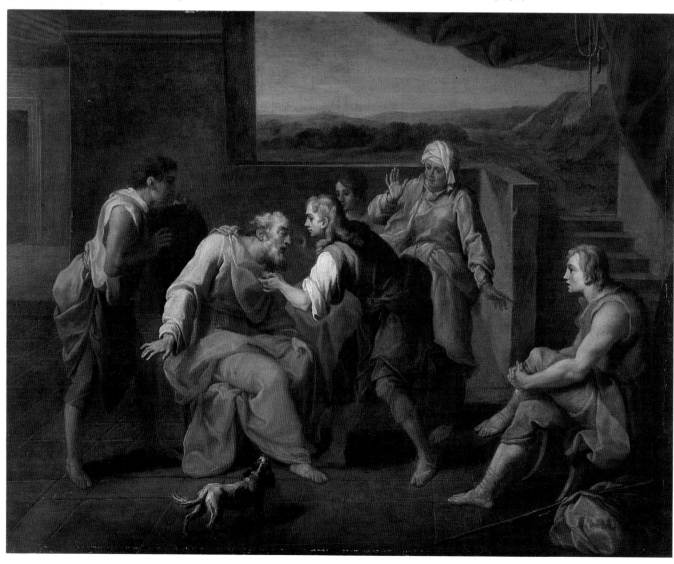

Jules Breton 1827–1906

22 Plantation d'un calvaire

(Procession to erect a Crucifix)

Oil on canvas, 135 x 250 cm
Signed and dated lower right: Jules Breton
Courrières. 1858

The *Plantation d'un calvaire* by Jules Breton is of special importance as one of the first works to introduce the theme of the daily life of the peasant. When he exhibited it at the Salon in 1859, Breton had been taking part in the Salons arranged by the Société des Artistes Français for ten years. In Ghent he was a pupil of Félix de Vigne, his future father-in-law. Then in Paris he was taught by Michel-Martin Drölling at the Ecole des Beaux-Arts, where he won his first success in 1853 with his painting entitled *The Return of the Harvesters* (Paris, Musée d'Orsay). This work, which depicts the reality of the peasant way of life, is parallel to the contemporary work of Jean-François Millet. The latter exhibited

his *Harvesters' Meal* (Boston, Museum of Fine Arts) the same year and had been looking to the country-side for his subject matter since 1846.

In 1857 – the year of the famous *Gleaners* by Millet (Paris, Musée d'Orsay) – Breton exhibited at the Salon a picture entitled *The Blessing of the Wheat in Artois* (Paris, Musée d'Orsay), which developed the theme of an open-air procession and was a forerunner of the *Plantation d'un calvaire*.

From then on Breton's work aroused comment, usually praise. Alexandre Dumas spoke with enthusiasm about his 'robust women', which he contrasted to the '*femelles*' depicted by Courbet, and he was often likened to Millet: 'There is Millet's profound, innocent feeling' (E. Thierry, 1855). However, from 1857 his degree of realism was sometimes criticised: 'there is feeling, order, but there is something common in this painting . . .' (Maxime du Camp, 1857, p. 120).

The present work was the result of a long process of evolution. In addition to the work of Millet, Breton's sources of inspiration

included Courbet's *Burial at Ornans* (1849–50; Paris, Musée d'Orsay), whose realism caused a scandal when it was exhibited at the Salon. We know about the circumstances in which the *Plantation* was painted from Breton's own memoirs, much of which concern the villagers whom he used as models: 'There was a lot of fuss about this *Plantation d'un calvaire*, as well as a few problems. In the village one cannot get on with something without encountering some trouble on the way. First there was excitement about the costume for the singers. The white dress was unanimously accepted, but when my uncle suggested a black sash, because the ceremony should have a funereal character, there was strong opposition among the band of women. My uncle stood by his suggestion and they had to wear the black sash. This resulted in some people resigning: the prettiest as well as the most coquettish left and never came back.' (Breton 1890.)

There are several oil sketches which show that the development of the composition, and of the procession of people leaving the church and spreading out in the little cemetery,

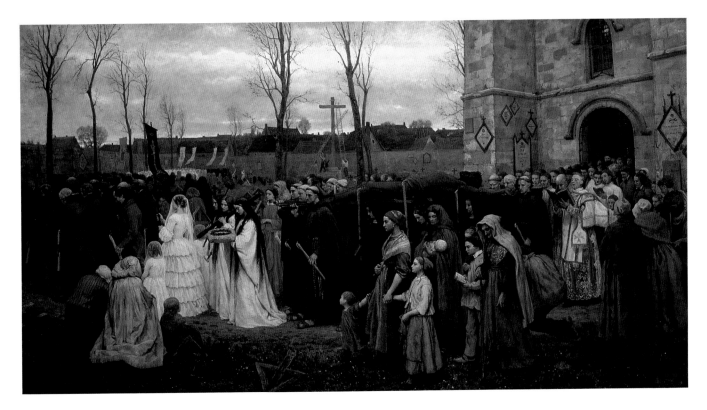

did not come easily. Breton made numerous sketches of the faces and the poses of each group of people, using models from his native village of Courrières – where the canvas was painted.

The critical response in 1859 was positive enough to give the artist no cause for regret. Théophile Gautier found in the work the 'grave, serious, strong poetry of the countryside'; H. Delaroche considered this 'simple genre scene' to be one of the 'most profoundly serious paintings and one of the freshest and most original to have appeared for ages'. Others qualified their praise. Paul Mantz found something timid in the over-careful execution of an otherwise admirable work; A.-J. du Pays found something rather ugly in the painting of subordinate figures. The absence of evident compositional artifice is remarkable when the work is compared with that of William Bouguereau – which is so much more theatrical in conception – or that of Alphonse Legros – which seems contrived and religious. Its disciplined realism seems to possess ethnographical value as evidence of the life of the peasantry and clergy in this period. It prepared the way for such late nineteenth-century regionalist painters as Alfred Guillon, Jean-Eugène Buland and Charles Cottet

VP

Exhibited by the artist at the Antwerp Salon in 1858, no. 86, and at the Paris Salon in 1859, no. 410; acquired in 1866 by the Commission de l'Exposition des Beaux-Arts from M. Péreire. Inv. 524.

Cleveland etc. 1980–2, no. 82; Omaha etc. 1982–3, no. 95; Lille 1985, no. 96; Yokohama etc. 1991–2, pp. 162–3, no. 26.

Opposite
Jules Breton, *Plantation d'un calvaire*, detail.

Carolus-Duran *1837–1917*

(Charles Durand)

23 The Sleeping Man

Oil on canvas, 87 x 85 cm
Signed and dated lower right:
1861 Carolus-Duran

The Sleeping Man, exhibited at the Salon of 1861, at first glance recalls Courbet's *Wounded Man* of 1844 (Paris, Musée d'Orsay), and like that picture it is probably a self portrait, developing a theme begun in a slightly earlier work, *The Convalescent* (1860; Musée d'Orsay). Carolus-Duran scrutinises himself with the eye of a novelist, less dramatically than Courbet in his series of self portraits of the 1840s, but nonetheless in a romantic vein of introspection.

The handling is tighter and more dense than Courbet's and the red of the unknotted tie against the stiff crumpling of the shirt demonstrates Carolus-Duran's own lyrical virtuosity. The book and the glass of water are the accessories of a sober Realist style, to which Carolus-Duran partly adhered, and derive from the Spanish and Dutch seventeenth-century paintings much in favour in the little circle around the painter François Bonvin (1817–87).

LW

Gift of the artist in 1862. Inv. 584.

Yokohama etc. 1991–2, p. 164, no. 30, ill. p. 47.

Carolus-Duran *1837–1917*

(Charles Durand)

24 The Kiss

Oil on canvas, 92 x 91 cm
Signed and dated lower left:
Carolus-Duran 1868

In 1861, the year in which Carolus-Duran showed *The Sleeping Man* at the Salon, he went with a group of friends, including Henri Fantin-Latour and Amand Gautier, to congratulate Edouard Manet on the success of his *Spanish Guitar Player* (1860; New York, Metropolitan Museum). 'The Spanish musician was painted in a certain new, strange way that the astonished young painters had believed to be their own secret, a kind of painting lying between that called Realist and that called Romantic.' (Desnoyes 1863, pp. 40–1; quoted in Paris, New York 1983, p. 67.) Although, as Annie Scottez has pointed out, *The Kiss,* like *The Sleeping Man,* recalls a work by Courbet, *Two Lovers in the Country* (after 1844; Paris, Petit Palais) – the handling as well as the composition having something in common with the older artist – there is now also a perceptible affinity with Manet's handling, and with the new genre of fashionable modernity – of toilettes, fans, gloves, flowers, and the small routines of social life – portrayed by Alfred Stevens, by James Tissot and at times by Manet himself. The strongest influence, however, was probably provided by Carolus-Duran's recent extended visit to Spain, where he copied Velázquez and Murillo, which perhaps accounts for the melting softness of the dress, and the pearly skin, which seem to anticipate the later Renoir. The couple (probably the artist and his wife – also an artist, Pauline-Marie-Charlotte Croizette) emerge dramatically from the dark background of what was once an oval picture. An unusual genre, part portrait, part narrative, it appears faintly theatrical, perhaps operatic. The intensity of the colour in this artist's work seems at times to break out of the pictorial requirements into an autonomous existence, and, as sometimes happens in the work of Manet, an exquisite still life lies detached on the surface of the picture – in this case a pair of violet gloves with white chrysanthemums against a yellow fan.

LW

Gift of Mme Buyse, 1986. Inv. 1984.

Yokohama etc. 1991–2, p. 170, no. 44 (with full bibliography).

Théodore Caruelle d'Aligny 1796–1871

25 Landscape

Oil on canvas, 36 x 24 cm
Signed lower right with monogram

Théodore Caruelle d'Aligny was one of the most talented landscape painters of the 1820s. He received a solid training in the art of drawing in the studios of Watelet and Regnault, two undisputed masters of their time, and immediately began painting landscapes. He made his début at the Salon of 1822, after which he made the then customary trip to Italy, which was to prove productive. He remained there until 1827, becoming a 'leader in the reform of landscape painting' (Lenormant 1853). He was also a supporter of the young Corot, who arrived in Rome in 1825 and immediately had to endure the mockery of his fellow painters for his desire, then considered naïve, to paint 'what he saw' directly from nature, in the open air.

The two men became friends, sharing the same artistic ambitions and a passion for landscape painting. Their relationship was complementary, Corot giving d'Aligny the freshness and the precision of his realist vision, while d'Aligny, with the benefit of his rigorous academic training, taught Corot the art of drawing and composing in the open air, which was to prove crucial to him.

The present work dates from a later period, around 1860, a time when d'Aligny had become a 'sculptor of the landscape', skilfully painting landscapes which were entirely recomposed in the studio after a long period. He was no longer trying to reproduce the effects of *plein-air* painting, although he often worked out of doors.

Although he was one of the first painters to work at Barbizon and despite his experience of *plein-air* painting in Italy (where he returned several times), d'Aligny remained a classical painter in the tradition of Poussin (Thuillier 1979). He painted in Fontainebleau, but did not belong to the Barbizon School; he appreciated Corot, but did not follow his Realist vision of painting; and he died in 1871, without having encountered Manet. In a century when colour seemed to prevail his work was based on composition, but he left some important pictures which have a special place in French landscape painting.

VP

Gift of Charles Delannoy, 1883. Inv. 908.

Vergnet-Ruiz and Laclotte 1962, p. 225; Orléans etc. 1979, no. 33.

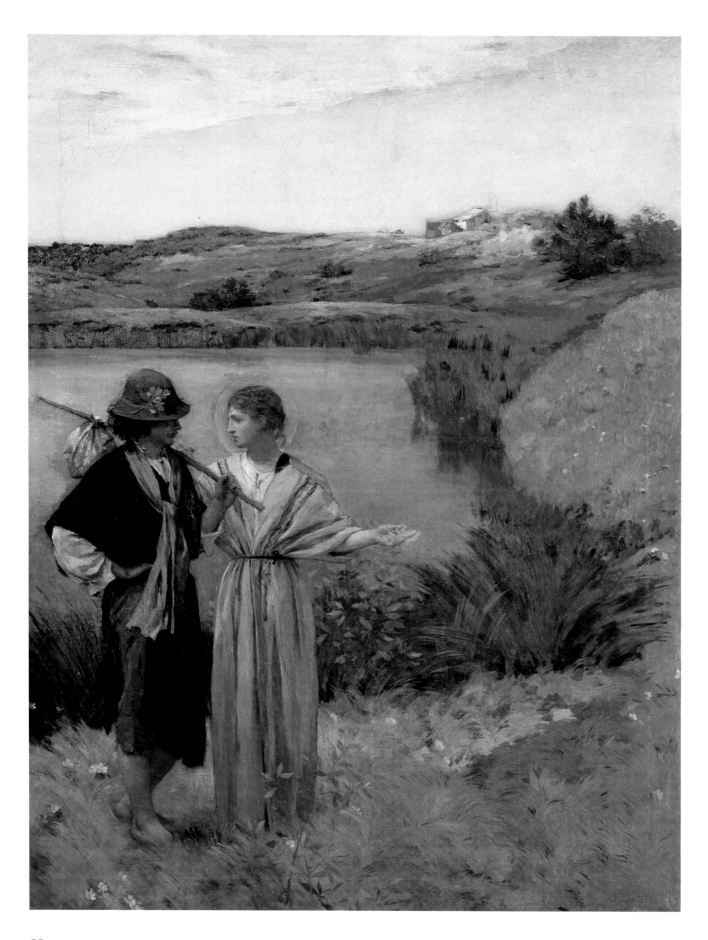

Jean-Charles Cazin
1841–1901

26 Tobias and the Angel

Oil on canvas, 186 x 142 cm
Signed and dated lower right: J. Cazin 80

Cazin studied in the free school of Lecoq de Boisbaudran in Paris with Henri Fantin-Latour, Alphonse Legros, Léon Lhermitte and Auguste Rodin, all of whom remained his friends, and from 1862 he worked in the forest of Barbizon beside Millet, who had lived there since 1849. He exhibited for the first time at the Salon des Refusés in 1863 and was associated with innovatory painters such as Whistler, Puvis de Chavannes and Manet – whose *Déjeuner sur l'Herbe* (Paris, Musée d'Orsay) was exhibited in that year. Having worked as drawing master and curator in Tours, he then stayed with Legros in England between 1871 and 1874. From there he returned to Paris with the resolve to apply a Realist aesthetic to Christian subjects, an ambition inspired by Courbet, and even more so by Millet. *The Flight into Egypt*, which he exhibited at the Salon of 1877, was his first major work in this mode and attracted much attention, ensuring the success of his *Hagar and Ishmael* (Tours, Musée des Beaux-Arts) and *Tobias and the Angel* when they were exhibited in 1880.

For the story of Tobias see the commentary on the painting by Bon Boullogne (No. 21), which, together with Delacroix's copy of Rembrandt's version of the theme (No. 44), reminds us that the subject was far from new. Cazin's composition follows the text of the Apocrypha closely, depicting the moment when Tobias, looking for a travelling companion, meets the Archangel Raphael who declares himself to be a fellow Israelite (5: 4–22). Cazin's choice of this subject reflects the movement of social Catholicism, with its preference for a simple and humane, as opposed to a trium-phalist and elevated, role for the Church.

The setting is sober, the attitudes mundane, without emphatic emotion or evident artifice. Tobias is identified by his travelling sack, and the Archangel Raphael by a timid aureole and by drapery which evokes the Antique (slight concessions to tradition). The landscape recalls the scenery of the Pas-de-Calais and makes no reference to the Orient. Cazin's landscapes are typified by a lightness and transparency perfectly adapted to such a devotional subject: 'The effects dear to him are the most fugitive, those of dawn or dusk, of imminent storms, of the lull before the storm, or of sun filtered through mists . . .' (Fourchaud 1891).

Tobias and the Angel, together with his *Hagar and Ishmael*, won Cazin a first-class medal at the Salon, and was commended by the critics for its impact and novelty (see especially Huysmans 1883). These two works put Cazin at the heart of a new school of Christian Realism of which the figurehead was Puvis de Chavannes, whose *Prodigal Son* (Paris, Musée d'Orsay) was shown at the Salon in the previous year. This painting had an even more limited narrative action than *Tobias and the Angel*, and a similar but more distinct detachment of the figures from their background appropriate to mural decoration. After the failure of Cazin's *Departure of Judith* at the Salon of 1883, he withdrew from figure compositions and confined himself to landscape.

VP

Bought from the artist in 1880. Inv. 568.

London 1979–80, no. 39; Oursel 1984, p. 224; Yokohama etc. 1991–2, pp. 172–3, no. 50.

Jean-Siméon Chardin
1699–1779

27 The Silver Goblet
(Les Apprêts d'un Déjeuner)

Oil on canvas, 81.5 x 64.5 cm
Signed lower left: Chardin

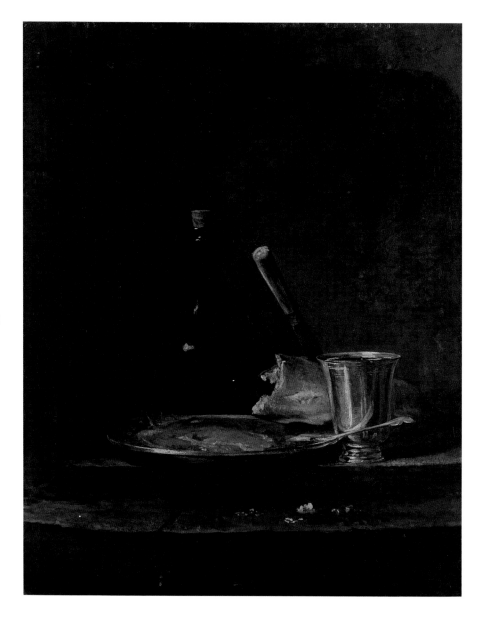

Raised by two steps, set in a stone niche, the objects in Chardin's painting take on a sacramental quality that might anyway be suggested by the juxtaposition of the bread and the wine. Indeed the knife stuck so prominently into the bread might reinforce the association. However, there is no reason to suppose that Chardin intended to paint devotional pictures masquerading as still life, nor that his contemporaries so interpreted them. Rather it is the quality of the painting, its self-sufficiency, its completely resolved composition, and the satisfying presence of its objects which permit such speculation.

Painted around 1726–8, about the time that Chardin was beginning to establish his reputation, this still life demonstrates both his gift for composition and his mastery of the depiction of different materials – cork, glass, the bone of the knife handle, bread, silver, pewter and stone. The goblet appears in a number of Chardin's paintings – it was possibly one of two footed goblets, both of silver, recorded in the inventory made after the death in 1737 of his first wife, Marguerite Saintard.

X-ray photography has shown that originally a cabbage was placed behind the knife, and a fruit, perhaps a plum, to the left of the goblet. Chardin later painted over these, giving the painting its compelling rigour.

There exists a nearly identical version of the painting, last recorded on the art market and now attributed to a pupil or assistant of Chardin.

HW

Sylvestre sale?, Paris, 28 Feb.–25 March 1811, no. 15; Gounod sale, Paris, 23 Feb. 1824, 3–part; collection Barroilhet, sold 10 March 1856, no. 18?; 2–3 April 1860, no. 102, and 15–16 March 1872, no. 3; acquired Baroness Nathaniel de Rothschild before 1876, then with Henry, then James de Rothschild; sold anon. Galerie Charpentier, 23 May 1951, no. 23; Victor Lyon, Geneva; Paris, private collection; acquired 1990. Inv. 1998.

Paris etc. 1979, no. 9 (with extensive bibliography); Rosenberg 1983 (I), p. 4; and 1983 (II), no. 15; Brejon de Lavergnée 1990; Broeker 1991; New York 1992, no. 23.

Théodore Chassériau
1819–1856

28 An Arab presenting a Mare

Oil on panel, 40 x 54.3 cm
Signed and dated lower right:
Théodore Chassériau 1853

Chassériau, like Delacroix, painted orientalist subjects before travelling to North Africa and continued to do so long after his return. Critics invariably compared his work with Delacroix's, although it has a refinement of manner which is distinctive; the mood in Chassériau's pictures is still and dreamy, the composition often frieze-like, and the colouring pale and brilliant. Like Delacroix, Chassériau may have felt that the East was the true source of the antique ideal; while visiting Rome before his journey to Algeria in 1846, he had become disenchanted with the ideals of his youth and with the artistic personality of his former master, Ingres, whose work now seemed incompatible with his own.

The strange grace which Chassériau found in North Africa was not only expressed in his purely oriental subjects. His strongly imaginative response to North Africa can also be felt in several of his religious subjects – the decoration at St-Roch in Paris, for example, and perhaps most of all in the memorably graceful figure of Saint Mary of Egypt in the church of St-Merri in Paris. The present picture ostensibly represents a North African horse dealer with a customer, but the elegant pose of the figure to the left, and the dreaming appearance of the young Arab to the right, leaning on the horse, and the movement from left to right of the figures across the foreground, remind us that Chassériau was drawing on memories already six years old, which he combined with the antique ideals of his youth.

LW

Chassériau sale, Paris, 1857, no. 18; Cusinaud collection, Bordeaux; Baron Arthur Chassériau collection; bequeathed to the Louvre, 1934, R.F. 3892; deposited at Lille, 1937. Inv. 1710.

Sandoz 1974, p. 358, no. 221 (with full bibliography) ill.; Scottez-De Wambrechies 1992, pp. 80 and 81, ill.

Antoine Chintreuil
1816–1865

29 Landscape

Oil on canvas, 31 x 40 cm
Signed lower left: Chintreuil

Antoine Chintreuil was a follower of Corot, who had the highest aspirations for him, and transformed him from a hesitant, unlucky artist (who worked modestly as a painter, despite having spent a short period in Paul Delaroche's studio in 1842) into a great landscape painter, passionately concerned with problems of light and the transparency of colours.

After meeting Corot in 1843, Chintreuil moved to the Bièvre valley in search of original picturesque motifs. Having worked in Barbizon and seen how the work of his friend, Charles-François Daubigny complemented Corot's oeuvre, he combined their two styles. Later generations have not always recognised that this combination of the Barbizon realist approach (with its sense of composition inherited from Neo-Classical landscapes) with a sensitivity to light and reflections originating in the 1850s, was a crucial factor in the history of French landscape painting, preparing the way for the Impressionists.

A friend of Corot, Rousseau and Pissarro, Chintreuil was truly at the crossroads of pictorial trends in nineteenth-century landscape painting. The present work beautifully illustrates the ideas of an artist who is important to our understanding of the aesthetic trends of that period.

VP

Exhibited Ecole des Beaux-Arts 1874, no. 216; the artist's studio sale, 1875, no. 126; given to the museum by F. Cuvelier in 1875. Inv. 519.

Henriet 1857; Vergnet-Ruiz and Laclotte 1962, p. 230; Bourg-en-Bresse 1973, no. 47.

Attributed to

Jean-Baptiste-Camille Corot 1796–1875

30 Castel Sant'Angelo, Rome

Oil on paper mounted on canvas,
27 x 40 cm
Signed lower right: Corot

Corot spent three years in Rome and the surrounding countryside, from 1825 to 1828, before he had even completed his training with Jean Victor Bertin. He had only been a professional painter for four years, and, though he had already worked in Normandy and the forest of Fontainebleau, this trip to Italy was the first major chapter in his artistic life. The luminosity of the Mediterranean skies, the colours of the towns and the costumes, the care-free *douceur de vivre* of Rome made an indelible impression on him. His famous views of Rome, especially those in the Louvre, date from this first Italian period, during which he painted the Colosseum, the Forum, the Villa Medici – and the Castel Sant'Angelo.

Corot travelled to the Mediterranean again in 1834, but remained only for a few months – his father, who financed the trip, felt that another journey was superfluous and he was not allowed to go beyond Florence. He visited northern Italy, Genoa, Florence, Milan, Bologna, Volterra and Venice. Corot finally returned to Rome in 1843, when he was welcomed by the painter Achille Benouville, and rediscovered the sites he had admired on his first visit.

Corot's trips to Italy mark his discovery of *plein-air* painting directly from the motif, a practice which flourished among landscape painters working in Italy at the turn of the century. They also provided Corot with innumerable motifs for his future compositions, which he made use of in his famous *Souvenirs d'Italie*. His views of Italy are among the first in the nineteenth century to use light colours, and to be solely concerned with light and colour.

Four paintings by Corot of the Castel Sant'Angelo are known, three of which have the dome of St Peter's in the distance (Robaut and Moreau-Nélaton, II, nos. 70, 70 *bis* and 71) and one which shows the same view as the present work but also includes the riverbanks and neighbouring houses (ibid., no. 73; Paris, Louvre). All four date from Corot's first visit to Italy, as do several drawings (ibid., IV, nos. 2479, 2486 and 2532). Differences in style and in the framing of the composition between this work and the version in the Louvre have led scholars – Germain Bazin in particular – to question the

attribution to Corot and to propose an attribution to his close friend Caruelle d'Aligny, who worked with him in Rome. Corot's signature is clearly not original, but this means little since many of his genuine works carry false signatures. The provenance is more of a problem. The work was owned by Caruelle d'Aligny and bought at the sale after his death (8 and 9 March 1878, lot 65) by the dealer Camille Benoit, who presented it to the museum as a work by Corot. Caruelle d'Aligny may well have owned works by Corot (who certainly owned works by him) and a confusion might have occurred. Robaut and Moreau-Nélaton would not include it in their catalogue, and assessment of its authenticity is made more complicated by the fact that Corot recomposed some of his sketches in the studio. The Louvre version falls into this category and is less spontaneous than the Lille painting. The question of authorship cannot be finally resolved here but an attribution to Caruelle d'Aligny would not be a dishonour, for he was one of the great landscapists of his time.

VP

Gift of Camille Benoit, 1882. Inv. 544.

Vergnet-Ruiz and Laclotte 1962, pp. 142 and 225; Châtelet 1970, p. 182, no. 84; Bazin 1973, pp. 88–9 and 104–5, note; Orléans etc. 1979, no. 1; Oursel 1984, p. 196; Yokohama etc. 1991–2, p. 157, no. 14; New York 1992, no. 41.

Gustave Courbet 1819–1877

31 Une Après-dinée à Ornans

Oil on canvas, 195 x 257 cm

Painted with the help of two un-stable ingredients, litharge (used to dry thick oil quickly) and bitumen (to give a rich, essentially transparent brown glaze), this picture gives only a dim suggestion of its original appearance. It was exhibited at the Salon of 1849, where it impressed Ingres (who was afraid, however, that it might set a bad example), and Delacroix, who admired it without reserve.

Courbet's own note on the picture survives: 'It was in November, we were at our friend Cuénot's house. Marlet had come in from hunting, and we had asked Promayet to play the violin.' (Paris, Louvre, Archives; quoted London 1978, p. 206, no. 134.) Courbet spent the period between September and December 1848 at home in Ornans; he returned to Paris during December and began work on Une Après-dinée. At this time he frequented the Brasserie Andler, a meeting place for certain Bohemian and Realist coteries. A drawing, now lost, shows him sitting at a table at the Brasserie with two friends; the arrangement of the composition, the corner of the table, Courbet's air of reverie, and the solidly Realist technique suggest a point of departure for the present work. Margaret Stuffmann has suggested that they represented respectively Courbet's life in Paris and in the Franche-Comté (Hamburg, Frankfurt 1978–9, pp. 340–2, no. 311; cited Fried 1990, p. 93, n. 16).

The subject of this work, painted in Paris, is deliberately rural and provincial, and relates to various paintings with picturesque rustic subjects, such as the scenes of Breton life painted by Armand Leleux, or the interiors painted by Courbet's friend François Bonvin, who was inspired by seventeenth- and eighteenth-century scenes of everyday life. It fits logically into a pattern of work produced by Courbet in the 1840s – the long series of self portraits in imaginary roles which led the painter towards the large-scale autobiographical paintings: A Burial at Ornans (1849–50; Paris, Musée d'Orsay), Peasants of Flagey (c.1850/55; Besançon, Musée des Beaux-Arts), and finally The Painter's Studio (1855; Paris, Musée d'Orsay). The series of self portraits may have been suggested by the example of Rembrandt; the self portrait known as The Desperate Man (c.1843; private collection) revealed an interest in Spanish art; and presumably his friend Champfleury discussed with him his own particular interest, the Le Nain brothers. The figure with tilted head in the background of Une Après-dinée was long assumed to be Courbet himself, and looks like him, but is now accepted as being a portrait of the host on that occasion, Urbain Cuénot. To the left is Régis Courbet, the artist's father; their friend Alphonse Promayet sits well into the embrasure of the chimney as he bends over his violin, and Marlet (Adolphe or his brother Tony) lights his pipe with a glowing brand he has taken out of the fire. Michael Fried rightly points out the satisfyingly rhythmic alternation of the figures, from near to far, and back again, as well as the differences of angle and orientation. He emphasises, too, the nearness of the image as a whole – the table, the chair legs, the grandly painted mastiff (Fried 1990). The limited nature of the space, and the harmonious relation of the figures, accord well with the communal listening, no one wishing to move from the debris of the meal, each figure plunged in reverie in the fading light.

The picture won a second-class gold medal at the Salon, enjoyed critical success, and was bought by the Republican government. Courbet retired to Ornans, where he began work on his great Burial, in which he developed the theme of provincial life on an even larger scale.

LW

Bought by the state, Salon of 1849; given
to the museum. Inv. 522.

New York 1992, no. 40 (with full
bibliography).

Gustave Courbet *1819–1877*

32 Amand Gautier

Oil on canvas, 55.5 x 46.5 cm
Signed and dated lower left: 67 G. Courbet

Amand Gautier (1825–94), who came from Lille, was, like Carolus-Duran, a pupil of François Souchon. He may be called a shadowy figure, not only because many of his pictures are lost and little is known about him, but also because he had a melancholic and reclusive temperament. He went to Paris in 1850 with a scholarship and began a long friendship with Courbet, whom he met at the Brasserie Andler, and whose political views he later shared. He seems to have been particularly drawn to painting subjects of institutional life; in 1857 he sent a large canvas to the Salon entitled *The Madwomen of La Salpêtrière* (now lost; Lille has recently acquired a preparatory study), and *Sisters of Charity* in 1859 (Lille). Baudelaire was struck by the latter and wrote in his review of the Salon: 'Studying this work, painted with a broad and simple touch which matches the subject, I felt something of the spiritual response induced by certain works of [Eustache] Lesueur, and the best pictures of Philippe de Champaigne, those which describe monastic habits.' The narrow face, protuberant brow, intent, perhaps apprehensive expression, give some idea of the character generally ascribed to this somewhat sad figure.

LW

Gift of Paul Gachet, 1952. Inv. 1771.

Riat 1906, p. 246; Mack 1951, p. 210; Cleveland etc. 1980–2, p. 176, no. 150, ill. (including exhibitions).

Gustave Courbet *1819–1877*

33 Landscape: a View at Honfleur

Oil on canvas, 43 x 65 cm
Signed lower left: G. Courbet

This landscape has traditionally been known as a view of Honfleur, presumably because it was described thus by its owner Auguste Richebé, the mayor of Lille, who bought it from Courbet and gave it to the museum in 1861. As Annie Scottez has noted, it does resemble the Normandy coast (Yokohama etc. 1991–2, p. 159, no. 18), and the faintly visible arm of land to the left may some day be identified. Courbet's biographer, G. Riat, was tempted to associate it with Courbet's visit to Le Havre in 1859, when he met Eugène Boudin who

encouraged him to paint the English Channel. When the picture was shown in London in 1977, it was dated much earlier because of the apparently unsophisticated placing of the screen of trees, and a general timidity. Benedict Nicolson felt at the time, however, that the clothes of the young woman suggested the fashion of a slightly later date, and that 'the clouds look post-Boudin'. Annie Scottez has recently suggested a date of 1845–8, later than that suggested in the London catalogue, though Klaus Herding, who has detected the use of the spatula and commented on the fluffy painting of the clouds, excludes altogether a dating in the 1840s, suggesting that it is closer to *The Pont de Scey* (private collection; London 1978, no. 24). It should be pointed out, however, that the dating for this picture too is only conjectural, and it has been put as late as 1864. The dress and hat of the young woman

resemble those of one of the sisters in *Les Demoiselles de Village* of 1851 (Leeds City Art Gallery); the fashion for hats with floating ribbons, for the country, was at its height in the mid-1850s in England, though perhaps earlier in France. Possibly the model was indeed Courbet's sister, as Benedict Nicolson suggested. She appears to be sketching, and the boy beside her, in a pose which brings to mind the young boy in *The Stone Breakers* (destroyed, formerly Dresden, Gemäldegalerie), seems to be scrutinising her work, perhaps offering encouragement or criticism – a role which recalls the child standing beside the artist in the great picture of 1855, *The Painter's Studio* (Paris, Musée d'Orsay).

Annie Scottez rightly describes the scene as 'powerful and picturesque, serious and light'. It has a quality of unemphatic 'plein-airism'; the matching in paint texture of the distinct and separate character of

sea, sky, land and foliage is held in balance with a serene objectivity which is unexpected.

LW

Bought from the artist by Auguste Richebé; given by him in 1861. Inv. 545.

Nicolson 1978, p. 174; Yokohama etc. 1991–2, p. 159, no. 18 (with full bibliography), ill. p. 35; Herding 1991, p. 242, n. 29.

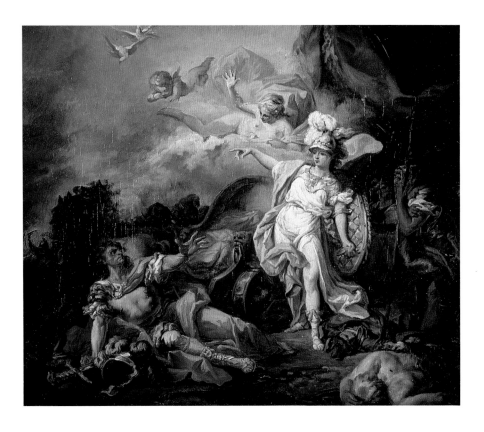

Jacques-Louis David
1748–1825

34 The Combat between Minerva and Mars

Oil on canvas, 26.4 x 34.5 cm

This is probably a highly resolved sketch for David's painting of the subject (Paris, Louvre), with which he won second prize in the Prix de Rome contest of 1771. The first prize was won by J.-B. Suvée's painting (No. 94).

It was David's second attempt to win the Grand Prix. The previous year he had not been among the chosen finalists, and it was not until 1774 that he won with his *Antiochus and Stratonice* (Paris, Ecole des Beaux-Arts).

In his fragmentary manuscript autobiography David admitted not having told his teacher, Joseph-Marie Vien, that he had entered the Prix de Rome competition in 1771; when Vien found out, he warned David that this was not the sort of competition for playing around. David believed that the judges favoured him and that he would have won but for the intervention of Vien, who advised his pupil that: 'I ought to regard myself sufficiently fortunate to have pleased the judges, [and] that besides I should be seen a second time. I had the second prize. I really believe that he spoke to me thus out of regard for me (at least I cannot think of any other thought on the part of a teacher).' (Wildenstein 1973, p. 156.)

The other reasons which David later gave for failing to win were first that he was up against two experienced rivals, Suvée and Taillasson, and secondly that he saw too late that he had made the figures in his painting too small and decided to begin again, leaving only a month in which to finish the work. The result was a work of a dissatisfyingly uneven composition, strongly influenced by Boucher in its artificial colouring, which deservedly lost to Suvée's more resolved and mature effort.

HW

Galerie Cailleux; purchased 1985. Inv. 1983.

Rome 1981–2, fig. 1, p. 29; Lee 1984; Paris 1985, no. 6; Oursel and Scottez-De Wambrechies 1986; for an extensive bibliography of the painting to which this sketch is related, see Paris, Versailles 1989–90, p. 48; Yokohama etc. 1991–2, no. 1.

Jacques-Louis David
1748–1825

35 Belisarius

Oil on canvas, 288 x 312 cm
Signed and dated lower left: L. David
faciebat/anno 1781 Lutetiae (?)
Inscribed: DATE OBOLUM BELISARIO

According to the Byzantine historian
Procopius, Belisarius (died AD 565)
was a successful general, loyal to his
emperor, Justinian, but brought
down by the latter's envy. Unjustly
accused of conspiracy in AD 563,
and according to later tradition
deprived of his property and blinded
on the emperor's orders, the old
Belisarius was reduced to begging in
the streets of Constantinople. The
story would have had particular
resonances in France, since a general
in the French army, Lally-Tolendal,
hero of the battle of Fontenoy, had
been held responsible for the French
defeat in India and executed for
treason in 1766. This event was
doubtless the catalyst for Jean-
François Marmontel's novel,
Bélisaire, published the following
year. Lally-Tolendal's son cam-
paigned for his father's posthumous
rehabilitation, supported by liberal
opinion, and with Marmontel's
novel being condemned by the
Sorbonne for advocating religious
tolerance, the obscure Roman
general was transformed into a
symbolic victim of oppression and
intolerance.

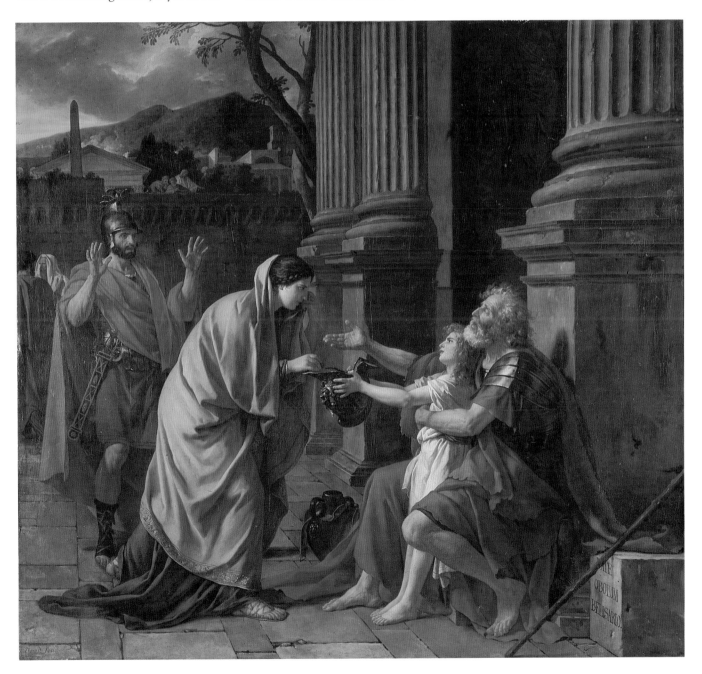

In spite of these parallels with contemporary events, the immediate impact on painters of Marmontel's novel was limited. Only Nicolas-René Jollain exhibited a *Belisarius* (now lost) at the 1767 Salon, and after that no known version appeared before Louis-Jean-Jacques Durameau's *Return of Belisarius to his Family* (Montauban, Musée Ingres) at the 1775 Salon. Significantly, however, the Salon catalogue stated that Durameau's picture was owned by the comte d'Angiviller, the king's minister for buildings and the arts, so giving the subject a quasi-official seal of approval consistent with the more tolerant policies of Louis XVI's government. There followed a small spate of Belisarius pictures, doubtless further stimulated by the continuing debates on religious tolerance and the Lally-Tolendal affair. At the 1777 Salon François-André Vincent exhibited his *Belisarius Begging* (Montpellier, Musée Fabre). At that of 1779 Jean-Charles Levasseur showed his print after Durameau's painting, while in 1779 Peyron's *Belisarius receiving Hospitality from a Peasant* (Toulouse, Musée des Augustins), commissioned by the French Ambassador to the Holy See, Cardinal de Bernis, was shown at the Palazzo Mancini in Rome.

David had watched Peyron at work on his painting in Rome – indeed it was he who loaned David his copy of Marmontel's novel. In the year that Peyron exhibited his *Belisarius* David signed a compositional drawing which in all respects except its vertical format was to be close to his own painting. This it seems David did not begin until after his return to Paris in the autumn of 1780. Its debt to Peyron was not in the detail but in a seriousness of approach derived from Poussin.

The more direct artistic antecedent was possibly one of Hubert-François Gravelot's engravings for Marmontel's novel (fig. 63), which like David's first known compositional drawing also had a vertical format (Boime 1980). David adapted Gravelot's compositional scheme for the figures and architecture, as well

as the engraver's gestures for Belisarius and the Emperor Justinian (used in the latter case by David for the Roman soldier). David also borrowed from Gravelot the motif of Belisarius' stick leaning on a cut block of stone. David, however, increased the sentiment with the addition of the almsgiver, the child and the more pathetic attitude of Belisarius, at the same time making the architecture and setting more severe. Additionally, his attention to gesture, meticulous draughtsmanship and smooth finish represented a departure from his own and others' earlier more loose and suggestive technique.

Shown to the Académie in August 1781 for his acceptance as a provisional member, the painting was unanimously approved, so permitting it and numerous other paintings and studies by David to be exhibited at that year's Salon. Generally admired there, David's *Belisarius* was not bought by Louis XVI as the artist had hoped. D'Angiviller, however, commissioned a reduced version (Paris, Louvre), and David felt sufficiently encouraged to write to his mother (27 August 1781): 'I am not yet rich except in glory, in cash even less, but I very much hope that that will not be delayed.' In the event David did not sell the *Belisarius* until October 1786 when it was acquired by Clemens Wenzeslaus, Prince Elector of Treves.

The painting was originally square and was cut down to its present shape by the artist before its sale (Schnapper 1991; Seelig 1990, addendum, p. 86).

HW

Shown at the Académie on 24 Aug. 1781 as the artist's *tableau d'agrément*; exhibited at the 1781 Salon under the title 'Belisarius, recognised by a Soldier who had served under him, at the Moment when a Woman gives him Alms', no. 311; purchased in October 1786 by Clemens Wenzeslaus, Prince Elector of Treves, by whom sold at auction (possibly via intermediaries) in Brussels in March 1793; bought by Louis Vollant; confiscated Dec. 1794 following the execution of Vollant, but restored to his

father and brother in 1796; offered for sale in Paris, April 1796 and 4 April 1799 (Fould, Saint-Morice, Savalete sale, no. 112), and again 24–6 Feb. 1801 (Tolozan sale, no. 87), where bought for Cardinal Fesch by whom ceded to Lucien Bonaparte by 24 Sept. 1802; acquired by Lucien Bonaparte's mother and bought from her by the Earl of Shrewsbury in 1829; at his residence, Alton Towers, by 1835; Christie's 6 July 1857 (Shrewsbury sale, no. 18); the Northwick sale, 26 July–30 Aug. 1859, no. 457, there bought by Meffre; withdrawn from his sale, Paris, 9–10 March 1863, no. 15, and sold to Lille in 1868. Inv. 436.

Reynart 1872, no. 115; Sizer, ed., 1953, p. 108; Haskell 1975; Geneva 1979, no. 81 (copy in pencil by Hubert Robert); Bukdahl 1980, I, pp. 123–4, II, pp. 197, 199; Oursel 1984, p. 184; Lajer-Burchart 1989; Paris, Versailles 1989–90, no. 47 (with extensive bibliography); Seelig 1990; Schnapper 1991; New York 1992, no. 28; Pinelli 1992.

Fig. 63 Hubert-François Gravelot, illustration for Marmontel's *Bélisaire*, Paris 1767. Paris, Bibliothèque Nationale.

Jacques-Louis David
1748–1825

36 Compositional study for 'The Oath of the Horatii'

Pen and black ink with grey wash and white highlights over black chalk, on paper, 22.9 x 33.3 cm
Signed lower right in ink: L. David inv.; dated by another hand?: 1782

David's *Oath of the Horatii* (fig. 64), painted for Louis XVI during the artist's second stay in Rome in 1784–5 and exhibited at the 1785 Paris Salon, made a striking impact on his contemporaries. The critics, generally admiring, used words like 'strong', 'vigorous', 'energetic', 'bold', 'direct'. With its disjunctions of composition, its emphatic model-ling of musculature, its virtually unrelieved severity and its rejection of anecdotal inessentials, the *Oath* represented a determined repudiation of painting's function primarily to please, which had been dominant since around 1700.

The story of the Horatii was told by ancient authors including Livy, in Pierre Corneille's tragedy *Les Horaces* (1640) and in Charles Rollin's *Histoire Romaine depuis la Fondation de Rome jusqu'à la bataille d'Actium* (1752), although in none of these is the episode of the oath recounted. The three Horatii brothers were chosen by the Romans to do battle with the three Curiatii brothers, the champions of the Albans. The outcome would determine the dominance of one tribe over the other. However, Horatius, the eldest of the Horatii, was married to Sabina, a sister of the Curiatii; and Camilla, the only daughter of the aged Horatius, was betrothed to Curiatus, the eldest of the Curiatii brothers. In the battle, two of the Horatii and all the Curiatii were slain. When the young Horatius, the only survivor, returned to Rome, he murdered his sister, Camilla, for mourning the death of Curiatus.

It was this last episode which David first considered, as indicated by a drawing of 1781 in the Albertina, Vienna (Paris, Versailles 1989–90, no. 52). In February 1782 the government approved a commission for David to paint a different episode, namely the plea in the defence of the young Horatius by his father, after the former had been condemned to death for Camilla's murder. The painting was never executed, although early in 1784 David was still thinking of it. However, he was by then also thinking of the incident of the oath. The present drawing was probably executed

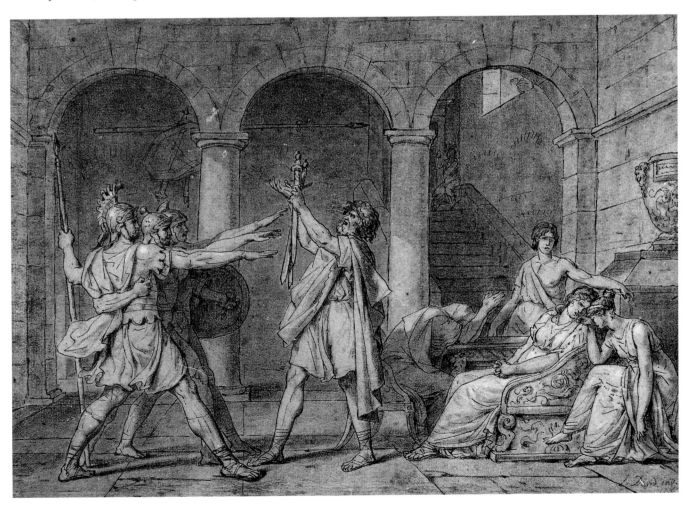

shortly thereafter, during the artist's second stay in Rome, despite its dating of '1782' (see Paris, Versailles 1989–90, pp. 164 and 171).

The proximity of the present drawing to the finished painting can be measured by comparing it with an earlier one (fig. 65), which is close in conception to J.-A. Beaufort's *Oath of Brutus* (private collection). In this earlier drawing the virtual separation of male and female spaces within the composition is evident, but the attitudes of the elder Horatius and his sons are those of regret and farewell. An intermediate drawing in the Louvre (R.F. 29 914) shows the Horatii brothers with partially raised arms but their uncompromising assertiveness first appears in the Lille drawing. The gesture of the raised arm was inspired by the lictor at the left of Poussin's *Rape of the Sabines* (Paris, Louvre; Péron 1839, p. 31).

In the final painting, David suppressed the standing figure at the right of the Lille drawing, the amphora at the extreme right, the detail of Sabina's chair and the staircase leading back into space. The walls appear unadorned and the arches are brought forward to emphasise the generational and gender divisions between the characters. At the same time, David replaced the figure hiding her head in her arms with that of the mother of the Horatii embracing her grandchildren. The late addition of the children served to heighten the emotive impact of a tragedy which David showed as inevitable within the uncompromisingly severe context of ancient Rome.

The division between male and female in the painting, and between patriotic duty and familial sentiment which it expresses, has often been commented on. This conflict is, however, somewhat at odds with Rollin's account: 'While each side exhorts its representatives duly to undertake their duties in representing to them that the tutelary gods of Rome or of Alba, their country, their fathers <u>and their mothers</u>, every one of the citizens present or absent, have their eyes fixed on their weapons and their right arms.' (Rollin 1752, p. 90.)

HW

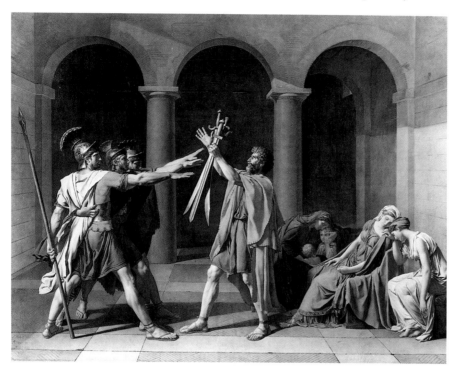

Collection Jean-Baptiste Wicar; bequeathed to the Société des Sciences, de l'Agriculture et des Arts de Lille in 1834. Inv. Pl. 1194.

Paris, Versailles 1989–90, no. 71 (with extensive bibliography).

Fig. 64 Jacques-Louis David, *The Oath of the Horatii*, 1784. Oil on canvas, 330 x 425 cm. Paris, Musée du Louvre.

Fig. 65 Jacques-Louis David, *Compositional study for 'The Oath of the Horatii'*. Graphite, pen and brown ink on paper, 20 x 26.8 cm. Paris, Ecole Nationale Supérieure des Beaux-Arts (inv. 733).

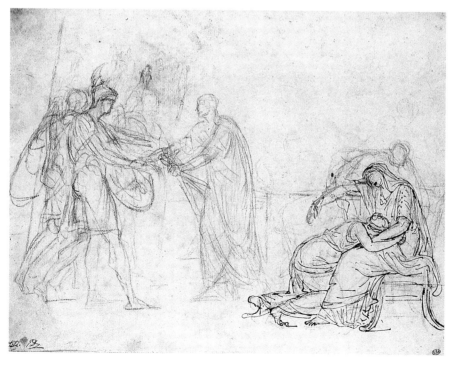

Jacques-Louis David
1748–1825

37 Study for the Figure of Hersilia

Graphite partially reinforced with black ink on paper, squared for transfer,
30.3 x 21.8 cm

This study relates to the central part of David's painting *The Intervention of the Sabine Women* (fig. 66). Following the rape of the Sabine maidens by the Romans, the Sabine king, Titus Tatius, shown at the left of the painting, advanced on Rome with an army seeking vengeance. After several exhausting battles the Sabine women, by now mothers of children fathered by Romans, rushed between the Romans and the Sabines and reconciled them henceforth to living as one nation. The prime mediator was Hersilia, the only married woman carried off by the Romans, when, according to Livy and Plutarch, she became the wife of Romulus, one of Rome's founders – who is depicted on the right facing Tatius. Although the painting was not finished until 1799, it was conceived by David soon after he was imprisoned in the Luxembourg Palace in September 1794, as a plea for reconciliation between the factions that divided France.

The figure of Hersilia in the final painting bears a close resemblance to that in David's first known compositional sketch (fig. 67). The differences are in the adoption of more revealing drapery and in the elongation and slightly lower elevation of her arms. There is no significant difference between Hersilia in that sketch and in the present drawing apart from the addition of the headdress.

The function of this drawing was doubtless to try to work out the spatial relationships firstly between Hersilia, Titus and Romulus, and secondly between Hersilia and the subsidiary figures surrounding her. The problem was to show Hersilia in the mêlée while at the same time giving her enough space to stand out from it. Thus, the mother holding up her child and the mother holding onto Titus' left leg were both moved further to the left in the painting, and the woman to the right of Hersilia in the drawing was entirely eliminated. The additional space created by Hersilia's unnaturally elongated arms then became part of a 'frame' for the mother kneeling in the centre foreground. Traces of alterations in the drawing, for example to the mother holding up her child, show the artist's constant revisions as he worked. An example of David's fine tuning is in the position of the head of that child. Facing left or in three-quarter view in this and other studies (Paris, Versailles 1989–90, nos. 151 and 152), it was pulled round in the painting to face the viewer, who is thus confronted more directly by the horror of the Sabines' spears threatening the vulnerable body.

In working out the composition of the painting and the individual figures, David consulted antique sources and Raphael. John Flaxman's illustrations to the *Iliad* (Symmons 1973), a large painting by David's contemporary François-André Vincent of the same subject, exhibited at the 1781 Salon (Rosenblum 1962), and James Gillray's engraving *Sin, Death and the Devil*, published in June 1792

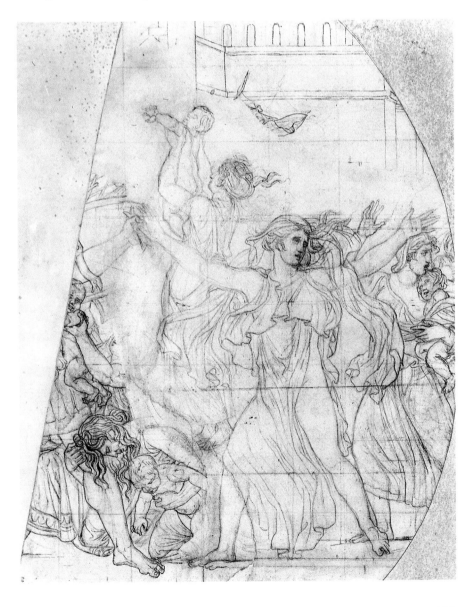

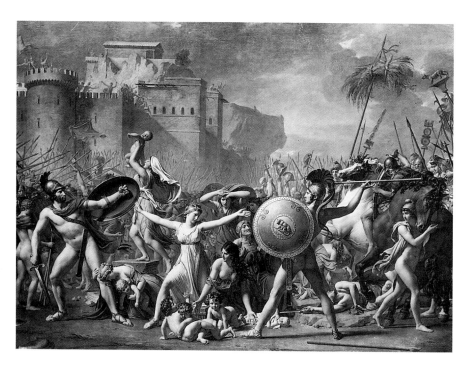

Fig. 66 Jacques-Louis David, *The Intervention of the Sabine Women*, 1799. Oil on canvas, 395 x 522 cm. Paris, Musée du Louvre.

Fig. 67 Jacques-Louis David, *Compositional study for 'The Sabines'*, 1794. Black chalk, pen and black ink, grey wash, white highlights, on brown paper, 25.6 x 35.9 cm. Paris, Musée du Louvre, Département des Arts Graphiques (R.F. 5200).

(Domenici 1983), have been suggested as other possible sources for the central group of Titus Tatius, Hersilia and Romulus. The Gillray print was published within days after publication of its model, a print by Thomas Rowlandson and J. Ogborne, itself after Hogarth's *Satan, Sin and Death* (London, Tate Gallery; see Bindman 1970). The Rowlandson print, therefore, has at least an equal claim to the Gillray as an artistic precedent for David.

HW

Collection Ph. de Chennevières (1820–99); sale, Paris, Hôtel Drouot, 9 Feb. 1972, no. 13, where acquired. Inv. W. 3494.

Paris 1889, 1, no. 144; London, Cambridge etc. 1974–5, no. 14; Lille 1983, no. 16; Moscow, Leningrad 1987, no. 26; Paris, Versailles 1989–90, no. 153, and no. 146 (with extensive bibliography on *The Sabines*); Warsaw 1991, p. 40.

Jacques-Louis David
1748–1825

38 Warrior drawing his Sword

Black chalk on paper, 13.2 x 7.5 cm
Inscribed upper right in ink: 98(?);
and at bottom centre: ED

The sketchbook from which this drawing was taken included a number of graphite and black chalk studies connected principally with two of David's paintings, *The Distribution of the Eagles* (Versailles), finished in 1810, and *Leonidas at Thermopylae* (Paris, Louvre). The latter was first conceived by the artist in 1800 or perhaps a little earlier, but not completed until 1814. Another sketchbook in the Louvre (R.F. 6071) also contains studies for both paintings, suggesting an interchangeability in David's mind between these two military subjects. But whereas *The Distribution of the Eagles* was a triumphant tribute to the loyalty of the French military to Napoleon, the *Leonidas* was a more sombre recollection of the heroic self-sacrifice of the 300 Spartans who saved Ancient Greece from being conquered by an army of 600,000 Persians.

The soldier in the present drawing appears in neither painting nor in their related composition studies; nor can his armour clearly relate him to the *Leonidas*, since another drawing from the same source (Inv. Pl. 1246) of a soldier in an antique helmet is connected with *The Distribution of the Eagles*. The action of drawing his sword may have been, as suggested by Annie Scottez, one of a number of possibilities considered by David for the figure of Megitias in the *Leonidas*, who, according to David, 'carries the arms and costume [of Hercules and] hastens to marshal his troops in battle.' Or the drawing may have been an alternative study for a figure at the bottom and extreme left of David's first compositional sketch for the painting, now known only through an engraving by Jules David. That figure is close to another study in the same sketchbook as the present drawing (Inv. Pl. 1232). In both the soldier is armed with a shield and sword, so David partially ignored his own note about Spartan armour copied from the Abbé Barthélemy's *Voyage du jeune Anacharsis en Grèce* on a drawing in Montpellier (Musée Fabre, inv. 838.6): 'The principal arms of the Spartan footsoldier are the spear and the shield; I do not count the sword which is only a type of dagger which he carries at his belt. It is on the spear that he bases his hopes . . .'

David customarily drew nude studies for individual figures or groups of figures in his history paintings. The retention of nudity in the publicly exhibited paintings of *The Sabines* and the *Leonidas* was, however, a matter of controversy at the time.

HW

Given to the municipality of Lille in 1850 by François Souchon, director of the Ecole de Peinture de Lille. Inv. Pl. 1239.

Benvignat 1856, no. 168; London, Cambridge etc. 1974–5, no. 17; Lille 1983, no. 50; Rome 1984, no. 50; for a discussion of David's *Leonidas* and of some of the related drawings, see Paris, Versailles 1989–90, pp. 486–512.

Eugène Delacroix
1798–1863

39 Medea

Oil on canvas, 260 x 165 cm
Signed and dated lower left:
Eug. Delacroix 1838

Delacroix here depicts Medea after she has been abandoned by Jason, fleeing from the avenging citizens of Corinth, whose king and princess she has just murdered, and on the point of killing her children by way of revenge. There is no specific source for this scene in the best-known literary versions by Euripides, Seneca and Corneille, although the setting of act III of Corneille's play in Medea's magic grotto might have suggested the rocky background. It is possible that the inspiration was an opera, as Cecilia Powell has suggested (Powell 1982, pp. 12–18, ill. III, p. 14). She has noted that Mayr's *Medea in Corinth* was first performed in Paris in 1823, with Madame Pasta in the title role. Delacroix's journal does not exist for this period, but we know of his admiration for her, and it would seem most likely that he saw this performance, particularly as he listed Medea in his journal in 1824, together with a Moses subject, and we know that the theme of Moses was suggested by a performance of Rossini's opera.

The story preoccupied Delacroix throughout his working life, probably because it epitomises the disturbing fantasies underlying so many of his paintings. His first recorded mention of the subject was in 1820 (Johnson 1981–9, III, p. 80), while children of that type and particular pathos are first seen in drawings made at the time of *The Massacre at Chios* (1824; Paris, Louvre); Lee Johnson has brought to my attention a sheet sold at Phillips in London on 5 December 1990, which contains studies for this picture and also a figure resembling Medea. The final concept owes something to the allegorical *Greece on the Ruins of Missolonghi* (Bordeaux, Musée des Beaux-Arts),

and to *Liberty leading the People* (Paris, Louvre), in both cases a powerful woman associated with death and destruction.

In his comments on Meissonier's *Barricade* (fig. 80), Delacroix wrote of the difficulty in attaining 'that indefinable thing which makes of an

odious object an object of art'. In this case, the painting of an event which is profoundly horrifying is nonetheless one of Delacroix's most affecting works. Lee Johnson has related the composition to the woman holding a child under her right arm in the foreground of

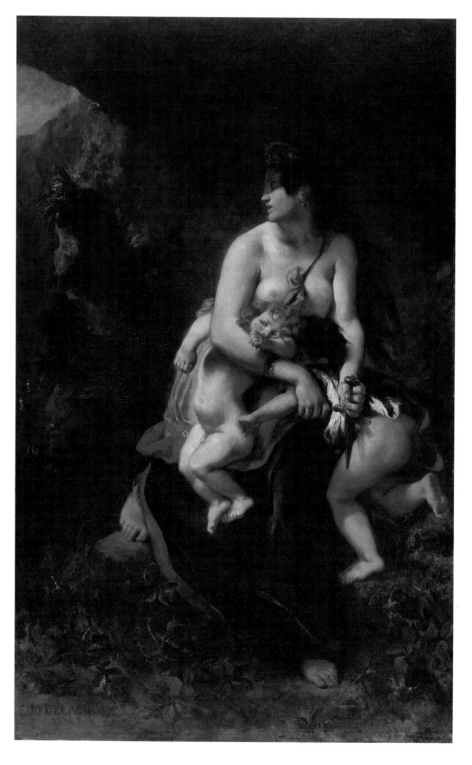

116

Marcantonio Raimondi's engraving of Raphael's *Massacre of the Innocents*, a figure which Delacroix copied in about 1819 (Paris, Louvre, R.F. 23356, fol. 44), and has noted that Delacroix bought an impression of this print in April 1824, shortly after mentioning the subject of Medea in his journal (Johnson 1981–9, III, p. 80). He may also have borrowed from the central figure, a fleeing woman looking over her shoulder of a type to be found in a number of Mannerist prints, of which Delacroix had a large collection. The theme of the Massacre of the Innocents is undoubtedly an important source for Delacroix's picture. Clearly it also paraphrases several of Raphael's groups of the Holy Family, and owes something to Leonardo's *Virgin of the Rocks* (Paris, Louvre; London, National Gallery), but perhaps owes most to Andrea del Sarto's *Charity* (Paris, Louvre), a work which Delacroix mentioned with admiration.

The babies, however, are not classical; the visible tears of the one and the pose of the other rather recall Rembrandt's *Ganymede* (Dresden, Gemäldegalerie). In most treatments of the theme, the children are older, but here their youth allows Delacroix to use the image of a mother and two children, a traditional emblem of Charity, to reinforce the horror of Medea's unnatural crime

LW

Bought by the state for the museum, 1838. Inv. 542.

Johnson 1981–9, III, no. 261 (with full bibliography), IV, pl. 79; Oursel 1984, no. 39, ill.; Tokyo, Nagoya 1989, p. 120, no. 41, ill.; New York 1992, no. 37; Scottez-De Wambrechies 1992, pp. 77 and 78, ill.

40 Oil sketch for 'Medea'

Oil on canvas, 46 x 38 cm

In his journal Delacroix frequently mentioned the difficulty he encountered in maintaining the inspiration of his first sketch through to the final composition. This oil sketch for the painting *Medea* of 1838 (No. 39) evokes the emotion the episode inspired in Delacroix with a vivacity which gives way in the final picture to more studied, static qualities. The essential composition is closely related to the drawing (No. 42), with a number of adjustments: the dagger in the oil sketch is in Medea's left hand, and the pursuing figures, visible in related drawings, have been eliminated. The colours retain the quality Etienne Delécluze described as a 'richesse de coloris coquet'. They are delicately resolved in the final work into the pink ribbon across Medea's chest and the blue-green drapery it supports. By assimilating the solemn language of Renaissance art, Delacroix enriched the theme without loss of verve; in the final painting Medea's pallor, the half shadow across her features, the dark grotto and the multiplicity of iconographic reference, sum up in more classical and terrible language all that

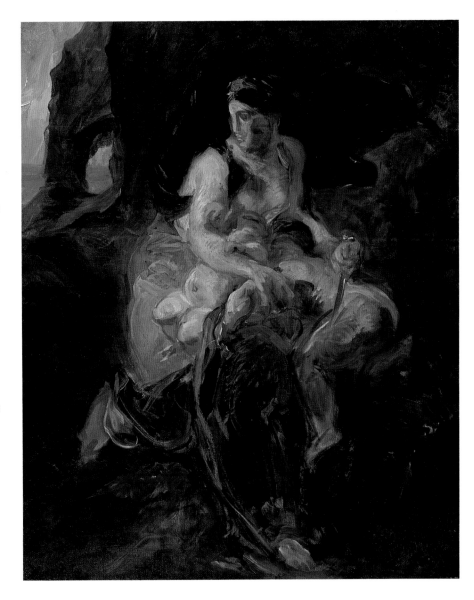

Delacroix was able to suggest in the sketch with the hurrying figure and fluttering draperies.

LW

Johnson 1981–9, III, no. 259 (with full bibliography), IV, pl. 78; New York 1992, no. 38.

41 Studies for 'Medea' and 'Saint Sebastian'

Pen and wash on paper, 19 x 30.5 cm
Inscribed on the left: Perfectus scilicet homo qui/fata perfecit; peritus qui/periit; contentus/qui/tumulo demum continetur

The three drawings by Delacroix illustrated here form part of a lot of twenty-seven bought for the museum at Lille from Delacroix's posthumous sale for 195 francs. The present sheet is probably one of the earliest, since it also bears a study for the picture of Saint Sebastian which was completed in 1836. It differs from subsequent studies in that the child on the left is standing, and the group thus reveals most clearly one of the obvious sources for Medea – the type of triangular grouping of the Holy Family established by Raphael, whose *Belle Jardinière* (Paris, Louvre) Delacroix copied. In this study, Medea holds the dagger in her right hand, but the conflicting themes of maternity and destruction jar, and their combination within this grouping must have seemed difficult. Perhaps it was at this stage that Delacroix reverted to the iconography of a Massacre of the Innocents, which necessitated the hasty bundling of a child under the right arm, as in the figure suggested as a source by Lee Johnson – that is, the woman on the lower right in Marcantonio Raimondi's engraving of Raphael's composition (see No. 39). This solution introduces the difficulty of a convincing placing of the dagger.

Delacroix changed the composition from the orientation of the present study; in subsequent drawings, Medea's head is turned dramatically in the direction of her pursuers, thus conveying an essential element of narrative.

It is possible that Delacroix made use of this figure for the beautiful figure on the right of his *Saint Sebastian*, shown at the Salon of 1836 (church of Nantua), since her face too is in the half shadow he was to use with such effect in the final composition of *Medea*. If this is the case, the idea may have come to him while he was working in the wash medium of this drawing.

LW

London, Cambridge etc. 1974–5, no. 26 (with bibliography), pl. 78.

42 Study for 'Medea'

Graphite on paper, 22.4 x 15.5 cm

The drawing on this sheet is so close to the oil sketch that it may mark the point at which Delacroix was ready to arrange his palette and begin painting. Two pursuing figures visible in related studies have been omitted here, and the narrative is suggested by the figure of Medea alone, as in a piece of Classical sculpture.

Haste and terror are in every line of this study; the turmoil of the ample drapery is retained in the oil sketch, although in the final painting it falls in stately folds. The children's heads, rounded to heighten the sense of their vulnerability, press against Medea's breasts in what is to remain the central ironic motif of the composition – although Delacroix placed the heads lower in the final version. The amplitude of the drawing illustrates Delacroix's advice to 'draw from within'; it has little in common with the refined contour of Ingres and even less with the linearity of his pupils.

LW

Bought at the posthumous sale of the artist, Paris, Feb. 1864. Inv. Pl. 1269.

Sérullaz 1963, p. 189, no. 252 (with bibliography).

43 Study for 'Medea'

Pen on paper, 21 x 32 cm

Unlike the two accompanying studies, this drawing has more in common with a version of *Medea* which Delacroix began in 1856 (fig. 68). The work, once in Berlin (Nationalgalerie), is now lost.

When Théophile Gautier saw the 1838 version of *Medea* (No. 39) at the Exposition Universelle in Paris in 1855, he was struck by a certain resemblance to the 'viperish grace' of the great actress Rachel. Delacroix's friend the playwright Ernest Legouvé, whose *Adrienne Lecouvreur* had been one of the few modern plays in Rachel's repertoire, had promised to write a new part for her. Perhaps Gautier's comparison had also occurred to him; whatever the inspiration, he eventually wrote a *Medea*, but to his annoyance Rachel would not take the role, which was finally given to her rival from Italy, Adelaide Ristori. On 13 April 1856, Delacroix dined with Legouvé; he went to see *Medea* on 19 April, and on 26 May mentioned two versions of his own *Medea*, one of which, commissioned by M. Bouruet-Aubertot, was probably the Berlin picture (Johnson 1981–9, III, p. 149). It is possible that Legouvé's play and Adelaide Ristori's acting, which was very different from that of Rachel, may have suggested to Delacroix the possibility of a new treatment.

The Berlin version has less of the complex horror of the 1838 picture. Medea herself is nervous and more obviously vulnerable. Several drawings at Lille can be related to the second project. The notable difference is in the stance, in that she seems to be stepping on to her left foot as if on to a rock to escape her pursuers. The child to the right has one arm on her shoulder, as if to push himself away at the moment when, with dawning horror, he realises her intentions. One of these drawings is squared for transfer (fig. 69) and might therefore suggest a pupil's collaboration, since squared drawings are not frequently found in Delacroix's surviving output and the Berlin version does look as if it may not have been entirely Delacroix's own work.

It is not certain, however, that the drawings, which suggest the composition of the later version, date from the 1850s. They may relate to an arrangement which Delacroix thought about then abandoned in 1836–7, taking it up again later. The angular character of the pen drawing on this sheet, and the vigorous hatching, are not incompatible with drawings datable to the 1830s; Lee Johnson has pointed out to me a preparatory study for *The Fanatics of Tangiers* (1838; Minneapolis Institute of Arts), for example (Johnson 1964, no. 139, ill. 72). However, the upper left study is for a figure unrelated to the *Medea* composition, and has been proposed by Hervé Oursel as a preparatory sketch for *The Capture of Rebecca* (1863; Sir Edward Boyle collection), another subject which Delacroix reworked in the 1850s in more melodramatic vein. The pose of the child on Medea's right is somewhat closer to the Berlin version; her arm encircles him in a manner clarified by the reworking in the lower left study, while in the 1838 version he almost slips from her grasp as her maternal role gives way to that of murderess.

LW

Bought at the posthumous sale of the artist, Paris, Feb. 1864. Inv. Pl. 1277.

London, Cambridge etc. 1974–5, no. 29, pl. 80.

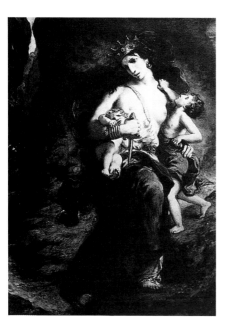

Fig. 68 Eugène Delacroix, *Medea*, 1856–9. Oil on canvas, 131 x 98 cm. Formerly Berlin, Nationalgalerie.

Fig. 69 Eugène Delacroix, *Study for 'Medea'*. Graphite on paper, squared for transfer, 22 x 15.5 cm. Lille, Musée des Beaux-Arts, Inv. Pl. 1268.

Attributed to
Eugène Delacroix
1798–1863

44 Tobias and the Angel, after Rembrandt

Oil on canvas, 36 x 27 cm

The story of Tobit, healed of his blindness by his son Tobias assisted by the Archangel Raphael (see Nos. 19 and 26), touches on two subjects to which Rembrandt frequently returned: the theme of blindness and that of angelic intervention in human life. Rembrandt's painting of the angel leaving Tobias and his family, which has been in the Louvre since 1785, depicts both subjects through an expressive use of light. The present copy heightens and concentrates the theme as the angel rushes upwards out of the darkness towards a bright cloud, and Tobit alone among the members of his gathered family receives in full the light from the departing figure.

Delacroix never took Rembrandt for a model as literally as he did Rubens or Veronese, whose works he copied on several occasions, but he referred to him with increasing reverence over the years. In 1850 he was particularly impressed by Rembrandt's *Tobias curing his Father* (Stuttgart, Staatsgalerie), which he saw in the duc d'Arenberg's collection in Brussels. His enthusiasm was confirmed the

120

following year when several galleries in the Louvre were re-opened after a period of renovation. 'Perhaps', he wrote in his journal on 6 June 1851, 'people will discover that Rembrandt was an even greater painter than Raphael.'

Scholars have generally linked the copy in Lille with this period of increasing interest in the work of Rembrandt. However, Lee Johnson has drawn my attention to a comment by Théophile Silvestre which makes such a dating improbable: 'Delacroix retained a taste for copying the Old Masters throughout his life, though he was not able to satisfy it as he would have liked. One might frequently have seen him working at the Louvre, even in recent times, had not an army of young copyists made the place hateful to everybody.' (Silvestre 1864, p. 21.) Perhaps it dates from the 1820s when, as Patrick Noon has recently pointed out, several young artists in Richard Bonington's circle were encouraged by the engraver S.W. Reynolds to study Rembrandt's work (New Haven, Paris, 1991–2, p. 56). Bonington shared a studio with Delacroix in 1826; they both admired and copied Northern as well as Italian Old Master paintings at this period. There is another copy of Rembrandt's *Angel leaving Tobias and his Family* in the Fogg Art Museum (Cambridge, Mass.), which is attributed to Bonington, but neither this attribution nor that of the copy at Lille can be proved with certainty.

Lee Johnson has pointed out to me that in the case of the present copy, there is no documentary evidence to suggest that it is the work of Delacroix. It does not appear in the inventory drawn up after the artist's death, unless it can be identified as the unattributed *'Tobie et l'ange d'après Rembrandt'* (Bessis 1969, no. 71). It was not in the studio sale, and Robaut, who knew the pictures at Lille, does not mention it in his *catalogue raisonné*. Remains of a red wax seal on the back, bearing the initials E.D., which was affixed to works by Delacroix in the studio sale, are also found on the copy

by Hippolyte Poterlet of Rembrandt's *Supper at Emmaus* (private collection). Lee Johnson suggests that both of these pictures might have been intended for the sale and that their seals were removed when it was decided that they were not by Delacroix. (Similar traces of a seal appear on the back of a flower piece in the National Gallery, London, now attributed to Delacroix's pupil Pierre Andrieu.) Poterlet, a close friend and collaborator of Delacroix in their early years, made many copies after Rembrandt and might have been the author of the present copy, or perhaps, painted it in

collaboration. There can be no doubt that Delacroix knew and admired the original as several of his own pictures of angelic companions echo it: *The Genius of Socrates*, for example (from the library of the Palais Bourbon, Paris), or the angel in the late version of *Daniel in the Lions' Den* (1853; Zurich, Emil Bührle Foundation).

LW

Bought from Camille Benoit, 1878. Inv. 491.

Yokohama etc. 1991–2, p. 160, no. 21 (with full bibliography), ill. p. 38.

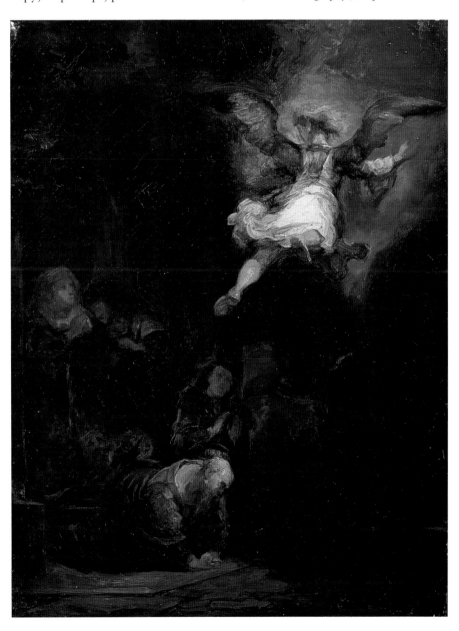

Eugène Delacroix
1798–1863

45 Bouquet champêtre

Oil on paper, mounted on canvas,
62 x 87 cm
Signed lower right: Eug. Delacroix

The events of 1848 produced in Delacroix a mood of bitter pessimism. In September he left Paris for his country estate at Champrosay, where he began work on a series of flower paintings which was to absorb him throughout the winter. He did not intend them to be botanically precise studies arranged with curtains or columns in the tradition of flower painting. On 6 February 1849, he wrote to his friend Constant Dutilleux: 'I have tried to do studies of nature as it occurs in a garden, but gathering together in a probable manner the greatest possible variety of flowers.' He intended to send five flower pictures to the Salon of 1849; in the end he sent only four, was not satisfied with them, and finally retained only two, *Basket of Fruit in a Flower Garden* (Philadelphia Museum of Art), and *Basket of Flowers overturned in a Park* (New York, Metropolitan Museum). Both these pictures were praised by critics for their verve and 'exquisite realism' (Johnson 1981–9, III, pp. 262 and 263); Théophile Gautier discussed them poetically and at length. The present picture is even less of an arrangement than the two Salon pictures; it is without setting, and there are no accessories, except a socle and a basket, against an ochre ground whose greenish and reddish tones echo the dominant notes of the composition. It is not possible to identify the flowers in this artfully disordered bunch, where Delacroix has subordinated details to the overall effect. The result is an explosion of light as well as of colour. Some, however, are recognisable – poppies, daisies, campion – an unusual collection, not the select cultivars of seventeenth- and eighteenth-century flower painters. Perhaps they were found in a cottage garden running wild. They would seem to be June flowers, and if Lee Johnson is right when he suggests that they are later than the more formal and contrived Salon pictures (Johnson 1981–9, III, p. 265), then it is tempting to quote this entry from Delacroix's diary for 24 June 1849: 'In the afternoon I went into the wood, through the gate on the marquis's side: I hadn't seen this side since last year. It suddenly occurred to me to pick a bunch of flowers, which I did, through the thicket, at great cost to my fingers and clothes, which I scratched on the thorns. The walk seemed exquisite. The heat, which had been oppressive and stormy in the morning, had entirely changed character, and the sun gave everything a cheerfulness which I used not to feel at sunset. As I grow older, I am less susceptible to the more than melancholy feelings nature used at one time to give me; I congratulated myself on it as I walked along.'

LW

M. Panis (R Ann.); Charles Delaroche; sold by him to the museum, July 1895. Inv. 533.

Robaut 1885 (R Ann.); Johnson 1981–9, III, p. 265, no. 504 (with full bibliography), IV, pl. 301; Yokohama etc. 1991–2, p. 159, no. 19, ill. p. 36; Scottez-De Wambrechies 1992, p. 79.

Jean-François de Troy
1679–1757

46 Rinaldo and Armida

Oil on canvas, 53.8 x 76.6 cm

A frequently depicted subject in seventeenth- and eighteenth-century European art, the story of Rinaldo and Armida is contained in Tasso's *Gerusalemma Liberata* (XIV, 65–7), an epic poem first published by its author in 1581, and translated into French in 1595. In Tasso's story, Armida plans to kill the Christian warrior Rinaldo in his sleep, but as she is about to strike the mortal blow, she falls in love with him instead. A fresh translation of Tasso's poem (by J.P. Mirabaud) was published in 1724 and may have provided the immediate impetus for a painting of this subject. De Troy's rendition, however, was close to the story as expressed in Quinault's tragedy, *Armide*, first published in 1686 and republished in 1715. Here, as Armida realises that her love for Rinaldo has aborted her mission, she calls to the surrounding demons: 'transform yourselves into kindly Zephyrs . . . hide my weakness and my shame in the most distant wilderness; fly, take us to the end of the universe.' (*Le Théâtre de Monsieur Quinault,* Paris 1739, II, V, pp. 432–3). The river Orantes, on whose banks Rinaldo slept, is personified by the figure at the bottom right, while at the left is a nymph, presumably one of those whose song lulled Rinaldo to sleep.

The present work is a sketch for the finished painting (now lost), itself exhibited at the 1725 Salon and measuring more than a metre high by nearly two metres wide. This was bought by Henri-Camille, marquis de Béringhen (1693–1770), then Premier Ecuyer to Louis XV, who, it seems, commissioned Jean Restout to paint another Armida subject as a pendant some time before 1736.

The group of Rinaldo and Armida is composed as a triangle, the two sides of which are accentuated by the line of the nymph's body at the left and that of the oar held by the river god at the right. De Troy often repeated his figures, and nymphs similar to the ones in this painting, but facing the other way, are to be found in his *Pan and Syrinx* of 1720 (Cleveland Museum of Art), and his *Diana surprised by Actaeon* of 1734 (Basle, Kunstmuseum). The figure of Armida is like that of Iphigenia in de Troy's *Sacrifice of Iphigenia*, exhibited at the 1725 Salon (fig. 70), and a half nude female in a jewelled turban was also the central figure in de Troy's reception piece of 1708 for the Académie, *Niobe and her Children slain by Apollo's and Diana's Arrows* (Montpellier, Musée Fabre).

Oustretched arms were used by Antoine Coypel for the figure of Armida in his painting of *Rinaldo and Armida* executed by 1707 and now known only through an engraving (see Garnier 1989, pp. 160–1). A river god and a nymph looking on also appear in Coypel's painting, and it can be assumed that de Troy was familiar with it or with the engraving.

An autograph sketch similar to the present work is in a British private collection.

HW

Acquired on the Paris art market 1970. Inv. 1860.

Brière 1930, 2, pp. 6, 45, no. 12; Brussels 1975, no. 30; Dunkerque etc. 1980, no. 71; Albuquerque 1980, pp. 36–7.

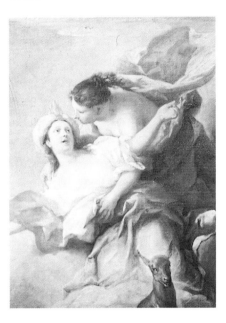

Fig. 70 Jean-François de Troy, *Sacrifice of Iphigenia*, detail, 1725. Oil on canvas, 81 x 101 cm. Potsdam, Schloss Sanssouci.

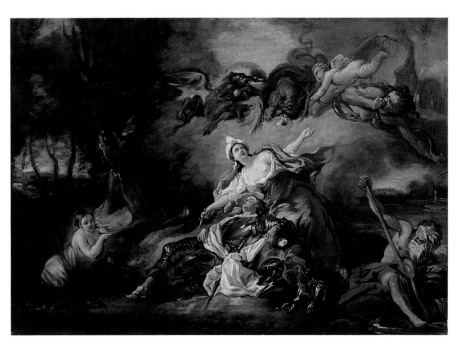

Louis-Joseph Donvé
1760–1802

47 Piat-Joseph Sauvage

Oil on canvas, 116 x 89.3 cm
Inscribed on the cartouche on top of the
original frame: Donvé 1786

The sitter is the painter Piat-Joseph
Sauvage (1744–1818) who became a
member of the Lille academy in 1776
and of the Académie Royale of Paris
in 1783. He specialised in painting
fictive bas-reliefs in grisaille. It is this
fact that doubtless explains Donvé's
conceit of portraying Sauvage
dressed entirely in white. But both
Donvé, who had studied under
Greuze in Paris after initial training
in Lille, and his judges at the Lille
academy, to whom this painting was
submitted as a reception piece,
would probably have been aware of
the enormous success of J.-B.
Oudry's *White Duck* (private col-
lection). The *White Duck,* which was
probably returned to France from
abroad in 1784 (Fort Worth 1983,
p. 211) had been exhibited at the
1753 Salon to illustrate a point
Oudry had made in his lecture to the
Académie in 1749. This was that
there were different sorts of white –
as could be demonstrated by juxta-
posing a silver vase, linen, paper,
satin, and porcelain (see Paris
1982–3, pp. 269–70). Donvé at-
tempted a similar exercise in painting
the different whites of satin, linen,
lace and of Sauvage's wig.

The vertical position of the palette
– surely not a usual means of holding
a flat surface on which more or less
liquid substances are placed – can
possibly be explained by the meta-
phorical implications of the
arrangement of the colours on it.
Although it was usual to place white
near the thumb-hole, by showing it
at the bottom of the palette, Donvé
perhaps expresses the idea that white
pigment is both fundamental and, by
artful mixture, can be superseded by
other colours. The pigments of
Sauvage's palette have been de-
scribed (see Schmid 1958), but to
date there has been no technical
analysis to see whether they
correspond to any of those used by
Donvé in this portrait.

HW

The artist's reception piece at the Lille
academy in 1786; transferred to the
museum in 1803. Inv. 339.

Calais etc. 1975–6, no. 27 (with extensive
bibliography).

Jean-Germain Drouais
1763–1788

48 and 49 Compositional studies for 'Marius at Minturnae'

48 Pen and black ink, grey wash and graphite, on paper, 18.4 x 25.6 cm
49 Pen and brown ink, grey wash over graphite and black chalk, on paper, 15.4 x 20.7 cm
Inscribed in ink by J.-L. David: ne changez rien/Voilà le bon

Both drawings are studies for Drouais's painting of *Marius at Minturnae* (fig. 71), executed in Rome in 1786 and exhibited to considerable acclaim at the home of the artist's mother in Paris early in 1787. The evolution of this work shows the explicit influence of David on his pupil. The subject is from Plutarch's *Life of Marius*, according to which, after defeating the Cimbrians, Caius Marius (157–86 BC) fled Rome. Captured and condemned to death, a Cimbrian soldier was sent to kill him, but fled when confronted by Marius exclaiming in a dreadful voice from the darkness of his room: 'Man, durst thou kill Caius Marius?' The subject had been painted by David's rival, Peyron, who had been *agréé* in 1783 at the Académie on showing the work (now known only through a drawing in Madrid, Biblioteca Nacional). A devoted pupil and disciple of David, Drouais wrote to his master in October 1786: 'We apparently have the same antipathy for [Peyron's] person as for his merit', and it seems likely that Drouais's *Marius* was deliberately composed as an 'answer' to that of Peyron.

The composition, extreme in its bipolarity, in its movement parallel to the picture plane, and in the dramatic gestures of the figures, was worked out in the early study (No. 48), of which a replica, probably autograph, is in the Musée des Arts Décoratifs, Lyon. The soldier's pose and the general relationship between the two figures here were possibly inspired by a drawing of the same subject by David to which Drouais had access (Ramade 1988, p. 366 and fig. 36). The principal differences between this study and the painting are in the accessories. In the painting, Marius' military status is shown by the addition of the helmet on the table; but the fact that that status is a thing of the past is indicated both by the helmet's marginalisation in the picture, and

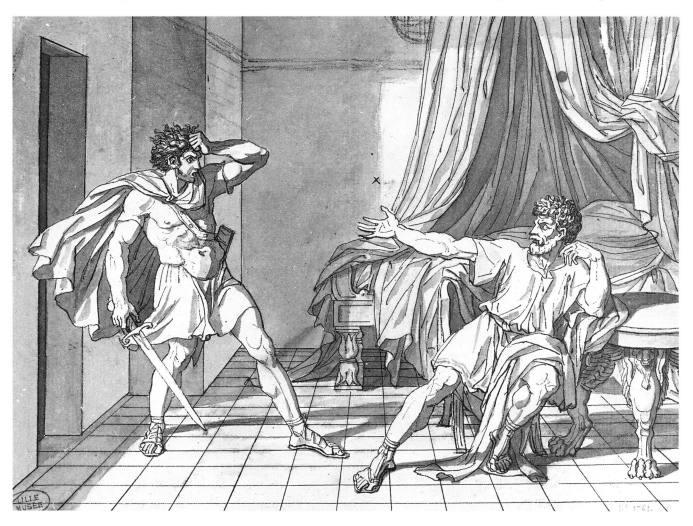

125

by the removal of the hero's sandals.

In the other drawing (No. 49) the Cimbrian soldier's cloak and the table on which Marius leans correspond closely to the painting. Once folded in four, it was probably sent to David in Paris, who wrote on the drawing: 'Change nothing, that is as it should be.' It was probably David who corrected in ink the soldier's drapery and outlined at left the simple table as more appropriate to Marius' status as prisoner. These corrections are incorporated into another composition study at Lille (Inv. Pl. 1324; fig. 24, p. 33). The heavy carved legs of the bed in the back-ground of the earlier study were, however, retained in the final painting.

HW

Both purchased from M. Smith in 1876. Inv. Pl. 1322 and 1323.

Rome 1981–2, pp. 198, 203; Lille 1983, nos. 66 and 67 (with bibliography p. 91); Rennes 1985, nos. 12 and 13; Ramade 1988; Montauban 1989, no. 21.

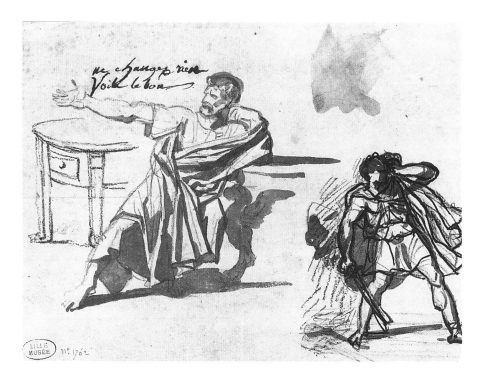

Fig. 71 Jean-Germain Drouais, *Marius at Minturnae,* 1786. Oil on canvas, 271 x 365 cm. Paris, Musée du Louvre.

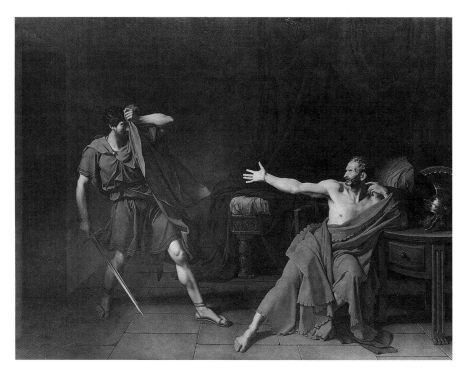

Constant Dutilleux
1807–1865

50 Meadow in the Forest of Fontainebleau

Oil on canvas, 46 x 36.5 cm

Constant Dutilleux was born in Douai. He soon abandoned his law studies, and his brother-in-law, Félix Robaut, taught him to draw. He arrived in Paris in May 1826, aged nineteen. Here he attended Louis Hersent's studio and then the famous Académie Suisse. He also studied in the Louvre, where he copied many Dutch and Flemish masters. When he left Paris for good in 1830 he went to live in Arras, where he founded the Société Artésienne des Amis des Arts in 1859, which was to become one of the most active provincial artistic societies. He also set up a studio which trained many young artists.

In Paris he had assimilated the intense and provocative work of the young Delacroix – an artist whom he admired as the absolute master of modern painting, and who was later to become his friend. Though Dutilleux initially exhibited many portraits, he was particularly interested in the subject matter and technique of the Barbizon School, and from 1850 visted the forest of Fontainebleau several times. Here he formed important friendships with Rousseau, d'Aligny, Millet, Antoine-Louis Barye and Paul Huet.

Dutilleux met Corot in 1848. Corot became one of his dearest friends, regularly coming to relax and work in Arras or Douai, while Dutilleux travelled with Corot to Holland, Belgium and Dunkerque. Corot inspired Dutilleux with his freshness of vision and Dutilleux – whose son-in-law ran a printing business – helped to develop Corot's interest in printmaking, especially *cliché-verre* (a 'quasi-photographic' technique). Dutilleux admired Corot without reserve, even wondering whether he was not superior to Delacroix.

Paradoxically, for a provincial artist with a mostly classical technique, Dutilleux participated in the celebrated Salon des Refusés of 1863. His vision of landscape painting is neatly encapsulated in a letter of 1835 to one of his favourite pupils and first biographer, Gustave Colin: 'The fall of a yellowed leaf softly carried by the wind and the cries of a flight of sparrows behind a bush made me pity the Old Masters and all their teaching . . . Line! But is this what engrosses me, is this what I see? All contours are blunted, lost, sunk, entangled. Colour! But it isn't there to be seen. There is neither yellow, red, blue, green, grey, or white – what there is is air and light . . .' (Colin 1866).

The present work, painted in the forest of Fontainebleau, typifies all the best aspects of Dutilleux's work in this genre, and perfectly illustrates the thoughts expressed in his letter.

VP

Bought 16 January 1974 from Mlle Courmont, a descendant of the artist. Inv. 1885.

Hippolyte Flandrin
1809–1864

51 **The Scattering of the Peoples**

Oil on cardboard, 48 x 60 cm
Signed and dated lower right:
H. Flandrin 1861

With the extensive programme of
building and renovating churches in
the early years of the Restoration,
Ingres's pupils, including Chassériau,
Amaury-Duval, Henri Lehmann and
Mottez, were successful in obtaining
commissions to decorate chapels in
Paris, as well as in the provinces.

Hippolyte Flandrin, perhaps Ingres's
most exemplary and favourite pupil,
combined a flourishing practice in
portrait painting with a career
otherwise devoted to church deco-
ration, beginning with the chapel of
St-Jean, at St-Séverin in Paris. He
used a mixture of wax and pigment
which had a matt appearance, like
medieval fresco, but was resistant to
damp. Flandrin had fewer archaic
mannerisms than his fellow pupils;
his admiration for early art reveals
itself only in an austere simplicity
and severe drapery. But he was to
criticise the Nazarenes for not
always drawing from life, and his
commitment to nature, learned from
Ingres, and reinforced in Rome by
his study of Raphael and antique

sculpture, tempered his taste for the
primitive. Flandrin, unusually, dec-
orated not only chapels but entire
churches, causing him to be popu-
larly thought of as a latter-day Fra
Angelico. In 1848, he began work in
St-Vincent-de-Paul (near the Gare du
Nord in Paris) on possibly his best
work – a double processional frieze,
recalling Giotto, Ravenna, and
antique sculpture.

The commission to decorate the
interior of St-Germain-des-Prés, also
in Paris, which occupied him inter-
mittently from 1842 until his death
in 1864, probably came to him
initially through his friend the sculp-
tor Edouard Gatteaux, a fellow pupil
in Ingres's studio, who was a mem-
ber of the Conseil Municipal. Later

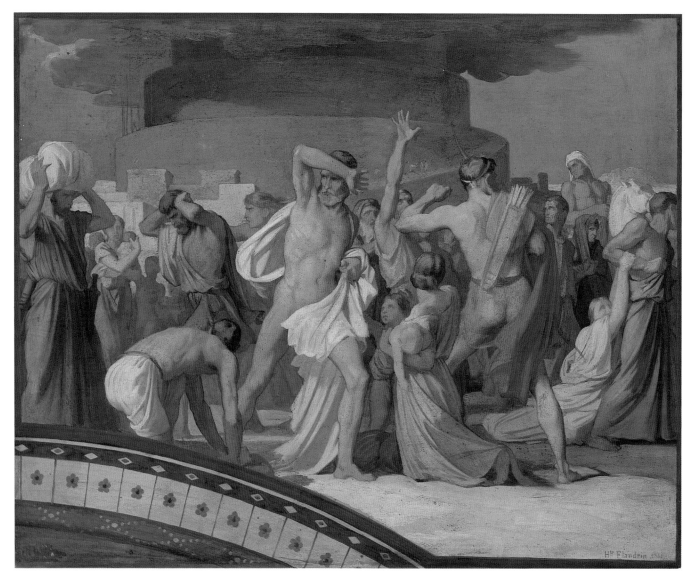

commissions for other parts of the programme were perhaps due to the intervention of Victor Baltard, the architect, who had been a Rome prize-winner at the same time as Flandrin, and was put in charge of the restoration in 1843. Flandrin collaborated with the polychromatic decorator Alexandre Denuelle, part of whose scheme can be seen in the bottom left of this composition.

The decoration of the nave, which is comparable in concept with early Italian cycles, takes the form of a narrative of events from the life of Christ, juxtaposed with parallels from the Old Testament in a programme worked out by two Jesuits, Père Cahier and Père Martin (Paris, Lyon, 1984–5, p. 131). *The Scattering of the Peoples*, from the story of the Tower of Babel (Genesis 11: 1–9), sums up all that Flandrin owed to Ingres and to Rome. The shallow crowded space and dramatically posed figures recall Ingres's painting of *The Martyrdom of Saint Symphorien* of 1834 (Autun Cathedral), which Flandrin loyally admired. It has also been compared with David's *Intervention of the Sabine Women* (No. 37, fig. 66), a work which itself derives from Raphael's *Massacre of the Innocents*. The two central male figures may be based on the *Dioscuri* of the Piazza del Quirinale in Rome. The mother and child to the left come from Raphael's *Miracle at Bolsena*, the simplest and perhaps most explicit of his Vatican decorations, demonstrating the working of grace on an unbelieving priest. As we know from Flandrin's letters from Rome, it was a work he particularly admired (Delaborde 1865, p. 188, no. 1). The present painting is a modello, slightly simplified in the final fresco, which accompanies *Christ's Mission to the Apostles*, on the right-hand wall of the nave.

LW

Bought at the posthumous sale of the artist, Paris, 15–17 May 1895, no. 15. Inv. 453.

Paris, Lyon 1984–5, p. 150, no. 73 (with full bibliography), ill.

Hippolyte Flandrin
1809–1864

52 Drapery study

Black chalk on lilac paper, 27.5 x 15.5 cm
Inscribed lower left: aout 1859

This full-length figure study, squared for transfer, is almost certainly for Saint John, who in Flandrin's mural of the Crucifixion at St-Germain-des-Prés, in Paris, stands to the right of the Cross. The pose is close, although the position of the arms differs from the final version, and the date, August 1859, inscribed below, corresponds with the time when Flandrin finished this part of the cycle. There is a comparable figure on the right in *The Crossing of the Red Sea* in the same church, but the present drawing is closer to the Saint John, and the arc, faintly indicated on the right, suggests the arch which divides *The Crucifixion* from *The Sacrifice of Isaac*.

The markedly vertical lines of the drapery and the clear contours are characteristic of Flandrin, as are a faintly impersonal quality and an attention to pose and gesture rather than to physiognomy, which remind us of his interest in early Christian art – though the drapery has at the same time a depth and richness learned from Raphael and the Antique. The shading is drawn with unemphatic cross-hatching; the spacious reserves of blank paper possess a simple eloquence. Only the upraised elbow (a favourite gesture), the increased pressure of the chalk along the profile and the eye, and the pressure of left palm on right hand, combine to suggest agony of mind.

Louis Lamothe, a former pupil of Flandrin who frequently collaborated with him, reused this figure of Saint John in a squared drawing for a Crucifixion scene (see Aubrun 1983, ill. 34), perhaps the picture which he sent to the Salon of 1859 (present whereabouts unknown). Through Lamothe, this assured but reticent technique of drawing passed to his own pupil, Edgar Degas, who inherited, at several removes, the mastery of drawing which was characteristic of Ingres's school.

LW

Gift of Mme veuve Hippolyte Flandrin. Inv. Pl. 1352.

Paris, Lyon 1984–5, p. 143 (as possibly *The Crossing of the Dead Sea* or *The Ascension*).

François-Louis Français
1814–1897

53 **View at Frascati**

Pen and wash with touches of gouache, on white paper, 22 x 28.8 cm
Signed lower right: Français
Inscribed lower left: Frascati 1848

On his arrival in Paris in 1828, Français became a clerk in a book shop, then a caricaturist, before entering Jean Gigoux's studio in 1834, where he learnt the art of landscape painting. From 1835 he put this teaching into practice in the forest of Fontainebleau, alongside d'Aligny, Corot and Rousseau. He also became friends with Narcisse Diaz de la Peña, Auguste Anastasi and Louis Cabat, who were all members of the Barbizon School.

Français exhibited at every Salon between 1836 and 1897, and, following in the footsteps of Corot, whom he admired greatly, he made three trips to Italy: between 1846 and 1848 he visited Genoa, Pisa, Florence and Rome, and returned twice more – in 1858–9 and in 1865–6.

This drawing of Frascati, made in 1848, is highly polished and carefully composed, and reveals the artist's skill as a colourist and painter of light.

VP

Given by the artist 1865. Inv. Pl. 1368.

Yokohama, etc. 1991–2, p. 179, no. 69.

Louis Gauffier *1762–1801*

54 **The Monastery of Santa Scolastica at Subiaco**

Oil on paper mounted on canvas, 18.5 x 24.5 cm

The practice of sketching with oils in the open air was already established in the seventeenth century. We know that François Desportes worked out of doors: 'he took into the country-side his brushes and a loaded palette in metal boxes; he had a stick with a long pointed steel tip to hold it firmly in the ground, and fitted into the head was a small frame of the

same metal, to which he added the portfolio and paper.' (Quoted in Cambridge, London 1980–1, p. 17.)

This view of an Italian hillside, painted lightly on paper which has been laid on to canvas at a later date, probably follows Desportes's method. Studies of this kind are notoriously difficult to ascribe to any particular artist; this one, however, was attributed to Louis Gauffier in 1969, by Albert Châtelet. Gauffier won the Prix de Rome in 1784, and thereafter spent most of his short life in Italy. He left Rome for Florence in 1793, after the execution of Louis XVI provoked reprisals against the French, and most of his landscapes are associated with this later period. The best known are probably some beautiful views of Vallombrosa, four of which were owned by his friend François-Xavier Fabre (Cavina 1987,

pp. 591–603). Gauffier was already admired as a landscape artist before he left Rome, however, as a letter from Conrad Gessner to his father indicates (quoted by Cavina in Paris 1989, p. 296). Dr Cavina has kindly confirmed that the present painting is a view of the monastery of Santa Scolastica at Subiaco, seen from the valley of the Aniene, and she dates it to Gauffier's period in Rome, that is before 1793. He was at that time in contact with a number of artists interested in landscape, including Fabre, Nicolas-Didier Boguet, and Jean-Joseph Xavier Bidauld (Paris 1974–5, p. 426). Bidauld himself worked at Subiaco, which is some twenty miles to the east of Rome, and the place continued to be particularly popular with landscape artists well into the nineteenth century.

Although more precise in his notation and more obviously interested in a view than either Thomas Jones or Valenciennes, whose *plein-air* studies he may have known, Gauffier shared with them a responsiveness to the pleasing effects of light on the simple geometry of Italian buildings.

LW

Collection Rouzé-Huet; bought from Emile Hornez in 1898. Inv. 600.

Hazebrouck 1956, no. 32 (as nineteenth-century French school); Cavina and Galbi 1992, p. 32.

Théodore Géricault
1791–1824

55 The Race of the Riderless Horses

Oil on paper, mounted on canvas,
45 x 60 cm

Géricault, who had a lifelong passion for horses, chose as his first master the horse painter Carle Vernet, from whom he moved on to the studio of Pierre-Narcisse Guérin, where Delacroix and Ary Scheffer were later to be students. He had always a classical sense of form, but at this stage was already looking for an alternative to a purely Davidian style, by studying the art of Rubens and by making copies of Old Master paintings at the Louvre. Although he did not win the Prix de Rome (and later spoke disparagingly about the excessively long terms of residence in Italy), he went to Florence, and on to Rome in 1816, where he spent two years. He responded eagerly to the excitement of life in Rome, as well as to the works of Michelangelo and Raphael, which were to determine his pictorial language thereafter; indeed, Raphael's *Entombment* (Rome, Villa Borghese) is one of the more unexpected sources for the variant of the present composition in the Musée des Beaux-Arts in Rouen.

Among his friends in Rome were several artists working on small picturesque genre subjects, which were eminently saleable, and Géricault described himself as 'working for albums' (Eitner 1983, p. 102). The race of the riderless horses was the picturesque subject most likely to attract Géricault, as it did his friend Bartolomeo Pinelli only very slightly later (fig. 72). It was an event which took place in mid-February, at the end of the Roman carnival; Barberi horses, as they were called, of small and stocky breed, were released in the Piazza del Popolo, and galloped along the Corso to the Piazza di Venezia. Géricault made numerous drawings and paintings of the subject, perhaps with a large-scale composition in mind. They range from documentary naturalism to classical abstraction. All the oil studies are, like this one, on oiled paper, so that Géricault could trace over preliminary studies,

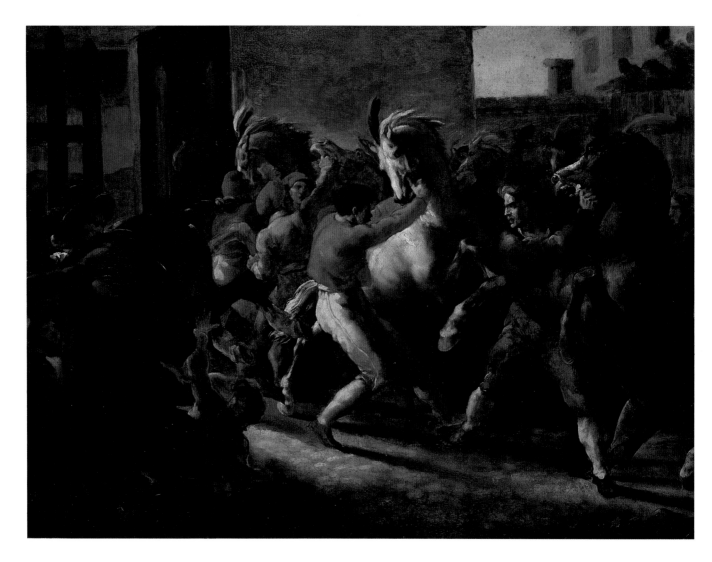

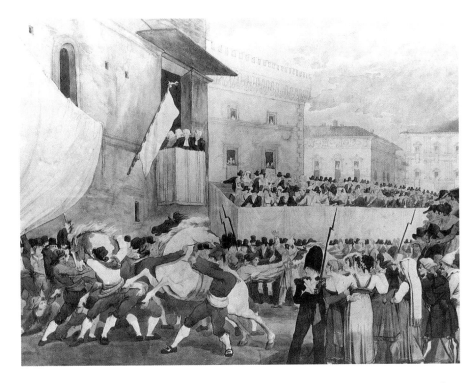

Fig. 72 Bartolomeo Pinelli, *Ripresa dei barberi* (The Capture of the Barberi Horses), 1818. Watercolour, 42 x 54 cm. Museo di Roma.

and could reverse sections at will. The appearance and dress of the figures, who wear the characteristic red cap of the Roman countryside, are the accessories of the picturesque draughtsman – as we can see from Pinelli's picture; but the poses recall a variety of sculptural sources, most obviously the *Dioscuri* of the Piazza del Quirinale in Rome, and Guillaume Coustou's *Marly Horses* at the entrance to the Champs-Elysées in Paris. The whole has something of the quality of an Attic frieze, of a kind certainly known to Géricault through prints. The underdrawing here, still visible, shows the figures unclothed, as they are in two related drawings, one at Truro (Royal Institution) and the other in Stockholm (Nationalmuseum). The latter, wild and dramatic, matches the present work very closely. This tumultuous scene, suggesting panic, where spectators are trampled underfoot while others flee in horror, has sometimes been thought to represent the capture of the horses at the end of the race. However, as Lorenz Eitner has pointed out, 'some vaguely indicated scaffolding on the left and a hint of draped stands on the right indicate that this disorder is meant to

represent an episode at the start of the race.' (Eitner 1983, p. 123.) By this stage, in any case, Géricault had already transformed the subject into a stylised version. The next transformation was probably the oil painting at Rouen, an abstract vignette of a single motif. In the drawings which apparently follow, Géricault departed from the wilful confusion of the present picture in the pursuit of compositional order and symmetry, then, as if regretting the loss, returned in the last version (Paris, Louvre), to something of its brio. In Eitner's words: 'The picture at Lille, too little noticed, is a milestone in his work, and in French art of the period.' (Eitner 1983, p. 245.)

LW

Possibly included in the posthumous inventory of the artist's collection under no. 81 as 'huit tableaux esquisses dont six représentant des courses de Rome'; possibly no. 13, posthumous sale of the contents of the artist's studio, Paris, Hôtel Bullion, 2–3 Nov. 1824; possibly sold Paris, 11–12 March 1846, no. 10; Mme Maracci; bequeathed to the museum 1901. Inv. 475.

Paris 1991–2, p. 360, no. 116, ill.; New York 1992, no. 36 (with full bibliography); Scottez-De Wambrechies 1992, p.77, ill.

Théodore Géricault
1791–1824

56 Study for 'The Raft of the Medusa'

Pen and brown ink on paper, 21 x 26.8 cm
Erased inscription upper left
Verso: Study of a Horse

The Raft of the Medusa (fig. 73) is one of the most familiar of all modern-life subjects of the nineteenth century, and Géricault has often been seen as the artist who most dramatically broke with the stoic Neo-Classicism of David, making possible the development of a whole generation of young Romantic artists. Nevertheless, the painting, begun just after the artist's return from Italy, clearly speaks of its debt to antique sculpture and to the heroism of Michelangelo's nude figures. Other less familiar sources,

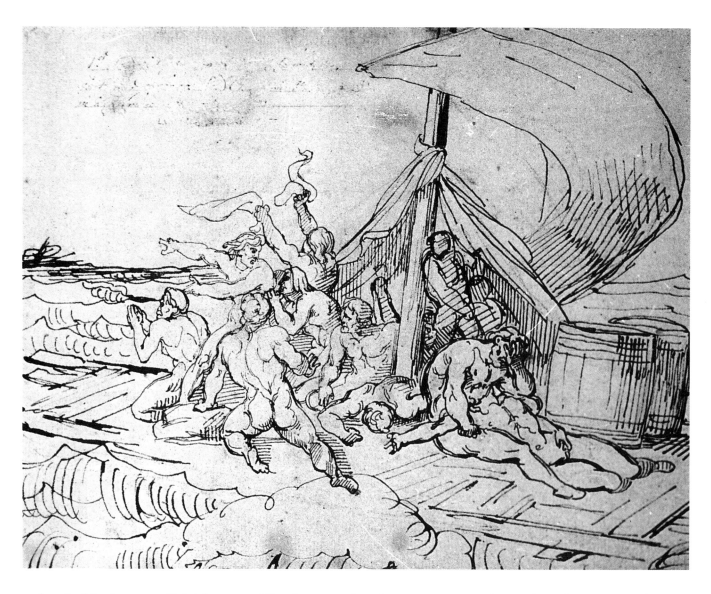

such as Lethière's master, Gabriel-François Doyen, and Rubens – particularly the latter's *Fall of the Rebel Angels* (Munich, Alte Pinakothek) – contribute formal qualities and deposit a range of literary references which impart a quality of universal significance to be found in the final composition.

Géricault brought the work to its conclusion by the slow, and, to him, painful process of making sketches and studies, balancing his borrowed sources with studies from life, from groups of little wax figures, and of severed limbs. The result, however, was at the opposite pole from Meissonier's reportage (see No. 75); the final effect of the *Medusa* is that of an emblem.

The picture was based on a recently published firsthand account of a shipwreck, told by two survivors, the surgeon Savigny and the naval engineer Corréard. The government frigate *La Méduse*, leading a convoy carrying soldiers and settlers to the colony of Senegal, ran aground on 2 July 1816 off the coast of West Africa, through the incompetence of the captain. There were only six lifeboats, which were taken over by the captain and senior officers. The remaining crew and passengers, about 150 people, were consigned to a hastily made raft which the men in the boats at first towed, but later detached by cutting the cables. Géricault's preparatory studies show that he considered

taking as his subject several of the dramatic incidents recounted – mutiny, cannibalism, the hailing of the boat which finally rescued them. The incident depicted here, which Géricault used in the final painting, occurred in the morning of 17 July; Captain Dupont had sighted a ship on the horizon: 'We did all we could to make ourselves observed, we piled up our casks at the top of which we fixed handkerchiefs of different colours. Unfortunately, in spite of all these signals, the brig disappeared. From the delirium of joy, we passed to that of dejection and grief.'

There is a slightly earlier sketch for *The Sighting* at Rouen (Musée des Beaux-Arts), but the man pointing to the *Argus* here is new, and the group

134

of father and son are incorporated for the first time, though they appear upside down and separately in the Rouen drawing. The present drawing is seen in reverse, a device Géricault frequently used to establish his final composition.

LW

Collection Julien Boilly; his sale, Paris, 19–20 March 1869, lot 118. Bought by the museum. Inv. Pl. 1391 *recto*.

Paris 1991–2, p. 381, no. 197 (with full bibliography), ill. 236.

57 Study for 'The Raft of the Medusa'

Pen and brown ink wash on paper, 17.6 x 24.5 cm
Inscribed lower left in graphite: Pl. 1392
1748
Verso: Study of a Male Nude; Two studies of Lions

The idea for this figure group first appears in a study illustrating an incident of cannibalism which occurred on the raft of *The Medusa*, and assumed increasing importance during the preparatory studies for the work until finally it became the point of departure for the whole composition, forever countering the gesture of hope with a note of tragedy.

At this stage, the orientation of the figures matches the final composition (fig. 73), and Géricault presumably drew it at about the same time as a pen and wash drawing at the museum in Rouen (Eitner 1983, p. 171, fig. 160), in which the composition is first articulated into distinct groups, as we can faintly discern in the pencilled grouping which appears to the left of the figures in this drawing.

Although there is no basis for the incident in the survivors' account of the shipwreck, this group has been known as *The Father with his Dead Son* from the first appearance of the picture. It may be based on a somewhat excessively pathetic account in the narrative, describing the death of a twelve-year-old boy on the fifth day at sea: 'He expired in the arms of Mr Coudin, who had not ceased to show him the kindest

attention.' The strong note of elegiac sentiment accompanying the long description of the death finds an echo in this mourning group. The bounding outline and summary wash, suggesting only the main areas of light and shade, give it a generalised character very different from Géricault's more naturalistic life studies, and reminiscent of his terracotta sculpture. Early critics noticed the group's resemblance to familiar representations of Count Ugolino and his sons (who were starved to death in a tower): those by Joshua Reynolds (known through an engraving), John Flaxman and Fuseli, for example (Nicolson 1954, pp. 241–5). This association may have been exploited by Géricault (who also made a drawing of Ugolino, now in the Musée Bonnat at Bayonne, inv. 2056, N.I. 735), as sufficient reference to the incident of cannibalism.

LW

Camille Marcille collection; his sale, Paris, Hôtel Drouot, 6–9 March 1876, second sale 8–9 March, no. 78; sold to M. de L'aage; an annotated catalogue bears the price '2.020', 'bought by the town', according to Pluchart. Inv. Pl. 1392 *recto*.

Paris 1991–2, p. 383, no. 201 (with full bibliography), ill. 257.

Fig. 73 Théodore Géricault, *The Raft of the Medusa*, 1819. Oil on canvas, 491 x 716 cm. Paris, Musée du Louvre.

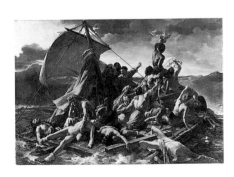

Théodore Géricault
1791–1824

58 Battle Scene

Graphite, watercolour and gouache on
white paper, 26.5 x 37.9 cm
Inscribed by Lehoux in ink, lower left: le no
154 du catalogue de Mr Clément; lower
right: Gericault. (Lhx)

Géricault often took his inspiration
from minor artists, particularly
during his second visit to England in
1820–1, though it is already evident
in his earlier work. *The Race of the
Riderless Horses* (see No. 55)
transformed a picturesque episode
associated with Pinelli and the genre
painters; *The Derby at Epsom* (Paris,
Louvre) recalls the work of Henry
Alken; a second-rate composition by
Ben Marshall, *A Farmer with Horse*

and Cart, dated 1809 (Upton House,
Bearstead collection), must have
been the source for the unforgettable
frontispiece to the set of London
lithographs of 1821; while the
present watercolour, according to
Géricault's biographer, Charles
Clément, was based on George
Jones's 'Panorama of Waterloo'
(Clément 1879, p. 362, no. 154).
Captain Jones painted a number of
large versions of the battle, which as
a soldier he documented with the
utmost care. The versions belonging
to the National Museum of Wales
and to the Royal Military Hospital
in Chelsea contain no incident
resembling this watercolour. How-
ever, that in the Royal Collection
(fig. 74) has in the left foreground a
motif which could easily have been
the one which Géricault has freely
rendered from memory. The picture
shows the final defeat of the French.

In Jones's composition, the horse-
man is an English officer of hussars,
mounted on a white horse. Géricault
depicted instead an English dragoon
mounted on a black horse, and
added an unhorsed French cuirassier.
This second figure probably derives
from an earlier, more classical image
of nude warriors on horseback
(Bayonne, Musée Bonnat, inv. no.
2025, N.I. 704; illustrated in
Grunchec 1982, p. 74), and is a
typical fusion of antique art and
scenes of contemporary life.

We do not know when Jones
began his picture (for a discussion of
the versions and exhibition history,
see Millar 1969, pp. 57–8, and also
Harrington 1989, pp. 239–52).
However, Sir Thomas Lawrence,
whose portrait of George IV was
soon to hang between Jones's two
battle pieces of Waterloo and
Vittoria in the Throne Room at

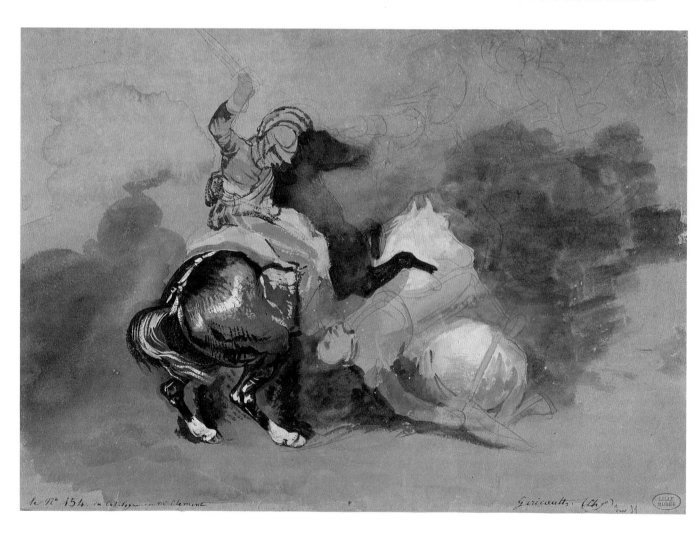

St James's Palace, may have taken Géricault to see the picture in Jones's studio. Lawrence admired the French artist, collected his drawings and befriended him while he was in London.

Suzanne Lodge has suggested that the Lille watercolour may have formed part of a series for a planned battle picture (Lodge 1965, p. 626; also London, Cambridge etc. 1974–5, no. 44). If this is the case, it may be possible to relate it to a comparable work signed and dated 1822, in a Swiss private collection, which Philippe Grunchec rightly associates with an oil painting in the Wallace Collection (*A Cavalry Skirmish*; Grunchec 1982, p. 174).

LW

Gift of M. Lehoux, 1883. Inv. Pl. 1394.

Yokohama etc. 1991–2, p. 177, no. 62 (with full bibliography), ill. p. 81.

Fig. 74 George Jones, *Battle of Waterloo*, detail. Oil on canvas, 238.1 x 321.3 cm. Royal Collection.

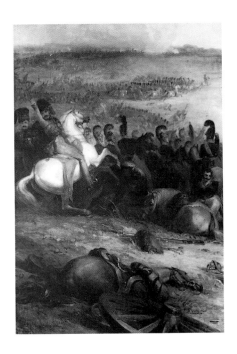

Anne–Louis Girodet
1767–1824

59 The Fight with the Harpies

Graphite on white paper, 21.1 x 36.6 cm (a strip added to the left side of the sheet)

Girodet was one of the chief illustrators of the works of Virgil published in 1798 by Didot Frères. He was a passionate admirer of ancient literature and resolved to illustrate the *Aeneid*, not merely with a plate for the opening of each book but with illustrations fully integrated throughout the text. We do not know whether it was a plan of Girodet's or of his friend Firmin Didot – but it must have been prompted by the great success of John Flaxman's line engravings of Homer. Work was well advanced in 1811. When Girodet died, 172 out of the 200 illustrations proposed had been completed – 72 of these were published as lithographs in 1827 and 17 are now in the museum at Lille. This composition and No. 60 are among the most notable, although they were not included among those lithographed.

Book 3 of the *Aeneid* describes the many adventures of Aeneas and his companions after their departure from Troy. This drawing illustrates the long passage when they are attacked on the Strophades by the Harpies, mistresses of those islands. These huge, stinking, screeching birds descend from the hills grabbing some of their food and polluting the remainder. The Trojans re-lay their tables and re-light their altars beneath rocks protected by trees lest the birds ambush them again. Commanded by Aeneas to fight the Harpies, they conceal weapons in the grass and charge when the birds reappear, slashing at them but failing to wound them. The birds soar away unharmed by the attack.

As in other illustrations for this series, Girodet condensed the episode, placing the scene on the shore site of the first attack by the Harpies, although the fight took place in the shade of the rocks. The strip of paper added to the left of the sheet indicates either that Girodet had not at first planned so broad a composition or that he was unhappy with his first ideas for this part of it.

The composition evokes that of *The Oath of the Seven Leaders before Thebes* (Paris, Ecole des Beaux-Arts). In disposing his warriors around a central space the artist divides their action in pairs and elaborates this choreography by the arabesque-like motion of their limbs. In a strange ballet, cinematographic in spirit, but cunningly adapted to the fantastic subject, the actions of the combatants are unifed with an abstract elegance of line, and the heroism of the subject matter becomes one with the dexterity of the draughtsman.

AS

Collections Antoine-Claude Pannetier (pupil and friend of the artist), De La Bordes Cafter (1859), and of the Firmin Didot family (after 1867); sold Paris, Hôtel Drouot, 17 Nov. 1971 (no. 32); acquired for Lille. Inv. W. 3486.

Boucher 1930, p. 309; Lille 1983, pp. 120–1, no. 90 (with full bibliography); Rome 1984, pp. 97–8, no. 89.

Anne-Louis Girodet
1767–1824

60 Hercules killing Cacus

Graphite on white paper, 11.7 x 18 cm
Inscribed in pencil upper edge to right:
LIB. VIII. 6

The story of Hercules and Cacus is recounted in Book 8 of the *Aeneid* by King Evander to whom Aeneas has appealed for help against Turnus. The monstrous Cacus, son of Vulcan, steals the bulls awarded to Hercules after his victory over Geryon. Hercules, furious, finds a way into Cacus' cave, hurls rocks at him, and when Cacus, belching smoke, sets the cave on fire he seizes

him, ties him in a knot and makes him choke.

For a discussion of Girodet's illustrations of Virgil's *Aeneid* see No. 59. As with No. 59, the present drawing was not among the illustrations lithographed. It may be that Girodet projected a painting on this theme and indeed Perignon listed an 'esquisse vigoureuse de ton et d'effet' of this very subject (Perignon 1825, p. 17, no. 60).

The episode had attracted many artists in the eighteenth century but both François Le Moyne and Nicholas Cochin had given it a picturesque landscape setting, while here the fight is closer to that in a Roman marble relief (Montfaucon 1719, III, ii, p. 292, pl. CLXVII). The violence, the knotted figures, the sinuous muscles and the flowing contour, remind us of the great admiration which Girodet felt for Michaelangelo, but also call to mind the heroic manner of the Danish sculptor Bertel Thorvaldsen, whose treatment of this theme, dated 1805, is in the Thorvaldsen Museum, while the forceful presentation and powerful contour endow the composition with a visionary character reminiscent of William Blake or Fuseli.

AS

Provenance as No. 59, no. 77 in sale of 1971. Inv. W. 3492

Boucher 1930, p. 309; Lille 1983, pp. 126–7, no. 96 (with full bibliography); Rome 1984, p. 102, no. 95.

LIB.VIII. 8.

59

60

Jean-Baptiste Greuze
1725–1805

61 The Ungrateful Son

Brush, brown and grey ink wash, over graphite, on white paper, 32 x 42 cm

62 The Punished Son

Brush, brown and grey ink wash, over graphite, on white paper, 32 x 42 cm

In the 1760s Greuze executed pendant drawings both of contrasting subjects, for example *The Death of a Father mourned by his Children* and *The Death of Cruel Father abandoned by his Children*, and of consequential ones, for example *The Departure for the Wet Nurse* and *The Return from the Wet Nurse*. The pendant drawings exhibited here, which were probably exhibited at the 1765 Salon, fall into the latter category and are concerned with the moment of choice in the first drawing and its consequences in the second.

In this pair the choice is made by the young man who in the first drawing, heedless of his father's pleading, leaves his family to join the army. In the second drawing the son is shown returning home just as his father has died, and having, as the critic Diderot noted at the time, lost the leg which he had used to push away his mother in the first drawing.

Thus, the son's physical loss is compounded by his emotional loss, since, unlike the prodigal son of the New Testament, he has lost his father and also the possibility of his forgiveness. This unalleviated misery was too much for the critic Mathon de la Tour, who advised Greuze never to execute paintings of these scenes: 'One suffers too much on seeing them. They poison the soul with a feeling so profound and so terrible, that one is forced to avert one's eyes.' (Mathon de la Tour, *Troisième Lettre à Monsieur ****,* Paris 1765, p.13.) This was possibly a commonplace reaction since in his

review of the Salon of 1765 Diderot declared that, 'taste is so wretched, so small-[minded] that perhaps these two sketches will never be painted, and . . . if they are painted, Boucher will be more likely to have sold fifty of his indecent and insipid puppets, than Greuze his two sublime paintings.'

Notwithstanding this advice Greuze painted both subjects in 1777–8 as *The Father's Curse: The Ungrateful Son* and *The Father's Curse: The Punished Son* (figs. 75 and 76). In the latter the main differences between drawing and painting are the addition in the painting of the boy kneeling in the foreground, the elimination of the visible sources of light, and the restoration of the son's left leg. As Munhall has pointed out, these changes and the elimination of other anecdotal details create a total effect like a classical history painting (Hartford etc. 1976–7, p. 178).

The differences between drawing and painting of *The Ungrateful Son* are more radical: the father's begging has become a curse and the son's disdainful gesture one of horror. Additionally, the composition has been reversed. Given the usual left-to-right reading of Western art, it is the father who in the painting is given the role of confirming the family tragedy even if it was the son who precipitated it.

Both drawings are more finished than necessary for compositional drawings and were executed with a view to being exhibited, thus increasing Greuze's exposure to the public and to critical comment, and operating as 'trailers' for the paintings to come.

HW

Fig. 75 Jean-Baptiste Greuze, *The Father's Curse: The Ungrateful Son*, 1777–8. Oil on canvas, 130 x 162 cm. Paris, Musée du Louvre.

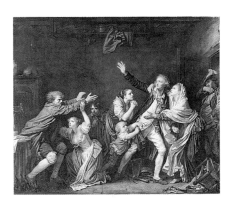

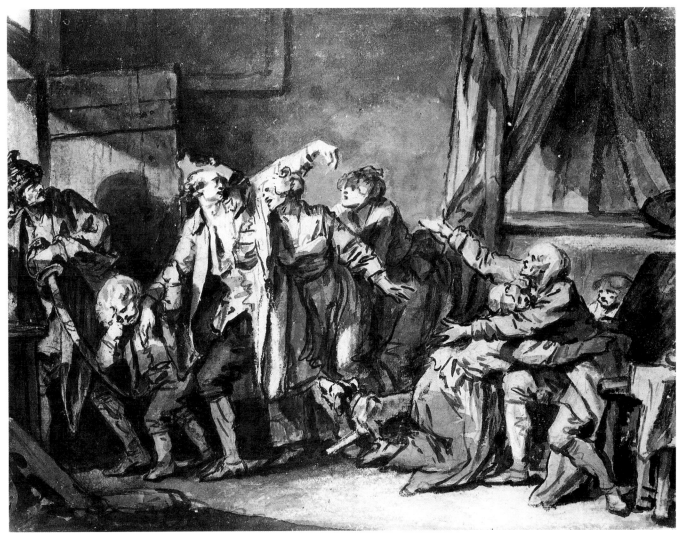

Fig. 76 Jean-Baptiste Greuze, *The Father's Curse: The Punished Son*, 1777–8. Oil on canvas, 130 x 163 cm. Paris, Musée du Louvre.

Fig. 76 Jean-Baptiste Greuze, *The Father's Curse: The Punished Son*, 1777–8. Oil on canvas, 130 x 163 cm. Paris, Musée du Louvre.

Marquis de Laborde sale, Paris, 16 May 1783, nos. 40 and 41, sold to Dulac and to Paillet respectively; Houtelart, Lille; given by him to the museum, 1864. Inv. Pl. 1430 and 1431.

Salon de 1765, nos. 124 and 125?; Paris 1984–5, nos. 66 and 67 (with extensive bibliography), also pp. 110–21, English translation in *Oxford Art Journal*, 1985, vol. 8, no. 2, pp. 36–51; Cologne 1987, no. 136 (*The Punished Son*).

Jean-Baptiste Greuze
1725–1805

63 Psyche crowning Love

Oil on canvas, 147 x 180 cm

Apuleius' story of Cupid and Psyche had been a frequent source for artists since the Renaissance and remained so into the early nineteenth century. Among French painters contemporary with Greuze who had, or would subsequently, use the story were Fragonard, Prud'hon and J.-L. David. Greuze's painting is curious, however, for its abandonment of Apuleius' text, which nowhere refers to Psyche crowning Cupid; anymore

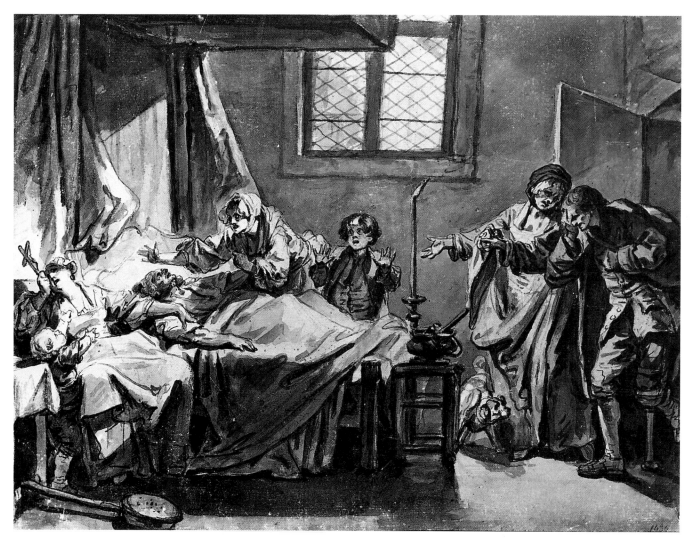

than did La Fontaine's *Les Amours de Psyché et du Cupidon* (1669). According to Apuleius, Cupid fell in love with Psyche whose beauty had aroused the furious jealousy of Cupid's mother, the goddess Venus. Venus, who had enlisted Cupid's help to gain her revenge, only became reconciled to the match at the very end of the story when Psyche was immortalised, enabling Psyche to be married to Cupid amid feasting, singing and dancing. In Greuze's painting, Venus' statue (the celebrated *Venus de' Medici*) appears in the niche, presiding over Psyche crowning her lover. Greuze therefore imagined this as he did the figure of Modesty at the right, and conflated the story of Psyche and Cupid with the then frequently depicted scene of the lover being crowned. For Apuleius' festive and overtly sensual scene, Greuze has substituted a languidly erotic tableau in which the viewer is invited to participate as a voyeur: Psyche's costume has been designed to reveal her breasts, and the figure of Modesty in attempting to veil Psyche succeeds only in revealing herself.

The absence of early documentation or of universally accepted related drawings makes the dating of the painting uncertain. (Greuze's authorship of a compositional drawing at Lille (fig. 77) is a matter of debate.) Suggested dates range from 1785 to the 1790s. The planarity of the composition recalls Greuze's *Septimius Severus reproaching Caracalla* exhibited at the 1769 Salon (Paris, Louvre), as do the motifs of the drapery behind the principal figures and the goat's feet of the stool. The principal motif of the lover being crowned was the subject of another of Greuze's paintings, *The Votive Offering to Cupid* of 1767 (London, Wallace Collection). The relative positioning of the figures is strongly reminiscent of Joseph-Marie Vien's *La Marchande d'Amours*, exhibited at the 1763 Salon (Fontainebleau, Château), and it was also Vien in the same year who included a piece of furniture called an *athénienne*, like that at the right of Greuze's picture,

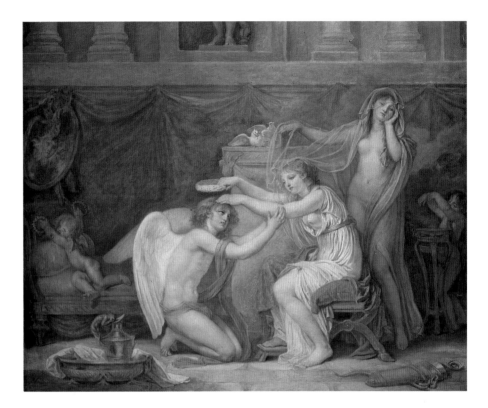

in a painting known as *The Virtuous Athenian* (Strasbourg, Musée des Beaux-Arts), which was engraved by Flipart in 1765. Yet the attenuation of the figures and their insipid characterisation suggest a work of the late 1780s.

A related oil sketch (38 x 46 cm), known to the author only from a photograph and belonging to the Musée Borély, is presently deposited with the Musée des Beaux-Arts, Marseille (inv. no. 68–270). The viewing point of the figures is slightly more distant in the painting than in the sketch, which shows (indistinctly) only the feet and ankles of the *Venus de' Medici*. There is no information to indicate when the sketch was executed.

HW

Fig. 77 Jean-Baptiste Greuze (?), *Study for 'Psyche crowning Love'*. Chalk, pen and brown ink, grey and brown wash on yellowed paper, 30.3 x 25.7 cm. Lille, Musée des Beaux-Arts (Inv. 1682 c).

Anne-Geneviève (called Caroline) Greuze sale, Paris, 25–6 Jan. 1843, lot 1; Meffre sale, Paris, 25–6 Nov. 1845, lot 33; comte de Mornay sale, Paris, 24 May 1852, lot 8; Alexandre Leleux by whom bequeathed 1873. Inv. 389.

London 1972, no. 121; Lille 1974, no. 28; Moscow, Leningrad 1978–9, no. 36; Lille 1983, p. 136; Paris etc. 1991–2, no. 65 (with extensive bibliography); New York 1992, no. 27; Munhall, *catalogue raisonné* of J.-B. Greuze in preparation.

Henri Harpignies
1819–1916

64 Landscape with a Pool

Oil on canvas, 46.5 x 61.5 cm
Signed and dated lower left:
H. Harpignies 83

Harpignies, who was a follower of Corot and the Barbizon School, had a long and prolific career. His aesthetic and thematic vision of landscape painting, the only genre he was to paint throughout his life, remained deeply pantheistic: 'everything for art, everything for beauty, everything for God's work, so good for those who love him.' He remained deeply inspired by the notion of *plein-air* painting as defined by Corot or Rousseau in the 1830s, and advised his pupils: 'to educate the eye. Examine nature under all conditions and love it like a mistress . . . and above all never be unfaithful to it.' He applied Rousseau's notion of pictorial realism, as well as recalling Valenciennes' strict teaching and his advice about the treatment of landscape painting, published in 1800: 'If your sky is good, your painting is already almost finished.' (*Mémoires d'Henri Harpignies*, quoted by Gosset 1982.)

Although Harpignies' style was exciting, it was based on a tradition already fifty years old, and was sometimes radically different from the art of the Impressionists, which he felt to be lacking in discipline, distinctness of form and in composition (as he warned E. Moreau-Nélaton in a letter of 26 October 1885). For him, drawing was always more important than colour.

The present work is a synthesis of his ideas: a classical spatial composition, organised around the vertical form of a solitary tree, which cuts the picture into two equal sections; a luminous sky, painted in light tones, which contrast with the dark tones of the earth; a landscape which is not chosen for its picturesque qualities, but because it emits a strangely poetic emptiness; and a passion for almost hyper-realist details.

VP

Given to the museum by M. Dierickx, 1892. Inv. 552.

Valenciennes 1970, no. 37; Gosset 1982, fig. 20; Gifu and Kamakura 1982–3, no. 26.

Jean-Auguste-Dominique-Ingres 1780–1867

65 The Apotheosis of Homer

Watercolour, heightened with white gouache, over graphite on tracing paper, 56.6 x 62 cm
Signed lower right: Ingres inv. et pinx. au Musée Charles X. Pencil annotations above lower edge of frame: Salamine, Rhodes, Athenes, Smyrne, Colophonte, Ios, Argos

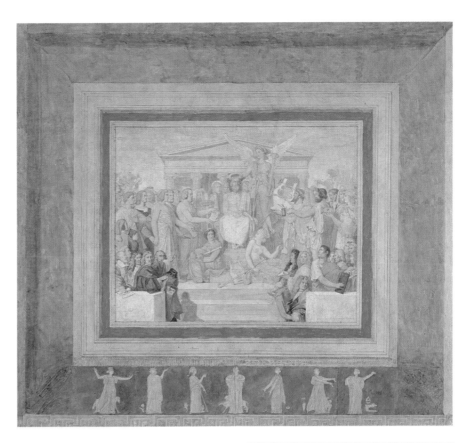

In 1826 the director of the Louvre, the comte de Forbin, commissioned eight artists to decorate a suite of new rooms, built to house the Greek and Egyptian collections. The decoration of the Musée Charles X, as it was called, was supervised by the architects Charles Percier and Pierre-François Fontaine. Forbin gave the Salle Clarac to Ingres, who took as his subject the Apotheosis of Homer, working on the canvas in his studio with his assistants. It was in place, though not entirely finished, by the end of 1827 (fig. 78).

The scene on the ceiling of the Salle Clarac, as in this small watercolour version, is one of an imaginary company of great men of the past gathering to pay tribute to Homer. The choice of the Immortals gathered round the throne contains a few figures who were in high favour in the 1820s: Dante, Shakespeare, Tasso and Camões. Ingres's own musical preferences led him to include Mozart and Gluck, otherwise the choice was unexceptionable. The Ancients, who are more numerous, have invited Dante, Raphael and Michelangelo to join them. Poussin and Molière, as affable hosts, invite us to contemplate the scene. Raphael, whose *Parnassus* (Rome, Vatican) provides the form of the present work, has a role in the picture second only to that of Homer, since Ingres, like Géricault, looked back to the sixteenth century for a style based simultaneously on nature and the Antique.

The traditional view of this watercolour as a modello for the 1827 composition has recently been questioned by several scholars who have dated it after 1840, when Ingres reworked the theme in preparation for an engraving (Louisville, Fort Worth 1983–4, no. 43; Montauban 1991, no. 41). However, the present version is extremely close to a wash drawing in the Louvre (R.F. 1447), though not traced from it. That drawing must predate the final composition of 1827, if only because the features of Boileau, Molière, Racine and Poussin have not yet been finally settled. The most striking differences between this watercolour and the final painting – Victory here holds a torch in her left hand, and the Odyssey (seated at Homer's feet) is unclothed and turns gracefully back towards Homer in the attitude of Raphael's Erato in the *Parnassus* – can be connected with a number of preparatory life drawings in the Musée Ingres at Montauban which are self-evidently studies for the ceiling.

In his final version, Ingres inclined towards a dignified, static ideal based on antique sculpture rather than to the lively grace of the

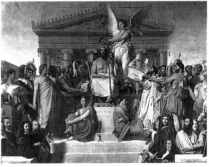

Fig. 78 J.A.D. Ingres, *The Apotheosis of Homer*, ceiling of the Salle Clarac, 1827. Oil on canvas, 386 x 515 cm. Paris, Musée du Louvre.

Parnassus which is still evident in this watercolour. Here, the collage of allegorical figures representing the seven towns each claiming to be Homer's birthplace has been added to an existing blue ground; the figures differ somewhat from those now in the Salle Clarac, where the background for the figures is a shade of Pompeian red rather than blue. The alternative schemes of moulding

indicated here and the wash line of shading indicating the recession of the ceiling, all suggest that this was not in fact a reworking, but an early, finished study – perhaps the 'dessin arrêté', which Ingres mentioned in a letter to his friend Gilibert in February 1827 (quoted by Ternois, Paris 1967–8, no. 142).

LW

Benvignat collection; bought from Francis Petit, 1867. Inv. Pl. 1480.

Yokohama etc. 1991–2, p. 178, no. 66 (with full bibliography), ill. p.85.

Ingres with a starting point for his own type of Madonna, with eyes cast down in contemplation.

The present sheet of drapery studies, perhaps arranged on a lay figure, is usually associated with the first version of *The Virgin of the Host*, commissioned by the future Tsar Alexander II when he was in Rome in 1841 (Moscow, Pushkin Museum). However, the pose is close to a study now in the Fogg Art Museum for an early version of *The Vow of Louis XIII*, a painting commissioned by the Minister of the Interior in 1820 for Montauban Cathedral and received with enormous acclaim at the Salon of 1824. The early version, an oil sketch known as the Cambon version (Montauban, Musée Ingres),

shows the Virgin standing, hands clasped to the right of her head, looking down towards her left.

Momméja's list of the huge collection at the museum at Montauban mentions fourteen studies for the Cambon version, of which four are for the headdress, four for the left arm, and one a sketch of a Virgin and Child. Momméja, however, does not list any drapery studies for *The Virgin of the Host* (Momméja 1905). The evidence therefore suggests that the sheet of drapery studies at Lille was, in all likelihood, made for *The Vow of Louis XIII*, which cost Ingres unusual trouble in the preparatory stages.

The inscription on this sheet, which appears to read 'Voile

Jean-Auguste-Dominique Ingres *1780–1867*

66 Drapery study

Graphite on laid paper, graphite framing, 38 x 32 cm
Abbreviated signature lower right: Ing.
Inscribed at the top: Voile(?) changeant

Ingres's lifelong cult of Raphael began long before he entered David's studio, when as a child he was enchanted by a copy of the *Madonna della Sedia* (Florence, Pitti Palace), a composition which appears like a leitmotif in several of his early works. In 1817 he made a copy, which he dedicated to the Italian composer Cherubini, of *The Madonna of the Candelabra*, then in the Villa Borghese in Rome, and attributed to Raphael, and this was to be the source of his own numerous variations on the theme. This picture, now in the Walters Art Gallery in Baltimore, where it is attributed in the catalogue to Raphael and his workshop, has probably been cut down. The Virgin appears to be looking abstractedly to her left, where once she looked down, perhaps at Saint John, and thus by accident the picture provided

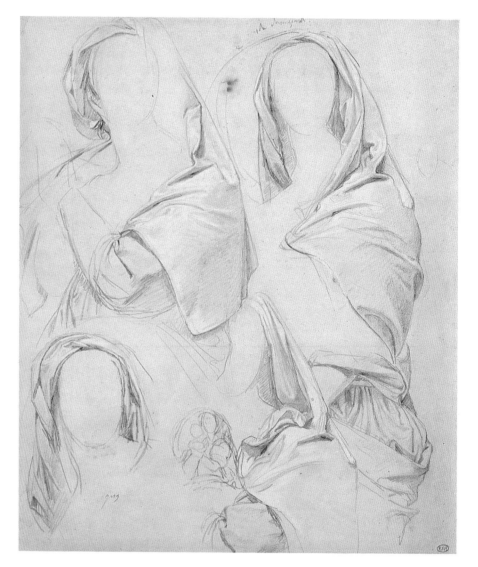

changeant', aptly describes the purpose of these variations of the drapery and the veil, which Ingres has combined on the page with characteristic elegance. The version in the left corner, where the clasped hands would interrupt any elaborate drapery, shows a braided arrangement of the veil rather like that of the *Madonna della Sedia*, or even Ingres's own *Grande Odalisque* (Paris, Louvre). Ingres continues with an elaboration of the fall on the right, culminating in a version where the veil returns to lie on the shoulder in an arrangement comparable with that of *The Virgin with a Blue Veil*, painted for the comte de Pastoret in 1822 (New York, Wildenstein collection). The tiny Madonna and Child which appears here is not related to the theme of the Virgin adoring the Host, and would also suggest an earlier dating, perhaps between the Cambon painted sketch and the final version of *The Vow of Louis XIII*.

LW

Gift of Edouard Gatteaux, 1866. Inv. Pl. 1481.

Gonse 1877, p. 84; London, Cambridge etc. 1974–5, no. 57, pl. 68.

Jean-Baptiste Jouvenet
1644–1717

67 Study of a Male Nude carrying a Vessel

Black chalk, heightened in white chalk on buff paper, squared up in black chalk, 39.7 x 23.7 cm
Verso: Study for an Assumption

At the end of the seventeenth century Jean Jouvenet was the leading religious painter in France. His major work was a series of four huge canvases – *The Miraculous Draught*

of Fishes, *The Resurrection of Lazarus*, *Christ driving the Money-Changers from the Temple*, and *The Feast in the House of Simon* – intended for the church of St-Martin-des-Champs in Paris. This drawing refers to one of these, the first version of *The Feast in the House of*

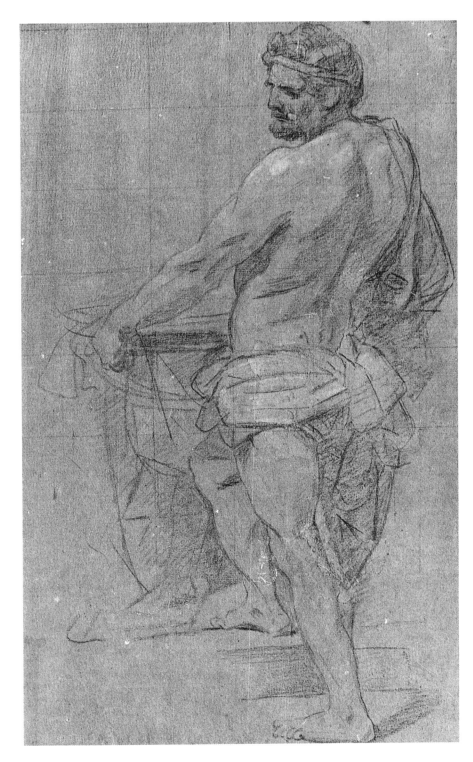

Simon, now in the church of Vervins in Aisne, and is for the servant on the extreme right of that composition. The final version for St-Martin-des-Champs was completed in 1706 (Schnapper 1974, no. 117, fig. 120). It was also to be reproduced as a Gobelins tapestry, for

which Jouvenet produced a cartoon in 1711 (Arras, Musée des Beaux-Arts).

Many variations were made between the Lille drawing and the final composition: in the painting, the left foot is no longer parallel to the picture plane, but is at an angle of forty-five degrees, and the left arm is nearer the body. The man is wearing breeches as well as drapery around his hips, and the position of his head is very different – facing in the opposite direction with the features no longer visible. In a study of the same figure in the museum at Alençon the pose is closer to the artist's final version, indicating a later date than the Lille drawing (Schnapper 1974, no. 176, fig. 124).

This beautiful life-drawing is a rare example of a preparatory figure study for a painting by Jouvenet. The energy in the execution and the importance given to the play of light and shade contribute to the power of the figure. Jouvenet's vigorous technique, using black chalk heightened with white chalk, stems from the tradition of Simon Vouet and Charles Le Brun, which was in turn indebted to the Bolognese academic tradition founded by the Carracci.

On the *verso*, the artist has drawn in black chalk an initial idea apparently for an *Assumption of the Virgin*. However, the only *Assumption* by Jouvenet known at present has a very different composition (private collection; Schnapper 1974, no.140, fig. 159).

SR

Chennevières Collection; bequeathed by Dr Trachet June 1949. Inv. W. 3164.

Rouen 1966, no. 17; Schnapper 1974, no. 175; London, Cambridge etc. 1974–5, no. 60.

Nicolas Lancret 1690–1743

68 Studies of Seated Figures

Red and white chalk on buff paper, 21.7 x 31.1 cm

Seated side by side, a woman and a man observe each other. They are placed against a neutral background and in the centre of the picture their arms and hands are unfinished. However, the space between the man's arms, and particularly the position of the fingers on his left hand, suggest that he could be playing a tune on a theorbo. This would explain the expression of the young woman, who, with her hand at her breast in an emotive gesture, seems to be touched by the tune.

These two figures, even if considered separately, do not appear in any painting by Lancret, but they recall the couple in the background on the left of *The Little Mill in Front of the Arbour* (Collection Robert de Rothschild; reproduced Wildenstein 1924, fig. 35) and in *The Dance in a Pavilion* (Potsdam, Schloss Sanssouci; Wildenstein 1924, fig. 34). During his apprenticeship with Claude Gillot, around 1712, Lancret met Watteau who had a determining influence on him, notably in encouraging him to work always from nature. But, departing from Watteau's very synthetic style, Lancret expanded his own repertoire of effects, so that through the refinement of poses, the rendering of materials and the elongation of forms, he created his own poetic world. The artist appears to have been more concerned with the study of the play of light on the relief of fabrics, than on the accuracy with which he depicted the figures. In particular, the proportions of the man's legs and body are obviously drawn to different scales and do not fit together. On the other hand, a series of short, vigorous, sometimes very emphatic lines, alternating with white chalk scumbling, create the effect of materials shimmering in the light. These characteristics, together with the somewhat geometrical outlines, suggest a dating from the 1720s.

SR

Purchased in Paris in 1887. Inv. Pl. 1495.

London, Cambridge etc. 1974–5, no. 61.

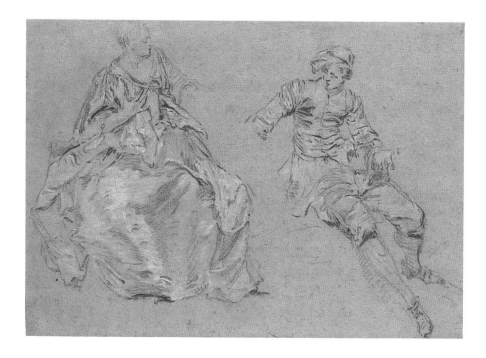

Albert Lebourg *1849–1928*

69 The Ile Lacroix at Rouen

Oil on canvas, 38.5 x 61 cm
Signed lower left: A. Lebourg Rouen

Albert Lebourg described his art as being definitively that of a follower of Impressionism: 'I am an Impressionist in the sense that I am impressed by the present moment.' He had learnt to 'draw and paint haphazardly, without any great principles . . . , from nature which I learnt to interpret and admire.'

Far from being simply an imitator, Albert Lebourg took an active part in the Impressionist movement. Although he spent the crucial years of 1872 to 1877 working as a drawing teacher in Algeria – where he found the North African light a revelation – and was therefore unable to work alongside Monet, Renoir and Sisley in Argenteuil, he did exhibit with the Impressionists in Paris in 1879 and again in 1880.

Lebourg's technique was permanently influenced by this experience and from 1879 until his death he 'followed impressionism', taking his landscape motifs from the countryside to the west of Paris (Chatou, Puteaux, etc.), from the Auvergne, which he called his 'second home', and, particularly, from the area around his native Rouen, finding that he was best able to interpret the luminosity and colours of the Seine valley. Far from being revolutionary, Lebourg's oeuvre is clearly in the Impressionist tradition and he was one of its most productive heirs.

VP

Bought 23 May 1935 at the sale of Paul Engrand. Inv. 1706.

L. Bénédite 1922; Vergnet-Ruiz and Laclotte 1962, p. 242.

Jean-Jules Antoine Lecomte du Noüy
1842–1923

70 Invocation to Neptune

Oil on panel, 39 x 31 cm
Signed and dated lower left: Lecomte-Dunouy 1866

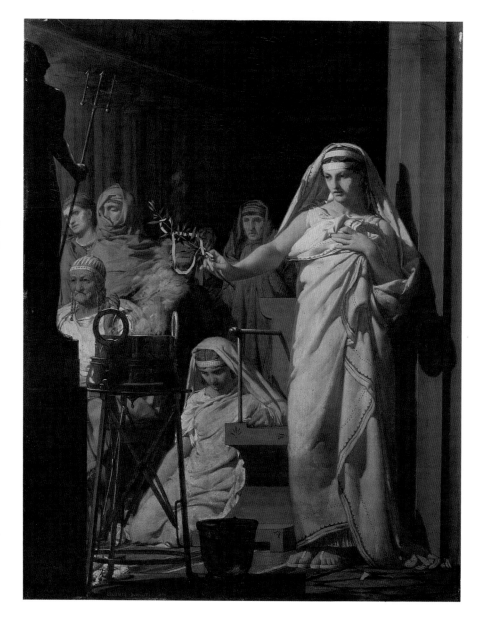

Invocation to Neptune is a reworking, in antique terms, of the theme of the Vow to the Madonna, which was particularly popular in the nineteenth century among artists who travelled to Italy and recorded picturesque customs. The artist was a pupil of Charles Gleyre, who was an important influence on the development of the neo-Greek taste in painting which was favoured in the early years of the Second Empire by the pupils of Paul Delaroche (whose studio Gleyre took over). Lecomte du Noüy later moved on to work with Gérôme, the chief exponent of the cult, whom he admired as the inventor of an entirely new form of historic genre painting, which combined erudition with a highly polished, precious style. At Gérôme's suggestion, the young artist accompanied the painter Félix-Auguste Clément to Egypt. This journey, coloured by Théophile Gautier's *Roman de la Momie*, provided him with a rich vein of future subject matter (see Richon 1985, pp. 34–44). While he was in Egypt, he began work on this picture, which is based on an ancient prayer to Poseidon for safety at sea, one of a group of poems known conventionally as the 'Homeric Hymns'. Gautier, who saw this small refined work at the Salon of 1866, responded, not surprisingly, to its strongly literary character: 'There is nothing to equal the mysterious solemnity of this antique scene. The statue of Poseidon, in the stiff style of Aegina, is seen from the back, trident in hand, and occupies the foreground, so that we are facing the family who is sacrificing to the god in order that he will look kindly on the absent one, exposed to the perils of the sea. A young woman, clad in long white draperies, her hair held with a band, holds out a branch, and in calm but fervent attitude pronounces the sacramental words. Further back, an old woman in a cap decorated with strange designs seems to be repeating the words of the hymn. One is the wife, the other is probably the mother of the traveller; other members of the family, young people already growing up, are also beseeching help. Monsieur Lecomte-Dunouy has a rare, deep feeling for the Antique. Although the small size of *The Sacrifice to Neptune* will mean that it will escape the attention of the crowd, it is nevertheless one of the most serious and elevated works at the Salon.' (Gautier 1866.)

LW

Bought at the Exposition des Beaux-Arts, Lille, 1866. Inv. 678.

Montgailhard 1906, p. 16; Gautier 1866.

Jean-Jules Antoine Lecomte du Noüy
1842–1923

71 Portrait of Mlle E.T.

Oil on canvas, 116 x 89.5 cm
Signed and dated upper left: Lecomte du Nouy 1869, and signed again lower centre right

When Lecomte du Noüy exhibited this picture at the Paris Salon of 1869, it was described as being a portrait of 'Mademoiselle E.T.'. However, as du Noüy's biographer, Guy de Montgailhard, lists it in his catalogue as 'Madame Eglantine Pujol', it was perhaps an engagement portrait. If so, it would appear that neither sitter nor fiancé can have been entirely pleased, since it remained in the artist's possession until he presented it to the museum in 1874. Critics discussing the portraits at the Salon of 1869 were particularly enthusiastic about Alexandre Cabanel's *Portrait of Madame C.*, Paul Baudry's portrait of the fashionable and successful architect Charles Garnier (both Versailles), and, above all, Carolus-Duran's portrait of his wife, entitled *The Lady with the Glove* (Paris, Musée d'Orsay). *Mlle E.T.* seems to have escaped critical attention, although the painting did win a medal.

The style is somewhere between Ingres and Gérôme: du Noüy being clearly an admirer of one, and was a pupil of the other. The ponderous stillness of the pose, the boneless hands, the economy of palette (it is a muted version of the colouring of Ingres's standing portrait of Madame Moitessier in the National Gallery of Art, Washington), and the scrupulous rendering of a few chosen accessories, are all indebted to Ingres, but the artist does not impose an elegance of his own; instead the work possesses a self-sufficient photographic singularity, which is more like the work of Gérôme. The fan and flowers, like those in Carolus-Duran's *Kiss*, are hallmarks of the *mondaine* genre subject, the 'going out' motif associated with Alfred Stevens. Ingres was perhaps the first painter to perceive the potential of this theme.

Lecomte du Noüy was not in general a painter of portraits, until late in life at the court of Queen Elizabeth of Romania, a vivacious blue stocking, when he painted several pictures of the queen in which he flatteringly depicted some of her many talents. Among his other recorded sitters is Marcel Proust's father, whom he painted in 1882. However, the connection here was a family one by marriage. Their mutual relation, Madame Marthe Peigné-Crémieux, translated *The Stones of Venice* in 1916, thus briefly reviving Proust's interest in Ruskin.

LW

Gift of the artist, 1874. Inv. 989.

Montgailhard 1906, catalogue (as Madame Eglantine Pujol).

Henri Lehmann 1814–1882

72 Le Repos

Oil on panel, 23.6 x 31.7 cm
Signed and dated lower left:
1864 H. Lehmann

When Henri Lehmann exhibited the first version of this picture (now at Béziers, Musée des Beaux-Arts), at the Salon of 1864, he was returning to the kind of Italian genre subject popularised by Victor Schnetz and Léopold Robert in the 1820s, and subsequently practised by countless painters travelling in Italy. Lehmann himself, while a young man in Rome, had painted an immensely successful picture in this vein, *Mariuccia* (private collection), which was acclaimed at the Salon of 1842. The picture at Béziers, however, painted some twenty years later, is an evocation rather than a recording of Italy. According to Léon Lagrange, the figures were modelled on two of the wandering Italians frequently seen on the embankment of the Seine, playing pipes in courtyards, or posing for artists, in picturesque rags. William Bouguereau specialised in exactly this kind of picturesque genre, with immense commercial success, and like Lehmann brought to his subjects a pensive languor, perhaps derived from the religious themes in which both artists specialised.

Lehmann, who was a pupil of Ingres, not surprisingly showed a classical taste for drapery, but added a liking for rich, saturated colour and a distinctively tactile character, which he brought with him to France from his native Germany. After he was appointed professor at the Ecole des Beaux-Arts in 1875, he felt strongly that he should be represented in the Luxembourg by a work of his maturity and wrote to the government to request the purchase of *Le Repos* (Paris 1983, pp. 147–8). The state bought the picture from him in 1876 and it was transferred to Béziers in 1934. The popularity of the picture is attested by an inscription on the *verso* of the present work: 'M.H. Lehmann réduction no. 2. du 1er envoi', indicating that the artist made at least two smaller versions of *Le Repos*, of which the picture at Lille is one.

LW

Bequeathed by Alexandre Leleux in 1873. Inv. 601.

Lille 1974, p. 59, no. 39.

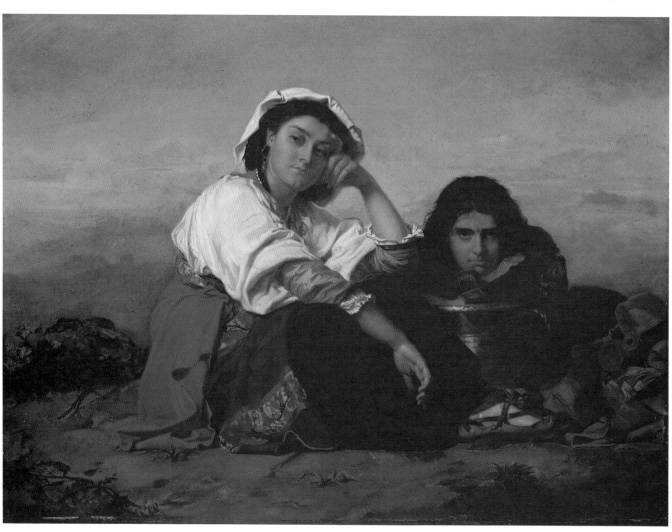

Stanislas Lépine *1835–1892*

73 Brie-sur-Marne

Oil on canvas, 38.5 x 60.5 cm
Signed lower right: S. Lépine

Stanislas Lépine was fortunate to work in a period when Corot's influence dominated landscape painting. He learned a great deal from Corot, whom he met in St-Lô, and presented himself as his pupil at the 1866 Salon. His work was also profoundly influenced by his friendship with Eugène Boudin and Johann-Barthold Jongkind – whom he knew through their mutual patron, Count Doria, and whose paintings did so much to help stimulate the original development of the Impressionist movement in the 1870s.

In 1880 Lépine was again working in Corot's style, preoccupied with the problems of light and colour. He had exhibited at the first Impressionist exhibition in Paris a few years earlier in 1874, aligning himself at an early stage with this revolution in landscape painting. But his pictures only received public recognition after 1884, when he was officially commended for his contribution to the Salon.

Lépine's work is sensitive and delicate as can be seen by the Lille canvas, which was painted in 1873 (according to Durand-Ruel's label on the reverse). At that time he lived in Montmartre, but also painted regularly in the Ile-de-France. Lépine's first significant canvases date from this period, though he had been painting since 1857.

VP

Zygomalas Collection, Marseilles; Zygomalas sale, Paris (Georges Petit), 1903; Given to the museum by Denise Masson, 5 July 1979. Inv. 1943.

Couper 1969; Marcq-en-Baroeul 1983, no. 81.

Lethière *1760–1832*
(Guillaume Guillon)

74 Oil sketch for 'The Death of Virginia'

Oil on paper mounted on canvas, 40 x 61 cm

This sketch relates to one of a series of four large paintings in which Lethière planned to illustrate examples of Roman virtue. Only *The Death of Virginia* and its companion *Brutus* were completed (both Paris, Louvre). The subject comes from the early history of the Roman Republic. Appius Claudius, a decemvir, laid claim to the daughter of Virginius by declaring that she was not free-born, but the slave of his client Claudius. To save the honour of his daughter, Virginius snatched a knife from a nearby butcher's stall, killed her, and after withdrawing the knife laid a curse on Appius Claudius. The incident led to the end of the rule of the decemvirs.

As Annie Scottez has noted, the subject was painted by a number of artists from the mid-eighteenth century onwards, including Lethière's master, Gabriel-François Doyen. Nathaniel Dance was one of the first to focus on the father's savage sense of honour, inspired, as Peter Walch has pointed out, by Hubert-François Gravelot's frontispiece to the second volume of Charles Rollin's *Histoire Romaine* (1730–8), which was probably also Doyen's source (Walch 1967, pp. 123–6). Earlier artists who treated this theme generally took the death itself as their subject. Rollin's account, based on Livy's history of Rome, repeatedly stressed paradigms of antique morality and heroism, which is the aspect Lethière chose to depict.

He sent a drawing of the subject to the Salon of 1795 (fig. 79) and thirty-six years later, at the Salon of 1831, exhibited the version now in the Louvre, which differs surprisingly little in its composition from the 1795 drawing. Perhaps the

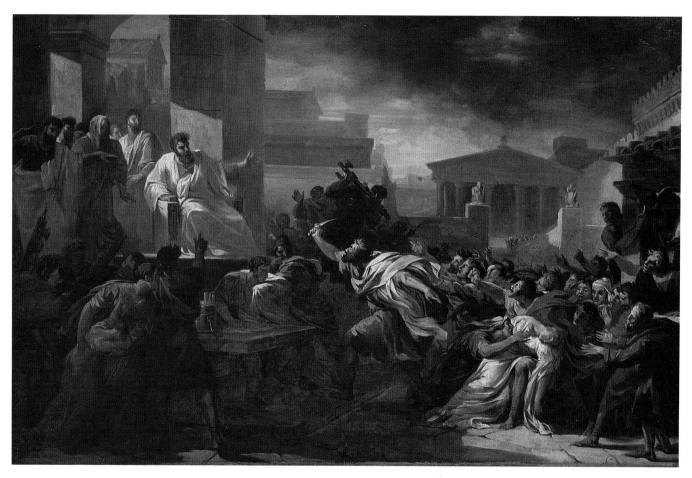

austere example of David discouraged Lethière from developing the almost operatic intensity of the sketch in Lille, which owes much to Doyen's rich painterly handling and must represent an early stage in his development of the theme. All others, including a sketch in the Musée des Beaux-Arts at Orléans, show Appius Claudius standing, thus losing the *enchaînement* of highlighted figures, from Virginia through to the already alarmed figure of Appius Claudius, while the threatening faces and gestures of the people form a chorus presaging his downfall.

Vittorio Alfieri, who, like Rollin, admired the heroic gestures of antiquity, published his *Virginia*, based on Livy's account, in Paris in 1788. It has been suggested that the play might have been the source for Vincenzo Camuccini's enormous canvas (Naples, Capodimonte), which, like Lethière's version, owes something to Doyen's picture of

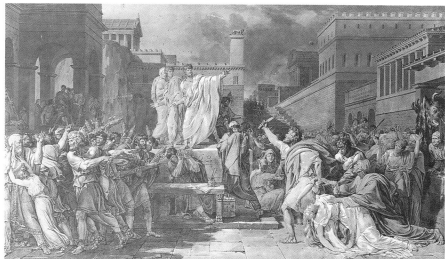

1759. (Parma, Galleria Nazionale). Camuccini's picture, which was completed in 1804, during the period when Lethière was director of the French Academy in Rome, may have encouraged Lethière to return to his own composition.
LW

Fig. 79 Lethière, *The Death of Virginia*, 1795. Pen and wash of brown ink, 54 x 98 cm. Musée de Pontoise.

Lethière sale; acquired from M. Benoit, 1879. Inv. 447.

Yokohama etc. 1991–2, no. 8 (with full bibliography), ill. p. 25.

Jean-Louis-Ernest Meissonier 1815–1891

75 Study for 'The Barricade'

Black chalk heightened with white chalk on blue paper faded to brown, mounted on beige paper, 13.5 x 19.5 cm
Signed lower right with a monogram

This drawing is one of a number of figure studies made for *The Barricade* (fig. 80), shown at the Salon of 1849, a scene from the so-called 'June Days' of 1848. During an armed insurrection against the new Republic, Meissonier participated in an attack on a barricade in the rue de l'Hôtel de Ville (then the rue de la Mortellerie). He first recorded his impressions in a watercolour, which he gave to Delacroix who greatly admired it. Although the finished scene appears to be one of terrible and impartial realism, 'the pitiless fidelity of the daguerreotype', as one critic put it, it was in fact carefully contrived in the studio to create an effect of reportage. His early experience as a vignette artist working for the publisher Curmer encouraged him to fill all available space with telling details, adding three bodies to those depicted in the watercolour (Hungerford 1979, pp. 277–88). This man, with outflung arm, was there from the first. The crosshatched white highlights at the left side of the jacket, like Prud'hon in technique (see No. 82), the emphatic occasional strengthening of the line, the elegant treatment of the crumpled folds, all invite comparison with Lancret (see No. 68). This was a time when the Rococo was again in high fashion, following a reaction against the taste for the Antique which dominated French art in the lifetime of Lethière. Meissonier had an early success in the 1830s as an exponent of this revival. His style now appears characteristic of a mid-nineteenth-century French Realist, but his abiding interest in the eighteenth century continued to provide him with a rich vein of

Fig. 80 Jean-Louis-Ernest Meissonier, *The Barricade, rue de la Mortellerie*, 1848. Oil on canvas, 29 x 22 cm. Paris, Musée du Louvre.

subjects. Delacroix, pondering how far the horrifying could provide the subject for a work of art, commented that Meissonier's studies for *The Barricade* seemed to be 'traced with the same pencil as Watteau's coquettes and pretty drawings of shepherds'.

LW

Sale of 'G', Paris, 14 April 1896, lot 49; bought by the museum. Inv. W. 1969.

153

Luc-Olivier Merson
1846–1920

76 The Wolf of Agubbio

Oil on canvas, 88 x 133 cm
Signed and dated lower left: Luc-Olivier-
Merson-1877

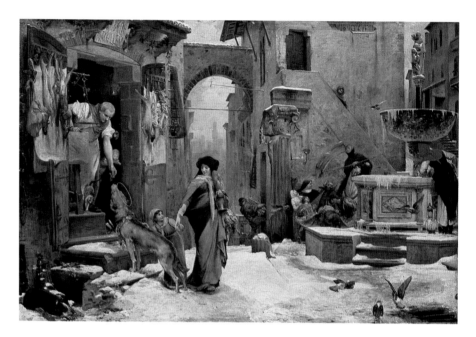

In the spring of 1874, Augustus Hare made his way to Gubbio, a small and remote town in Umbria – the last part of the journey probably taken in the 'wretched diligence' he later described in his guide book – and found that it 'singularly preserves the character of the Middle Ages'. When he published his account, he included the following story, summarised from *The Little Flowers of Saint Francis*, and which Bernard Berenson called 'the most specifically Franciscan of the legend': 'Saint Francis was often at Gubbio. His story tells that a wolf who had long ravaged the neighbourhood was rebuked by Saint Francis, who promised it a peaceful existence and daily food if it would mend its ways. The wolf agreed to the contract, and placed his right paw in the hand of Saint Francis in token of good faith. "Brother Wolf", as Saint Francis called him, lived afterwards for two years tamely at Gubbio in good fellowship with all, and finally died, much regretted, of old age.' (Hare 1884, pp. 125–6.)

Luc-Olivier Merson may have visited Gubbio (once known as Agubbio) at almost exactly the same time, since he sent a sketch of the episode of the conversion from Rome to Paris in 1873. He returned to the theme in 1877 with this picture, set in a small square of the upper town, in which he has rendered the tenor of life of its inhabitants, human and animal, its high doorways, steep views, and picturesque detail in naturalistic terms and with an arresting refinement of touch. Sassetta illustrated part of the same story in the panel now in the National Gallery in London, representing the scene as a formal legal compact in the presence of a notary (Berenson 1910, pp. 25–6). Merson's account of the saintly wolf also stresses the contract, by which he was to be fed daily in return for his good behaviour. Brought within the law, he is now the friend of cats, dogs, birds and children. Rather like an English Pre-Raphaelite, Merson set himself to render the supernatural through an intensification of naturalism, which, as Bruno Foucart has suggested, may have had some connection with the Franciscan revival in mid-nineteenth-century France (Foucart 1984, pp. 157–66).

Merson's first *envoi* after he won the Prix de Rome in 1867 was a scene from the life of Saint Edmund (Troyes, Musée des Beaux-Arts), which included an animal, something between a dog and a wolf. He had some difficulties with the foreshortening, and his father wrote to his old friend the *animalier* Emmanuel Frémiet for help (Troyes 1989, p. 34). Merson seems thereafter to have retained a particular fondness for the wolf, which led him to the present subject, since in 1880, ignoring the account which described the wolf as remaining in Gubbio, he re-introduced him into a picture of Saint Francis preaching to the fishes (Nantes, Musée des Beaux-Arts).

LW

Collection Hayen?; bought by the museum at the Exposition des Beaux-Arts, Lille, 1881. Inv. 500.

Yokohama etc. 1991–2, p. 171, no. 47 with full bibliography), ill. p. 64.

Opposite
Luc-Olivier Merson, *The Wolf of Agubbio*, detail.

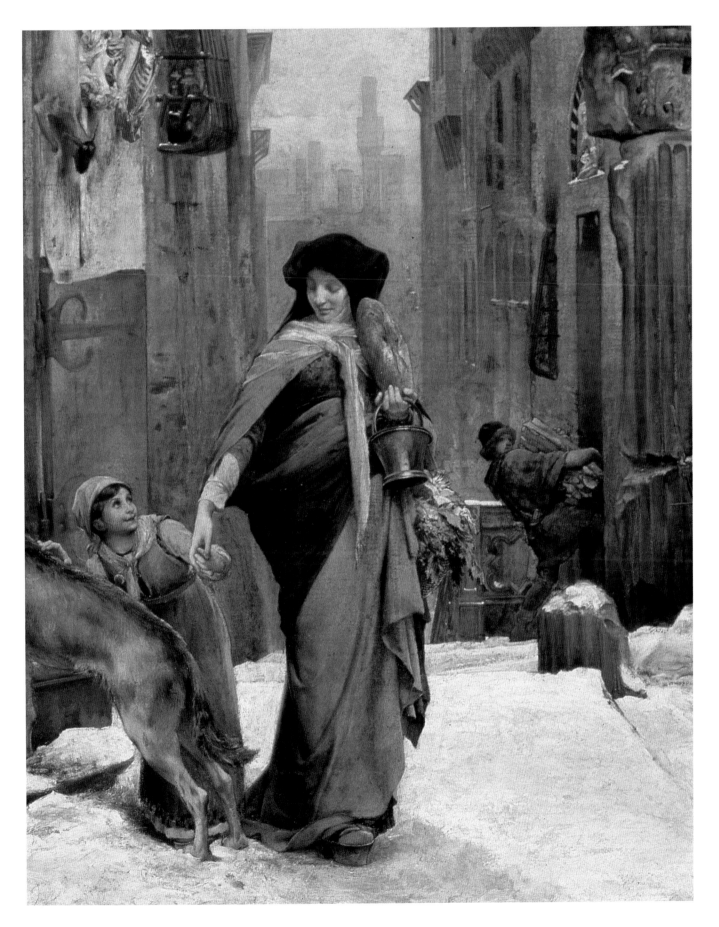

Luc-Olivier Merson
1846–1920

77 Study for the Head of an Angel in 'Saint Isidore'

Graphite on paper, 31 x 25 cm
Signed with a monogram and dated lower right: L.O.M. 1878. Inscribed lower left: Etude pour le Saint Isidore

In 1864 Luc-Olivier Merson became a pupil of the gifted draughtsman Isidore Pils. The young Merson early showed a remarkable talent for drawing, but his style, which was strong and fluent, had not yet developed the characteristic refinement associated with his later works. His early subjects were neo-Greek in inspiration, but the four years he spent in Rome as a prize-winner, from 1869 onwards, confirmed his appreciation of Raphael, Correggio and the Quattrocento, which he had already studied at the Louvre. As a result, he prolonged into the twentieth century the taste for fine academic drawing in a tradition stemming from the Renaissance. On his return to France in 1873, he exhibited at the Salon of that year his *Legendary Vision in the Fourteenth Century* (Lille), winning a first-class medal and establishing the archaic idiom appropriate to the religious subjects with which he was associated for the next decade.

The present drawing is a study for the head of the angel leading the plough horse in his *Saint Isidore*, shown at the Salon of 1879 (fig. 81). It exemplifies Merson's technique of suggesting the supernatural by a simultaneous sharpening and purifying of detail. His economical and effective use of white paper to convey light is sufficient in itself to suggest the miraculous. The finest of lines describes the ideally rounded head, with disjointed strokes, breaking the tension with a light touch there and in the few curling strands at the brow.

LW

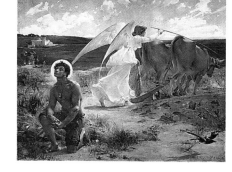

Gift of Charles-Olivier Merson, the artist's father, 1881 or 1882. Inv. Pl. 1565.

London, Cambridge etc. 1974–5, no. 67, pl. 102.

Fig. 81 Luc-Oliver Merson, *Saint Isidore*, 1878. Oil on canvas, 240 x 300 cm. Rouen, Musée des Beaux-Arts.

Jean-François Millet
1814–1875

78 La Becquée

Oil on canvas, 74 x 60 cm
Signed lower right: J.F. Millet

Jean-François Millet is now chiefly remembered as a painter of life-size naturalistic scenes of rural life, the painter of the seasons who endowed the lives of the peasants with eternal majesty. But Millet made his début at the Salon of 1840 as a portraitist and was always attracted to subjects taken directly from daily life. His more exalted and poetic themes were alternated with lighter and more mundane ones. *La Becquée* has many precedents in his work, going back to the *Young Mother preparing a Meal* of 1847 (University of Minnesota, Tweed Museum of Art), but the most important being *Maternal Care* of around 1856 (Paris, Louvre). This painting was deliberately provocative, both on account of the triviality of the subject and the realism of its pictorial treatment, and yet the numerous preparatory works reveal that it was planned as a major work. The Lille painting dates from about three to five years later.

The subject was surely not studied from life, but probably composed entirely from memory. As his biographer Alfred Sensier would recall, Millet used to say that to extract the essence of an idea you must let it settle quietly for a while in your head. It is likely that Millet began work on the composition as early as April 1859, for he spoke to Sensier of a drawing of this subject at that date. At least five preparatory drawings are known (four in the Louvre, one in Melbourne), and there is a pastel in the Institute of Arts, Detroit (which looks as if it is later in date than this painting). From a letter to Sensier (Leprieur 1914) we know that Millet wanted to develop the metaphor of the woman feeding her children as a bird with its nest of young, but also

emphasised the labour of the male – his chief subject as an artist: 'Man toils to give these [i.e. wife and children] nourishment.' The man digging in the garden in the background of his painting is significant in this connection. Thus Millet's apparently banal scene of daily life has a resonance in his philosophy of the soil, of labour, of the noble and natural service of man – a philosophy which had prompted him to support (with Daumier and Courbet) the short-lived adventure of the Second Republic in 1848.

Millet, a deft colourist, blends here clear blues and strong reds which enliven the cold tints of the farm-yard, certainly studied from those of

Barbizon and its neighbourhood and recalling those painted by his friend Charles Jacque or by Alexandre-Gabriel Decamps. The influence of this work can be seen in the naturalist paintings of the late nineteenth century, from the peasant subjects of, for example, Jules Bastien-Lepage or François Bonvin, to the Realists of Montmartre, such as Steinlen or Willette.

VP

Bought from the artist by Mme G. Maracci; given by her to the museum, 1871. Inv. 543.

Paris, London 1975–6, no. 155; Oursel 1984, pp. 59–60; Brice 1987, p. 50; Yokohama etc. 1991–2, p. 164, no. 29.

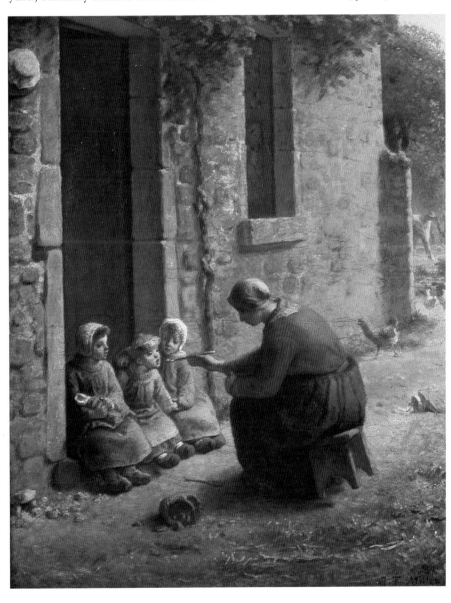

Jean-François Millet
1814–1875

79 The Seated Shepherd

Black chalk on paper, 28 x 38 cm
Signed lower right: J.F. Millet

In the 1840s, when Millet specialised in rustic themes painted in the fashionable neo-Rococo style, he produced decorative, painterly works of a kind typified by *The Whisper* (London, National Gallery). *The Winnower* of 1848 (London, National Gallery) marked the beginning of a move towards a more sober and monumental naturalism, and set the tone for the series of rural subjects which Millet sent to the Salons during the 1850s. During these years he began to develop his own powerful, fluent drawing technique, which found favour with an increasing number of collectors, several of whom were introduced to him by his friend and biographer Alfred Sensier. Returning for a short time from Barbizon to his native Normandy in 1854, he renewed contact with the bucolic scenes and subjects which meant most to him, and came back with a large quantity of sketches which formed the basis for drawings and paintings for some time to come.

This drawing of a solitary shepherd, dreaming under the trees while his flock huddles at a distance, may be based on such a memory and, like much of Millet's art, intentionally conveys a strain of Virgilian poetry. Moreau-Nélaton relates it to a number of drawings produced for sale between 1856 and 1857, although Robert Herbert has suggested a slightly earlier date. The rigorous economy with which Millet pared down his preparatory studies, thus emptying his compositions of all superfluities, gives his work a classical composure which attracted Puvis de Chavannes and also Léon Bonnat, whose collection of drawings at Bayonne is especially rich in Millet's work.

LW

Collection Alfred Sensier; his sale, 1877 (no. 262?); bought by the museum. Inv. Pl. 1568.

London, Cambridge etc. 1974–5, no. 68 (with full bibliography), pl. 87.

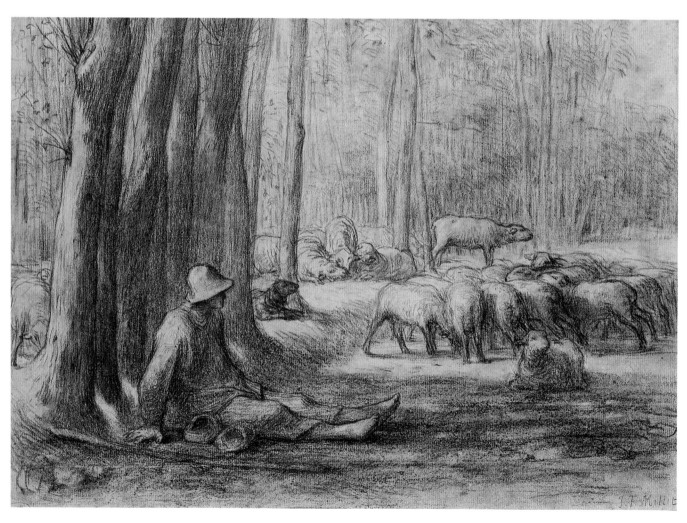

Victor Mottez *1809–1897*

80 Charles Benvignat

Oil on canvas, 105 x 84 cm

After spending a short time in François Picot's studio, Victor Mottez became a pupil of Ingres and, like Lehmann, Amaury-Duval and Flandrin, received numerous commissions for religious pictures, while also specialising in portraiture. For his work at St-Séverin in Paris he revived the traditional techniques of fresco, an interest which he had acquired in Italy and which led him to translate Cennino Cennini's treatise on painting, *Il Libro dell'Arte*. He was a lifelong friend of the sitter in the present portrait, Charles Benvignat (1806–77), a prominent Lille architect, member of the commission of the Musée Wicar and museum benefactor. Both artist and sitter collected pictures, and some of the pictures which came to Lille through Benvignat were acquired in the company of Mottez.

Following a long-established convention for portraits of architects, the artist depicts his sitter holding a plan as he stands beside an antique fragment. The chiaroscuro of the modelling, the elegant black of the costume and the three-quarter length reveal Mottez's interest in Venetian art, though the picture can probably be related to a more recent model. The clear modelling and unpretentious dignity of Ingres's portrait of Monsieur Bertin (1832; Paris, Louvre) must have been in the painter's mind and played some part in this formulation, as he knew the Bertin family well and carried out mural decorations for their house. Mottez, waiting with some trepidation for Ingres's comments on the portrait when it appeared at the Salon of 1859, was relieved when Ingres, who was on the whole approving, only advised him to whiten the linen a little.

LW

Gift of M. Benvignat, 1874. Inv. 879.

Yokohama etc. 1991–2, p. 163, no. 27 (with full bibliography), ill. p. 44.

Jean-François-Pierre Peyron *1744–1814*

81 Study for 'The Funeral of Miltiades'

Pen and brown ink, grey-brown wash, white highlights and traces of graphite on buff paper, 21.8 x 29.7 cm

This drawing, which is as much a drapery study as a compositional sketch, is a preparatory work for Peyron's *Funeral of Miltiades*, the first version of which the artist painted in Rome in 1782 (Paris, Louvre) and the second version probably in Paris a few years later (fig. 82).

The Louvre version was painted for the comte d'Angiviller, Louis XVI's Director of Royal Buildings. The commission was given in 1780 while Peyron was in Rome through the agency of the painter Joseph-Marie Vien, then director of the French Academy there. D'Angiviller requested a pair of paintings, suggesting *The Death of Socrates* as the subject for one of them. Peyron instead chose a subject from *Justinian's Histoires Philippiques de Trogue Pompée* (II, 15) as an inscrip-

tion on a related drawing in the Musée de Guéret (inv. D. 149) indicates. In this episode from ancient history, the Athenian general Miltiades, conqueror of the Persians at Marathon, was accused of treason. Originally condemned to death, his sentence was commuted to a fine. Unable to pay, he was thrown into prison where he died of an old wound. To ensure him a decent burial, Miltiades' son Cimon offered to take his place. The painting shows the latter being put in chains as his father's body is being carried from the jail.

Peyron finished his painting in 1782. Exhibited during the last two days of the 1783 Salon, the only immediate response was that of the *Journal de Paris*, which criticised the perspective of the group of Miltiades and the bearers. It was this that

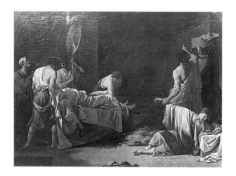

Peyron altered in the second version.

Whether the present drawing was preparatory for the first or second version is unclear. However, it is only in the second version that the head of Miltiades is covered by a shroud, and it has been suggested that the drawing was made after the Louvre painting had been executed and at a time when Peyron was considering a radical revision of the composition involving a reversal of this group (Rosenberg and van de Sandt 1983, p. 101). The indications in pencil of additional figures suggest possible compositional alterations.

HW

Auguste Millot collection; acquired Paris, Hôtel Drouot, 30 June 1976. Inv. W. 3873.

Lille 1983, no. 135; Rosenberg and van der Sandt 1983, no. 67.

Fig. 82 Jean-François-Pierre Peyron, *The Funeral of Miltiades*, after 1782. Oil on canvas, 98 x 136 cm. Musée de Guéret.

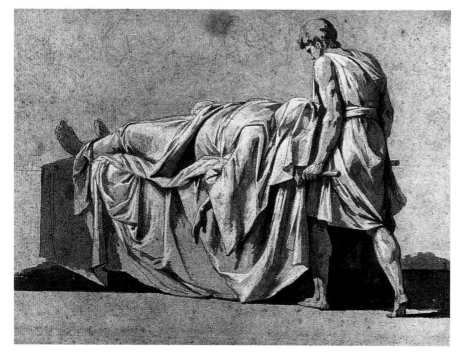

Pierre-Paul Prud'hon
1758–1823

82 Academic study of a Male Nude

Black and white chalk on blue paper, 60 x 44 cm
Verso: Male Nude

Prud'hon's sense of form, like that of Géricault, who admired his work, was essentially sculptural, modelled with strongly marked contrasts of light and shade, but with an added grace and sensibility very different in its nature from the robust forms of the younger artist. Drawings like this were known as *académies* because the study of the live model had a fundamental place in the curriculum

of the drawing schools. Prud'hon began making drawings of this type when he was a student with François Devosge in Dijon, and he continued throughout his life. After his death he left over a hundred life drawings which were rapidly divided among enthusiastic collectors like Boisfremont, the Goncourts, and the Marcille brothers, who also collected work by Géricault.

Prud'hon's interest in the expressive possibilities of shadow, which he admired in the work of Leonardo, led him to develop the extraordinary technique we see here, at a partially completed stage. Hervé Oursel has cited part of Edmond de Goncourt's description of Prud'hon's working method: 'As soon as he has lightly traced the outlines and the shadow on the blue paper . . . noted the position, measured the proportions, he gives a flicker of his handkerchief over these initial proportions, melting the black chalk . . . He then places his nude on the soft shades and the moonlit blue of his paper by means of straight, well-spaced, seldom intersecting chalk lines, which mould the muscles. It is as if out of this whole network, under this white armour, some luminous *écorché* would rise out of the twilight.' (London, Cambridge etc. 1974–5, no. 81.)

The use of blue paper, which was cheaper than white, perhaps originated in Venice and was much used as a foil to pastel, and also to white chalk. Earlier in the century Louis de Boullogne had used it consistently, with a technique of white highlighting similar to that subsequently employed by Prud'hon. He and his brother, Bon Boullogne, in common with Prud'hon, made a practice of studying the model by artificial light in order to heighten the effects of light and shade.

Annie Scottez has related this drawing to several others using a comparable pose, and has suggested the identification of the model with Lena, whom Goncourt has mentioned as usually posing for Prud'hon. The resemblance is particularly striking in a drawing exhibited at the Galerie Cailleux in Paris in 1973. The pose is entirely characteristic of the life class, though the ardent profile and the intensity of the gaze already possess pictorial qualities, and if we compare this figure with that of Adonis in the *Venus and Adonis* of the Wallace Collection, London, for which there is a beautiful finished drawing in the National Gallery of Art in Washington, we can see how easily such a single-figure study could be transformed.

LW

Camille Marcille collection; his sale, Paris, Hôtel Drouot, 8–9 March, 1876; bought by the museum. Inv. Pl. 1623.

Lille 1983, p.183, no. 137 (with full bibliography), ill. p. 182.

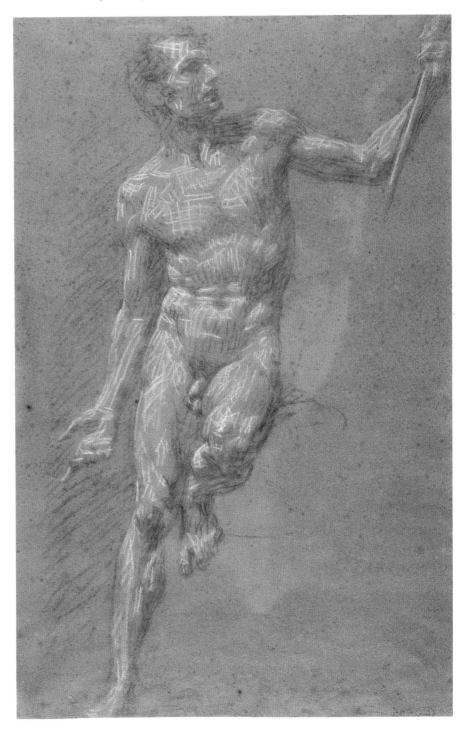

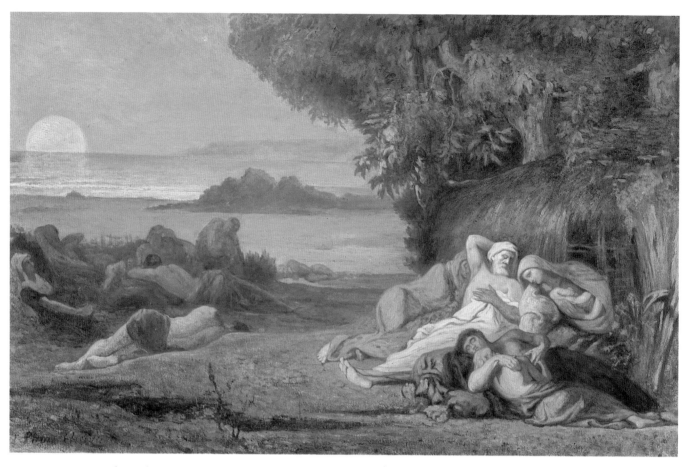

Pierre Puvis de Chavannes
1824–1898

83 **Study for 'Sleep'**

Black chalk, graphite, and oil, heightened
with charcoal on cream paper, graphite
framing, 36.9 x 58 cm
Signed lower left: Puvis Ch . . . (illegible)

In 1861 Puvis de Chavannes exhib-
ited two large pictures resembling
murals, which he entitled *Concordia*
and *Bellum*. The state bought
Concordia, and Puvis then made a
present of *Bellum*. Two years later
he exhibited *Work* and *Peace* and all
four were eventually installed as
mural decoration in the new museum
at Amiens. The fifth painting in the
series, *Sleep* (fig. 83), shown at the
Salon in 1867, remained in the
artist's possession on deposit with
his dealer Durand-Ruel until it was
bought for the Lille museum in
1888. The series illustrates universal

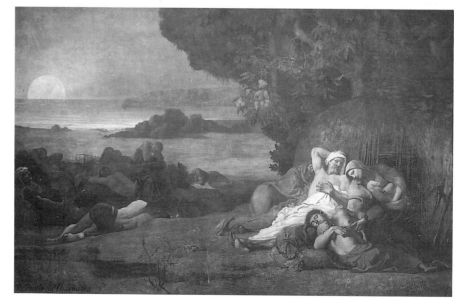

themes, set in a remote but
unspecified period of history, and
surprised critics by its remoteness
from contemporary taste. Théophile
Gautier wrote, 'At a time when so
many palaces and monuments were

Fig. 83 Pierre Puvis de Chavannes, *Sleep*,
1867. Oil on canvas, 381 x 600 cm.
Lille, Musée des Beaux-Arts. Inv. 625.

162

being completed, and awaiting their clothing of fresco', France had just discovered a young painter who required 'not an easel, but scaffolding and great wall spaces to cover' (quoted by Louise d'Argencourt in Paris, Ottawa 1976–7, p. 62).

The entry for *Sleep* in the catalogue of the Salon cites a passage from Book 2 of Virgil's *Aeneid*, 'Tempus erat quo prima quies mortalibus aegris/Incipit . . .' (This was the time when peace first comes to weary mortals), describing the sleep of the Trojans before the sack of their city. Virgil's poetry, abounding in pictorial images, must have given Puvis a starting point for his composition but it can never have been intended as an illustration of it. A number of preparatory studies contain details which suggest some kind of narrative – tents, a stag, a watchful female figure – but these were eliminated in the final version, which the present picture closely resembles. The group on the right may have been inspired by Aeneas' account of his subsequent wanderings, the old man could be a reference to Aeneas' father, Anchises, and the vast expanse of sea lit by the moon recalls the site of Troy, but the final picture is no more than an evocation of night and sleep.

This version, which was published recently for the first time (Yokohama etc. 1991–2, no. 76), may be one of a number of small pictures which Puvis made after his large works. However, it bears numerous passages of clearly visible underdrawing and is more likely to be a reworking of a preparatory study for sale or exhibition after the picture was completed, since Puvis, like Ingres, was in the habit of picking up such studies and reworking them, particularly during the 1880s and 1890s when Durand-Ruel was asking for such works to sell.

LW

Probably from the artist's family. Inv. 1358 *bis*.

Yokohama etc. 1991–2, p. 181, no. 76 (with full bibliography), ill. p. 95; New York 1992, no. 85.

84 Oil sketch for 'Sleep'

Oil on canvas, 55 x 81cm
Signed lower right: P. Puvis

Puvis de Chavannes invariably made separate figure studies and preliminary sketches for all his compositions. The museum at Lille possesses three studies for *Sleep*. One in pen and brown ink with wash shows a very different composition with the figures concentrated on the left rather than on the right as in the final canvas (fig. 83), although all the main features – distant sea, isolated figure in the middle distance and foreground with clustered slumbering figures – are all present. The present sketch, the second in the sequence, represents a more developed stage in the evolution of the composition. It is painted with all the vigour and strength of a first draft. The handling is different from the final work; more romantic and agitated and more evocative of sleep after an exhausting day. Though the sea occupies less space than it does in the final work, it is still present, juxtaposed with the undergrowth where two deer (which disappear in the final composition) drink from a pool. The foreground figure, who keeps watch while others sleep, profoundly alters the general character of the composition.

The third of the preparatory works in Lille, also in oil (No. 83), relates closely with the final version and in it a restless chiaroscuro is replaced with a more poetic luminosity. The figures are less cramped and more harmoniously arranged, as suited to a more monumental conception. This monumentality is also reflected in the treatment of the landscape as superimposed bands with a flatness which gives a foretaste of Gauguin's style.

The present work belonged to the painter J. Francis Auburtin, a pupil of Puvis de Chavannes and himself a mural decorator. It was bought by the state from his widow in 1943 and sent to Lille from the Louvre in 1946 because of its connection with the final painting of *Sleep*.

VP

Collection of J.F. Auburtin (died *c*.1930); sold by his widow to the state in 1943; deposited by the Louvre in 1946 (R.F. 1943–71). Inv. 1722.

Paris, Ottawa 1976–7, pp. 88–91, no. 65; Foucart-Walter 1986, V, p. 321; Yokohama etc. 1991–2, p. 169, no. 41.

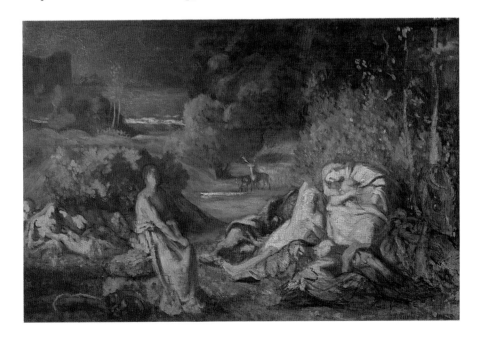

Pierre Puvis de Chavannes
1824–1898

85 Study for 'The Beheading of Saint John the Baptist'

Red chalk on paper, squared for transfer,
42 x 27.5 cm
Inscribed upper right: coude gauche/entre
les deux pie/la tête de femme/l'exécution

After the critical success of his large allegorical paintings, Puvis returned in the late 1860s to painting a series of smaller compositions, religious as well as allegorical, some of which recall the romantic imagery of his friend Chassériau. The style of the paintings was stark, simple and idiosyncratic and met with no critical success. These compositions, however, were based on a series of preparatory drawings and sketches of a conventionally precise, academic character made from the nude model, like the present drawing.

This study, squared for transfer, represents the final idea for the figure of the executioner brandishing a sabre on the left side of *The Beheading of John the Baptist*, of which two versions exist, one in the National Gallery, London, and the other, smaller version in the Barber Institute in Birmingham (fig. 84). The two pictures are different in effect; the unfinished London version which, as Jon Whiteley has pointed out to me, seems to have been inspired by Andrea del Sarto's composition of the execution in the cloister of the Scalzi in Florence, was to be pared down to the grimmer and emptier picture in Birmingham, though the pose of the executioner remains essentially the same.

Red chalk had been a favourite medium for life drawing from the age of Leonardo until the eighteenth century when it suddenly went out of fashion. Puvis, who was aware of its use in the Renaissance, used it frequently, as did a number of artists working on church commissions in the mid-nineteenth century. As his career as a mural painter developed in the 1870s, the increasingly flat, decorative style of his finished work led him to abandon this kind of sculptural modelling, which is such an impressive feature of his drawing style in the 1860s.

LW

Gift of the artist's heirs, 1899. Inv. W. 2005.

Fig. 84 Puvis de Chavannes, *The Beheading of Saint John the Baptist*, 1869. Oil on canvas, 124.5 x 166 cm. Birmingham, Barber Institute of Fine Arts.

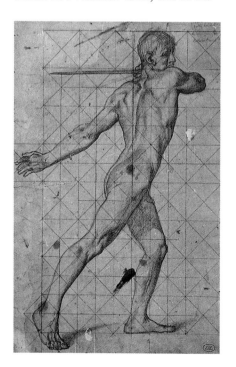

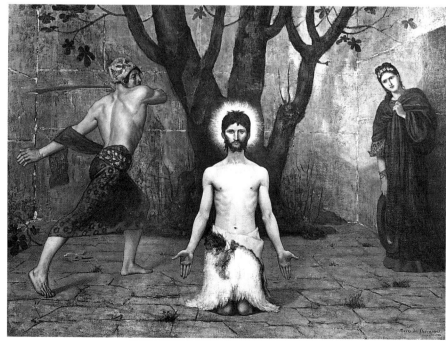

Jean Raoux 1677–1734

86 Virgins of Ancient Times (The Vestal Virgins)

Oil on canvas, 92 x 72.5 cm
Signed and dated: I. Raoux Ft 1727

87 Virgins of Modern Times

Oil on canvas, 92 x 72.5 cm
Signed and dated: I. Raoux Ft 1728

Given the difference in dates, these two paintings were not necessarily originally conceived as a pair. Nevertheless, *Virgins of Modern Times* is an ironic contrast to the earlier painting. In the latter, the inscription on the altar shows the women to be virgin priestesses of the Roman goddess of the hearth, Vesta. It was the duty of the Vestal Virgins

to maintain the eternal fire which burnt on the altar of Vesta's sanctuary in the Forum. The Temple of Vesta was round, and Raoux has so shown it. The goddess, like her attendants, was regarded as chaste, and she represented both the union among families and among citizens. Whereas the Vestal Virgins are united by a common purpose, their modern equivalents are shown engaged in a number of unrelated activities, typified both by the figures moving or looking out of the picture, and by the self-absorption of the girl reading.

The subject matter of these two paintings would inevitably have recalled the parable of the Wise and Foolish Virgins (Matthew 25: 1–13). Part of the legend to a print of *The Foolish Virgins* by Abraham Bosse (1602–76) seems applicable to Raoux's *Virgins of Modern Times*: 'Tu vois comme ces Vierges Foles/S'amusent inutilement/Après des actions frivoles/Dont Elles font leur Elément' (You see how these silly maidens uselessly amuse

themselves in the frivolous pursuits in which they immerse themselves). More specifically, however, the two paintings contrast the assumed simplicity of ancient times with the luxury of the present day. The point is made by the different architecture in the two paintings; the mono-chromatic building of ancient times articulated by pairs of pilasters has been replaced in the modern scene by a complex building of indeterminate shape sporting pillars of green marble with gilded capitals. Moreover, the ceiling decoration here shows the ancient gods presided over by Apollo, the god most closely identified with music and the arts, whereas in *Virgins of Ancient Times* the statue of a Vestal Virgin resting on the pedestal at the left holds a statuette of Minerva, goddess of Wisdom. Further to emphasise the point, Raoux has shown two of the modern virgins dressing with luxury objects a buffet with a blue marble top and elaborately carved giltwood legs. The two paintings can therefore be seen as light-hearted commentary

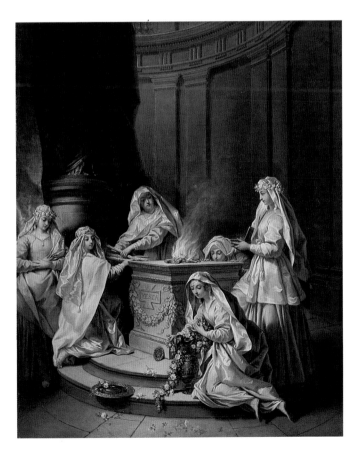 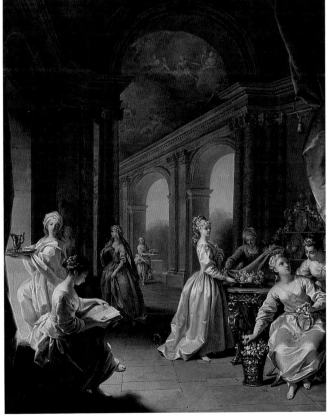

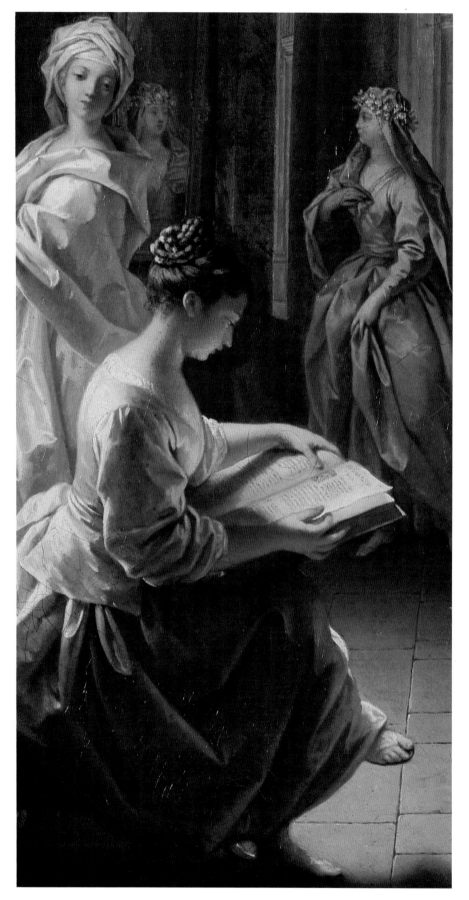

on contemporary debates about the extent to which luxurious living and the acquisition of luxury objects was morally justifiable.

Among the participants in this debate were Montesquieu and Voltaire, who was familiar with Raoux's paintings. The contemporaneity of Raoux's paintings is underlined by the publication in 1725 of the Abbé Nadal's *Histoires des Vestales avec un traité du luxe des dames romaines* (Paris) in which the author regretted the increasing opulence of the Roman Empire replacing the simplicity of the early Republic.

Raoux painted a number of other paintings of Vestals (for example, *Virgins of Ancient Times*, Nancy, Musée des Beaux-Arts; *Two Vestal Virgins*, Brunswick, Herzog Anton Ulrich Museum), or of contemporary women portrayed as Vestals. His only contemporary biographer, Dezallier d'Argenville, particularly praised Raoux for his rendering of satins, which, he said, 'could compete with those of the celebrated [Caspar] Netscher' (Dezallier d'Argenville 1762, IV, p. 378).

A version of No. 86 dated 1728 was recorded in a Paris sale in 1922.

HW

In the inventory of objects reserved for the nation from the property of 'Cailleux femme Sénozan' condemned in year II of the Republic (1793); collection Princess Emmanuelle de Croy and Princess Catherine de Croy; Galerie Cailleux, Paris, from whom bought in 1979. Inv. 1947 and 1948.

No. 87 only, Oursel 1984, pp. 172–3; No. 87 only, Lille 1985, no. 97; New York 1992, nos. 24 and 25.

Jean Rauox, *Virgins of Modern Times*, detail.

Jean Restout 1692–1768

88 The Supper at Emmaus

Oil on canvas, 280 x 147 cm
Signed and dated: J. Restout 1735

The subject is from the New Testament (Luke 24: 13–35). Three days after Christ's Crucifixion, two disciples failed to recognise him on the road to Emmaus. They invited Christ to share their meal and finally knew him when he broke the bread. The incident was frequently depicted as evidence of Christ's resurrection, but also had a connection with the breaking of bread at the Last Supper, at which the sacrament of Holy Communion was instituted. The Last Supper is alluded to by the prominently placed pitcher and basin, which recall the episode of the washing of the disciples' feet, said to have occurred at that gathering.

The power of the composition derives both from its piety and from its simplicity. An emphatic pyramid with the head of Christ at its apex is disturbed by few accessories or extraneous figures: the three-branched oil lamp hung between Christ's gaze and the heavens, possibly to recall the Trinity; the servant at the right who appears to see the miracle but, unlike the disciples, does not understand it; and the servant at the left who neither sees nor understands. To the right of this figure another holding up a dish can be faintly discerned.

The work was painted in 1735 for St-Germain-l'Auxerrois, Paris, possibly for the Confraternity of Tailors in whose chapel it was recorded in 1787. Before the Salon started to become a regular event in 1737, church commissions were the most important means for artists to display their works and so gain in reputation. This painting was probably especially important to the artist because of the proximity of St-Germain-l'Auxerrois to the Louvre, where

Painting photographed before cleaning.

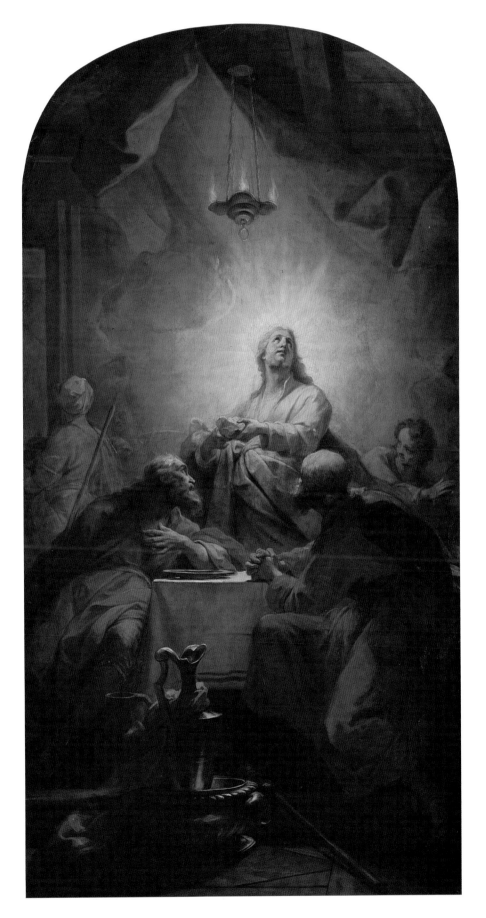

favoured members of the Académie had their studios.

Two preparatory drawings are known. In the earlier (No. 89 *verso*; fig. 85), the pyramidal structure is not yet apparent, and the disciple at the left is leaning back, presumably in astonishment. The servant holding up the dish is shown on the right. The later drawing (fig. 86), which has been squared up in black chalk, is clearly a more careful study. The two servants in the background are here shown close to their final positions, but the one holding the dish is not apparent. The main change, however, is in the posture of the disciple at the left. Between this drawing and the painting, the pose of that disciple has been simplified so that in the painting the line of his head, neck and shoulder reinforce the triangularity of the composition. More significantly, in doing this Restout replaced an attitude of astonishment with one of devotion.

HW

Painted in 1735 for the church of St-Germain-l'Auxerrois, Paris; confiscated during the Revolution and stored at the monastery of the Grands-Augustins, Paris (then a government warehouse for works of art), until sent to Lille in 1802. Inv. 405.

Rouen 1970, no. 14; Rosenberg and Schnapper 1977, pp 166–73; Young 1986; Rosenberg 1990–1, p. 120.

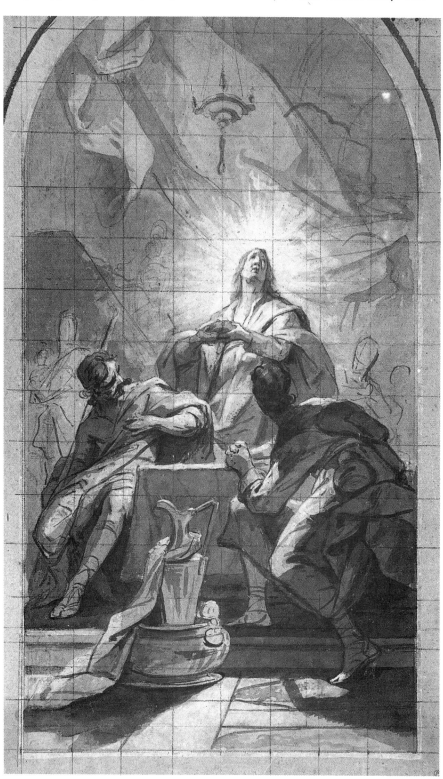

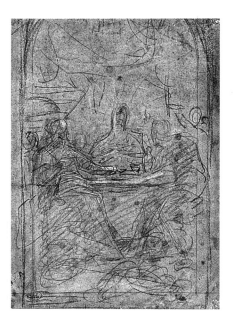

Fig. 85 Jean Restout, *Study for 'The Supper at Emmaus'* (No. 89 *verso*). Black chalk, graphite and white chalk on buff paper, 32.8 x 24.1 cm.

Fig. 86 Jean Restout, *Study for 'The Supper at Emmaus'*. Pen, grey ink, grey wash heightened with white over black chalk on blue paper, squared-up in black chalk, brush and grey wash framing, with arched top, 44.5 x 27.5 cm. Paris, Collection L.-A. Prat.

Jean Restout 1692–1768

89 The Good Samaritan

Brush and brown wash, black chalk
heightened with white chalk on buff paper,
32.8 x 24.1 cm
Verso: Study for 'The Supper at Emmaus'

This drawing is a preparatory study
for *The Good Samaritan*, painted by
Restout in 1736 for the Hôpital de la
Charité in Paris, and shown at the

Salon of 1747 (fig. 87). Another
study for this huge composition is in
the University of Wisconsin in
Madison (Rouen 1970, no. 14, fig.
XVIII). Although it is squared-up,
this drawing seems to be earlier than
the Lille study, which is much closer
to the final composition: between
these two drawings and the painting
the artist gradually tightened the
concentration on the central group.

Faithful to verse 34 of the parable
of the Good Samaritan according to
Gospel of Saint Luke, the artist
depicted the abandoned suffering of
the wounded man by slackening his

right arm and resting his head gently
on his left shoulder. This contrasts
with the Samaritan's lively display of
compassion and his eagerness to
bandage the victim's wounds. The
left leg appears to be drawn rapidly
with lots of black chalk marks, as
though the artist were seeking to
define the position of a leg which
was actually moving. Working
principally with a brush and wash,
Restout used a very pictorial
technique here, which is unusual in
his surviving drawings. He experi-
mented with the different degrees of
transparency produced by the wash
on the buff paper, emphasising the
density of the brown curves for the
outlines of the central figures, and
lightly heightening certain details in
white chalk. In contrast with the
Madison drawing, where he was
chiefly concerned with his
composition, Restout has here
emphasised the contrasting effects
caused by the play of light.

On the *verso* Restout has drawn
an 'initial thought' for *The Supper at
Emmaus* (see No. 88, fig. 85).

SR

Purchased 1865. Inv. Pl. 1637.

Rouen 1970, nos. 15 and 34.

Fig. 87 Jean Restout, *The Good
Samaritan*, 1736. Oil on canvas, 252 x
185 cm. Angers, Musée des Beaux-Arts.

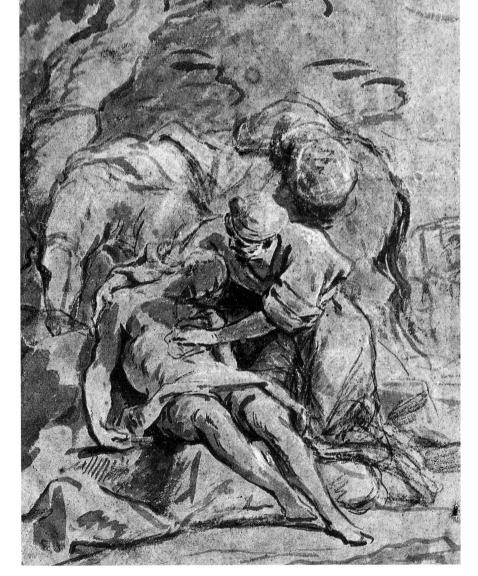

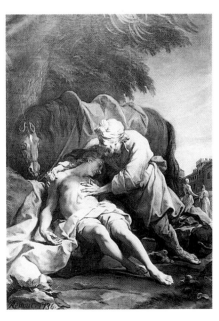

Robert de Séry 1686–1733
(Paul-Ponce-Antoine Robert)

90 Portrait of a Woman

Oil on canvas, 71 x 58 cm
Signed and dated: P.-P. Robert. 1722

This painting is one of the anomalies of French art. Painted in Rome (according to an engraving which Robert made of it in 1723, the year before he returned to Paris in the entourage of Cardinal du Rohan), it recalls Northern art: Rubens in the flesh tones, and Watteau in the spindly trees and the guitarist in the background. The directness of the portrayal, the informality of the pose and the apparent lack of idealisation of the features, however, run counter to the norm of French female portraiture of the period, which was intended to flatter.

The subject wears what appears to be an amethyst and diamond ring. The flowers she holds may be *Jasminium grandiflorum*, which flowers from July to October (Joyce Plesters: verbal communication).

HW

Gift of Paul Leroi, alias Léon Gauchez, in 1883. Inv. 347.

Paris 1968, no. 84; Dunkerque etc. 1980, no. 66 (with bibliography); New York 1992, no. 22.

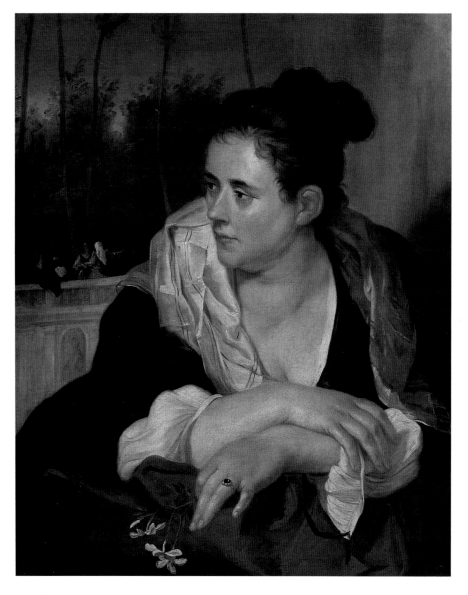

Ary Scheffer 1795–1858

91 Leonora: 'Les morts vont vite'

Oil on canvas, 59 x 76 cm
Signed lower left: Ary Scheffer

Ary Scheffer, who like Géricault and Delacroix trained in Guérin's studio, was one of a group of young artists whose illustrations of English and German literature in the 1820s gave a strongly literary bias to the vein of Romanticism launched by Géricault. The subject of this picture, set in spite of appearances in the eighteenth century, is taken from *Leonora*, a ballad by the eighteenth-century poet Gottfried August Bürger, based on an English tale, *The Suffolk Miracle* (Vaughan 1979, p. 110). English translations of *Leonora* appeared almost immediately, the best of them by W.R. Spencer in 1799, elegantly illustrated by Lady Diana Beauclerk. French versions appeared much later, probably because, as Madame de Staël, who was deeply impressed by it, remarked, 'It would be difficult to obtain the same result in French where nothing strange or odd seems natural.'

The poem tells the story of a young woman who, distraught when her lover does not return from the war, utters a blasphemous wish for death. Late that evening an armed knight stops at her door. She recognises her lover who gallops with her through the night to the repeated refrain, 'Die toten reiten schnell' (The dead ride fast). Before dawn they reach a church; the horse staggers, the rider reveals himself as a skeleton, and the earth opens to swallow them.

The phantasmagorical character of the ballad is well served by the sombre and sketchy execution. The painting has been linked to a song setting by Schubert, but there is no record of such a song, and there may have been confusion with the *Erlkönig*, the subject of a comparable work in watercolour by Delacroix (fig. 88). Horace Vernet and Louis Boulanger both treated the

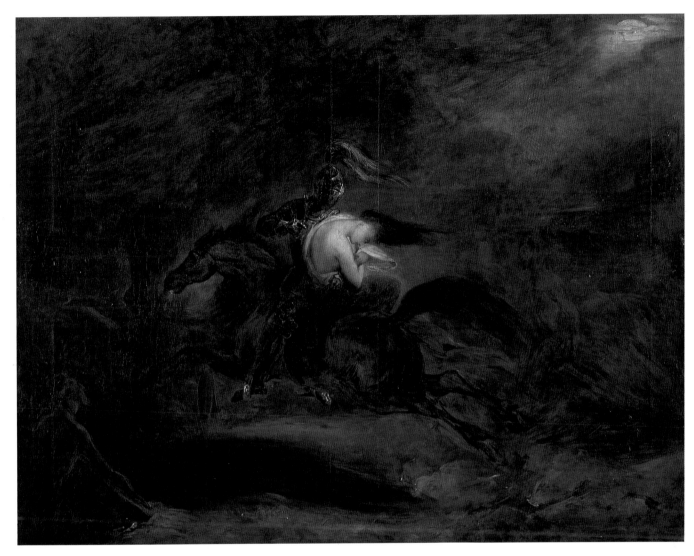

subject of Leonora, but Delacroix's *Tam O'Shanter* (1825; private collection) is probably the closest compositionally to this sketch. Ewals lists several versions by Scheffer, all of them sketches (Ewals 1987, p. 251).

Although it is sometimes suggested that Scheffer painted *Leonora* as a pendant to *The Return of the Army* (Musée de Guéret), which was shown at the Salon of 1831 and depicts an earlier incident in the story, it could belong stylistically to the mid-1820s and was certainly completed by the end of 1829, since it was exhibited at the Galerie Colbert, 'that monstrous den of Romanticism', as Ingres called it, at the very beginning of 1830.

LW

Bequeathed by Alexandre Leleux, 1873. Inv. 468.

Ewals 1987; Yokohama etc. 1991–2, pp. 155–6, no. 11 (with full bibliography), ill. p. 28; Scottez-De Wambrechies 1992, p. 79.

Fig. 88 Eugène Delacroix, *Der Erlkönig*, *c*.1835. Graphite with sepia wash, 19.8 x 30.1 cm. Rotterdam, Museum Boymans-van Beuningen.

Alfred Sisley 1839–1899

92 The Seine at Port-Marly, Hoar-frost

Oil on canvas, 46.5 x 65.5 cm
Signed and dated lower right: Sisley 1872

Sisley had been painting landscapes together with Monet, Renoir and Frédéric Bazille – his fellow pupils in Charles Gleyre's academy – when the outbreak of the Franco-Prussian War in 1870 overturned his entire life. His father (on whom he depended for financial support) became ill and eventually died. As the Prussian army advanced, Sisley abandoned his studio in Bougival and took refuge in Paris – he later claimed that he had lost most of his early work during the Prussian occupation. Afer the war and the bitter struggles of the Paris Commune, Sisley was able to renew his contacts with Manet, Renoir and Pissarro. He moved to Louveciennes in the winter of 1871–2 and embarked on a campaign of painting around this area, along the Seine, a few kilometres from Versailles. Sisley painted some of his best work at this period. Gradually abandoning the influence of his spiritual masters, Corot and, above all, Courbet, he worked beside Monet at Argenteuil, and helped formulate the Impressionist doctrine: colours in the shadow, broken brush-strokes, pure colour or colour mixed directly on the canvas, and a passion for light, colour and landscape. Snow was a subject of special importance for artists of that date. As early as 1850 Courbet had painted it and Pissarro followed his example before Sisley did. But Monet was the first of the group to paint snowy landscapes, for example *Cart under Snow at Honfleur*, and his famous *Magpie* of about 1868 (both Paris, Musée d'Orsay).

Sisley certainly went just as far as Monet in exploring the pictorial effects of a snowy landscape. The Lille painting was one of his first efforts, painted during the winter of 1872–3 in front of the motif. He produced similar – although perhaps less spontaneous – views in 1874, such as *Snow Effect at Louveciennes* (Washington, Phillips Memorial Gallery), and the following year painted one of his masterpieces, *Snow at Marly-le-Roi* (Paris, Musée d'Orsay). In 1876 – the year of his most famous picture, *Floods at Port-Marly* (Paris, Musée d'Orsay) – Sisley took this approach further in a systematic spirit with *Winter, an Effect of Snow*, another superb

canvas preserved in the museum at Lille. The motif of a snowy landscape enabled him to capture the unlimited variety in the spectrum of whites and all the possibilities offered by the luminosity and reflections which occur under snowy conditions.

VP

Sale of the collection of 'Dr X', Paris, 21 Nov. 1901, no. 59; Maurice Masson by whom bequeathed 22 May 1949. Inv. 1736.

Daulte 1959, no. 45; Châtelet 1970, p. 128; Lassaigne and Patin 1983, p. 86; Oursel 1984, pp. 64 and 66.

François Souchon 1817–1858

93 Roman Landscape

Oil on canvas, 26.2 x 49.2 cm

This outdoor study made in the Roman *campagna* belongs to the tradition of rapid jottings taken from nature, advocated and practised by Valenciennes. The subject, unlike that of Gauffier's *Monastery* (No. 54), was not in any sense a composition; the artist has rendered the scene quite simply, in alternating horizontal bands of light and dark.

François Souchon came from the south of France, like Valenciennes. He became a pupil of David, and early in his career was among a number of artists commissioned to record the coronation of Charles X. From 1836 he was director of the Lille art school. He travelled to Rome in 1833, with his friend Xavier Sigalon, whom Adolphe Thiers had commissioned to make a copy of Michelangelo's *Last Judgement* for the Ecole des Beaux-Arts. Presumably he made this study while on that visit. Corot made comparable studies in the Roman *campagna* at this period, but although some elements in this study invite comparison with his work, Souchon's handling of light and shade is not as broad, his palette is darker, and he shows more interest in picturesque detail – the finely indicated light along the sloping roofs of the foreground, for instance, touching the top of the wall with its broken edge and playing on the ruined arch.

The tonal contrast which was part of the aim of such studies gives an impression of finely worked detail in the background too, but the hills are, in fact, indicated in a summary manner, though probably with a small brush. The heavy cloud near their summit is a further reminder of Valenciennes's atmospheric studies in this vein.

LW

Bought from the artist in 1854. Inv. 432.

Lille 1955, no. 197.

Joseph-Benôit Suvée
1743–1809

94 The Combat between Minerva and Mars

Oil on canvas, 143 x 103.5 cm

The Prix de Rome subject for student painters at the Académie Royale in 1771 was taken from Book 21 of Homer's *Iliad*: as the Olympian gods quarrelled over the fate of the city of Troy, Ares (Mars) struck Athena (Minerva), whereupon she felled Ares, to whose assistance came Aphrodite (Venus). Suvée has shown the moment in the story when Minerva has struck down Venus for coming to the aid of Mars and 'the twain lay upon the bounteous earth'. While Mars represented mindless violence, Minerva represented wisdom, both in the guise of industry and art, and in that of diplomacy and controlled war to preserve the prosperity of the state from external enemies. As a Prix de Rome subject it therefore required the depiction of at least three figures in different poses, and with meaningfully different expressions; as an allegory it contained didactic contrasts between strife and wisdom, war and industry, passion and rationality.

It was with this painting that Suvée won the 1771 Prix de Rome, with David taking second place (see No. 34). Although Suvée's figure of Mars and the diagonals in the composition recall Boucher, his restrained use of colour, his deeper shades, the precision of his draughtsmanship and the clarity of his composition – the principal figures are clearly differentiated from those gods not relevant to the episode – show the direction being taken by some of the rising generation in the year following Boucher's death. By contrast David's submission for the 1771 Prix de Rome was more dependent on Boucher and more decorative, at a time when such art was beginning to go out of fashion. In preferring

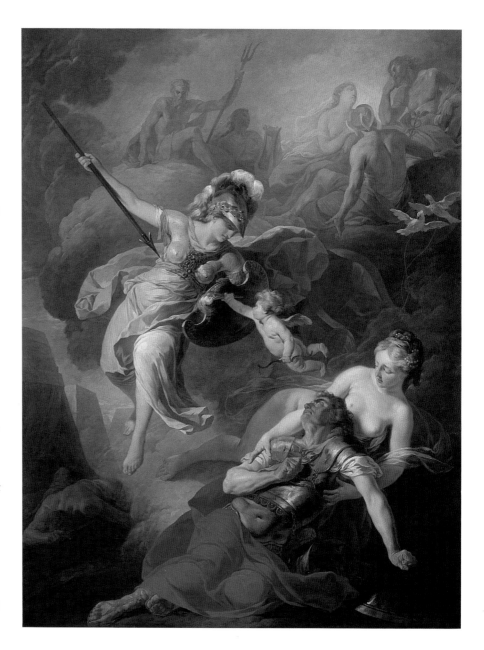

Suvée, the Académie was therefore encouraging those tendencies in French painting of which David would ultimately become the main, and more radical, exponent. The painting's importance to the artist is suggested by the fact that in his *Self Portrait* of 1771 (Groeningen Museum), Suvée showed himself sketching its composition on a canvas.

HW

Collection of the Académie Royale; transferred during the Revolution to the Louvre; given to Lille in 1873. Inv. 345.

Calais etc. 1975–6, no. 58 (including bibliography); Ixelles 1985–6, pp. 96–8.

Constant Troyon *1810–1865*

95 The Forest of Fontainebleau

Oil on canvas, 145 x 227 cm
Signed lower left: C. Troyon

The Salon of 1848, the first of the Second Republic, like those of 1824 or 1830, represents a crucial point in the artistic history of the last century. After being virtually rejected for more than fifteen years, the landscapes painted by the Barbizon School were finally accepted at the Salon. Théodore Rousseau, who had been systematically turned down since 1833, exhibited once again. The abolition of a jury for the Salon made it possible for the public to appreciate realism in landscape painting.

Constant Troyon, who had exhibited at the Salon since 1833, was represented by several important canvases. Prior to 1840 his sources of inspiration had alternated between his passion for Dutch seventeenth-century landscapes, which he copied at the Louvre, and historic landscapes. But between 1841 and 1847 two significant factors affected the development of his work. Around 1843, having already worked for a few years near Barbizon, Troyon strengthened his friendships with Narcisse Diaz de la Peña, Théodore Rousseau and, above all, Jules Dupré, and subsequently adopted their realist approach, which was already latent in his own work. He changed his style, abandoning the smooth surface for the visible brushwork favoured by Rousseau and Charles-François Daubigny and developed a strong interest in the study of light. The second important influence was his journey to Holland in 1847, when he discovered the work of Potter and Cuyp. From this time onwards

Troyon specialised in painting animals, though he also developed his interests as a landscape painter. His new style proved very successful. He was awarded a first-class medal at the Salon of 1846 and again in 1848.

The four works he sent to the Salon in 1848 clearly demonstrate the influence of his Dutch travels – indeed two of the landscapes were of Dutch scenes. *The Forest of Fontainebleau* was exhibited that same year. Outstanding in size, it also demonstrates Troyon's considerable technical skill, and prepares the way for his great masterpieces of the 1850s.

VP

Bought by the state at the Paris Salon in 1848, no. 4342; 'Envoi de l'Etat' in the same year to the museum. Inv. 469.

Hustin 1893, p. 16; Vergnet-Ruiz and Laclotte 1962, p. 253.

Pierre-Henri de Valenciennes 1750–1819

96 Arcadian Landscape

Oil on canvas, 88 x 126 cm

The landscape paintings for which Valenciennes was best known in his lifetime derive from the classical and literary tradition established in the seventeenth century by Claude and Poussin. At the same time they contain an occasional picturesque asymmetry and passages of rich dense foliage which are more typical of the Northern school. The subject of this picture, the finding of a tomb in a beautiful landscape, recalls Poussin's *Et in Arcadia Ego* (Paris, Louvre), a poetic meditation on transience and death, themes which were particularly enjoyed by Neo-Classical artists. The work of Dutch landscape painters like Berchem was also immensely fashionable in this period and it is not surprising to find both Poussin and Dutch art combined like this in the work of a late eighteenth-century French artist.

Valenciennes arrived in Paris from Toulouse at the age of twenty-one and became, like Lethière, a pupil of Gabriel-François Doyen. He subsequently spent several years in Italy and thereafter his landscapes, like this one, recall the sites he visited. Annie Scottez has suggested that the hilly view here may be based on the artist's travels in Sicily, which inspired his reception piece of 1787, *Cicero uncovering the Tomb of Archimedes in Syracuse* (Toulouse, Musée des Augustins), and his *View of Agrigente* (Paris, Louvre) painted in the following year. He exhibited frequently at the Salon from 1787 onwards, but the Salon catalogues do not mention a subject which corresponds with this, apart, perhaps, from an Italian landscape with bathers which he exhibited in 1791.

As the sunlight fades, it lights the trees to the left, the cliff, the little city, and touches the shoulders of the bathing girls. Valenciennes, though author of a treatise on perspective, was far from being coldly classical, as his beautiful *plein-air* sketches in the Louvre demonstrate; indeed, as Annie Scottez has pointed out, his own writings make his intentions clear: 'The artist does not paint a cold portrait of meaningless and lifeless nature, he paints it as speaking to the soul, affecting it with a specific expression which will communicate itself to any man of feeling.'

LW

Bequeathed by Mme Veuve Dufeutrel-Douriez in 1911. Inv. 1177.

Yokohama etc. 1991–2, p. 151, no. 2 (with full bibliography), ill. p. 19.

Jean-Louis Voille
1744–1804(?)

97 Madame Liénard

Oil on canvas, 65 x 54 cm
Signed and dated at right: Voille an 4e

This is probably one of several portraits which Voille exhibited at the 1795 Salon, the only one in which he is recorded as having participated, following his return from Russia, where he had been in the service of Grand Duke Paul Petrovich since about 1780. This is consistent with the sitter's costume and apparent age. The subject of the portrait is apparently Madame Liénard, the mother of the painter

Jean-Auguste-Edouard Liénard (1779–1848) and the wife of the engraver Jean-Baptiste Liénard. Jean-Baptiste Liénard was born in Lille in 1750 and engraved some of the plates for the first edition of Beaumarchais's *Marriage of Figaro* (Paris 1785).

The direction of the gaze, the strong colour contrasts and the smoothness of the paint are to be found in a number of portraits of the Revolutionary period.

HW

Bought at the Chamonin sale, 1873. Inv. 362.

Possibly the *Salon de 1795* (no. 535); Calais etc. 1975–6, no. 64 (with bibliography).

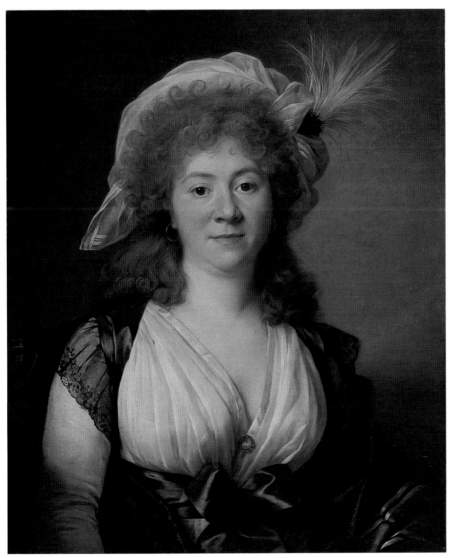

François Watteau
1758–1823

98 Une fête au Colisée

Oil on canvas, 75 x 91 cm

Although François Watteau was to succeed his father, Louis, as professor at the Lille academy, his style was formed in Paris, where he spent his formative years. He trained with the history painter Louis-Jacques Durameau, but later specialised in scenes of contemporary life and, while still in Paris, made designs for fashion plates, which must account for the absurdly smart appearance of many of the characters in the present scene. Although this episode from provincial life was painted after his return from Paris, the style of the picture is surely influenced by his numerous sketches in the gardens of the Palais Royal. The treatment is exaggerated almost to the point of caricature, particularly in the central figure seen in profile. Both the subject and the treatment recall Debucourt's famous pair of prints depicting fashionable life in the galleries and gardens of the Palais Royal during the last years of the *Ancien Régime* – a popular contemporary theme which Manet's *Music in the Tuileries Gardens* (London, National Gallery) echoed in the Second Empire. Like his father, François Watteau had a taste for sentimental narrative with an added Parisian elegance of manner.

The picture in undated, but the ubiquitous tricolour cockades place it firmly in the period after the fall of the Bastille in 1789 and before the Colisée closed in 1792. This arcadian pleasure garden, with a diverting informality *à l'anglaise*, was designed to import the manners of the capital to Lille. The architect was François Verly, a former student at the Ecole Royale d'Architecture in Paris. He completed it in 1787; five years later it was demolished when the site was needed to defend the town against the Austrian invaders. Laid out with tents, ballrooms and pavilions

arranged among rockeries, grottoes, woods, statues and waterfalls, it must have faintly recalled the ideal rural landscapes of François's great uncle, and provided an appropriate setting for his own polished late Rococo genre, in which he combined the *fête galante* with the *tableau de mode*.

LW

Gift of A. and J. Delannoy, 1861. Inv. 352.

New York 1992, no. 26 (with full bibliography).

Louis Watteau *1731–1798*

99 View of Lille

Oil on canvas, 72 x 96 cm
Signed and dated lower right:
L. Watteau, 1774

Louis Watteau and his son François are both known as Watteau de Lille, to distinguish them from Louis's famous uncle Antoine. Louis's subjects have something in common with Antoine Watteau's early military scenes, though they have nothing of his uncle's suppleness of composition and pose; they reveal instead a more literal rusticity depicted with Greuzian sentiment and an engaging naturalism. Here, for example, the sky has the extent and character more often associated with Northern art, and the artist has faithfully rendered all the towers, domes and spires in the long, pale but entirely distinct view of the skyline of Lille in the late eighteenth century.

The title which Louis Watteau gave the picture when he exhibited it at the Salon of the Lille academy in 1774, 'La réception d'un soldat arrivant dans sa patrie; le fonds du tableau représente la vue de Lille vue du Dieu de Marcq' (A soldier greeted on his return to his native country; the background of the picture shows Lille seen from the Dieu de Marcq), is illustrated by the group in the left foreground. The stubby child who has his back to us, and wears an immense three-cornered hat, reminds us of Boilly's native familiarity with this kind of Northern rural genre. The group on the far right, isolated against a little hill, is a self-contained pastoral of more frivolous character. The picture is characterised by isolated groups and single figures with the procession in the foreground providing a link between the two sides. Some of the figures – the man looking over his shoulder at the group on the right, the bent figure with a pack on his back stepping in from the foreground (perhaps a Savoyard), and the figure seated alone on a mound, head slightly tilted – reveal that Louis Watteau had, like his uncle, an instinctive feeling for a telling pose, bringing to mind the figures modelled at the great eighteenth-century porcelain factories. The composition, broken into little episodes, recalls the designs used by Christophe-Philippe Oberkampf for his printed textiles made at Jouy. This underlying decorativeness distinguished Louis Watteau's pictures from the work of his Dutch and Flemish predecessors.

LW

Acquired in 1803. Inv. 354.

Châtelet 1970, p. 158, no. 71, ill. (with bibliography); Marcus 1976, p. 23, no. 6, fig. IV.

Jean-Baptiste Wicar
1762–1834

100 Drapery study for 'Brutus'

Black chalk with white heightening on blue paper, 30 x 28.5 cm

In 1789 Wicar painted *Brutus vowing to Expel the Tarquins* as a presentation picture for his native city of Lille. In the following year he painted another version of this theme, emphasising the suicide of Lucretia more than Brutus' vow. He also tried out the same composition in reverse. A study for the figure of Brutus in this latter variant is in the collection at Lille (Lille 1984, no. 22) and it shows the hero striding to the right with his right arm raised and his left swung back. The present drawing is a study for the cloak worn by this figure, while the outline of Brutus' left arm from the elbow downwards is faintly indicated to the left.

Wicar, an accomplished draughtsman, with a skill borrowed from his master, David, blends black crayon, white chalk and tinted paper with great subtlety, imparting a sculptural depth and a vitality to the folds which anticipate both the studies made by David for *The Oath of the Horatii* (Angers, Musée des Beaux-Arts) and the beautiful drapery studies by Ingres.

AS

Bequeathed by the artist to the City of Lille in 1834. Inv. B. 176.

Beaucamp 1939, 11, p. 688, no. 176(b); Rome 1984, pp. 152–3, no. 149; Lille 1984, p. 39, no. 23 (with full bibliography).

Jean-Baptiste Wicar
1762–1834

101 La Patrie

102 La Justice

Black chalk with much stumping on paper, 16 cm in diameter
Both drawings inscribed (see below)

The drawings, as their inscriptions inform us, were 'dessiné par le chevalier Wicar, à la maison d'arrête du Plessis où il était retenu pendant le commencement de la réaction le 25 Prairial an III de la République', that is to say made (perhaps meaning finished) on 13 June 1795 in the converted college of Plessis where the artist was imprisoned between 3 and 25 June. Politics in Paris swung decisively against the Jacobins with whom Wicar had been associated (see No. 103). Wicar's supporter David had been imprisoned (for the second time) on 28 May. Wicar was accused, not without reason, of being a 'zealous supporter of the Terror' who had employed his influence with David to persecute other artists – a reference to his condemnation of Boilly (see Nos. 4 and 103). He compiled a long 'Mémoire justificatif' addressed to the Committee for Public Safety in which he professed his devotion to Justice as the only means of destroying the enemies of 'La Patrie'. These drawings must be associated with this plea. The motherland, bare-breasted but with a sword, urges Republican youths (one wearing the bonnet of Liberty, the other the Republican emblem of the triangle) to defend her. Justice with a desperate victim in her lap raises her sword to smite Calumny. Her fasces and scales are held by a child. Wicar was perhaps thinking of medals – which often combined urgent polemical messages with ancient Roman personifications – many of which were made and often also engraved in that period. The highly polished style of drawing with much use made of stumping seems to be

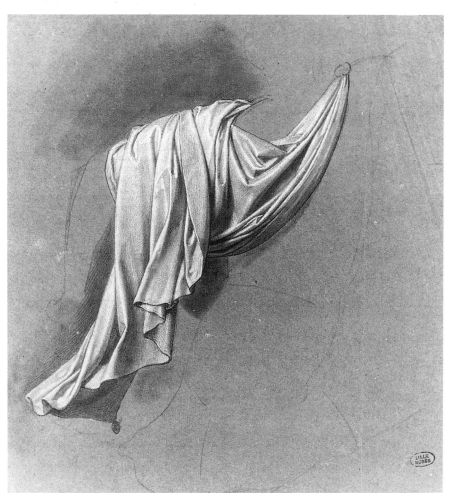

characteristic of Wicar only at this time (when he could not make paintings) and may suggest both a patinated metallic surface and certain types of engraving.

NP

Collection of J.E. Gatteaux by whom bequeathed in 1865. Inv. Pl. 1726 and 1727.

Beaucamp 1939, I, p. 206, II, p. 658, nos. 1 and 2; Lille 1984, nos. 30 and 31.

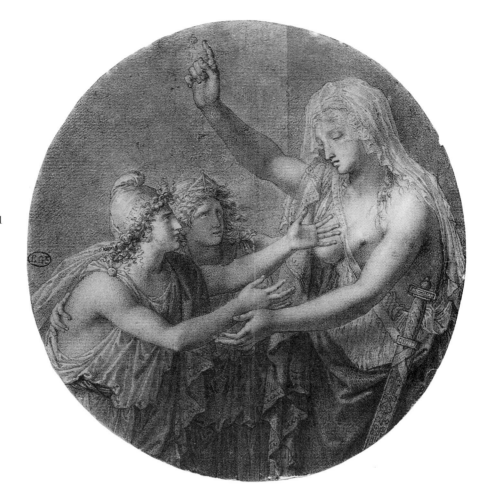

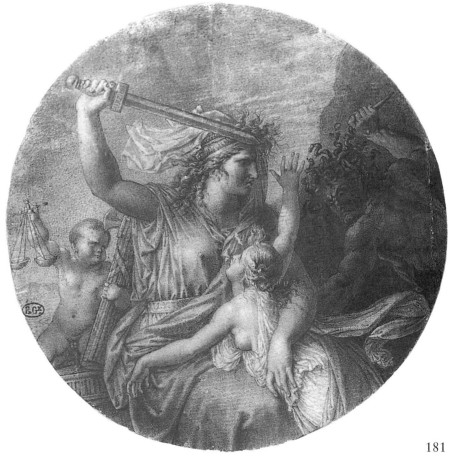

Jean-Baptiste Wicar
1762–1834

103 **Lesage-Senault**

Oil on canvas, 66.3 x 55.5 cm

J. Henri Lesage-Senault was elected as a deputy to the Convention in 1792, aged thirty. Previously he had been a tradesman in Lille. Now he played a large part on the political stage in Paris, voting for the death of the king. The portrait must date from Wicar's stay in Paris between his return from Florence early in October 1793 and his final departure for Florence in the late summer of 1795. Wicar had been deeply involved in Republican politics in Italy. In Paris he was close to David (who supported his career in many ways and secured him the position of curator at the new museum created in the Louvre) and he carried revolutionary politics into the world of art, denouncing, in his capacity as Secretary of the Société Républicaine des Arts, genre painters such as Boilly. By the summer of 1794 the political climate had changed, David had ceased to be unofficial dictator of art and Wicar's authority was also shaken. This portrait, so triumphalist in character, is perhaps of 1793 and is obviously influenced by David's self portrait of 1791 (Florence, Uffizi). Lesage-Senault is depicted by his fellow Lillois as alert, earnest, ready for action, eagerly pressing forward into our space, and not as a mere sedentary politician. Wicar after some difficulties achieved great success in his profession in Napoleonic Italy. Lesage-Senault condemned the coup d'état of 18 Brumaire by General Bonaparte and was thus excluded from government position. Exiled by the Bourbons, he died at Tournai in 1823.

NP

Bequeathed by the son of the sitter in 1860. Inv. 869.

Verly 1869, pp. 143–5 (for the sitter); Beaucamp 1939, II, p. 634, no. 38; Lille 1984, no. 3, p. 24.

Jean-Baptiste Wicar
1762–1834

104 Virgil reading the Aeneid before Augustus and Livia

Oil on canvas, 46 x 69 cm

The painting represents the power of art over the soul, also the moral stature of the poet and his eminence – a precarious eminence – at the court of the greatest ruler of the civilised world. According to the fourth-century commentary on Virgil by Tiberius Claudius Donatus, the poet read to the emperor's family from the sixth book of his epic. When he came to the famous passage 'Tu Marcellus eris', recalling the death of Marcellus on account of the intrigues of the Empress Livia, Octavia, the mother of Marcellus

and sister of the emperor, fainted. The tense, silent, moment was pre-eminently suited to the narrative painter. The limited cast, marmoreal setting and formal domesticity were highly attractive to Neo-Classical taste. The subject was enormously popular around 1800 and had been attempted by many painters, most notably perhaps by Wicar's friends Ingres and Vincenzo Camuccini. Livia suppresses her rage but reveals her guilt, the emperor halts the poet, the poet's great patron, Maecenas, rushes forward to help the fainting Octavia. Maecenas is appropriately a portrait of Count Giambattista Sommariva, the greatest art patron of Napoleonic, and immediately post-Napoleonic, Italy (see Haskell 1972 for an account of his glorious collection and shadowy life). The first, exceedingly large, version of this painting was commissioned from Wicar by Sommariva in January 1818 through the mediation of Wicar's friend Antonio Canova. It

was a great success when exhibited in Rome, Milan and Paris before being placed in Sommariva's villa at Cadenabbia on Lake Como, where it remains. Numerous preparatory drawings survive for the painting. Wicar also made two later reduced replicas of the composition, both of which he presented to his native city. One of these is a finished drawing in chalk dated 1820 (Lille 1983, pp. 213–14, no. 158) and the other is this undated oil painting. The drawing, which is squared, was certainly used by (and probably made for) an engraver; it may also have served to make the present work, which is the same size, although it has been suggested that the painting was made first.

NP

Bequeathed by the artist to the City of Lille, 1834. Inv. 442.

Dufay 1844, p. 51; Beaucamp 1939, II, pp. 498–9 and 634, no. 35; Calais etc. 1975–6, no. 77; Lille 1984, pp. 30–1, no. 11.

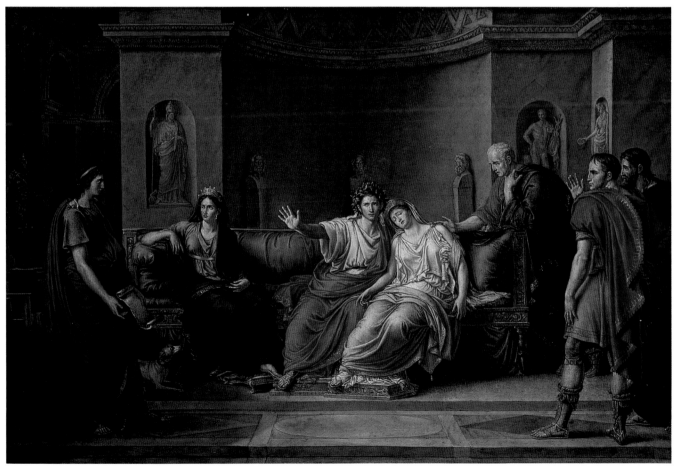

Bibliography

Books and articles

Amaury-Duval 1924
Amaury-Duval, *L'Atelier d'Ingres*,
reprinted Paris 1924.

Ananoff 1980
Ananoff, A., *L'Opera completa di Boucher*, Milan 1980.

Ananoff and Wildenstein 1976
Ananoff, A., and Wildenstein, D.,
François Boucher, Paris and Lausanne
1976, II.

Aubrun 1983
Aubrun, M.-M., 'Plaidoyer pour un
comparse(?): Louis Lamothe (1822-1869).
Chronologie critique et aspects de son
oeuvre originale', *Bulletin du Musée
Ingres*, nos. 51–2, Dec. 1983, pp. 11–51.

Bartsch 1803–21
Bartsch, A., *Le Peintre-graveur*, Vienna
1803–21.

Bazin 1973
Bazin, G., *Corot*, Paris 1973.

Beaucamp 1939
Beaucamp, F., *Le Peintre lillois Jean-Baptiste Wicar (1762–1834). Son oeuvre
et son temps*, 2 vols., Lille 1939.

Bénédite 1922
Bénédite, L., *Albert Lebourg*, Paris 1922.

Benisovitch 1958
Benisovitch, M.N., 'Une autobiographie du
peintre Louis Boilly', *Essays in Honor of
Hans Tietze*, New York 1958.

Benvignat 1856
Benvignat, Ch., et al., *Musée Wicar.
Catalogue des dessins et objets d'art légués
par J.-B. Wicar*, Lille 1856.

Bessis 1969
Bessis, H., 'L'Inventaire après décès
d'Eugène Delacroix', *Bulletin de la Société
de l'Histoire de l'Art Français*, 1969, pp.
199–222.

Bindman 1970
Bindman, D., 'Hogarth's *Satan, Sin and
Death* and Its Influence', *Burlington
Magazine*, CXII, 1970, pp. 153–8.

Boime 1986
Boime, A., 'Marmontel's *Belisaire* and
the Pre-Revolutionary Progessivism of
David', *Art History*, 1980, pp. 81–101.

Bordeaux 1984
Bordeaux, J.-L., *François le Moyne
(1688–1737) and His Generation*, Neuilly-sur-Seine 1984.

Boucher 1930
Boucher, H., 'Girodet illustrateur. A
propos des dessins inédits sur l'Eneide',
Gazette des Beaux-Arts, Nov. 1930,
pp. 303–19.

Brejon de Lavergnée 1990
Brejon de Lavergnée, A., 'Un Tableau de
Chardin pour le Musée des Beaux-Arts
de Lille', *Revue du Louvre*, 1990, pp.
353–4.

Breton 1890
Breton, J., *La Vie d'un artiste*, Paris 1890.

Brice 1987
Brice, I., 'La femme dans la peinture du
XIXème siècle. III. Les saintes femmes de
Jean-François Millet', *Gazette de l'Hôtel
Drouot*, 20 Feb. 1987.

Brière 1930
Brière, G., 'De Troy', in L. Dimier, *Les
Peintres français du XVIIIe siècle*, 2 vols.,
Paris and Brussels 1928–30, vol. 2, 1930.

Broeker 1991
Broeker, H., 'Farbraum und Bildzeit. Zur
Bildkonzeption der Stilleben Jean Siméon
Chardins', *Idea*, vol. X, 1991, pp. 103–25.

Brunel 1986 (I)
Brunel, G., *Boucher*, London 1986.

Brunel 1986 (II)
Brunel, G., *Boucher et les femmes*, Paris
1986.

Bukdahl 1980
Bukdahl, E.M., *Diderot, critique d'art*,
2 vols., Copenhagen 1980–2, vol. I, 1980.

Cailleux 1966
Cailleux, C.J., 'Four Artists in search of the
Same Nude Girl', *L'Art du XVIIIe Siècle*,
no. 16, April 1966, pp. I–V; *Burlington
Magazine*, supplement, no. 108, 1966.

Cavina 1987
Cavina, A.O., 'Le Strade per Vallombrosa,
dipinti di Louis Gauffier', *'Il se rendit en
Italie'; études offertes à André Chastel*,
Paris 1987, pp. 591–8.

Cavina and Galbi 1992
Cavina, A.O., and Galbi, E., 'Louis
Gauffier and the question of J.L. David's
"Vue présumée du jardin du Luxem-bourg"', *Burlington Magazine*, 134, Jan.
1992, pp. 27–33.

Châtelet 1970
Châtelet, A., *Cent chefs d'oeuvre du Musée de Lille*, Lille 1970.

Clément 1879
Clément C., *Géricault, étude biographique et critique*, 3rd edn, Paris 1879.

Colin 1866
Colin, G., *Constant Dutilleux, sa vie, son oeuvre*, Arras 1866.

Couper 1969
Couper, J., *Stanislas Lépine, sa vie, son oeuvre*, Paris 1969.

Daulte 1959
Daulte, F., *Sisley*, Paris 1959.

Desnoyes 1863
Desnoyes, F., *Salon des Refusés: La peinture en 1863*, Paris 1863.

Dézaillier d'Argenville 1762
Dézaillier d'Argenville, A.-J., *Abrégé de la vie des plus fameux peintres*, 4 vols., 2nd edn, Paris 1762.

Domenici 1983
Domenici, K., 'James Gillray: An English Source for David's *Les Sabines*', *Art Bulletin*, 1983, pp. 493–5.

Du Camp 1857
Du Camp, M., *Salon de 1857*, Paris 1857.

Du Camp 1859
Du Camp, M., *Salon de 1859*, Paris 1859.

Dufay 1844
Dufay, J.C., *Notice sur la vie et les ouvrages de Wicar*, Lille 1844.

Eitner 1983
Eitner, L.E.A., *Géricault, his Life and Work*, London 1983 (1st British edn 1982).

Ewals 1987
Ewals, L., *Ary Scheffer, sa vie, son oeuvre*, Nijmegen 1987.

Foucart 1984
Foucart, B., in *Revue de l'histoire de l'église de France*, no. 184, vol. 90, 1984.

Foucart-Walter 1986
Foucart-Walter, E., *Catalogue summaire illustré des peintures du musée du Louvre et du musée d'Orsay. Ecole Française*, vol. V, Paris 1986.

Fourchaud 1891
Fourchaud, L. de, *Salon de 1891*, Paris 1891.

Fried 1990
Fried, M., *Courbet's Realism*, Chicago 1990.

Frieze 1888
Frieze, H.S., *Giovanni Dupré. With two dialogues from the Italian of Augusto Conti*, 2nd edn, London 1888.

Gautier 1866
Gautier, T., *Feuilleton du Moniteur Universel*, III, 21 June 1866.

Gérome 1973
Gérome, R., *Jules Bastien-Lepage*, thesis for the University of Nancy, II, 1973.

Gonse 1877
Gonse, L., 'Le Musée Wicar', *Gazette des Beaux-Arts*, Jan. 1877, pp. 80–95.

Gonse 1900
Gonse, L., *Les Chefs d'oeuvre des musées de France. La peinture*, Paris 1900.

Gosset 1982
Gosset, P., *Henri Harpignies*, Ghent 1982.

Grunchec 1982
Grunchec, P., *Géricault: dessins et aquarelles de chevaux*, Lausanne 1982.

Hare 1884
Hare, A.J.C., *Cities of Central Italy*, vol. II, reprinted London 1884.

Harrington 1989
Harrington, P., 'The Battle Paintings of George Jones, R.A. (1786–1859)', *Journal of the Society for Army Historical Research*, LXVII, no. 272, Winter 1989, pp. 239–52.

Harrisse 1898
Harrisse, H., *L.L. Boilly, peintre, dessinateur et lithographe. Sa vie et son oeuvre, 1761–1845*, Paris 1898.

Haskell 1972
Haskell, F., *An Italian Patron of French Neo-classic Art*, Zaharoff Lecture, Oxford 1972.

Haskell 1975
Haskell, F., 'Un monument et ses mystères. L'art français et l'opinion anglaise dans la première moitié du XIXe siècle', *Revue de l'Art*, 1975, pp. 62–76.

Henriet 1857
Henriet, F., 'Antoine Chintreuil', *L'Artiste*, 1857.

Herding 1991
Herding, K., *Courbet: To Venture Independence*, tr. J.W. Gabriel, New Haven and London 1991.

Hungerford 1979
Hungerford, C.C., 'Meissonier's "Souvenir de guerre civile"', *Art Bulletin*, LXI, June 1979, pp. 277–88.

Hustin 1893
Hustin, A., *Constant Troyon*, Paris 1893.

Jean-Richard 1978
Jean-Richard, P., *L'Oeuvre gravé de François Boucher dans la collection Edmond de Rothschild*, Paris 1978.

Johnson 1981–9
Johnson, L., *The Paintings of Eugène Delacroix. A Critical Catalogue*, 6 vols., Oxford 1981–9.

Lajer-Burchart 1989
Lajer-Burchart, E., 'Les oeuvres de David en prison: art engagé après Thermidor', *Revue du Louvre*, 1989, pp. 310–21.

Lassaigne and Patin 1983
Lassaigne, J., and Patin, S., *Sisley*, Paris 1983.

Lee 1984
Lee, S., *Jacques-Louis David and the Prix du Rome*, unpublished Ph. D. thesis for the University of Reading, 1984.

Lodge 1965
Lodge, S., 'Géricault in England', *Burlington Magazine*, CVII, 1965, pp. 616–27.

Mack 1951
Mack, G., *Gustave Courbet*, New York 1951.

Marcus 1976
Marcus, C.G., 'Les Watteau de Lille: Louis et François Watteau dits "Watteau de Lille"', *Art et Curiosité*, no. 60, Jan.–Feb. 1976.

Marmottan 1913
Marmottan, P., *Le Peintre Louis Boilly (1761–1845)*, Paris 1913.

Millar 1969
Millar, O., *Later Georgian Pictures in the Royal Collection*, 2 vols., text and plates, London 1969.

Momméja 1905
Momméja, J., 'Collection Ingres au Musée de Montauban', *Inventaire général des richesses d'art de la France, Province, Monuments Civils*, VII, Paris 1905.

Montfaucon 1719
Montfaucon, B. de, *L'Antiquité expliquée et représentée en figures*, 10 vols., Paris 1719 (supplement 5 vols., 1724).

Montgailhard 1906
Montgailhard, G. de, *Lecomte Du Noüy*, Paris 1906.

Nicolson 1954
Nicolson, B., 'The Raft from the point of

view of subject matter', *Burlington Magazine*, XCVI, 1954, pp. 241–9.

Nicolson 1978
Nicolson, B., 'Current and forthcoming exhibitions', *Burlington Magazine*, CXX, 1978, pp. 170–4.

Oursel 1984
Oursel, H., *Le Musée des Beaux-Arts de Lille*, Paris 1984.

Oursel and Scottez-De Wambrechies 1986
Oursel, H., and Scottez-De Wambrechies, A., 'Jordaens, David et Carolus Duran', *Revue du Louvre*, 1986, pp. 284–6.

Pérignon 1825
Pérignon, M., *Catalogue des tableaux, esquisses, dessins et croquis de M. Girodet-Trioson*, Sale Catalogue of 11 April 1825 and days following, Paris 1825.

Péron 1839
Péron, A., *Examen du tableau du Serment des Horaces peint par David*, Paris 1839.

Pillet 1824
Pillet, F., *Une matinée au Salon ou les peintres de l'Ecole passés en revue*, Paris 1824.

Pinelli 1992
Pinelli, A., 'Gli "Orazi" et il "Bruto" di David: Simmetrie e Ribaltamenti', *Critica d'Arte*, LVI (1992), no. 5–6, pp. 136–40.

Pluchart 1889
Pluchart, H., *Musée Wicar. Dessins*, Lille, Musée des Beaux-Arts, 1889.

Powell 1982
Powell, C., '"Infuriate in the wreck of hope": Turner's "Vision of Medea"', *Turner Studies*, vol. 2, no. 1, Summer 1982, pp. 12–18.

Pupil 1985
Pupil, F., *Le Style Troubadour ou la nostalgie du bon vieux temps*, Nancy 1985.

Ramade 1988
Ramade, P., 'Jean-Germain Drouais: recent discoveries', *Burlington Magazine*, 130, 1988, pp. 366–7.

Reynart 1872
Reynart, E., *Catalogue des tableaux, bas-reliefs et statues exposés dans les galeries du musée des tableaux de Lille*, Lille and Paris 1872.

Riat 1906
Riat, G., *Gustave Courbet, peintre*, Paris 1906.

Richon 1985
Richon, O., 'Representation, the harem and the despot', *Block*, 10, 1985, pp. 34–44.

Robaut 1885 (R Ann.)
Robaut, A., *L'Oeuvre complet de Eugène Delacroix, peintures, dessins, gravures, lithographies, catalogué et reproduit par Alfred Robaut, commenté par Ernest Chesneau*, Paris 1885.
(R Ann.: Robaut's personal copy, with annotations, Paris, BN, Estampes.)

Robaut and Moreau-Nélaton 1905
Robaut, A., and Moreau-Nélaton, E., *L'Oeuvre de Corot: catalogue raisonné et illustré, précédé de l'histoire de Corot et de ses oeuvres*, 4 vols., 1905 (supplements 1948, 1956, 1974).

Rollin 1752
Rollin, C., *Histoire romaine depuis la fondation de Rome jusqu'à la bataille d'Actium*, 8 vols., Paris 1752.

Rosenberg 1983 (I)
Rosenberg, P., *Chardin: New Thoughts*, Kansas 1983.

Rosenberg 1983 (II)
Rosenberg, P., *Tout l'oeuvre peint de Chardin*, Paris 1983.

Rosenberg 1990–1
Rosenberg, P., *Masterful Studies. Three Centuries of French Drawings from the Prat Collection*, New York, National Academy of Design, 1990–1.

Rosenberg and Schnapper 1977
Rosenberg, P., and Schnapper, A., 'Some New Restout Drawings', *Master Drawings*, vol. 5, 1977, pp. 166–73.

Rosenberg and van de Sandt 1983
Rosenberg, P., and van de Sandt, U., *Pierre Peyron, 1744–1814*, Paris 1983.

Rosenblum 1962
Rosenblum, R., 'A New Source for David's *Sabines*', *Burlington Magazine*, CIV, 1962, pp. 158–62.

Sandoz 1974
Sandoz, M., *Théodore Chassériau 1819–1856: catalogue raisonné des peintures et estampes*, Paris 1974.

Schmid 1958
Schmid, F., 'Some observations on artists' palettes', *Art Bulletin*, XL, 1958, pp. 334–6.

Schnapper 1974
Schnapper, A., *Jean Jouvenet 1644–1717 et la peinture d'histoire à Paris*, Paris 1974.

Schnapper 1991
Schnapper, A., 'Après l'exposition David.

La Psyché retrouvée', *Revue de l'Art*, no. 91, 1991, pp. 60–7.

Scottez-De Wambrechies 1988 (I)
Scottez-De Wambrechies, A., 'Boilly et Houdon: deux amis', *Connaissance des Arts*, no. 441, Nov. 1988, pp. 128–33.

Scottez-De Wambrechies 1988 (II)
Scottez-De Wambrechies, A., 'L'oeuvre dessiné de Boilly', *L'Estampille*, no. 219, Nov. 1988, pp. 32–9.

Scottez-De Wambrechies 1992
Scottez-De Wambrechies, A., 'Une richesse méconnue du musée des Beaux-Arts de Lille. La peinture française du XIXe siècle', *Le Pays-Bas français*, no. 17, 1922.

Seelig 1990
Seelig, L., 'Tableaux des néo-classicismes français et belge de la Résidence de Coblence', *Revue de l'Art*, no. 87, 1990, pp. 52–8.

Sérullaz 1963
Sérullaz, M., *Mémorial de l'exposition Delacroix organisée au Musée du Louvre à l'occasion du centenaire de la mort de l'artiste*, Paris 1963.

Shaw 1991
Shaw, J., 'The Figure of Venus: Rhetoric of the Ideal and the Salon of 1863', *Art History*, 14, no. 4, Dec. 1991, pp. 541–70.

Siegfried 1990
Siegfried, S.L., 'The Artist as Nomadic Capitalist: The Case of Louis-Léopold Boilly', *Art History*, 13, 1990, pp. 516–41.

Silvestre 1864
Silvestre, T., *Eugène Delacroix, documents nouveaux*, Paris 1864.

Sizer 1953
Sizer, T., ed., *The Autobiography of Colonel John Trumbull, Patriot-Artist, 1756–1843*, New Haven and London 1953.

Symmons 1973
Symmons, S., 'French Copies after Flaxman's Outlines', *Burlington Magazine*, CXV, 1973, pp. 591–9.

Thierry 1855
Thierry, E., 'Exposition universelle de 1855: Beaux-Arts', *Revue des Beaux-Arts*, vol. VI, 1855.

Vaughan 1979
Vaughan, W., *German Romanticism and English Art*, New Haven and London 1979.

Velghe 1989–91
Velghe, B., 'Deux petits portraits par

Louis-Léopold Boilly aux Musées Royaux de Bruxelles', *Bulletin, Musées Royaux des Beaux-Arts de Belgique*, 1989–91, pp. 381–408.

Vergnet-Ruiz and Laclotte 1962
Vergnet-Ruiz, J., and Laclotte, M., *Petits et grands musées de France*, Paris 1962.

Verly 1869
Verly, H., *Essai de biographie lilloise contemporaine*, Lille 1869.

Walch 1967
Walch, P.S., 'Charles Rollin and early neo-classicism', *Art Bulletin*, XLIX, 1967, pp. 123–6.

Wildenstein 1924
Wildenstein, G., *Lancret*, Paris 1924.

Wildenstein 1973
Wildenstein, D., and Wildenstein, G., *Documents complémentaires au catalogue de l'oeuvre de Louis David*, Paris 1973.

Exhibitions

Albuquerque 1980
French Eighteenth-Century Oil Sketches from an English Collection, Albuquerque, University of New Mexico Art Museum, 1980.

Bourg-en-Bresse 1973
Antoine Chintreuil, Bourg-en-Bresse, Musée, 1973.

Brussels 1975
De Watteau à David. Peintures et dessins des musées de province français, Brussels, Palais des Beaux-Arts, 1975.

Calais etc. 1975–6
Trésors des musées du Nord de la France II. Peinture française 1770–1830, Calais, Musée des Beaux-Arts; Arras, Musée des Beaux-Arts; Douai, Musée de la Chartreuse; Lille, Musée des Beaux-Arts, 1975–6.

Cambridge, London 1980–1
Painting from Nature, catalogue by Philip Conisbee, Cambridge, Fitzwilliam Museum; London, Royal Academy of Arts, 1980–1.

Cleveland etc. 1980–2
The Realist Tradition: French Painting and Drawing, 1830–1900, Cleveland, Museum of Art; Brooklyn Museum; St Louis Art Museum; Glasgow City Art Gallery and Museum, 1980–2.

Cologne 1897
Triumph und Tod des Heldreu, Cologne, Museen der Stadt, 1987.

Dunkerque etc. 1980
Trésors des musées du Nord de la France IV. La peinture française aux XVIIe et XVIIIe siècles, Dunkerque, Musée des Beaux-Arts; Valenciennes, Musée des Beaux-Arts; Lille, Musée des Beaux-Arts, 1980.

Fort Worth 1983
J.-B. Oudry 1686–1755, catalogue by H. Opperman, Fort Worth, Kimbell Art Museum, 1983.

Geneva 1979
Un Album de croquis d'Hubert Robert (1733–1808), Geneva, Galerie Cailleux, 1979.

Gifu, Kamakura 1982–3
Paris autour de 1882, Gifu, Museum of Fine Art; Kamakura, Museum of Fine Art, 1982–3.

Hamburg, Frankfurt 1978–9
Courbet und Deutschland, Hamburg, Kunsthalle; Frankfurt, Städtischegalerie im Städelschen Kunstinstitut, 1978–9.

Hartford etc. 1976–7
Jean-Baptiste Greuze 1725–1805, catalogue by E. Munhall, Hartford, Wadsworth Atheneum; San Francisco, The California Palace of the Legion of Honor; Dijon, Musée des Beaux-Arts, 1976–7.

Hazebrouck 1956
Peintures françaises du 19e siècle, Hazebrouck, Musée, 1956.

Ixelles 1985–6
1770–1830. Autour du néo-classicisme en Belgique, Ixelles, Musée Communal des Beaux Arts, 1985–6.

Lille 1955
Bi-Centenaire de l'Ecole des Beaux-Arts de Lille, 1755–1955, Lille, Musée des Beaux-Arts, 1955.

Lille 1974
La Collection d'Alexandre Leleux, Lille, Musée des Beaux-Arts, 1974.

Lille 1983
Autour de David: dessins néo-classiques du Musée des Beaux-Arts de Lille, catalogue by Annie Scottez-De Wambrechies, Lille, Musée des Beaux-Arts, 1983.

Lille 1984
Le Chevalier Wicar: peintre, dessinateur et collectionneur lillois, Lille, Musée des Beaux-Arts, 1984.

Lille 1985
Au Temps de Watteau, Fragonard et Chardin, Lille, Musée des Beaux-Arts, 1985.

Lille 1988–9
Boilly 1761–1845: un grand peintre français de la révolution à la restauration, Lille, Musée des Beaux-Arts, 1988–9.

London 1972
The Age of Neoclassicism, London, Royal Academy of Arts and Victoria and Albert Museum, 1972.

London, Cambridge etc. 1974–5
From Poussin to Puvis de Chavannes: a loan exhibition of French paintings from the collections of the Musée des Beaux-Arts at Lille, catalogue by Hervé Oursel, London, Heim Gallery; Cambridge, Fitzwilliam Museum; Glasgow City Art Gallery and Museum, 1974–5.

London 1978
Courbet, 1819–1877, London, Royal Academy of Arts, 1978.

London 1979–80
Post-Impressionism, Cross-Currents in European Painting, London, Royal Academy of Arts, 1979–80.

London, Mannheim 1992
Manet: The Execution of Maximilian, London, National Gallery; Mannheim, Städische Kunsthalle, 1992.

Los Angeles 1980
The Romantics to Rodin. French Nineteenth Century Sculpture, ed. P. Fusco and H.W. Janson, Los Angeles County Museum of Art, 1980.

Louisville, Fort Worth 1983–4
In Pursuit of Perfection: The Art of J.-A.-D. Ingres, Louisville, Kentucky, J.B. Speed Museum; Fort Worth, Kimbell Art Museum, 1983–4.

Marcq-en-Baroeul 1983
Dans la lumière de Corot, Marcq-en-Baroeul, Fondation Septentrion, 1983.

Montauban 1989
La Révolution funéraire, Montauban, Musée Ingres, 1989.

Montauban 1991
L'Etude pour la fête de Boileau de J.A.D. Ingres et les esquisses peintes pour l'Apothéose d'Homère, Montauban, Musée Ingres, 1991.

Montrouge 1974
Amaury-Duval, 1808–1885, Montrouge, Salle des Fêtes, 1974.

Bibliography

Moscow, Leningrad 1978–9
De Watteau à David: tableaux français du XVIIIe siècle des musées français, Moscow, Pushkin Museum; Leningrad, Hermitage Museum, 1978–9.

Moscow, Leningrad 1987
Chefs d'oeuvres du Musée des Beaux-Arts de Lille à Moscow et Leningrad, Moscow, Pushkin Museum; Leningrad, Hermitage Museum, 1987.

New Haven, Paris 1991–2
Richard Parkes Bonington: 'Du plaisir de peindre', catalogue by P. Noon, New Haven, Yale Center for British Art; Paris, Petit Palais, 1991–2.

New York, Colnaghi 1989
1789: French Art during the Revolution, ed. A. Wintermute, New York, Colnaghi, 1989.

New York 1992
Masterworks from the Musée des Beaux-Arts, Lille, New York, Metropolitan Museum of Art, 1992.

Omaha etc. 1982–3
Jules Breton and the French Rural Tradition, Omaha, Joslyn Art Museum; Memphis, Dixon Gallery and Gardens; Williamstown, Sterling and Francine Clark Art Institute, 1982–3.

Orléans etc. 1979
Théodore Caruelle d'Aligny (1798–1871) et ses compagnons, Orléans, Musée des Beaux-Arts; Dunkerque, Musée des Beaux-Arts; Rennes, Musée des Beaux-Arts, 1979.

Paris 1967–8
Ingres, Paris, Petit Palais, 1967–8.

Paris 1968
Watteau et sa génération, Paris, Galerie Cailleux, 1968.

Paris 1974–5
De David à Delacroix: La peinture française de 1774 à 1830, Paris, Grand Palais, 1974–5.

Paris, London 1975–6
Jean-François Millet, Paris, Grand Palais; London, Hayward Gallery, 1975–6.

Paris, Ottawa 1976–7
Puvis de Chavannes, 1824–1898, Paris, Grand Palais; Ottawa, National Gallery of Canada, 1976–7.

Paris etc. 1979
Chardin, 1699–1779, Paris, Grand Palais; Cleveland Museum of Art; Boston, Museum of Fine Arts, 1979.

Paris 1982–3
J.-B. Oudry 1686–1755, Paris, Grand Palais, 1982–3.

Paris 1983
Henri Lehmann 1814–1882. Portraits et décors parisiens. Paris, Musée Carnavalet, 1983.

Paris, New York 1983
Manet 1832–1883, Paris, Grand Palais; New York, Metropolitan Museum of Art, 1983.

Paris 1984–5
Diderot et l'art de Boucher à David. Les Salons: 1759–1781, Paris, Hôtel de la Monnaie, 1984–5.

Paris, Lyon 1984–5
Hippolyte, Auguste et Paul Flandrin: une fraternité picturale au XIXe siècle, Paris, Musée du Luxembourg; Lyon, Musée des Beaux-Arts, 1984–5.

Paris 1985
Oeuvres de jeunesse de Watteau à David, Paris, Galerie Cailleux, 1985.

Paris 1986
Les concours des prix de Rome, 1797–1863, Paris, Ecole Nationale Supérieure des Beaux-Arts, 1986.

Paris 1989
Maîtres français 1550–1850, dessins de la donation Mathias Polakovits à L'Ecole des Beaux-Arts, Paris, Ecole Nationale des Beaux-Arts, 1989.

Paris, Versailles 1989–90
Jacques-Louis David, 1748–1825, Paris, Musée du Louvre; Versailles, Musée National du Château, 1989–90.

Paris 1991–2
Géricault, Paris, Grand Palais, 1991–2.

Paris etc. 1991–2
Les Amours des Dieux. La peinture mythologique de Watteau à David, Paris, Grand Palais; Philadelphia Museum of Art; Fort Worth, Kimbell Art Museum, 1991–2.

Philadelphia etc. 1979
The Second Empire 1852–1870: Art in France under Napoleon III, Philadelphia Museum of Art; Detroit Institute of Arts; Paris, Grand Palais, 1978–9.

Rennes 1985
Jean-Germain Drouais, 1763–1788, Rennes, Musée des Beaux-Arts, 1985.

Rome 1981–2
David e Roma, Rome, Accademia di Francia a Roma, 1981–2.

Rome 1984
Autour de David. Disegni neoclassici del Museo di Lille, Rome, Palazzo Braschi, 1984.

Rouen 1970
Jean Restout (1692–1768), Rouen, Musée des Beaux-Arts, 1970.

Tokyo, Nagoya 1989
Delacroix et le romantisme français, catalogue by Jacques Thuillier et al., Tokyo, National Museum of Western Art; Nagoya, Municipal Museum of Fine Art, 1989.

Troyes 1989
Prédilections académiques. Peintures et sculptures du XIXe siècle des collections du musée, Troyes, Musée des Beaux-Arts, 1989.

Valenciennes 1970
Henri Harpignies, peintre paysagiste français 1819–1916, Valenciennes, Musée des Beaux-Arts, 1970.

Verdun, Montmédy 1984
Hommage à Jules Bastien-Lepage (1848–1884), Verdun, Musée de la Princerie; Montmédy, Musée, citadelle, 1984.

Warsaw 1991
Rysunki Francuskie XVII–XX Wieku, Warsaw, Muzeum Narodne w Warszawie, 1991.

Washington, Chicago 1973–4
François Boucher in North American Collections. 100 Drawings, Washington, National Gallery; Chicago, Art Institute, 1973–4.

Yokohama etc. 1991–2
La Peinture française au XIXème siècle. Le Musée des Beaux-Arts de Lille, Yokohama, Sogo Museum of Art; Hokkaido, Obihiro Museum of Art; Osaka, The Museum of Art Kintetsu; Yamaguchi, The Yamaguchi Prefectural Museum of Art, 1991–2.

Index of Works

Index of Works

Picture Credits

Amsterdam, Stedelijk Museum: Fig. 68 (photograph).

Angers, Musée des Beaux-Arts: Fig. 87. Cliché Musées d'Angers.

Birmingham, Barber Institute of Fine Arts, The University of Birmingham: Fig. 84.

Bordeaux, Musée des Beaux-Arts: Figs. 9, 12.

Brussels, Musées Royaux des Beaux-Arts: Fig. 13. Copyright A.C.L.–Bruxelles; photo: G. Cussac.

Chantilly, Musée Condé: Fig. 59. Photo: Lauros-Giraudon, Paris.

Grenoble, Musée de Grenoble: Fig. 42. Photo: Musée de Grenoble – André Morin.

Guéret: Musées de Guéret: Fig. 82.

Lille, Collection Alain Gérard: Figs. 45, 49, 51, 55, 56.

Lille, Musée des Beaux-Arts: Figs. 20–33, 35, 37, 38, 40, 43, 46–8, 52, 69, 77, 83, 85. Archives: 50, 53, 54, 57, 58.

London, Courtauld Institute Galleries (Witt No. 3973): Fig. 19.

Lyon, Musée des Beaux-Arts de Lyon: Fig. 16. Photo: René Basset.

Mannheim, Städtische Kunsthalle: Fig. 18. Photo: Ursula Edelmann, Frankfurt.a.M.

Nantes, Musée des Beaux-Arts: Fig. 36. Cliché Ville de Nantes, Musée des Beaux-Arts – Alain Guillard.

New York, Courtesy of the Frick Art Reference Library: Fig. 62 (photograph).

New York, Private Collection: Fig. 6. Photo: M. Roy Fisher Fine Arts Inc.

Omaha, Nebraska, Joslyn Art Museum: Fig. 44.

Oxford, Ashmolean Museum: Fig. 41.

Paris, Bibliothèque Nationale: Fig. 63.

Paris, Collection L.-A. Prat: Fig. 86.

Paris, Ecole Nationale Supérieure des Beaux-Arts: Figs. 34, 65.

Paris, Musée du Louvre: Figs. 1–4, 11, 14, 17, 39, 60, 61, 64, 66, 71, 73, 75, 76, 78, 80, photos: Réunion des Musées Nationaux, Paris, © photo R.M.N.; 67, photo: Witt Library, Courtauld Institute of Art, London.

Paris, Musée du Petit Palais: Fig. 13. Cliché Photothèque des Musées de la Ville de Paris; © by SPADEM 1993.

Paris, Notre-Dame-de-Bonne-Nouvelle: Fig. 15. Photo: Emmanuel Michot, Jean-Claude Loty; © Ville de Paris – S.O.A.E.

Poitiers, Collection Musée de la Ville de Poitiers et de la Société des Antiquaires de l'Ouest: Fig. 7. Photo: Musée de Poitiers, Christian Vignaud.

Pontoise, Musées de Pontoise: Fig. 79.

Potsdam-Sanssouci, Staatliche Schlösser und Gärten: Fig. 70.

Rome, Museo di Roma: Fig. 72.

Rotterdam, Museum Boymans-van Beuningen: Fig. 88.

Rouen, Musées de Rouen: Fig. 81. Photo: Ellebé.

Royal Collection: Fig. 74. Royal Collection, St. James's Palace, © Her Majesty The Queen.

Toulouse, Musée des Augustins: Fig. 5. Photo: Jean Dieuzaide.

Versailles, Musée National du Château de Versailles: Fig. 10. Photo: Réunion des Musées Nationaux, Paris, © photo R.M.N.